Manet

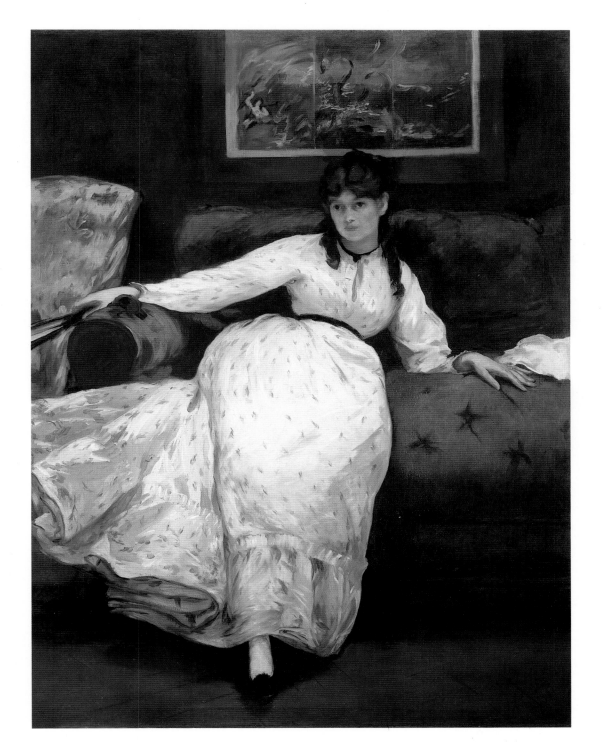

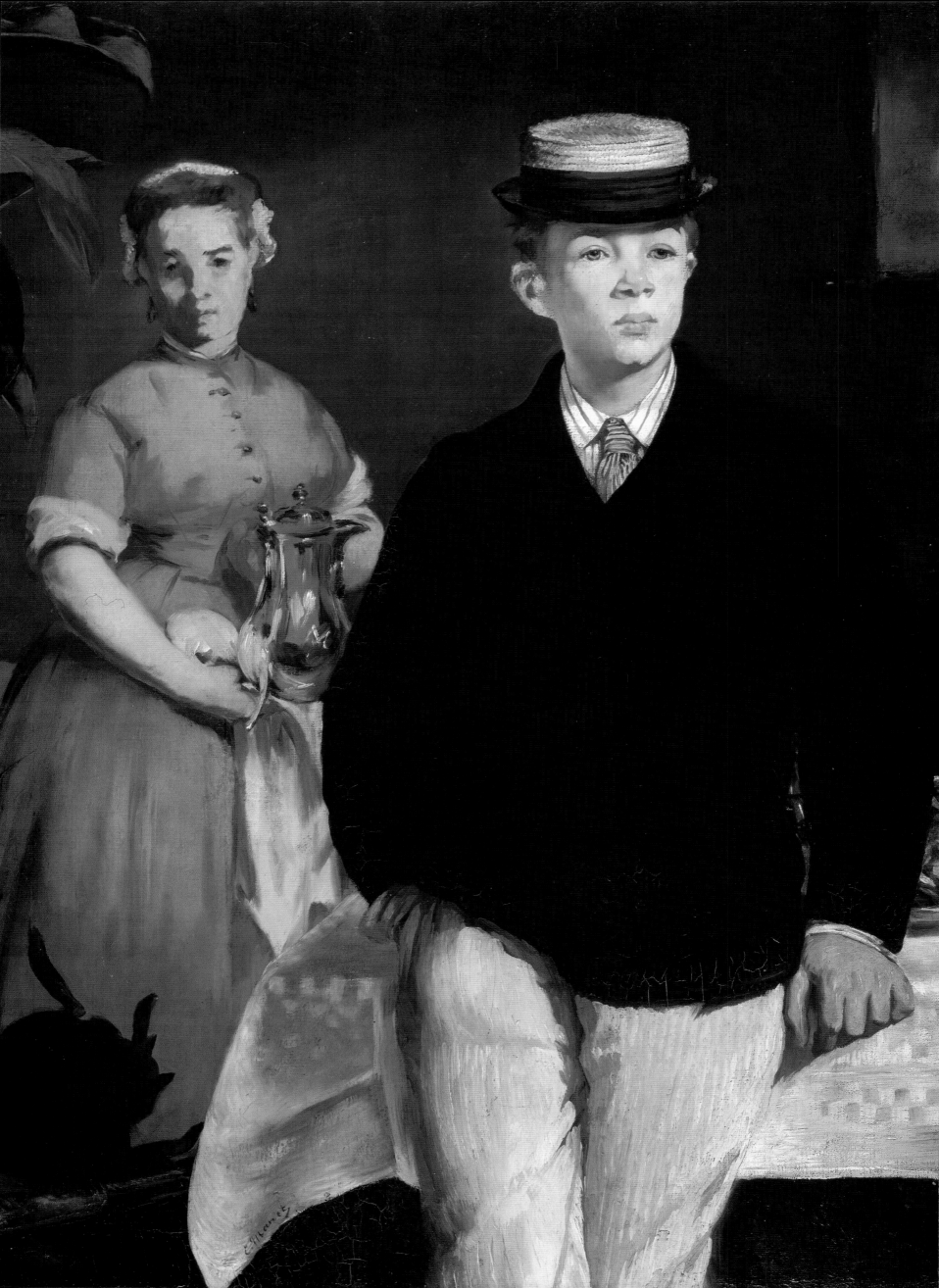

Manet

LESLEY STEVENSON

SMITHMARK

This edition published in 1992
by SMITHMARK Publishers Inc.,
16 East 32nd Street
New York, NY 10016

SMITHMARK books are available for
bulk purchase for sales promotion and
premium use. For details write or
telephone the Manager of Special Sales,
SMITHMARK Publishers Inc., 16 East
32nd Street, New York, NY 10016. (212)
532-6600.

Produced by Brompton Books Corp.,
15 Sherwood Place
Greenwich, CT 06830

ISBN 0-8317-5797-3

Printed in Hong Kong

10 9 8 7 6 5 4 3 2 1

Page 1: *Repose*, 1870
Page 2: *Luncheon in the Studio* (detail), 1868

Contents and List of Plates

Introduction

In the fall of 1912 the Cubist painters Albert Gleizes and Jean Metzinger published an essay on *Cubism* in which they attempted to validate the work of Picasso and Braque by securing it within the French tradition, tracing its lineage back to the middle of the nineteenth century and the painting of Courbet who:

inaugurated a yearning for realism which is felt in all modern work. However, he remained a slave to the worst visual conventions . . . he accepted without the slightest intellectual control everything his retina communicated . . . Edouard Manet marks a higher stage . . . We love him for having transgressed the decayed rules of composition and for having diminished the value of anecdote to the extent of painting 'no matter what.' In that we recognize a precursor . . . we call Manet a realist less because he represented everyday events than because he endowed with a radiant reality many potential qualities enclosed in the most ordinary objects.

The authors then went on to develop their argument that Cubism is an essentially realist mode of painting, by examining subsequent developments in French painting after Manet, each of which represented a successively 'higher stage': the work of Manet was followed by a cleft between the 'superficial realism' of the Impressionists and the 'profound realism' of Cézanne which in turn gave way to the realism of Cubism, based not on surface appearances but on an intellectual engagement with the subject.

The essay is important for a number of reasons: it sought to place Manet securely within the Modernist canon; it attempted to define an evolutionary theory of art, where stylistic advances made by one artist are progressively modified by subsequent artists with the pinnacle of artistic achievement being reserved for Cubism itself; and it denied that any real importance could be assigned to Manet's subject-matter – those objects that he chose to paint were merely pretexts for formal experimentation. None

of these ideas was new; they had been commonplace in the nineteenth century, and in fact some of them had been developed by Manet's earliest commentators, nor were they to lose their appeal in the twentieth century as Modernist critics consolidated the early emphasis on the innovatory quality of Manet's work.

This book will look at the problems inherent in each of these viewpoints and will investigate their enduring charm. It will question the validity of assigning Manet a central, crucial role in French painting, in which he is set apart from his contemporaries as a revolutionary but will demonstrate instead that he should be relocated within a more traditional context. It will show that subject-matter, rather than being of little consequence for Manet's work, was in fact of primary importance to him. Rather it was his early critics who in seeking to mold Manet into an artistic spokesperson for their cause deliberately misconstrued the significance of the content of his work.

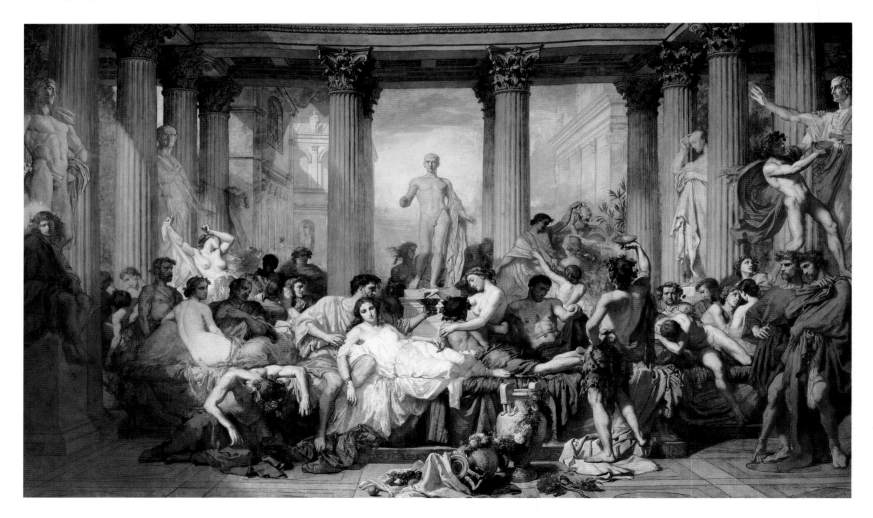

Below left: Although widely regarded as a typical, large-scale Salon painting, *The Romans of the Decadence*, 1846, by Manet's master, Thomas Couture, fused the classical and Romantic styles and introduced contemporary allusions.

Below: *Manet*, 1867, by Henri Fantin-Latour.

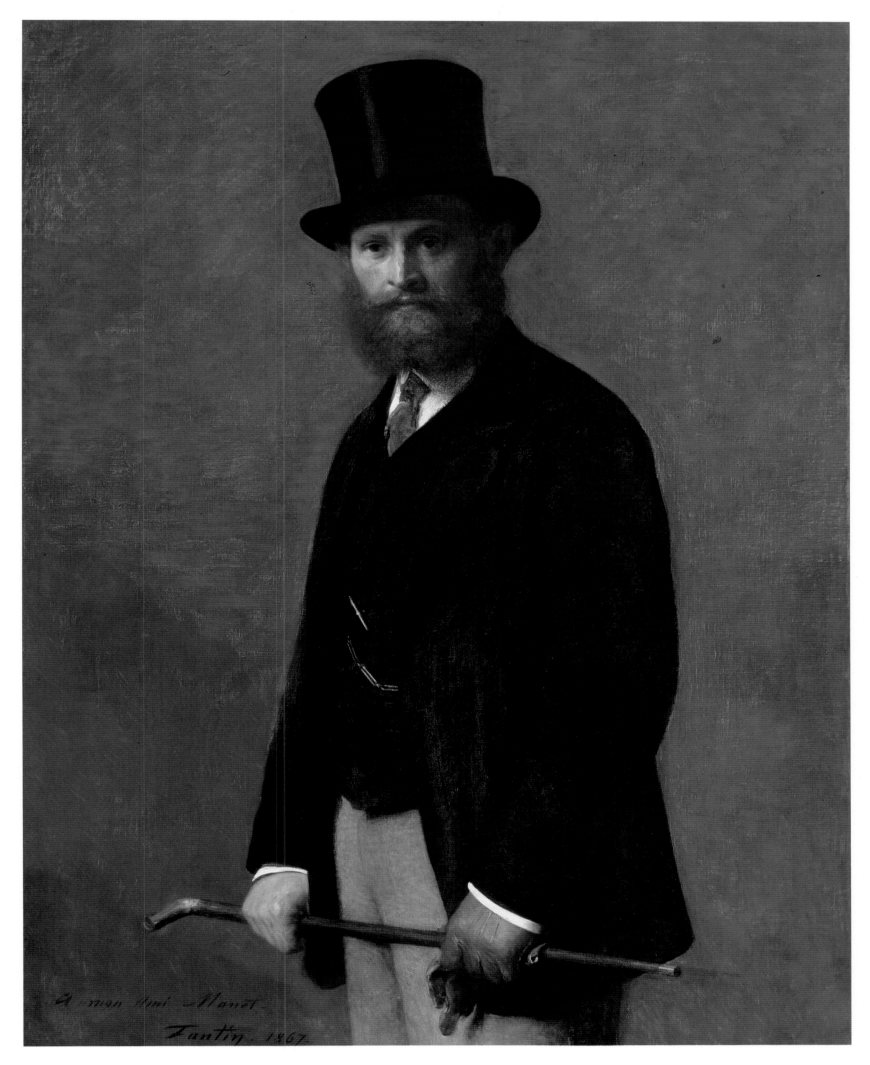

By attempting to assign to Manet the role of father of modern art, the Modernist critic has to construct an argument that is based solely on Manet's perceived stylistic innovations, wherein central place is given to the so-called 'radical' painting of the *Déjeuner sur l'herbe* (page 56) which was exhibited at the Salon des refusés, in 1863. It is suggested that that year saw a decisive break with the past in art, and the slow march toward abstraction began when Manet painted the *Déjeuner*. This notion is flawed on two counts: it denies the relevance of any happenings outside the studio door or within the artist's personality, managing to locate Manet outside society, and it suggests that his technique was in itself revolutionary. The importance of contextualization in Manet's art will be made clear by emphasizing other key works of the 1860s which focus both on his republication sympathies and his reaction to the changing face of Paris. His early career and training in the studio of Thomas Couture will indicate the importance of a traditional grounding in painting for Manet and a respect for the Salon as the proper forum for his art, which remained with him until his death.

Modernist interpretations of Manet's art draw on the notion of formalism, which suggests that the content of a work or the context in which it was produced is of little relevance and defines the painting in terms of the medium itself. The materiality of Manet's work, and its apparent insistence on the essential flatness of the medium of oil painting, is seen as being decisively new. Although artists had been interested in painterliness before Manet, it is suggested that none had been so consciously aware of the artificiality of the picture-making process. Works like the *Déjeuner, Olympia* (page 62) and *A Bar at the Folies-Bergère* (page 172) in which there is an overt engagement with the spectator, have been appropriated by Modernists as a comment on the artifice of painting itself.

Early Life

Edouard Manet was born on 23 January 1832 in Paris at 5 rue des Petits-Augustins, the eldest son of Auguste Manet (1797-1862) and his wife Eugénie-Désirée Fournier (1812-1885). The couple had two other sons, Eugène (1833-1892) and Gustave (1835-1884). Manet *père* was chief of staff at the Ministry of Justice and was decorated with the Légion d'honneur, while his wife was the daughter of a diplomat in Stockholm. The family belonged to the respectable and wealthy bourgeoisie and until he received his inheritance after is father's death, Manet's chief source of income was an allowance from his parents.

From 1844 he attended the Collège Rollin where he met Antonin Proust (1832-1905), one of Manet's earliest biographers and one of those most responsible for shaping his posthumous reputation. Proust's memoirs were serialised in the *Revue Blanche* in 1897 and as a book, *Edouard Manet, souvenirs* in 1913, and are generally regarded as the best source for Manet's own words, in view of the scarcity of letters and other primary documentation from the painter. However, their publication many years after Manet's death means that while they may give the flavor of the time and an entertaining account of Manet's general beliefs, detail is at best unreliable and the anecdotal quality of much of the work suggests an attempt at vindication in which the author carves out a niche for himself in the development of Manet's aesthetic. However Proust provides the reader with a description of Manet in his youth which is corroborated by contemporary witnesses:

Manet was of average height and very muscular. Straight-backed, well-balanced, his loose-limbed rhythmic gait gave his presence a special elegance. Though he often exaggerated his postures and affected the drawling speech of a Paris urchin, he could never be vulgar. You sensed his breeding.

After deciding on a career in the navy, Manet failed the entrance exam to the *Ecole Navale*, and went to sea in December 1848 as a cadet on board the training ship *Havre et Guadeloupe*, bound for Brazil. On his return to Le Havre, he again failed his entrance exam and was rejected for the navy. Seeing that his son could not pursue a professional career, Manet's father relented and gave his permission for him to become a painter. Around this time Manet was introduced to his future wife, Suzanne Leenhoff (1830-1906), a Dutchwoman who was employed by the family as a piano teacher.

In September 1850 Manet and Proust enrolled in the studio of Thomas Couture (1815-1879) in the rue Laval, and remained there until February 1856. Couture had opened his studio after the success of his huge painting *The Romans of the Decadence* at the Salon in 1847. The painting is typical of the kind of painting used by Modernist critics to act as a foil to the achievements of the work of Manet and the Impressionists. It appears ridiculously large at almost 8 metres in length, encumbered with spurious classical allusions and with little relevance to contemporary life. Yet it was a highly successful *machine*, popular both with the middle-classes and with the Salon jury. Even before its completion, on 25 June 1846, the work was purchased by the French state, and when it was exhibited at the following year's exhibition, it was given the place of honor in the Salon Carré in the Louvre. In fact, although it may now appear academic in both subject-matter and style, it was widely recognized at the time to attempt a fusion of the classical and

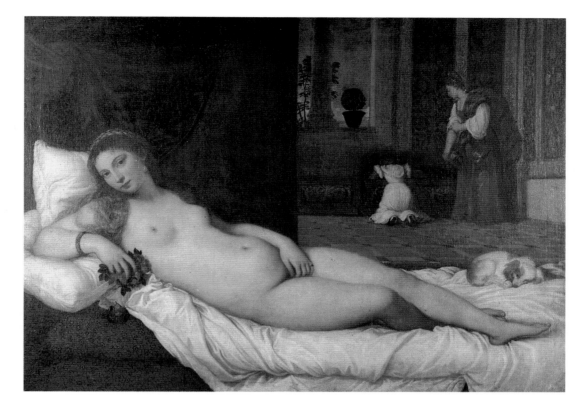

romantic styles into the so-called *juste milieu*. Much of the finish was regarded as perilously close to that of a sketch and Couture came in for some censure from more conservative critics because of his apparent abandoning of the academic reliance on the *fini*. Moreover, while the subject-matter belonged to the days of the Roman Empire, many of the people included were recognizable portraits of Couture's contemporaries and his attempt to infuse the classical with the contemporary was regarded as typical of the stylistic compromise of the *juste milieu*.

In his choice of subject-matter, Couture apparently managed to appease all classes of French society. In depicting the decline of the Roman Empire, Couture drew an analogy with contemporary French society and while conservatives could find a thinly veiled appeal for the restoration of the monarchy, radicals could read the work as a criticism of the Second Empire of Louis-Philippe and a demand for the return of the more austere virtues of the Republic. The government bought the work regardless of either of these interpretations. The middle-class browsers at the Salon and the academicians alike could relish in the frankly titillating subject-matter of the orgy and admire the center-piece of the languorous courtesan while appealing to their higher instincts, recognizing that the entire work was a large and sumptuous *vanitas*, a comment on the fragility and futility of worldy pleasures. The two figures in the right-

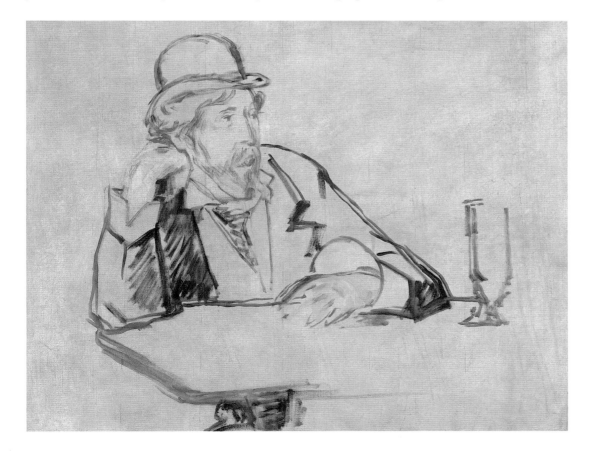

hand foreground could be construed as philosophers for whom this meaning is only too evident.

Manet would have been aware of these debates surrounding Couture's work and seems not to have hesitated about joining his studio. In doing so, he would have reconized that Couture did not offer a traditional, academic training, but instead his studio was one of a growing number of private *ateliers* in which the student was not prepared for the *prix de Rome* and the

kind of academic success that that implied, but instead was given access to the model and comment from the master at his twice-weekly visits, in return for an annual fee of 120 francs. In joining Couture's, Manet would have been aware that his was a progressive studio. Couture's often idiosyncratic pedagogy was formulated in his *Méthode et entretiens d'atlier*, published in 1868, in which he bemoaned the fact that art had become 'small and commercial.' By the time of the book's publication, some twenty years after his greatest success, the smaller, more intimate 'dealer pictures' had become more commonplace, but Manet's continued allegiance to the Salon demonstrated that in fact many of his artistic beliefs corresponded with those of his teacher.

According to Proust, Manet's time in Couture's studio was fraught with ideological clashes with his master. His *Souvenirs* are full of anecdotal incidents relaying Manet's disdain for Couture's outmoded principles. The painter apparently complained:

I don't know why I come here; everything that meets the eye is ridiculous. The light is wrong, the shadows are wrong. When I arrive here I feel as if I were entering a tomb. I am perfectly aware you can't undress a model in the street, but there's always the country: in summer at least one could do studies from life in the fields, since the nude it seems is the beginning and the end of art.

Proust's writing often seems to profit from the value of hindsight. In a recollection

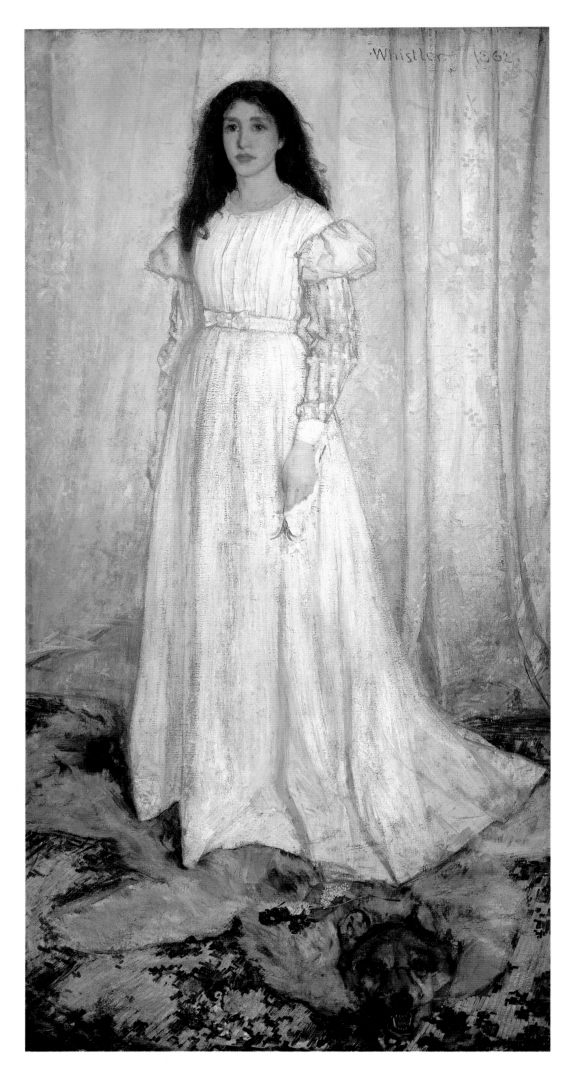

Below: *The White Girl*, 1862, by Whistler, exhibited at the Salon des refusés in 1863.

such as this, Manet has become a kind of proto-impressionist, abandoning the studio for sketching in the open air, a practice in which he rarely indulged. The idea of a painting of a nude in the countryside is reminiscent of what is now regarded as Manet's first important painting *Le Déjeuner sur l'herbe* (page 56), but which was begun over six years after Manet had left Couture's *atelier* and therefore far from being contemporary with this reminiscence.

Much of the tuition Manet received at Couture's studio was similar to what he would have received in any studio at the time, with an emphasis on copying from the model, close observance of the old masters in the Louvre, and above all attention to drawing as the basis for painting; but in other ways Couture was far from being an orthodox teacher. The spontaneity and originality of the sketch was fundamental to the outcome of the finished work, Couture believed, and its freshness should be retained in the finished painting, as he himself had demonstrated in the *Romans*, where certain passages are very broadly handled indeed. In some places, the underpainting, or *ébauche*, was still quite visible and influenced the appearance of the final work. In the *Entretiens* Couture advised his pupils to rely on 'a few rapid strokes, your own observations and notes made under the heat of your impressions . . .'

Manet observed this advice and indeed was frequently criticized for it in his Salon paintings, but when he or the impressionist painters allowed the material procedures of their works to remain visible they were criticized as revolutionaries. Eventually, that same 'revolutionary' practice, which was in fact far from new, became one of the talismanic qualities for Modernist critics who found in it an originality that seemed lacking in works with a more academic surface finish.

Following Couture's advice, Manet studied the masters, and his earliest extant works are all copies of their work. Early examples include works after Titian, especially his *Venus of Urbino* (page 9) which Manet copied in the Uffizi; Delacroix's *The Barque of Dante* (page 26), then in the Luxembourg, and Giorgione's *Concert Champêtre*, then in the Louvre.

The Salon

In 1859, three years after leaving Couture's studio, Manet produced *The Absinthe Drinker* (page 27), his first work destined for the Salon. This Parisian exhibition had

been established in 1663 as part of the decree founding the Royal Academy of Painting and Sculpture and had held its first exhibition ten years later. Until the revolution, only members of the Royal Academy were eligible to show their works at the Salon, but in 1791 the National Assembly had opened it to all artists who had wished to exhibit. During the nineteenth century, this open-door policy had been strictly controlled by a conservative jury, many of whose members had been appointed by the government. This policy of direct government interference meant that the arts in France were much more directly controlled by the State than elsewhere and the highest honors at the Salon tended to be reserved for those sympathetic to the government of the day. In addition, the self-perpetuating nature of the selection and awards meant that even when the administration of the Salon was overhauled in 1863, and a Republican government was in control in the 1870s, much of the work was artistically conservative.

Despite the support of Delacroix who was on the jury, *The Absinthe Drinker* was refused and it was two years before Manet could have a second attempt at the Salon. In 1861 he hedged his bets and submitted two works which were quite different in character. Hidden behind the title of the *Portrait of M and Mme M* (page 31) was a double portrait of the artist's parents, while his other submission was a lively genre painting entitled *Espagnol jouant de la guitare* (page 33). This work was at first hung near the top of the wall in the poorly lit Palais de l'Industrie where the Salon had been held since 1855, but such was the interest in it that it was moved to a more favourable position and earned Manet an honorable mention. *The Spanish Singer*

brought him to the attention of a number of critics, including Théophile Gautier who wrote in the *Moniteur universelle* on 3 July 1861:

Caramba! Here is a *Guitarero* who hasn't stepped out of the Opéra-Comique, and who would appear incongruous in a romantic lithograph. But Velasquez would have given him a friendly wink, and Goya would have asked him for a light for his *papelito* . . . There is a great deal of talent in this life-sized figure, broadly painted in true color and with a bold handling.

The debt to Spanish art was evident in the work and appeared to lend its realism a pedigree by claiming descent from Velázquez and Goya while the realist subject-matter was enhanced by its broad treatment, which in part derived its fluency from the retention of sketch-like passages, most evident in the guitar-player's linen. However this self-conscious quotation from other artists and the insistence on a broad treatment in order to enhance the realist subject-matter, were subsequently cause for criticism in Manet's next submission to the Salon in 1863, the *Déjeuner sur l'herbe*. However in 1861, at the age of 29, it looked as if Manet's career at the Salon was guaranteed.

From his first attempt with *The Absinthe Drinker* in 1859 until his death in 1883, there was a total of 21 Salons and Manet submitted works to all but two of these, demonstrating his allegiance to it as the main battleground for artists at the time. Despite the fact that unlike many of his contemporaries Manet did not have to use the Salon in order to attract commissions or to sell his works since he had a private income, he chose not to join the Impressionists at their independent exhibitions in the 1870s, presumably since to have aligned himself with these younger artists

would have demonstrated a rupture with the ideals of the Salon.

Modern Life

In 1862, the year following his early Salon success, Manet included five etchings in the first publication of the Société des Aquafortistes, which was promoted by the dealer and print publisher Alfred Cadart. Intended to encourage a revival in etching, other artists in the group included Bracquemond, Fantin-Latour, Ribot, Legros, Daubigny, and Jongkind. Manet's main work was *The Gipsies*, a large print, freely executed after an oil painting, which was subsequenly cut up by the artist. Like *The Spanish Singer* and *The Absinthe Drinker* the subject-matter was drawn from contemporary urban life, a theme which was increasingly to preoccupy Manet in the 1860s.

From 12 August until 2 November that same year, a troupe of Spanish dancers was appearing at the Hippodrome in Paris and Manet invited some of them to pose for him in the painter Alfred Stevens's studio (pages 49 and 55). The vogue for things Spanish had started with the romantic writers, notably Hugo and Gautier, in the previous generation and had been taken up by the general public. Until 1838 very few Spanish paintings were on display in the Louvre, but that year Louis-Philippe had mounted a special exhibition of some 500 works from his 'Spanish collection,' which had been acquired in Spain during the Carlist wars and which had been further augmented by the bequest of the Englishman Frank Hall Standish in 1842. Although Louis-Philippe regarded this as his personal collection and retained it after his abdication, Manet had seen it in the Louvre as a youth when he made sketches after a number of the works. The French

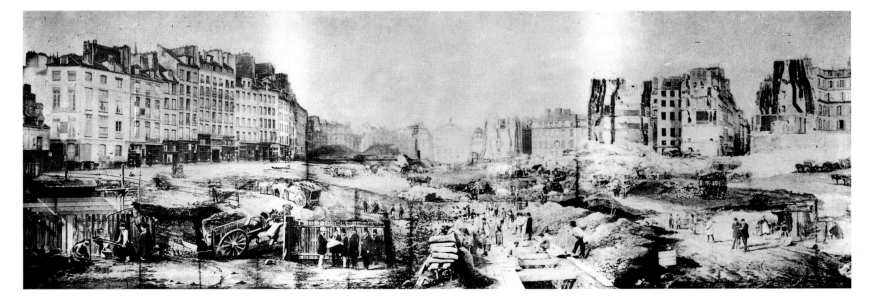

hispagnolisme had been further fuelled when Napoleon III had married a Spanish woman in 1853, and the popularity of the Spanish ballets in Paris in the 1860s attests to an enduring taste which Manet shared with the general public.

Technically, Spanish works were important for the formation of his style at this time and mark an alternative tradition to that which he had learned at Couture's in the 1850s. His broad paint application, as well as stemming from the practice of the *ébauche*, also derived from the kind of visual shorthand developed by Spanish artists like Goya and Velázquez, as did his appreciation of the use of black and gray as positive colors, a practice Manet upheld until the end of his life, even when their use was being eschewed by the orthodox impressionists.

However it was not simply an engagement with things contemporary that demonstrated Manet's allegiance to the depiction of modern life. Instead, his understanding of what constituted 'la vie moderne' embraced a wider appreciation of the social effects of living in Paris in the mid-nineteenth century. Implicit in many of his works is an acknowledgment of the effects of Haussmann's rebuilding of Paris and the encroaching industrialization and its effects on the poor and dispossessed who were increasingly marginalized by an expanding bourgeoisie, to which Manet belonged.

The demographic reasons for the rebuilding of Paris were evident enough: the city's population had doubled in the twenty years before Napoleon III seized power to just over 1 million inhabitants in 1851. Much of this was due to industrialization, with an influx of immigrant labor coming to the capital from the provinces in search of work in the new factories. Napoleon III's administration merely accelerated and centralized economic changes that had been happening before this time, albeit in a piecemeal fashion. The chief architect of the new Paris was Baron Georges-Eugène Haussmann (1809-91), préfect of Paris from 1853 until the collapse of the Second Empire in 1870. During his administration, France was modernized into a capitalist economy, which could compete with other European nations in trade, industry, and culture. Paris became increasingly wealthy and instead of being a city full of insanitary streets and buildings, became light and airy with improved sanitation, good communications, street lighting and open green spaces.

However, the political, social, and cultural penalties for such a dramatic transformation were enormous. As old streets and houses were demolished, whole communities were unsettled and forced to move to the outskirts of the city where the new factories were located, often living in makeshift, squalid dwellings far from their traditional roots. It has been estimated that although the new building program pro-

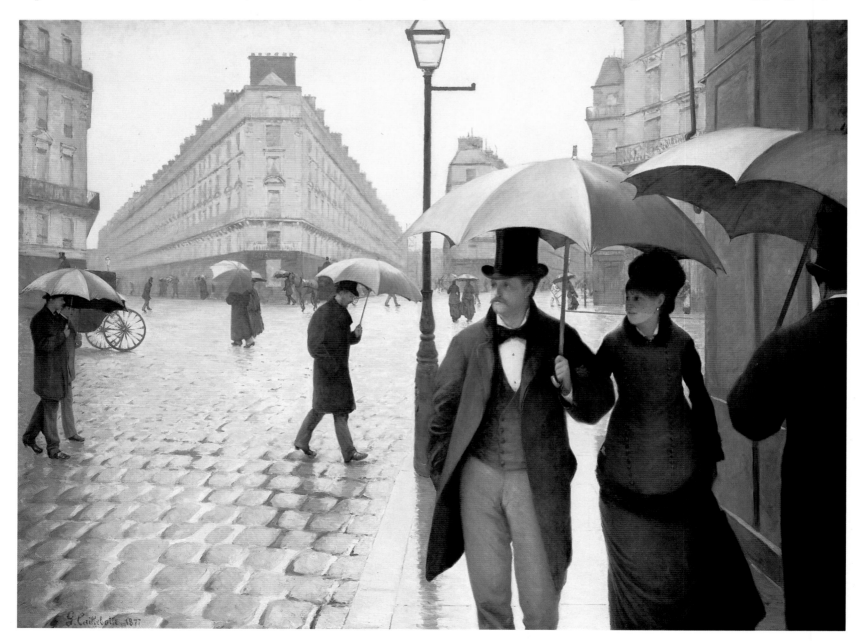

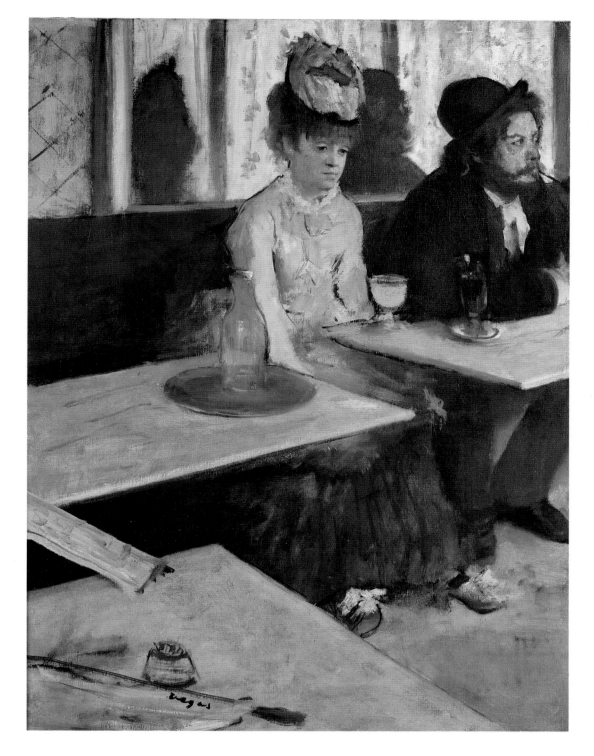

vided jobs for one in five Parisians at its height, it effectively displaced 350 000 people. And while the new, broad boulevards encouraged the growth of shops and cafés on their sidewalks, it was undeniable that one of Napoleon III's political stratagems in building them was to put an end to the type of popular insurrection that had contributed to his coming to power. The erection of barricades which had characterized the uprisings that had punctuated Parisian life from 1789 would be much more difficult in the future, while the charge of mounted police and troops brought in to quell any revolts could only be much easier. While the upper classes prospered and benefitted from Haussmann's sweeping changes, many of the poor lived on the brink of starvation.

Manet's first major painting that deals with this new Paris was *The Old Musician* (page 42). It is a huge work, almost 2½ metres in length with its strange assortment of life-size figures. Its ambitious scale and subject-matter suggest a Salon painting, but in the event it was never exhibited there. It was painted in Manet's Batignolles studio on the rue Guyot, an undeveloped site near Petite Pologne which was infamous for the type of 'bohemian' figures depicted in the work. In fact Manet used a series of well-known figures to model for the generic 'types.' The old musician himself was posed by Jean Lagrène, a gipsy who lived in the area and who made his living as an organ grinder, while the model for the figure behind him was Colardet, the ragpicker who had posed the *The Absinthe Drinker*. The abruptly attenuated figure to the right-hand side is probably to be identified as a wandering Jew. All of the figures, including the four children, would have been recognized as living on the fringes of society. The quotations and references to other artists' work are manifold and include references to the French Le Nain brothers and Watteau and to Goya as well as to an evident borrowing from his own painting of the *Absinthe Drinker*. Manet has frequently been criticized by Modernist writers for his apparent inability to compose all these disparate references into a convincing whole and this has been taken as demonstration of his lack of concern for the traditional skills of composition. However, to say this is to fail to appreciate Manet's equally important debt to popular culture, to contemporary illustrations of 'types,' such as those illustrated in *Les Français peints par eux-mêmes*. These references to popular imagery, previously ignored or spurned by 'high' art practice,

help to contribute to the sense of modernity in this and similar works. The sense of frozen dislocation evident in the figures means that what starts off as a simple genre scene transcends the limitations of its subject and becomes a comment on the plight of the impoverished in Paris at this time.

Rather than attempting to display the work at the Salon, which was perhaps its natural home, Manet opted instead to exhibit the work in the gallery of Louis Martinet (1810-94) on the boulevard des Italiens along with thirteen other of his paintings in March 1863. One of these was *Music in the Tuileries*.

More demonstrably 'modern' than any of his previous paintings, the *Music in the Tuileries* (page 50) eludes categorization. It has the epic sweep of a history painting, with overtones of Couture's *Romans* but with neither its scale nor moralising subject; it has the informality and the intimacy of a genre painting and the sense of this being a ritualized activity lends credence to

that view of the work, yet at the same time it works also as a group portrait in the tradition of Rembrandt or Hals, drawing together disparate members of a class and uniting them on the canvas. The whole has the immediacy and spontaneity of a slice of life, yet it is demonstrably inauthentic, for it is clearly a studio painting pieced laboriously together from a series of images, perhaps photographs, of Manet's friends and colleagues. Included in the scene are Baron Taylor, who had been responsible for obtaining Louis-Philippe's collection of Spanish paintings; the painter and printmaker Fantin-Latour; Manet himself and his brother Eugène; the composer Offenbach and the writer Baudelaire.

Manet and Charles Baudelaire (1821-67) had met a few years before, probably in 1859 and at a time when the poet was notorious for his poems, the *Fleurs du Mal*, six of which had been suppressed on the grounds of obscenity in 1857. Much of Manet's work while not overtly acknow-

Right: A photograph of Charles Baudelaire (1821-67), taken in 1865.

Below: Constantin Guys' *Two Women in a Calèche*, c. 1858.

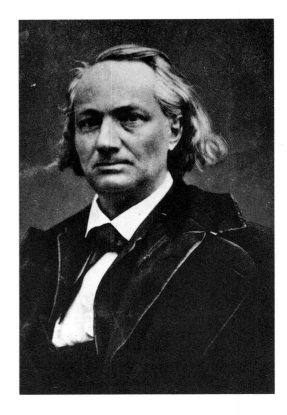

ledging these poems as sources, is redolent with their imagery and mood of depravity and corruption. His earliest Salon painting *The Absinthe Drinker* had been Baudelairean in mood and according to Proust, he was actually in the poet's company when he learned of its rejection by the jury.

The fairly specific notions about the representation of modern life which were addressed by the realist painters from the 1840s were schematized by Baudelaire in a series of Salon reviews. At his Salon début in 1845 he concluded his series of articles by making a plea

no one pays any attention to the wind which will blow tomorrow; and yet the heroism of *la vie moderne* surrounds us and presses us onward. Our true feelings choke us before we recognize them . . . He will be the painter, the true painter, who will know how to extract from daily life its epic quality, and makes us see and understand, with color and drawing, how great and poetic we are in our neckties and varnished boots . . .

His following year's Salon review was more explicit in its codification of 'the heroism of modern life,' and in fact his final article took that as its title and theme

All beauty contains . . . something of the eternal and something of the transitory – of the absolute and of the particular. Absolute and eternal beauty does not exist, or rather it is only an abstraction skimmed from the general surface of diverse beauties. The particular element of each beauty comes from the passions and as we each have our personal passions, we each have our own beauty.

These ideas were further elucidated in an extended essay which Baudelaire published in *Le Figaro* on 26 and 29 November and 3 December 1863, entitled 'The Painter of Modern Life.' In fact, the articles had been written between November 1859 and February 1860 and there is evidence to suggest that Manet had access to them then. Moreover 'The Painter of Modern Life' was a continuation of Baudelaire's earlier Salon criticism with which Manet would have been familiar. Ostensibly a piece about the French illustrator, Constantin Guys (1805-92), whom Baudelaire refers to throughout as 'M G,' the essays are in fact prescriptive in their intention, enjoining painters to deal with contemporary themes, distilling the essential beauty from apparently pedestrian subject-matter.

Guys had been a member of staff for the *Illustrated London News* for whom he had covered the Crimean War, working rapidly in pen and ink, and catching the fleeting impression. Manet himself subsequently owned 60 of Guys' works.

Devoting chapters to subjects like 'The dandy,' 'Women and prostitutes' and 'In praise of cosmetics,' Baudelaire recommended the depiction of recognizable Parisian 'types,' dressed in contemporary clothing and depicted in an urban setting. In retrospect, many of Manet's paintings, including *The Absinthe Drinker, The Spanish Singer*, the works dealing with the Spanish dancers, *The Old Musician* and

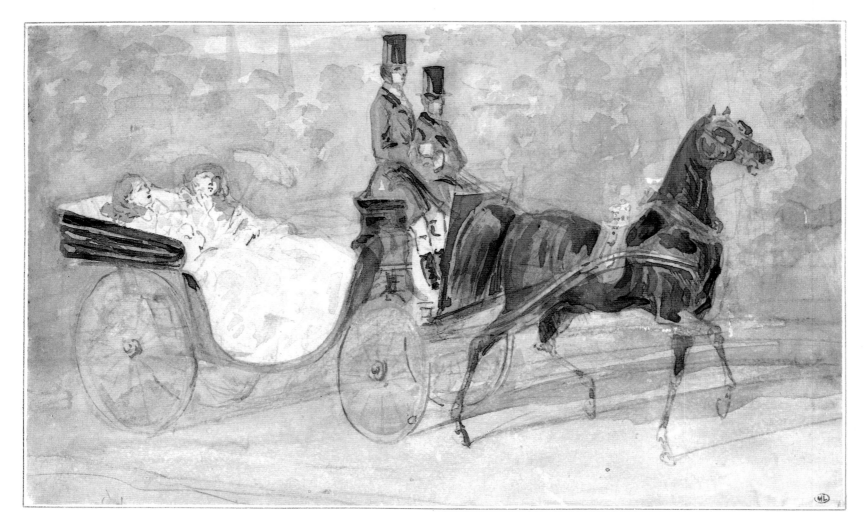

Music in the Tuileries, seem to come close to answering Baudelaire's demand for a painter of modern life.

The Salon des refusés

Manet submitted six works to the Salon jury in 1863 including three etchings: *Philip IV, after Velasquez, Little Cavaliers after Velasquez,* and *Lola de Valence*; and three oil paintings: *Mlle V in the Costume of an Espada* (page 49), *Young Man in the Costume of a Majo* (page 55), and *Le Bain,* subsequently retitled *Le Déjeuner sur l'herbe* (page 56). All six works were refused, along with an unprecedented number of other works. The outcry that resulted from this wholesale rejection of works reflected the emphasis which artists placed upon the biennial Salon in securing their sales, since there were very few dealers in Paris during the Second Empire. In a grandiose gesture, the Emperor issued a decree in the official government newspaper, *Le Moniteur universal,* on 24 April 1863 declaring that there would be an alternative to the Salon – the Salon des refusés – in which the rejected works would be displayed and which would enable the public to judge the jury's original decision for themselves. As a political gesture, it was typical of Napoleon III – it cost him little yet it enabled him to appear magnanimous and impartial, but was designed to exonerate and indeed support the jury which was sympathetic to his regime.

Recognizing the cynical manipulation of this counter Salon, or perhaps because they did not wish to branded as 'rejected,' a number of painters and sculptors withdrew their works. The *livret* for the Salon des refusés lists only 781 works, although of the initial 2800 which had been refused, just under half were finally included in the exhibition, which opened on 15 May 1863, two weeks after the Salon proper. Among those who allowed themselves to be held up to public scrutiny were Fantin-Latour, Cézanne, Whistler with his *White Girl* (page 10) and Manet with his six works.

The critics were uncomplimentary about the exhibits or chose to ignore them, although few were as harsh as Maxime Du Camp writing in the *Revue des deux Mondes*:

This exhibition, at once sad and grotesque, is one of the oddest you could see. It offers abundant proof of what we knew already, that the jury always displays an unbelievable leniency. Save for one or two questionable exceptions there is not a painting which deserves the honor of the official galleries ... These, then,

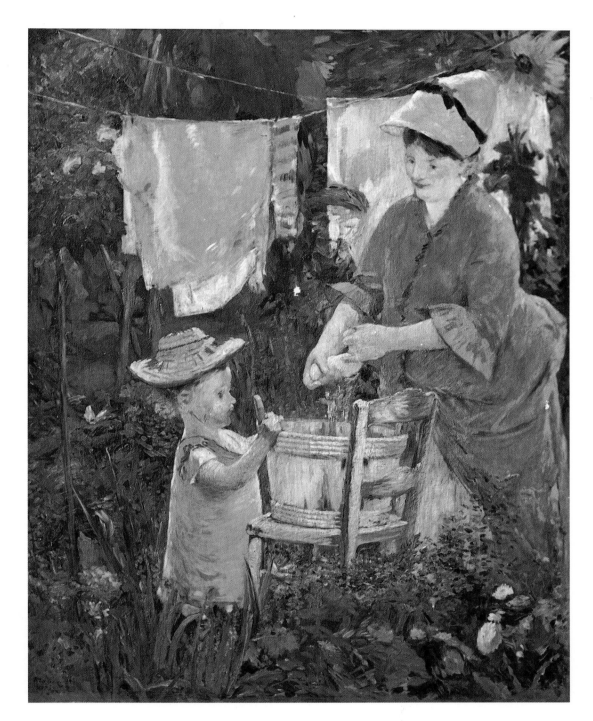

are the unrecognized geniuses and their productions! These are the impatient painters, those who complain, who rail at men's injustice, at their hard lot, who appeal to posterity! ... [The jury] can be thanked for having tried to spare us the sight of such lamentable things.

Manet's three canvases were displayed together. The *Young Man in the Costume of a Majo* hung to the left of the *Déjeuner*, while *Mlle V in the Costume of an Espada* hung on its right. Although the two costume pieces were reworkings of Spanish themes, akin to *The Spanish Singer*, and the *Déjeuner* drew on a number of prototypes, including Giorgione and Marcantonio Raimondi, all came in for censure from the critics. It was, however, *Le Déjeuner sur l'herbe* which was most ridiculed. Ostensibly a traditional

theme of male figures accompanied by two nymphs within an arcadian setting, the modernity of the subject was not lost on contemporary commentators. Louis Etienne recognized that the main nude was in fact a 'commonplace woman of the demi-monde, as naked as can be [who] lolls shamelessly between two dandies ...' Although Baudelaire's essay was not to appear until later that same year, two of the 'types' he had recommended as being suitable for the artist's attention are combined in this work. By apparently trying to validate such an immoral subject by references to old masters, Manet managed further to incur the anger of his detractors.

It has long been suggested that the Salon des refusés saw the birth of modern art – that it was somehow the start of a heroic movement, and Manet epitomized a revo-

lutionary fervor by exhibiting there. This is to overlook the facts of the case. The Salon des refusés was not an independent exhibition organized by the artists themselves like the first Impressionist exhibition of 1874; instead it was an attempt by the government to vindicate its selection procedure at the Salon. Manet did not choose to be excluded from the official Salon – it seems safe to assume that after the success of *The Spanish Singer* he must have been confident of being accepted in 1863. The 'radical' subject and technique of *Le Déjeuner sur l'herbe* have both been overestimated and in fact were simply a continuation of ideas and methods that had preoccupied him earlier in his career. Nor did Manet become a figurehead of an avant-garde which sought a rupture with the official Salon. Until the end of his life he continued to produce larger-scale works, painted in the studio which sought a reconciliation between the traditional works of the old masters and 'la vie moderne' and which were submitted to the Salon. Certainly Manet became better known than he had been before 1863, but already he had achieved a degree of success in getting an honorable mention at the age of 29 and by having a one-man show at Martinet's gallery. One positive outcome of the counter exhibition of 1863 was that the government had to accede to a number of reforms concerning the administration

of the Salon, the most far-reaching of which was that after 1863 exhibitions were held annually.

In October 1863 Manet married Suzanne Leenhoff at Zaltbommel in the Netherlands. Why he should have waited so long to marry her since they had been living together for some time, may perhaps be explained by the fact that Manet's father had died in the fall of 1862. Suzanne Leenhoff had given birth to an illegitimate son Léon-Edouard Koëlla (1852-1927) whom she introduced in company as her younger brother. It was generally accepted at the time and by later commentators that Léon was Manet's son and certainly Manet cared for him as a father and left him provided for in his will. The true nature of his clandestine relationship with Suzanne and Léon could not be admitted to his eminently respectable bourgeois father. It has recently been suggested, however, that Léon was in fact the son of Manet's own father, which would explain not only his protective attitude towards Léon but also his reluctance to marry Suzanne Leenhoff until after his father's death.

At the Salon of 1864 Manet, in characteristic fashion, covered himself by submitting two works of quite different subject-matter. The first of these was *Incident in a Bull Ring*, of which only fragments now remain, including *The Dead Toreador* (page 66), and *The Dead Christ with Angels*

page 63). The former was yet another scene of Spanish life, while the latter was a far-from-convincing religious work. Neither work met with much critical success and certain inaccuracies in *The Dead Christ*, most notably the wound on his left rather than on his right-hand side and the obvious corporeal nature of the two angels, led to speculation that Manet had been influenced by Ernest Renan's enormously successful *La Vie de Jésus* which had been published the previous year and which had sought to demystify Christ, making him into an historical figure.

In 1865 Manet again submitted a painting of modern life to the Salon along with another religious work which was presumably intended to mitigate the subject-matter of the courtesan in his *Olympia* (page 60). In some respects *Christ Mocked* (page 69) may be read as a transformation of *Olympia*. The traditional male heroic nude is in the female form an equally conventional reclining Venus, who owes much to Titian's *Venus of Urbino* (page 9) which Manet had copied in Florence in 1853 or 1856. In *Christ Mocked* the religious figure owes more to Renan than to an idealized vision of Christ, but in traditional fashion, the Roman soldiers wear modern clothing, effectively making the message of relevance to contemporary viewers. Once again, the model Janvier posed for the central figure of Christ.

Similarly *Olympia* was a curious blend of the traditional and the modern. Each of the main ingredients within the painting – the recumbent nude, the black servant, the cat and the prominent still-life details – were reworkings of Titian's subject-matter. Equally each of these owed something to Baudelaire: the courtesan and her cat are recurring motifs in his poetry and the black woman suggests a highly romanticized view of exotic lands. The defiant gestures of the nude and her evident unwillingness to conform to the bourgeois norms surrounding the 'fallen woman' made her into a graphic evocation of Baudelaire's prostitute as a 'woman in revolt against society.'

Contemporary critics recognized that Olympia was a courtesan and Gustave Geffroy's review in *La Vie Artistique* acknowledged her specifically modern appearance:

Olympia is a Parisian prostitute, the first who has appeared thus in the painting of our time . . . [Manet] has created a woman who embodies the habits of our city, the appearance of a class.

In many ways *Olympia* may be read as a conceptual pendant to *Le Déjeuner sur l'herbe* (page 56): both deal with the traditional subject-matter of the female nude, but rework it in Baudelairean terms as a prostitute, bringing it defiantly up to date.

In comparison with the acceptable face of the Salon nude – and the success of the 1863 Salon, Cabanel's *Birth of Venus* (page 17) must have been one of Manet's many artistic influences – *Olympia* is an ironic comment on the Salon nude itself. There is also a homage to Couture's *Romans of the Decadence* (page 6) in his using the female nude synecdochically to embody the decline of a society, but whereas his master's work was couched in euphemistically distant terms, Manet's had the uncomfortable proximity that might have been construed as threatening. Critics fell back on to a vocabulary normally reserved for male disapproval of the female prostitute and wrote of Manet's handling as being unclean and dirty, displacing their disgust at the subject-matter on to the technique itself. It is precisely that apparently 'revolutionary' technique, specifically the absence of half-tones, which subsequent critics regarded as being innovatory in Manet's work generally, adopting the language of the critics of 1865 while failing to question why is was used. Nor did they recognize that similar handling, characteristic of the *ébauche*, had been common practice before this time, evident even in the enormously successful *Romans of the Decadence*.

By 1865 Manet had painted the two key works, *Le Déjeuner sur l'herbe* and *Olympia*,

which was to make him the darling of Modernist critics. Both have similar subject-matter and both found little support from the conservative critics of the 1860s. However after this date the genre vanished from Manet's work and he did not paint another female nude for almost ten years. The prostitute did not reappear as the subject of a painting until *Nana* (page 141) in 1877. After the two religious paintings, *The Dead Christ with Angels* and *Christ Mocked,* Manet never returned to a representation of the male nude.

Emile Zola

Manet's Salon submissions in April 1866 were two life-size paintings, one of the actor Philibert Rouvière as Hamlet, later renamed *The Tragic Actor* (page 71), and *The Fifer* (page 73). Both paintings were refused despite their apparently innocuous subject-matter. Not only was this a blow to Manet's hopes for any sales resulting from an exhibition of his work, but he was further denied any kind of publicity in the press that might have been generated from his inclusion at the Salon. However Manet's cause was taken up by the writer Emile Zola (1840-1902) who had visited his studio in February with the painter Antoine Guillement and who was then art critic for *L'Evénement*, writing under the pseudonym 'Claude.'

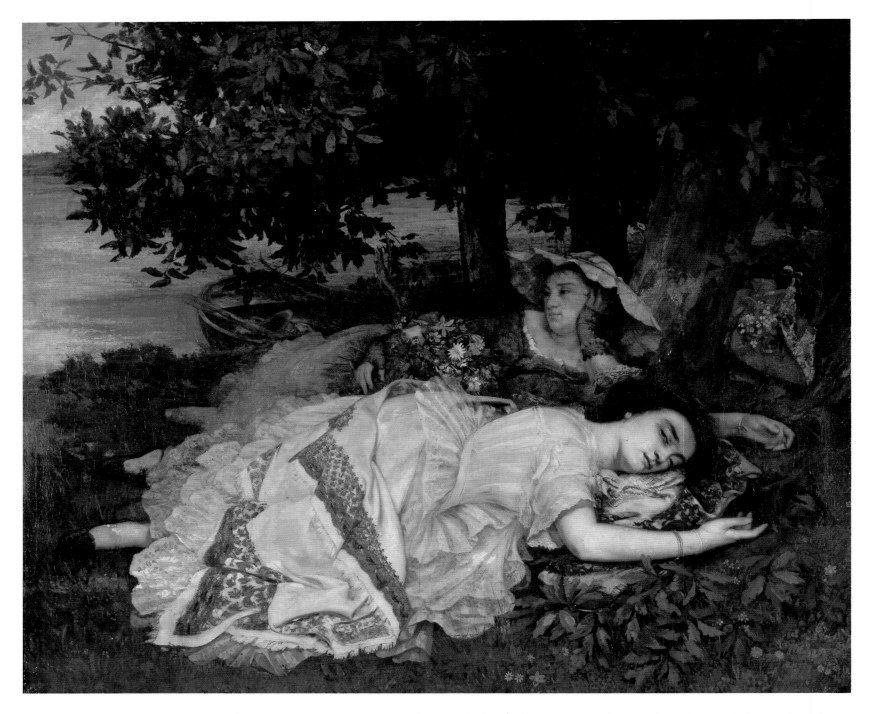

Like Baudelaire's championing of Guys, Zola used Manet's work as a representative example to demonstrate what was wrong with French art, and in his Salon criticism in 1866, published on 27 and 30 April, he began with an attack on the jury system. This was followed on 4 May by an article entitled 'The Artistic Moment' in which he suggested that there were two ingredients in a work of art 'the element of reality, which is nature, and the element of individuality, which is man.' The next article, published on 7 May 1866, was devoted to 'M Manet' whom he assured the reader would be '. . . one of the masters of tomorrow, and I should imagine I had struck a good bargain, if I had the money, to buy all his canvases today. In 50 years they will sell for fifteen or twenty times more, and certain forty-thousand-franc

paintings won't be worth forty francs.' Zola continued with a description of Manet, in which he was at great pains to make him appear at normal as possible:

I have only been once to Manet's studio. The artist is of average height, more small than tall; with blond hair and a delicately colored face, he looked to be about thirtyish; with a rapid, intelligent glance, a lively mouth, rather mocking at times . . . for all that, the man, in his gestures and his voice, has the greatest modesty and gentleness. He whom the public treats as joking dauber lives a secluded life with his family. He is married and has the well-ordered life of a member of the bourgeoisie. Moreover, he works doggedly, always searching.

After stressing Manet's upright character, Zola wrote about a few of his paintings, including *Le Déjeuner sur l'herbe* and

Olympia, but the work he preferred was 'The Fifer', this year's refused canvas. On a luminous gray ground, the young musician stands out, in a costume of red trousers and police cap. He blows into his instrument, looking straight at us.' And, concluded Zola, 'M Manet's place is reserved in the Louvre, like that of Courbet.'

Much of Zola's defense depended on not characterizing Manet as a revolutionary or an outsider, and what he found to say about his work was based on an aesthetic which was largely literary, singling out his Realism for specific praise, and prophesying ultimate vindication. Yet Zola's insistence that Manet's subject-matter was of little consequence, but rather the way in which it was treated was what accounted for Manet's importance, meant that his criticism was taken up by later commenta-

tors who were anxious to establish a link with those contemporary writers who were perceived as battling against the engrained prejudice of the public and the Salon jury. Nevertheless, this was the first time he had enjoyed a sustained and positive review of his work, regardless of the author's motivation, and Manet wrote immediately to Zola:

I don't know where to find you to shake your hand and to tell you how happy I am to be defended by a man of your talent. What a magnificent article! A thousand thanks. Your penultimate article ['The Artistic Moment'] was one of the most remarkable I have ever read and made a great impression on me. I want to ask your advice: where can I meet you? If it is convenient for you, I go every day to the Café de Bade, 26 boulevard des Italiens, between half past five and seven.

After cutting short his series of Salon reviews, and taking a swipe at his detractors in 'Farewell of an Art Critic,' published on 20 May 1866, Zola resigned from *L'Evénement* in a grandiose gesture. On 1 January 1867 he published a biographical and critical appreciation of Manet in *L'Artiste: Revue de XIXème siècle*, which was subsequently reissued as a brochure in the summer of that year to coincide with Manet's one-man show. In February 1868 Zola posed for his portrait (page 94) and Manet submitted the work to the Salon of that year.

The Exposition Universelle of 1867
In the summer of 1867 Napoleon III held an Exposition Universelle, following the success of a similar exhibition twelve years previously. Like its predecessor, the Exposition of 1867 was intended to demonstrate France's commercial and cultural successes to her own citizens and to her foreign business rivals and thereby consolidate and validate Napoleon III's reign. As early as January of that year, Manet had decided to mount a privately funded one-man show which would allow him the freedom to display his works without recourse to a capricious jury. In May, with the help of a loan of 18,305 francs from his mother, he built a temporary pavilion on a site on the pont de l'Alma across the Seine from the official exhibition space on the Champs de Mars. In part born from a frustration with a lack of critical or financial success at the Salon, the idea of a one-man show running counter to the official exhibition had already been used by Courbet in his 'Pavilion of Realism' in 1855. In

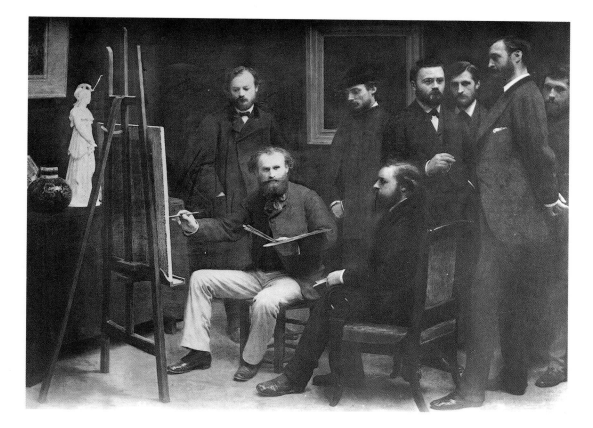

attempting to break with the conservative Salon system and by allowing the artist a degree of autonomy, it is these private shows rather than the Salon des refusés, which properly break with the State monopoly and were the precursors of the Impressionist exhibitions in the next decade.

The exhibition of 50 paintings opened on 24 May 1867 and included all of Manet's Salon submissions from 1859 to 1866, other than the portrait of his parents (page 31). Other important works like the *Music in the Tuileries* (page 50) and *The Old Musician* (page 42) were included. A catalog was issued with a preface which may have been written by Manet himself in collaboration with Zola. In it, the author gave the 'Reasons for a Private Exhibition':

Monsieur Manet has been exhibiting, or trying to exhibit, his work since 1861. This year he has decided to show the sum total of his works directly to the public. Manet received an honorable mention when he first exhibited at the Salon. But since then he has seen himself rejected by the jury too often not to think that, if the outset of an artist's career is a struggle, at least one must fight on equal terms. That is to say, one must be able also to exhibit what one has done. . . . The artist does not say today 'Come and see faultless work,' but 'Come and see sincere work.' This sincerity gives the work the character of a protest, although the painter merely thought of rendering his impressions. Manet has never wished to protest. Rather, the protest, quite unexpected on his part, has been directed against him; that is because there is a

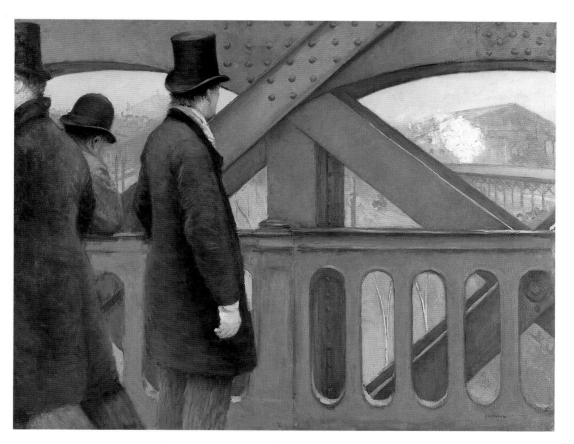

Below: Courbet's *Burial at Ornans.*

Right: Goya's *The Execution of the Defenders of Madrid, 3rd May 1808,* was in Manet's mind when he produced his scenes of the execution of the Emperor Maximilian (pages 86-90).

traditional system of teaching form, technique, and appearances in painting, and because those who have been brought up according to such principles do not acknowledge any other. It is from this that they derive their childish intolerance.

At this time, Manet began his *View of the Universal Exhibition* (page 84), an ironic comment on the public façade of the exhibition. Each of the discrete social groupings within the painting typifies a Parisian type: the military men, the dandies, the amazon, and Léon Koëlla-Leenhoff walking a dog in the foreground enjoy the landscaped gardens which are being tended by the workman in his blue blouse. In the background, the towers of Notre Dame, the spires of Sainte-Clotilde, and the domes of Les Invalides and the Panthéon are all visible. This is the view recommended by the guidebooks, and it falls like a theatrical curtain behind the players on the temporary stage in the foreground. This discrepancy between foreground and background has some basis in reality – the view which is being admired would in fact have been invisible from the vantage point Manet has chosen.

Such a controlled vision of Parisian superiority effectively deflected attention from the more unsavoury aspects of Napoleon III's foreign policy. In an attempt to extend French influence in the New World, Napoleon III had installed the Hapsburg Maximilian Joseph, Archduke of Austria, as a puppet ruler in Mexico, after the Conservatives had rigged the election

there in April 1864. Less than three years later and under diplomatic pressure, the French withdrew their support, leaving Emperor Maximilian vulnerable. The support for the Liberal Beniot Juárez grew stronger after the French troops withdrew and eventually Juárez's Liberal guerrillas captured Maximilian and his generals Miguel Miramón and Tomas Mejía on 15 May 1867 and executed them near Querétaro on 19 June 1867.

It was generally accepted in France that Maximilian had been a dupe in the whole affair and had intended ruling with a measure of paternalistic liberality. The venture had, however, been unpopular in France, partly because taxation had been increased in order to finance Napoleon III's expansionist policies. The coincidence of the showcase Exposition Universelle and Maximilian's execution fueled French liberal opposition to Napoleon III's régime as the news filtered into Paris over the summer of 1867. Between then and the early months of 1868 Manet worked on a series of paintings dealing with the theme of *The Execution of the Emperor Maximilian* (pages 86 to 90) and in total produced four oils and one lithograph.

The work now in Boston (page 86) is generally regarded as having been first, and is a typical *ébauche*, thinly painted and unresolved. The large version in the National Gallery, London (page 88), was next and in it the soldiers are wearing the French *képi* and uniform, effectively apportioning the blame for the atrocity firmly with

Napoleon III. The final version in Mannheim (page 90) is the most resolved and closest to the prototype of Goya's *Massacre of 3 May* (page 21), which was influential on Manet's composition. The lithograph was suppressed by the state and never published during Manet's lifetime.

Early in 1869 Manet was informed that his *Execution of the Emperor Maximilian* would be rejected by the Salon jury, and he decided to submit alternative works. These included five etchings and *The Luncheon in the Studio* (page 98) and *The Balcony* (page 100) for which his future sister-in-law, the painter Berthe Morisot (1841-1895), posed. Around this time, he was introduced to Eva Gonzalès (1849-1883) who became his pupil and who posed for the painting submitted to the Salon of 1870 (page 107).

The End of the Empire
In 1870 the Emperor's increasing problems abroad culminated in the Franco-Prussian war and the defeat of France at Sedan on 2 September. Napoleon III and his army was forced to surrender, precipitating the collapse of the Second Empire: in Paris a popular uprising on 4 September established a provisional republican government. The Prussians advanced on Paris and began blockading it on 19 September. After sending his family to Oloron-Sainte-Marie in the Pyrenees and closing his studio on the rue Guyot, Manet enlisted in the National Guard. Letters to his wife and mother, dispatched by balloon, recount the miseries of the siege and the joy of Manet and his two brothers when finally it

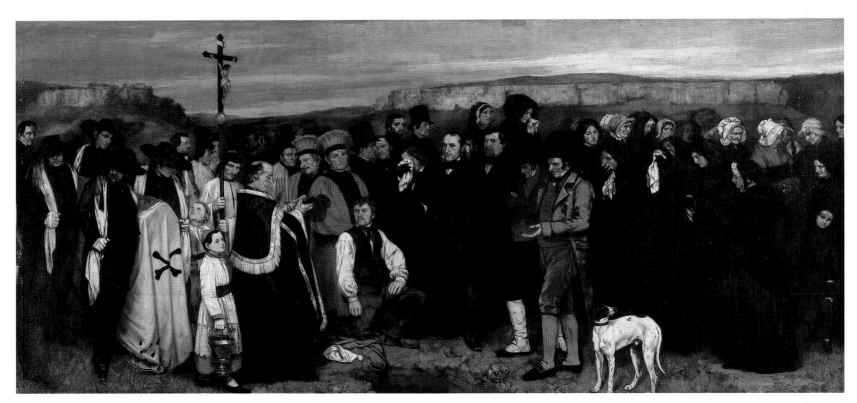

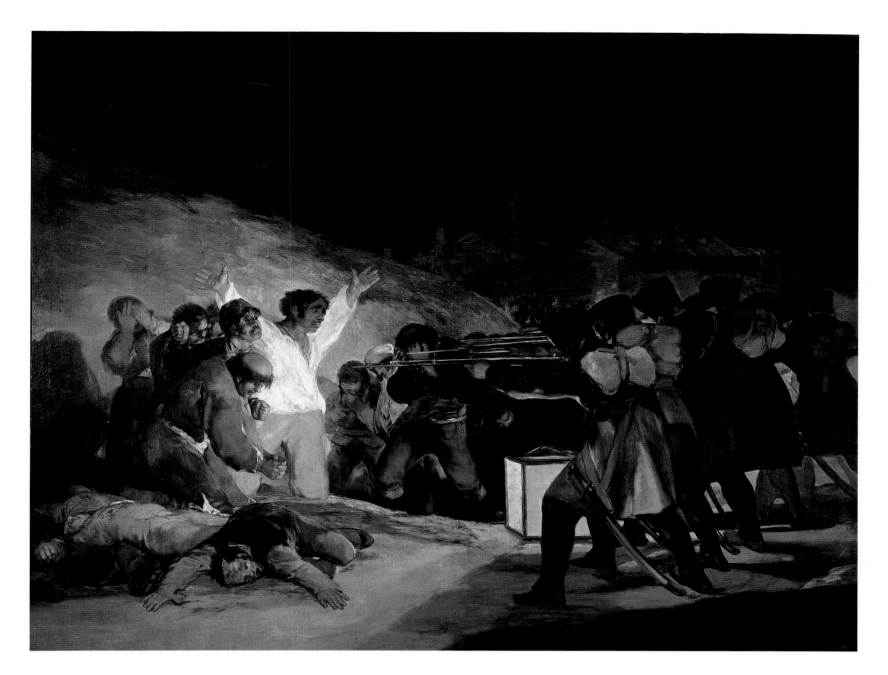

was over. He wrote to his family on 30 January:

It's all over and the three of us are still on our feet and all in one piece. There was no way of holding out. We are dying of hunger, and even now we are suffering very much. We are all as thin as laths!

Manet was with his family in the South of France during the worst fighting of the Commune but in his absence the *Journal officiel de la Commune* published a manifesto for the formation of a federation of artists to which he was elected with fifteen other painters, including Courbet, Corot and Daumier, and ten sculptors.

Surprisingly few of Manet's works deal overtly with the siege or the ensuing civil war, and there is nothing to rival *The Execution of the Emperor Maximilian* as a political statement in terms of size or treatment. After 1870 the overt engagement with controversial subject-matter disappeared from Manet's work, and much of what he produced after that date was either a consolidation of his earlier modern-life subject-matter or of an increasingly commercial nature. Critics treat the work after 1870 with ambivalence: Manet's role as an instigator of Modernism is effectively

exhausted and the stage has been set for the next scene in the heroic progression of vanguard styles with the work of the impressionists. Even when Manet is assessed on the basis of his individual achievements, his greatest accomplishments were in the earlier half of his career: he had had an early triumph at the Salon, a *succès de scandale* at the Salon des refusés, been championed by two of the leading writers of the nineteenth century, and unsettled the government. The majority of his large paintings dealing with modern life are from the 1860s and increasingly his work becomes smaller with more intimate and less contentious subject-matter.

Impressionism

At the Salon of 1873 Manet exhibited *Le Bon Bock* (page 116), a portrait of the engraver Emile Bellot but which in its handling, its atmosphere and its detail was reminiscent of Dutch seventeenth-century tavern scenes. The work was a great success and formerly hostile critics were forced to reassess his work. Writing in *La Renaissance littéraire et artistique*, Ernest d'Hervilly was typical. Noting the crowd in front of the painting, he wrote:

There the best-dressed people clutch their catalogues in their hot hands. Through tight lips they foam a little at the mouth. They contemplate the beer drinker in astonishment mingled with wrath. They no longer find the artist's method of painting odious. Not at all! They are overcome and almost convinced. They find 'certain qualities in this handsome canvas . . .' 'Oh dear!' they mutter in a low and unintelligible voice 'if only Manet were willing to paint grandmothers and grandchildren weeping in each others' arms for no particular reason, how we should like it! This is one of those subjects that a well-born artist ought never to touch. A beer drinker! Dear, dear!'

This unexpected popular success must have contributed to Manet's unwillingness to join the future Impressionists at the first independent exhibition, which opened at the photographer Nadar's studio on 15 April 1874 and lasted for one month. Despite invitations from them, he did not participate in the first or in any of the further seven Impressionist shows. Although Manet was acquainted with a number of the Impressionist painters, including Berthe Morisot, Cézanne (1839-1906) and Monet (1840-1926), whose name was frequently confused with his at

Both of Manet's paintings submitted to the 1876 Salon were rejected by the jury. *The Laundress* (page 15) was impressionistic in its subject-matter and technique, whereas *The Artist* (page 138), a portrait of the etcher Marcellin Desboutin (1823-1902) who was included that year at the second Impressionist exhibition, belonged to the group of traditional portraits of life-size, full-length solitary figures treated in somber tones, which Manet had first submitted to the Salon with *The Absinthe Drinker* (page 27). Rather than placing the refused works with the Impressionist group, Manet instead decided to open his studio to the public to display the paintings, a clear indication that he did not wish to align himself with 'the Intransigeants' but instead wished to be judged using the criteria of the Salon itself.

That Manet's concerns were quite different from those of the impressionist circle is evident from a letter he sent to the Prefect of the Seine on 10 April 1879 proposing a decorative scheme for the Municipal Council Chamber of the New Hôtel de Ville, which was being rebuilt after being destroyed during the Commune. He suggested:

A series of pictures representing 'the belly of Paris' (if I may use that hackneyed expression which illustrates my meaning very well) with the different guilds in their own surroundings, the public and commercial life of today. I would include the Paris markets, the Paris railroads, the Paris port, the Paris underground, the Paris racetracks and gardens. On the ceiling, there would be a gallery, around which would be shown, in appropriate activity, all those contemporary men who have contributed in the civic sphere to the greatness and richness of Paris.

Although Manet seems never to have received a response to this letter it is important as a statement of his artistic credo at the end of the 1870s. At a time when the impressionist painters, especially Cézanne, Monet, Renoir, and Pissarro were abandoning the subject-matter of modern Parisian life which had interested them in the 1860s and early 1870s for a more timeless, pastoral vision of people living in harmony within a natural environment, and in which the harsh facts of an industrialized society did not appear to intrude, Manet was still committed to a Realist aesthetic similar to that proposed by Baudelaire and Zola. Indeed, in choosing to take as his theme 'the Belly of Paris' Manet had borrowed the title of a novel by Zola first published in 1873 which dealt with the Parisian covered markets of Les Halles.

the Salon, he had very little in common with the younger painters other than a dislike of the jury-system of the Salon. Manet's work was still produced in the studio whereas the younger painters had been committed to painting intimate landscapes out of doors for several years. While Manet continued to paint using the traditional techniques of the preparatory sketch and *ébauche* and utilizing the blacks, browns and ochers that Couture had recommended, the Impressionists favored bright, prismatic hues, with less reliance on local color and worked on white-primed, portable canvases.

In the summer of 1874 Manet stayed at Gennevilliers, not far from Monet at Argenteuil and the two were often joined by Renoir (1841-1919). During this period he painted his most overtly impressionistic works like *The Monet Family in the Garden*

(page 130) and *Boating* (page 124). *Claude Monet Painting in his Studio Boat* (page 128) epitomizes impressionist practice at this time. Monet is represented in the open, positioned under the awning on his floating studio, working on a small, white canvas depicting a site midstream without the ugly factory chimneys which are visible in the background. Here Manet has adopted the impressionist *facture* of broken brushwork and rapid handling, but has clung to the use of black pigment outlawed by the orthodox impressionists.

In October the following year Manet took a trip to Venice with his wife and the painter James Tissot (1836-1902). A painting like *The Grand Canal, Venice* (page 136) synthesizes the informality of the impressionist brushwork with Manet's concern with pattern-making and a rigid compositional format.

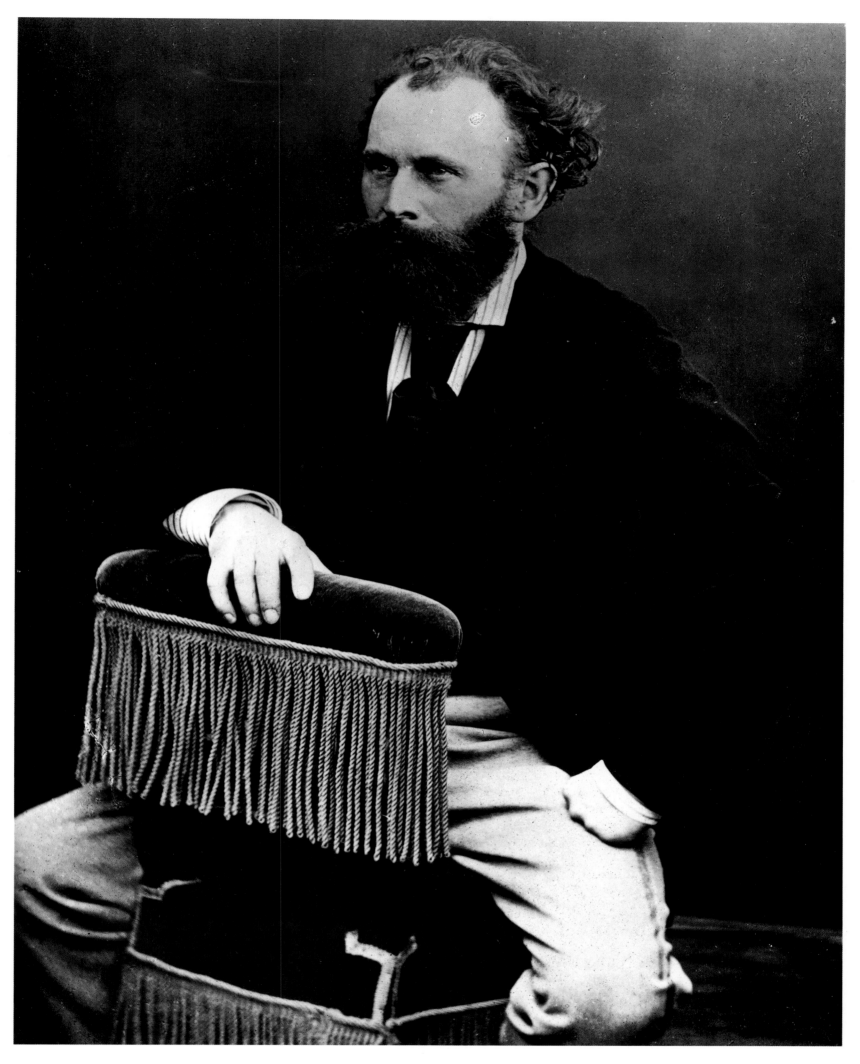

Unlike the impressionist painters, with the exception of Degas (1834-1917), Manet was a committed Parisian and an increasing interest in rural or suburban subject-matter from the end of the 1870s was due not to a deliberate change in his choice of subject-matter, but rather was necessitated by a number of trips made to spas and resorts for his ill health. In the fall of 1879 Manet spent six weeks at Bellevue taking spa treatment in attempt to treat the pain in his left leg caused by locomotor ataxy and at this time he met the opera singer Emilie Ambre whose portrait he painted. That winter she organized an exhibition of the final version of *The Execution of the Emperor Maximilian* (page 86) in Boston and New York but with little real success.

Right: *Monet Painting in his Garden at Argenteuil,* 1873, by Renoir.

Below: This view of the rue de Rivoli shows the devastation caused by rioters after the Commune of 1871.

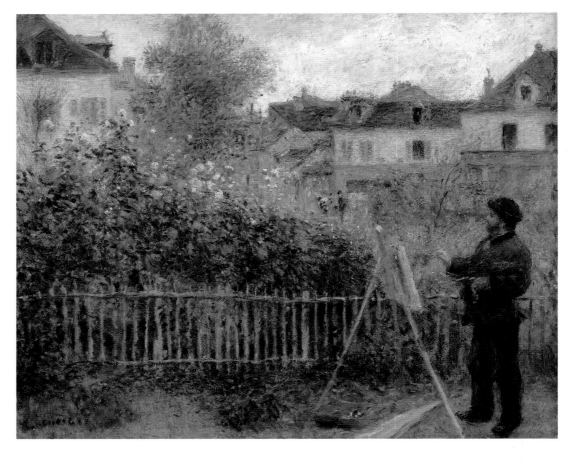

Critical Success

In 1880 Manet's health continued to deteriorate and he returned to Bellevue to follow a course of hydrotherapy and rest in the country. At the following year's Salon he exhibited the *Portrait of M Pertuiset, the Lion Hunter* (page 170) and the *Portrait of M Henri Rochefort*, a cousin of Marcellin Desboutin and a leading Communard. The latter work earned Manet a second-class medal, his first proper acknowledgment at the Salon since his success with *The Spanish Singer* (page 33) twenty years previously. That summer was spent undergoing medical treatment at Versailles where the pain in his legs restricted his movement and much of the time was spent sketching in his garden of painting still lifes of flowers and fruit indoors. On Manet's return to Paris, Gambetta appointed Proust Minister of Fine Arts and Manet was created a Chevalier de la Légion d'honneur at the end of December.

Despite his increasingly poor health and the pain which meant that the majority of his late works are small, Manet decided on a large and ambitious painting for the Salon of 1882. Because of the medal which he had earned at the previous year's Salon, Manet was exempt from submitting the work for the approval of the jury and was therefore free in his choice of subject-matter and technique. As with earlier Salon paintings, *A Bar at the Folies-Bergère* (page 172) was produced in a traditional manner with preparatory studies (page 171).

Taking as its subject the public places of Paris, which Manet had been painting since *Music in the Tuileries* (page 50) and *The Masked Ball* (page 120), the work is both a seemingly informal general comment on a class and at the same time a highly contrived group portrait with a number of Manet's friends included in the crowd re-

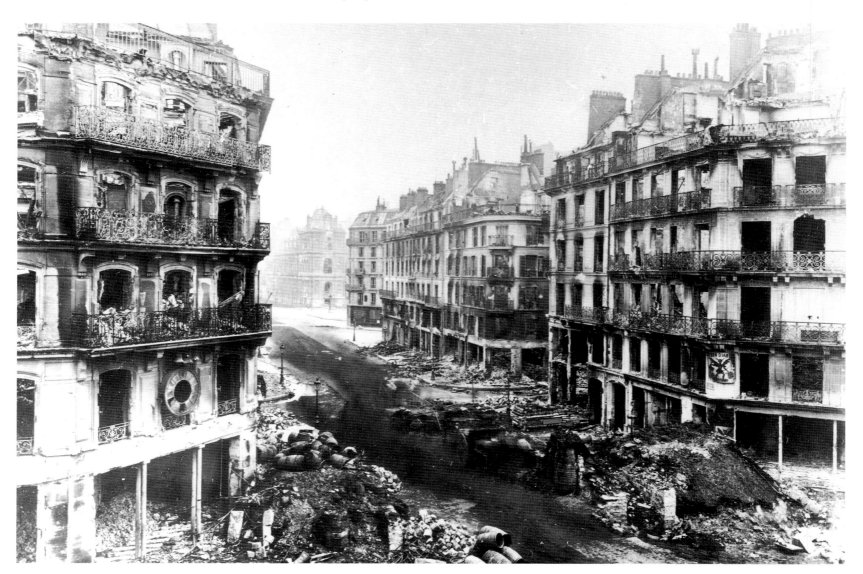

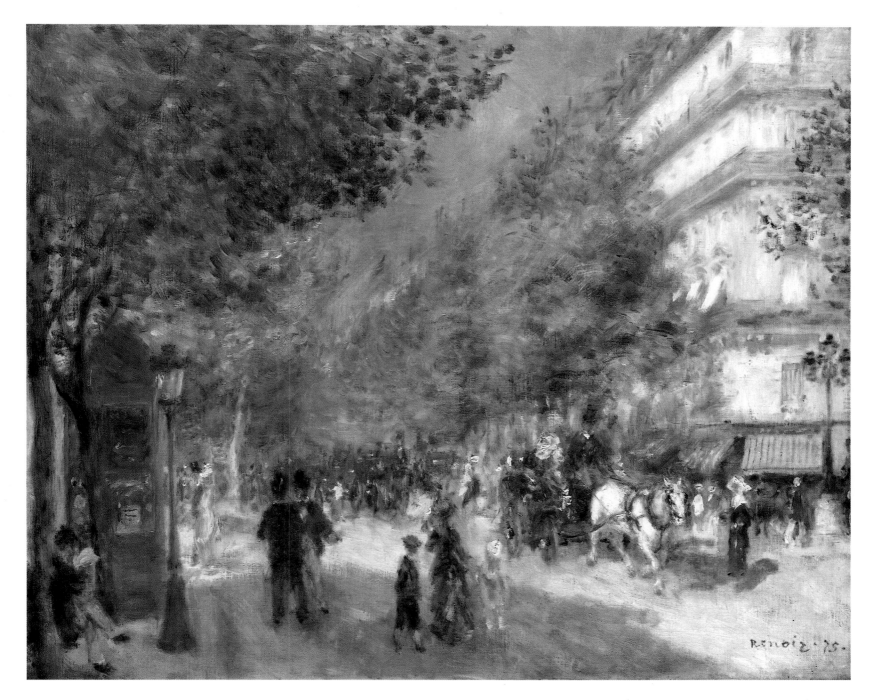

flected in the mirror behind the bar.

That year Antonin Proust wrote on the Salon for the *Gazette des Beaux-Arts* and it was the first time that he had had the opportunity to defend his friend in print. The eulogizing tone that he adopted meant that even then the work must have read like an obituary:

For almost 30 years Manet has been sending to the Salon studies which are sometimes incomplete but always novel and honest. I call these studies novel, because, as an artist of conviction, he does not believe he has the right to redo something which has been successful, and he thinks he must constantly experiment with the experiments already accomplished. . . . Even now, not one of Manet's works is in our public collections.

After spending the summer in Rueil where he produced several small landscapes and

still lifes, Manet drew up his will. On 20 April 1883 his left leg was amputated but he died ten days later. In the tributes that were printed after his death in the popular newspapers, much of Manet's subsequent reputation was established. Gustave Goetschy writing in *La Vie Moderne* on 12 May 1883 commented that:

It is by the noise a man makes falling, that one can measure exactly his stature when he was on his feet. On the very day after Manet's death, the daily Press was completely filled with his name and . . . the clamor caused by his death has not yet subsided. Manet was indeed one of those obstinate innovators who during his lifetime was always subject of controversy, who are attacked and laughed at, but who are missed as soon as they are dead – one of those innovators whose discoveries and teachings bear fruit in the long run; who leave behind

them a trail of glory. Whatever one might still think of his opinions and work, it cannot be denied, at least, that they have exercised considerable influence on modern art, and that this influence will grow every day. He was the first to show the New Way which all the young school is now following.

In the language of struggle, victory, and posthumous vindication the tone was set for later commentators who like Goetschy regarded Manet as a pioneering figure in French art, and whose innovation and struggle against the art establishment effectively established a pattern for later vanguard artists. In fact, up until his final submissions, produced under the most adverse conditions, Manet continued to regard himself as a Salon painter and as the catalogue produced for his 1867 exhibition clearly stated he 'never wished to protest.'

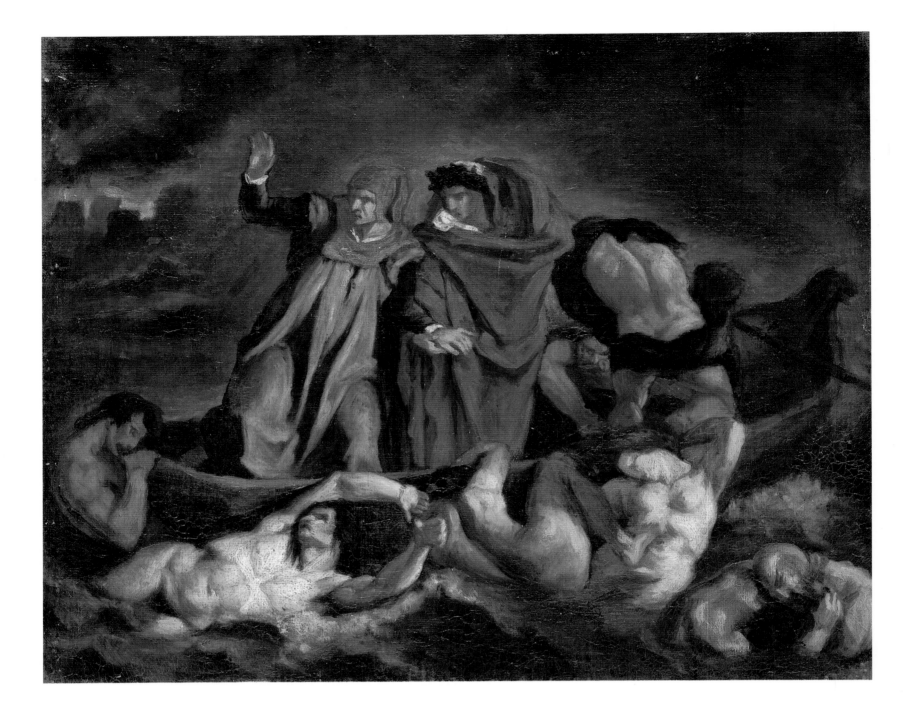

The Barque of Dante, after Delacroix, c.1854

Oil on canvas
15×18⅛ inches (38×46 cm)
Musée des Beaux-Arts, Lyons

The scarcity of oil paintings produced while he was a student at Couture's studio, suggests that Manet may have destroyed early works at some point. This little painting is a rough copy after Delacroix's *Barque of Dante* which was in the Musée du Luxembourg in the 1850s, was exhibited in Paris at the Exposition Universelle of 1855, and was transferred to the Louvre in 1874, eleven years after Delacroix's death. A second copy, much more freely handled and presumably later, formed part of the effects of Manet's studio and is in the Metropolitan Museum in New York.

The scene represented is from Dante's *Divine Comedy* and represents the author accompanied by the Roman poet Virgil being ferried through the Stygian marshes surrounded by the rotting souls of the Wrathful. This Romantic imagery does not appear to have influenced Manet's subject-matter; it seems rather as if he has copied

Delacroix in order to study his fluent technique which offered an alternative tradition to the slick Salon painting of the period, evident in a work like Cabanel's *Birth of Venus* (page 17). According to Proust's *Souvenirs* the painting was undertaken as a pretext to visit Delacroix and request permission to copy his work. Apparently Manet and he visited the older painter's studio in the rue Notre-Dame de la Lorette where they were received with great courtesy and encouragement. Such a story is typical of the anecdotal quality of Proust's memoirs but may be supported by Delacroix's alleged support for *The Absinthe Drinker* (page 27), Manet's first Salon submission. Certainly Manet seems to have held Delacroix in some regard, which was made explicit in Fantin-Latour's painting *Homage to Delacroix* of 1864 in which Manet is standing next to Delacroix's self-portrait.

The Absinthe Drinker, 1858-59

Oil on canvas
71¼×41¾ inches (181×106 cm)
Ny Carlsberg Glyptotek, Copenhagen

Manet's fist submission to the Salon was with *The Absinthe Drinker* in 1859; it was rejected by the jury despite the support according to Antonin Proust's *Souvenirs*, of Delacroix. The work deliberately breaks with the history painting of Couture, and Manet has chosen instead a life-size genre scene for his début. The model for the work was the ragpicker, or *chiffonier*, Colardet, and by working on such a large format Manet has effectively aggrandized the subject-matter, transcending the small scale normally reserved for low-life subjects like this. The work is summarily handled with the bold tonal manner normally reserved for the *ébauche*, and this is the reason often given for the work's rejection at the Salon. However this sketch-like treatment was not unprecedented in Salon paintings: both Couture and Delacroix used it to some extent in their work. Instead it would appear that the work was refused because of the obvious associations with Baudelaire's *Fleurs du Mal*, which had been suppressed on publication in 1857 on grounds of indecency. Indeed the imagery in *The Absinthe Drinker* seems like a direct quotation from one of the poems, 'le Vin des chiffoniers' which deals with a rag picker:

Look – there! in the streetlamp's dingy glow
– wind rattling the glass, lashing the flame –
out of the muddy labyrinth of streets
teeming with unruly, sordid types,
a ragpicker stumbles past, wagging his head
and bumping into walls with a poet's grace.

This not only helps explain the apparent inconsistency of the lighting of the painting, with its two light sources from the streetlamp, but also provides an explanation for Manet's apparent heroic treatment of this bohemian figure. Baudelaire's explicit idealization of the alcoholic *chiffonier* as a 'poet' was adopted by Manet in some of his paintings of 'philosophers' in the 1860s

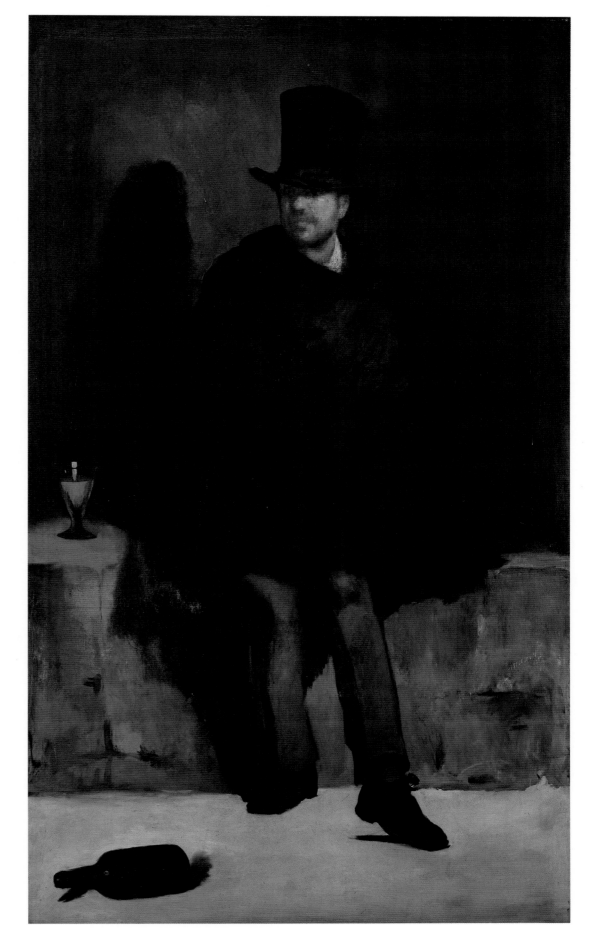

Spanish Cavaliers, 1859

Oil on canvas
17¾×10¼ inches (45×26 cm)
Musée des Beaux-Arts, Lyons

In his *Méthode et Entretiens d'Atelier*, published in 1868, Couture recommended copying from the Old Masters in the Louvre, and Manet applied to copy there on several occasions. One of the works he studied was a painting, then attributed to Valáquez but now believed to have been done by Mazo, the *Little Cavaliers*, which he applied to copy in 1859. Manet's *Spanish Cavaliers* is a reworking of parts of that composition, with the addition of the small child holding a tray in the foreground of the painting. It is often suggested that this figure was modelled by Léon Koëlla-Leenhoff, Suzanne Leenhoff's illegitimate son, but if this is so, Léon was seven or eight at the time of this painting, and clearly not the very much younger child depicted here. Alternatively, the *Spanish Cavaliers* may be earlier than the date of 1859 it is usually given.

Certainly this is one of the earliest examples of Manet's interest in Spanish themes, which was to be developed in the next few years (pages 33-55) and it is also one of the first works in which he consciously blends the traditional and the contemporary, borrowing seventeenth-century figures and coupling them with Léon and making the whole modern by virtue of the frank treatment of the *ébauche*.

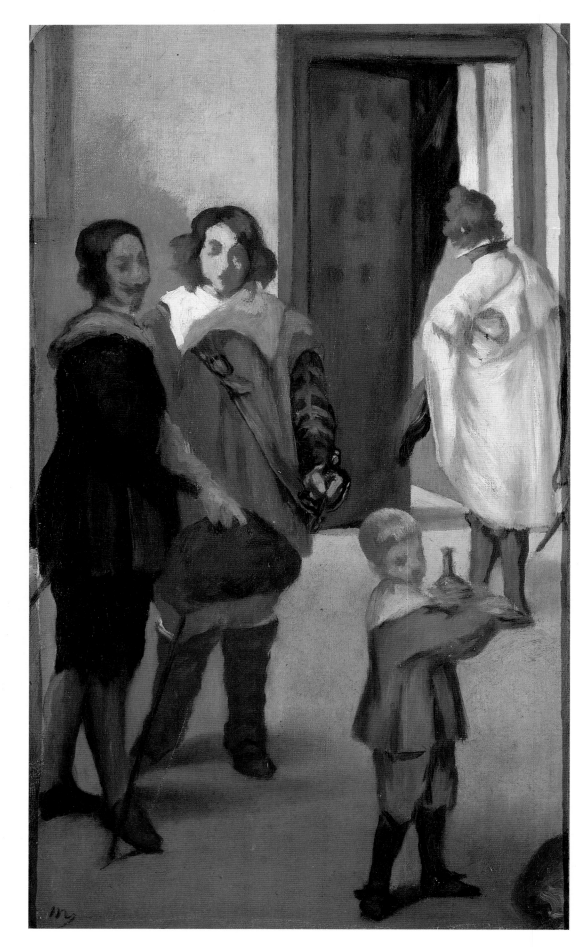

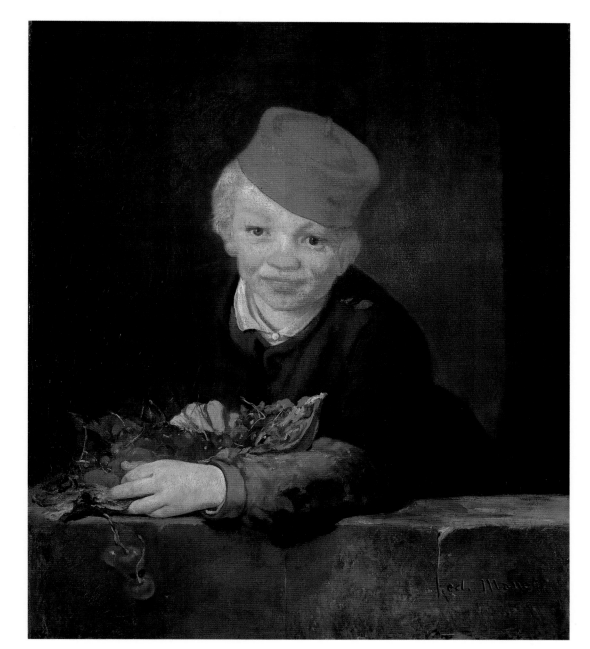

Boy with Cherries, 1859

Oil on canvas
25¾×21½ inches (65.5×54.5 cm)
Calouste Gulbenkian Foundation, Lisbon

The *Boy with Cherries* derives from a number of sources, particularly seventeeth-century Dutch genre scenes and the work of Caravaggio, in its depiction of a pretty youth, standing behind a parapet on which the artist has illusionistically carved his name, his arms overflowing with fruits which tumble from his grasp and appear to fall toward the viewer. The religious connotation of cherries is absent here, but rather the fruit may refer in a more general way to the brevity of life which becomes more poignant when coupled with the youthful subject. The model, a poor boy named Alexandre, apparently helped out in Manet's studio and committed suicide at the age of fifteen by hanging himself. Charles Baudelaire wrote a prose poem, entitled *The Rope* which he dedicated to Manet and which was first published in *L'Artiste.* In it, after describing Alexandre's death and Manet's horror at finding the corpse, Baudelaire focuses on the rope with which Alexandre hanged himself and its subsequent history, much in the manner of a religious relic. The painting was first exhibited in Martinet's gallery in 1861.

Portrait of M and Mme Auguste Manet, 1860

Oil on canvas
67½×35⅞ inches (171.5×91 cm)
Musée d'Orsay, Paris

Manet's first Salon success was in 1861 when he showed *The Spanish Singer* (page 33) and this portrait of his parents, which was listed as number 2099 in the catalogue, *Portrait de M et Mme*. Perhaps after the failure of the *Absinthe Drinker* (page 27) at the previous Salon, Manet had decided to submit a work which was less controversial in its subject-matter and this double portrait of two eminently respectable members of the *haute bourgeoisie* seemed suitable. Auguste Manet (1797-1862) was principal private secretary to the Minister of Justice, and had been decorated with the *Légion d'honneur* which he is wearing here. He had married Eugénie-Désirée Fournier (1812-1885), who was 14 years his junior, in 1831. She was the daughter of a diplomatic emmisary to Stockholm and like her husband enjoyed the privileges of a private income. They had three sons: Edouard, Eugène, who married Berthe Morisot, and Gustave.

The work displays the rich contrast of white and black offset by a few bright primaries which characterizes Manet's work from about this time, and shows a marked departure from earlier works in which the palette was much closer to that used by Couture. In other respects the treatment is as conventional as the subjects depicted with the sitters aloof and distinct from each other with little attempt at suggesting any kind of psychological interplay between them. The work was included in Manet's one-man show in 1867.

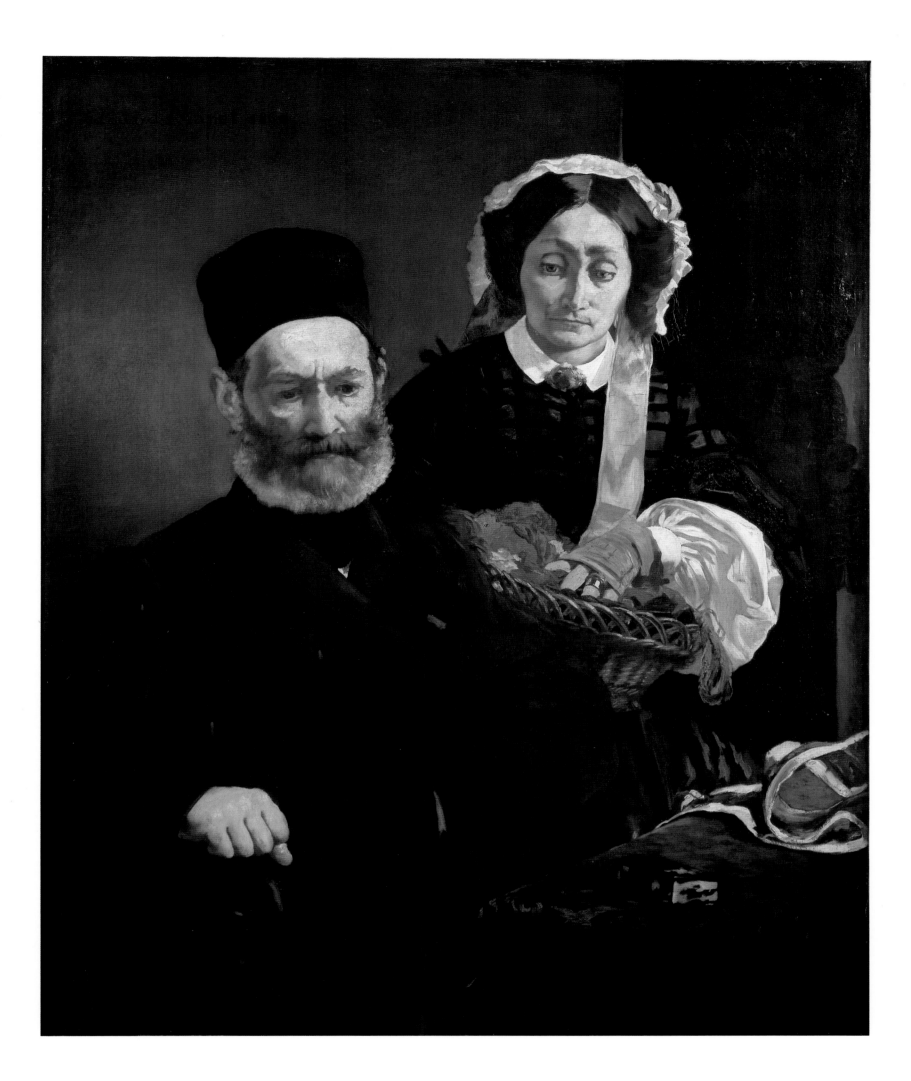

The Spanish Singer, 1860

Oil on canvas
57×44⅝ inches (144.8×113.3 cm)
Metropolitan Museum of Art, New York
Gift of William Church Osborn

Along with *Portrait of M and Mme Auguste Manet* (page 31), Manet submitted *The Spanish Singer* to the Salon of 1861. After being 'skied,' the painting aroused such interest that it was moved to a better location and proved to be Manet's first popular and critical success when he won an honorable mention at the close of the exhibition.

The subject of the poor guitar player was commonplace at the Salon and was typical of a contemporary taste for things Spanish in France in the middle of the nineteenth century. Effectively combining Romantic and Realist aspects within one painting, the work is in fact an elaborate fiction with Manet freely mixing Spanish and French clothing in the interests of an overall effect. Yet at the time, the work was praised for its

realism and Théophile Gautier's review in the *Moniteur Universel* was particularly favorable. In isolating Manet's work for commendation, Gautier may have been aware of the relationship between the artist and Baudelaire, who had dedicated *Les Fleurs du Mal* to him in 1857. Manet painted the two writers standing side by side in his *Music in the Tuileries* (page 50) the following year.

The Spanish Singer remained in Manet's studio after the Salon, and he exhibited it in 1867 at his show on the pont de l'Alma. In 1872 it was sold for the relatively large sum of 3000 francs to the dealer Paul Durand-Ruel who resold it the following year to the singer Jean-Baptiste Faure for 7000 francs.

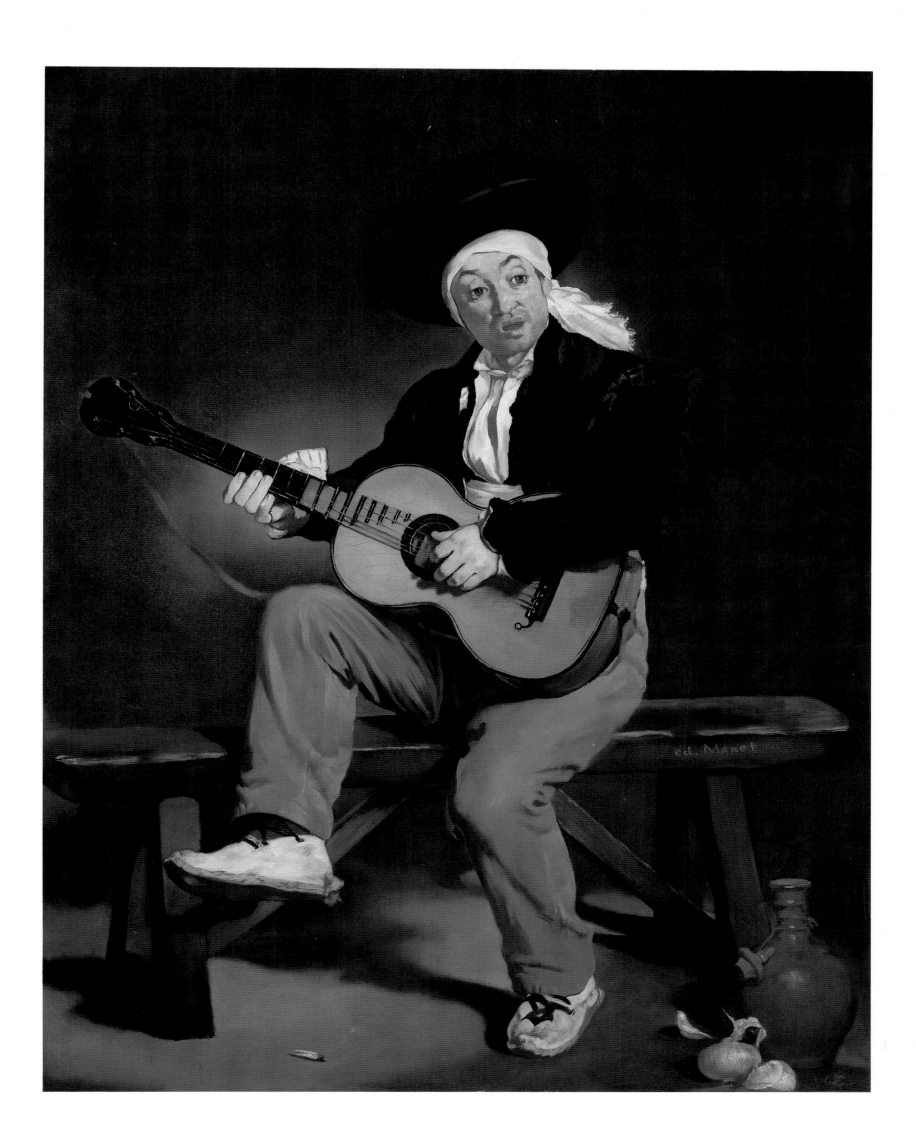

The Surprised Nymph, 1859-61

Oil on canvas
56⅞ × 44¼ inches (144.5 × 112.5 cm)
Museo Nacional de Bellas Artes,
Buenos Aires

Along with the *Déjeuner sur l'herbe* (page 56) and *Olympia* (page 60), *The Surprised Nymph* is one of Manet's major treatments of the quintessential subject-matter of academic practice: the female nude. Like the two slightly later paintings, this is a large work and one which clearly took Manet some time to produce. As in these other two works Manet has taken a contemporary Realist woman, reminiscent of works like Courbet's *Young Ladies on the Banks of the Seine* (page 18) and overlaid the work with references to a number of old-master paintings. The sources are manifold, but obvious influences include Boucher's *Diana at her Bath*, which he would have seen in the Louvre; Rembrandt's *Bathsheba* which was then in the private collection of Louis La Caze which was open to public inspection and was soon to go to the Louvre; and to Rubens' *Susannah and the Elders* which was illustrated in Charles Blanc's *Histoire des peintres*.

According to Léon Koëlla-Leenhoff, the model for the painting was Suzanne Leenhoff, Manet's future wife. In part, the work may be a pun on her name, for her pose is reminiscent of that of conventional depictions of Susannah disturbed by the elders, at once provocative and chaste. Around the time he produced this work, Manet moved into a new apartment on the rue de l'Hôtel de Ville with Suzanne and Léon and the ambivalent attitude of the nude woman may suggest the artist's response to his future wife who in later paintings (page 92) is shown as an upright member of the bourgeoisie. She is perhaps best understood in contrast to the nude woman in the *Déjeuner* for whom she represents both a prototype and a transformation. Whereas *The Surprised Nymph* depicts a naked bourgeois woman who shields her body from the gaze of the voyeuristic onlooker, Victorine Meurent in the *Déjeuner* as a professional working model apparently flaunts her body and subverts the traditional roles of the spectator and the nude.

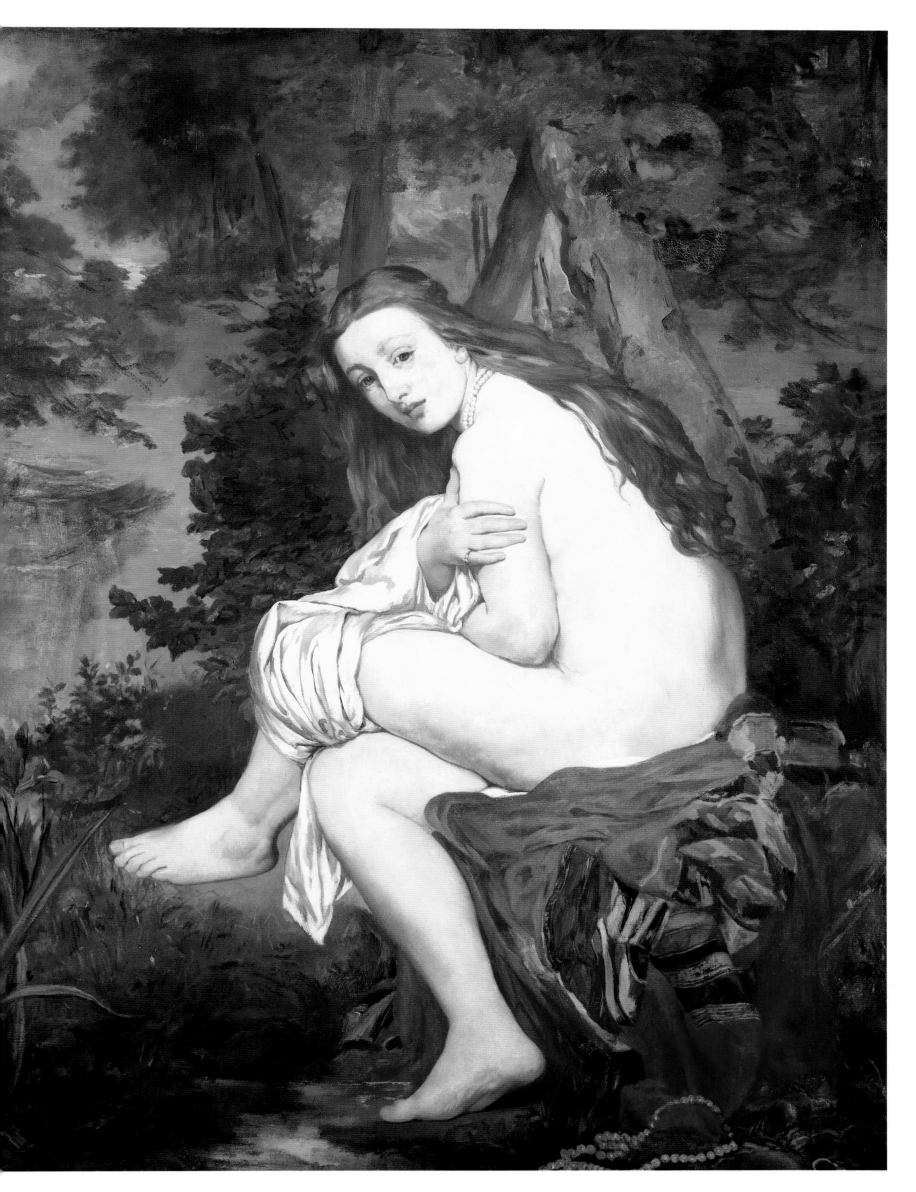

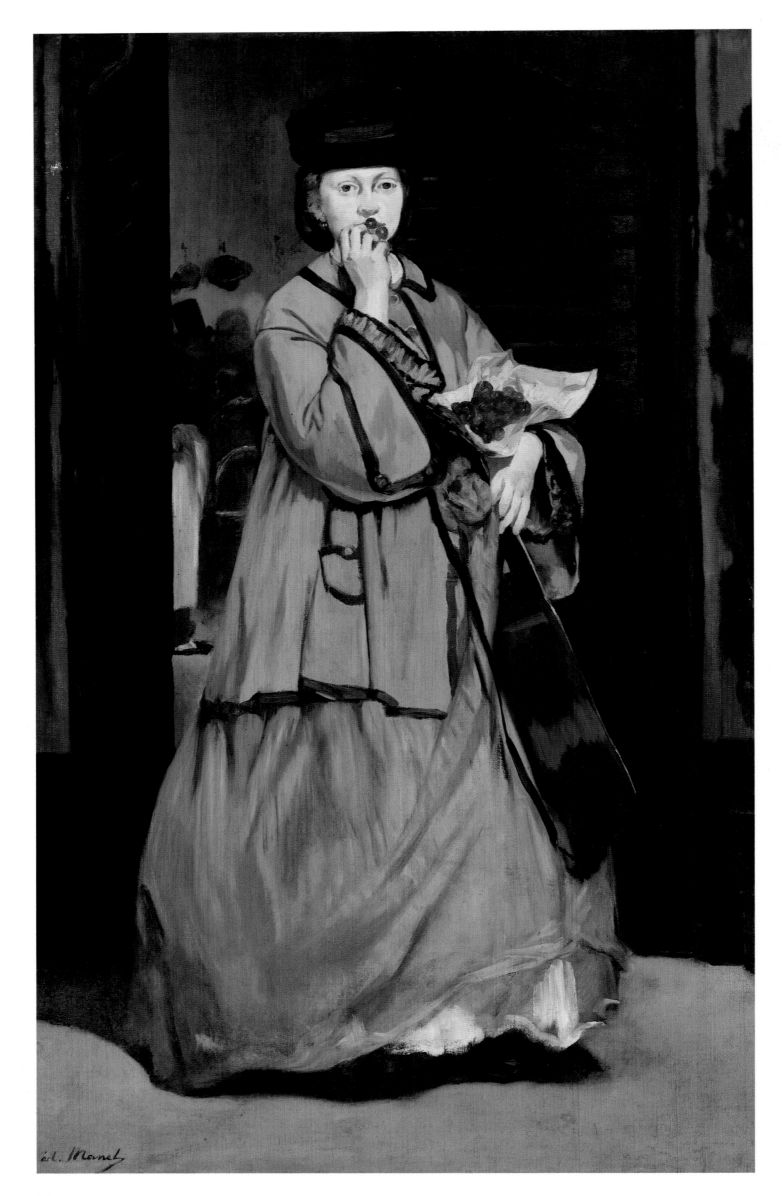

The Street Singer, c 1862

Oil on canvas
67¾×41⅝ inches (171.3×105.8 cm)
Museum of Fine Arts, Boston
Bequest of Sarah Choate Sears in
memory of her husband, Joshua
Montgomery Sears

A female equivalent to works like the *Absinthe Drinker* (page 27) in its isolation of a life-size Parisien 'type' against a rudimentary backdrop, *The Street Singer* was one of those works which Manet included in his exhibition at Martinet's gallery on 1 March 1863 and again on the Pont de l'Alma in 1867. In the brochure which accompanied the latter show, Emile Zola professed this his favorite work:

A young woman well-known on the heights of the Panthéon, is coming out of a brasserie eating cherries which she holds in a sheet of paper. The whole work is a soft, blond gray. The subject here seems to me to have been analyzed with extreme simplicity and accuracy. A work such as this has, aside from its subject, an aus-terity which makes it appear larger than it is; one senses a search for the truth, the conscientious labor of a man who, above all, wants to say what he sees.

In its subject-matter and technique the work appears extremely naturalistic and according to Proust the painting was based on a chance encounter on this rue Guyot between Manet and the female guitarist whom he asked to pose for him. In fact, the model for the painting was Victorine Meurent whom he met in 1862 and despite her bohemian air the musician was fashionably dressed. Like *The Spanish Singer*, this is an elaborate costume piece worked up in Manet's studio, with pretensions to an objective realism.

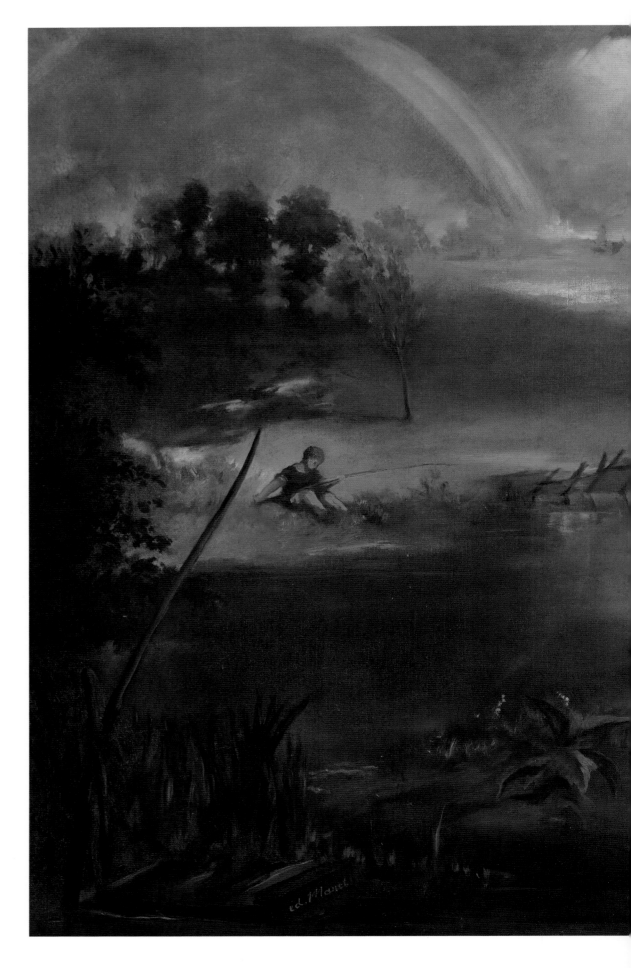

Fishing, 1861-63

Oil on canvas
30¼×48½ inches (76.8×123.2 cm)
The Metropolitan Museum of Art,
New York
Purchase, Mr and Mrs J Bernhard Gift

Included in Manet's exhibition at the Pont
de l'Alma in 1867, *Fishing* was explicity in-
fluenced by two of Rubens' paintings:
Landscape with the Castle Steen and *Land-
scape with a Rainbow* both of which Manet
would have known from Charles Blanc's
Histoire des Peintres where each was repro-
duced as a print. In the foreground of the
work Manet has included a double portrait
of himself and Suzanne Leenhoff, whom
he had recently portrayed as *The Surprised
Nymph* (page 35) and whom he was to
marry in the fall of 1863. Their seven-
teenth-century costume suggests a direct
quotation from Rubens' *Landscape with a
Rainbow* where the Flemish master had
depicted himself and his second wife,
Hélène Fourment, in the same position.
The work may therefore be read as a tradi-
tional celebration of their betrothal, where
the happy couple are depicted within a
timeless, arcadian landscape.

On the opposite side of the river, seated
under the arch of the rainbow, sits a small
child, normally identified as Léon Koëlla-
Leenhoff, the illegitimate son of Suzanne,
and who was either Manet's son or his half-
brother. The painting is sometimes inter-
preted as a tacit acknowledgment of his
paternity by Manet who did not wish to
outrage his respective bourgeois family by
openly declaring that the child was his.
This assumes that Léon was his son, but it
has recently been suggested that he was in
fact the son of Manet's father who only
died in 1862. If this is so, then the painting
may still be construed as a recognition of
Léon but it seems significant that Manet
had to cloak his rather unorthodox family
in the guise of the seventeenth century to
make concrete their relationship. In any
event, it is Manet's earliest self-portrait,
and his only work in which he and
Suzanne appear together.

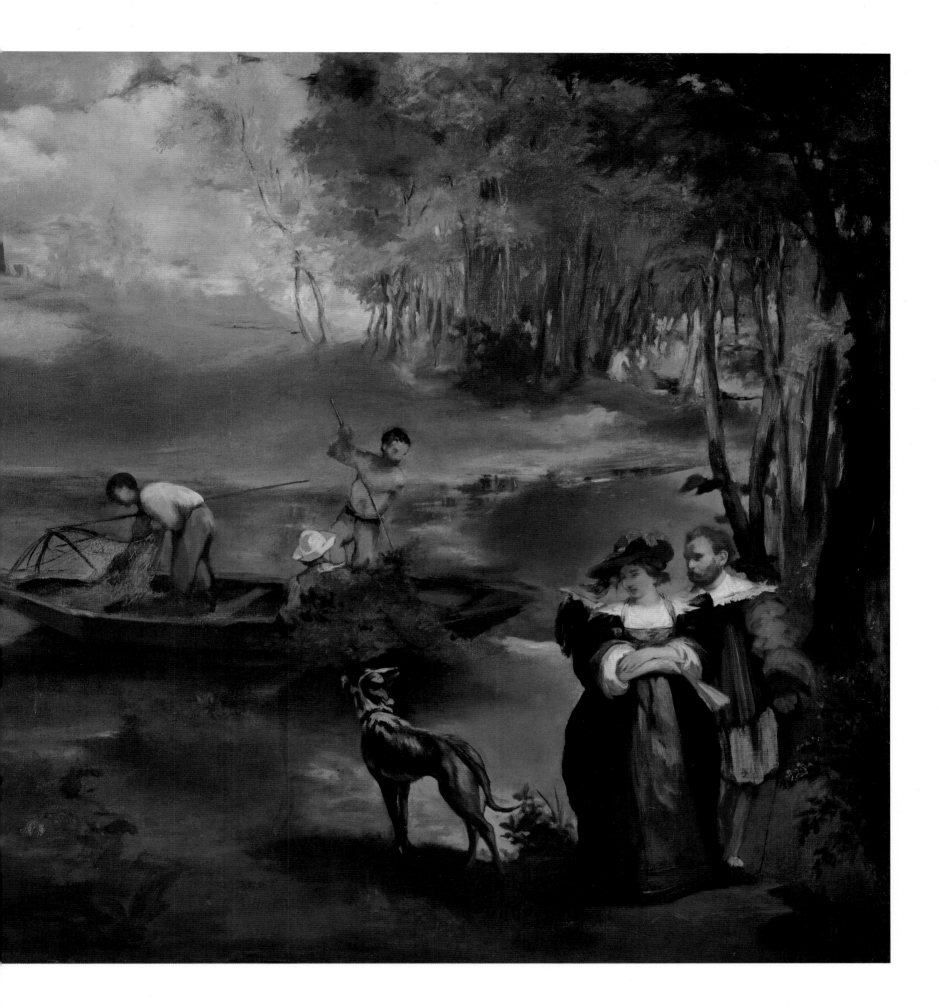

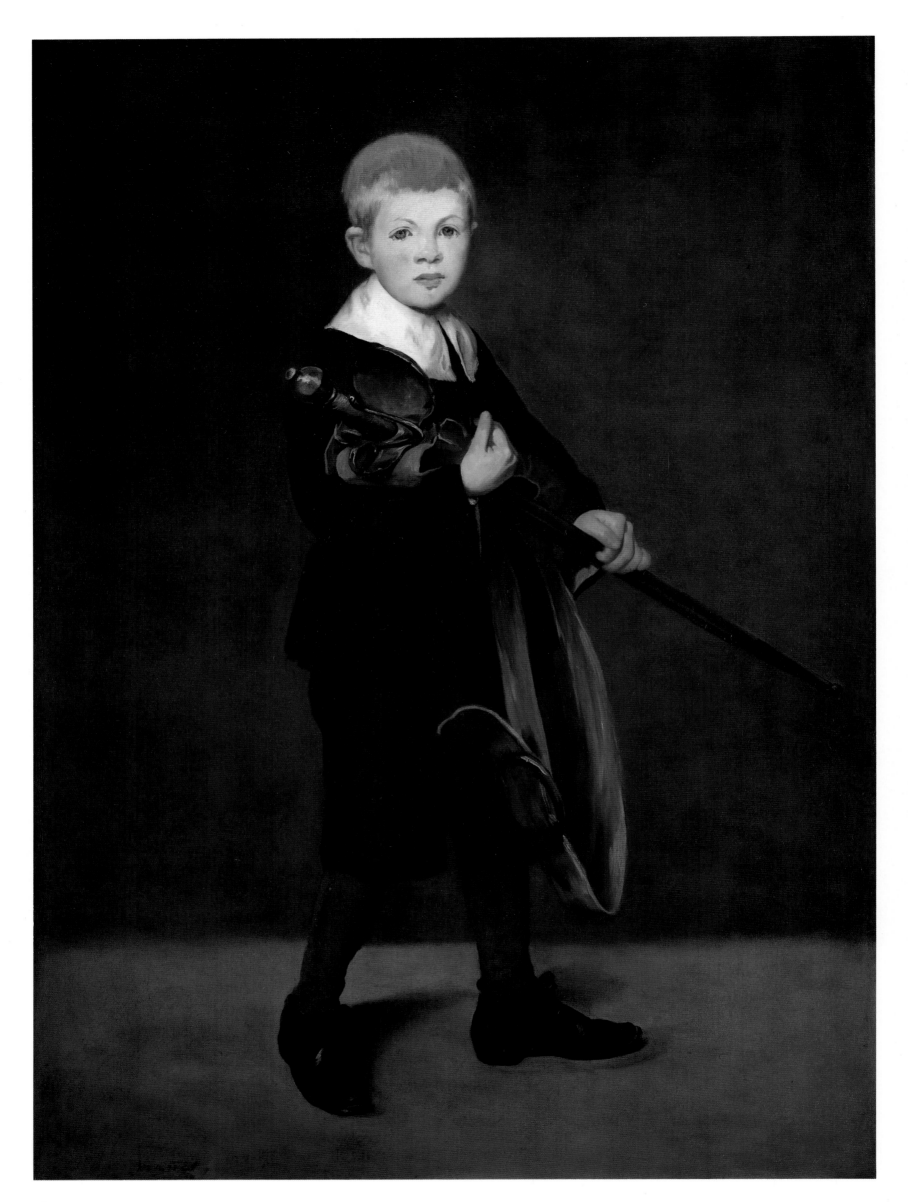

Boy with a Sword, 1861

Oil on canvas
51⅝×36¾ inches (131.1×93.3 cm)
The Metropolitan Museum of Art,
New York
Gift of Erwin Davis, 1889

With the *Bon Bock* (page 116), the *Boy with a Sword* was admired by those critics who were otherwise hostile to Manet's work, while the artist's early champion, Emile Zola, dismissed its 'studied niceties.' The slightly sentimentalized view of the pretty child dressed in seventeenth-century costume, clumsily holding the too-large sword appealed to critics like Ernest Chesneau who saw it when it was included in Manet's exhibition at Martinet's gallery which opened on 1 March 1863. He wrote that 'Manet had created one very fine painting, of unusual sincerity and feeling for color. I mean the *Boy with a Sword*.'

The model for the painting was Léon Koëlla-Leenhoff who had been born on 29 January 1852 and whose mother, Suzanne Leenhoff, was to marry Manet in 1863. Léon had previously been painted by Manet in a similar pose and costume in the *Spanish Cavaliers* (page 28) and was included in Manet's other pastiche of seventeenth-century painting, *Fishing* (page 38), with his mother and the artist. The preponderance of images of Léon by Manet and his treatment of the boy as delicately vulnerable help substantiate the claim that Manet was his father. Manet produced a series of etchings after the painting.

The Old Musician, 1862

Oil on canvas/linen
73¾×96¾ inches (187.4×248.3 cm)
National Gallery of Art, Washington DC
Chester Dale Collection

In 1862 Manet moved to another Batignolles studio, on the rue Guyot, one of Haussmann's newly created streets and not far from Petite Pologne, a bohemian and working-class area where people like those depicted in *The Old Musician* might be seen. The model for the itinerant musician himself was Jean Lagrène, the leader of a band of gipsies who lived in the Batignolles area and the model for the figure behind him was the *chiffonier* Colardet, a direct quotation from Manet's *Absinthe Drinker* (page 27). Equally the other figure are 'types': the wandering Jew whose form is abruptly cut off by the frame of the canvas, a young beggar girl and a little boy who may have been a player from the popular *Commedia dell'arte*. As generic types they would have been immediately recognizable from popular publications like *Les Français peints par eux-mêmes* and indeed although Haussmann's rationalization of Paris meant that the itinerant and poor figures included here were subject to greater police harrassment than previously, they were still common sights in certain areas of the city. Manet appears to have deliberately chosen people who were both impoverished and on the fringes of society and represented them in an odd frieze-like arrangement on the canvas in order to suggest their alienation from the embourgeoisement of Haussmann's Paris.

At the same time, there are several references to old-master paintings in Paris; to the work of the Le Nain brothers whose work was undergoing a revival at this time, to Watteau's *Gilles*, and to a Goya engraving after Velázquez. It is the painting's modern quality, however, which is striking and this is Manet's first painting of modern Paris, and on of the few where he deals specifically with the poorest sections of society, rather than with the fashionable world or the *demi-monde* which was to preoccupy him in his later work. The painting's scope and size suggests it might have been conceived as a Salon painting, and certainly it pre-empts Manet's *Déjeuner sur l'herbe* (page 56), painted the next year, in its size, its multiple references, and its combination of old-master imagery and contemporary life.

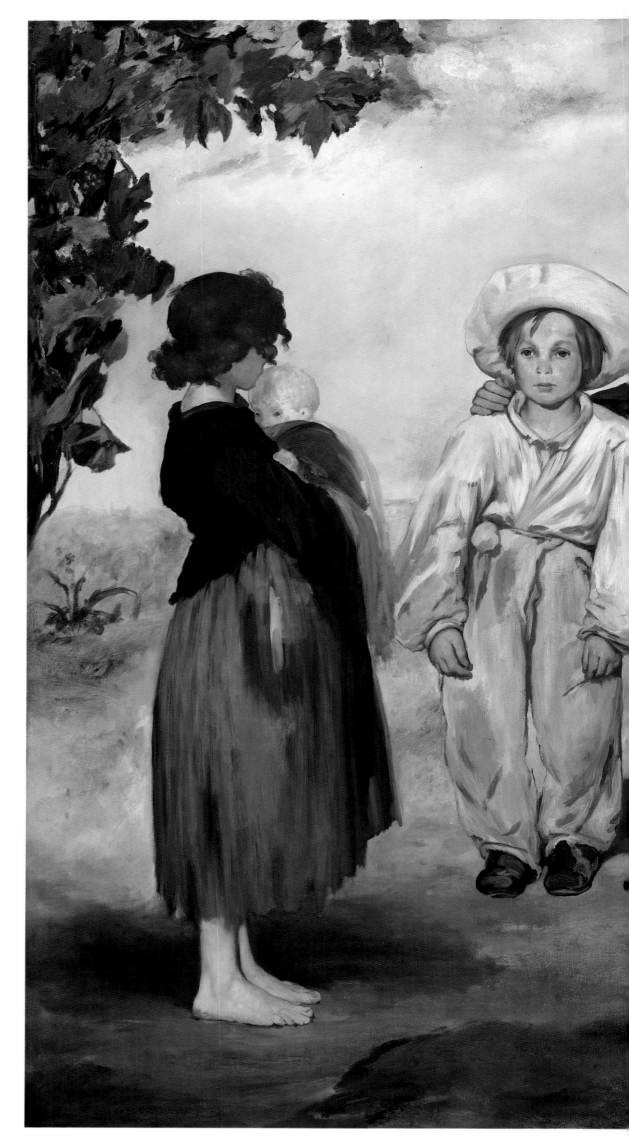

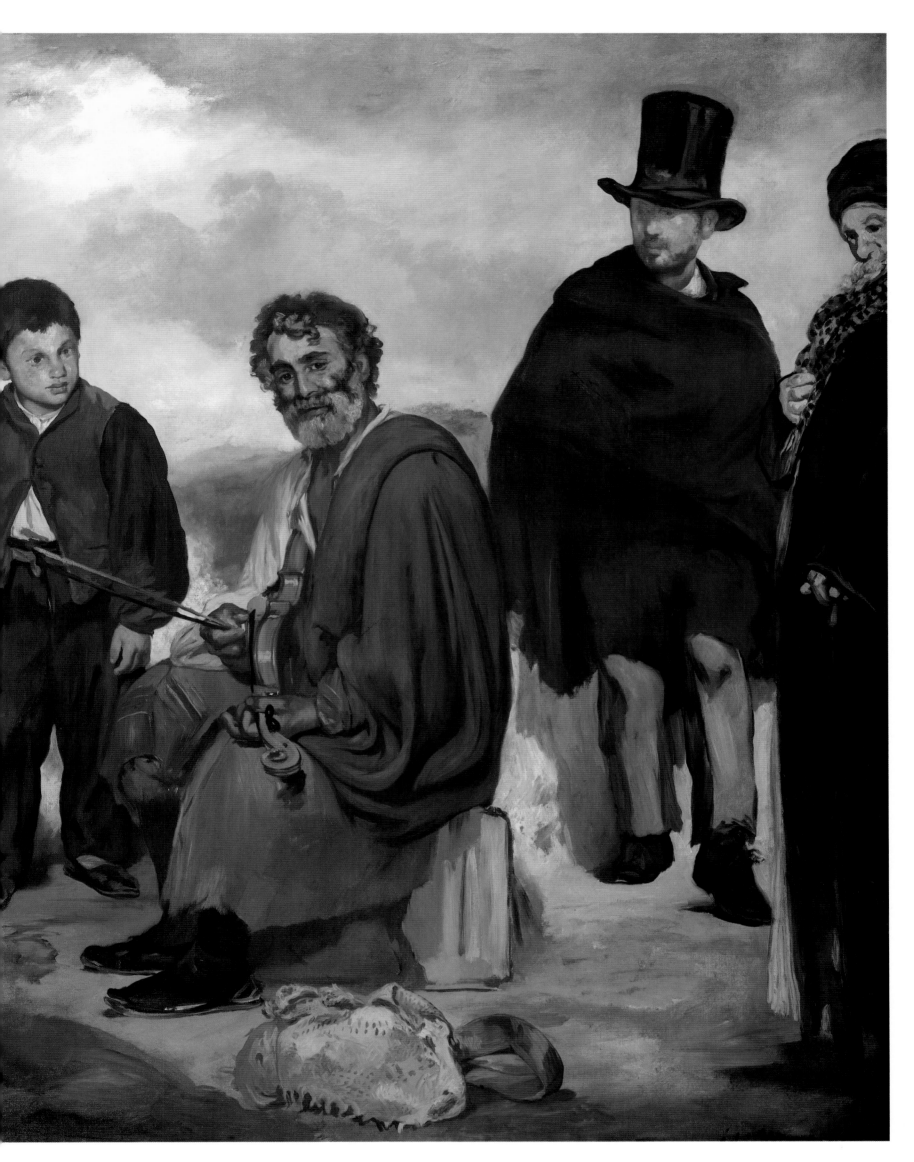

Portrait of Jeanne Duval, 1862

Oil on canvas
35½×44½ inches (90×113 cm)
Szépmüvészeti Múzeum, Budapest

Traditionally known as *Baudelaire's Mistress*, this work depicts Jeanne Duval an actress with whom the poet fell in love in 1842 when he was 21 and she was slightly older. At the time of painting Jeanne Duval must therefore have been middle-aged, although Manet has depicted her not as mature, but rather as a curious doll-like figure with a now-wizened face. At this point she was ill (she had been hospitalized the previous year) and half-paralyzed, which accounts for the odd angle of her leg. Writing much later, the critic Félix Fénéon commented on the work:

Ennobled with strangeness and with memories, another canvas shows the fabled mistress of Baudelaire, the wayward and dolorous *créole* Jeanne Duval. Before a window curtained in floating white, she lounges like an idol, like a doll ... The flat, swarthy visage abjures all emotion, and to either side swirls the implausible immensity of a summer dress with broad violet and white stripes.

Fénéon, like others, commented on the fact that Duval was black and his view of the work is overlaid with images of exoticism: he talks of her as being 'wayward' and 'dolorous,' suggesting the hidden passions then ascribed to blacks, and on which stereotype Manet played when he had *Olympia* (page 60) accompanied by a black servant. Duval's face, according to Fénéon is 'swarthy' and 'flat,' which descriptions have less to do with the actual woman than with perceived notions of otherness. In fact Duval was not black, but may have been of Mediterranean extraction; Baudelaire referred to her as his 'infante' suggesting Spanish origins.

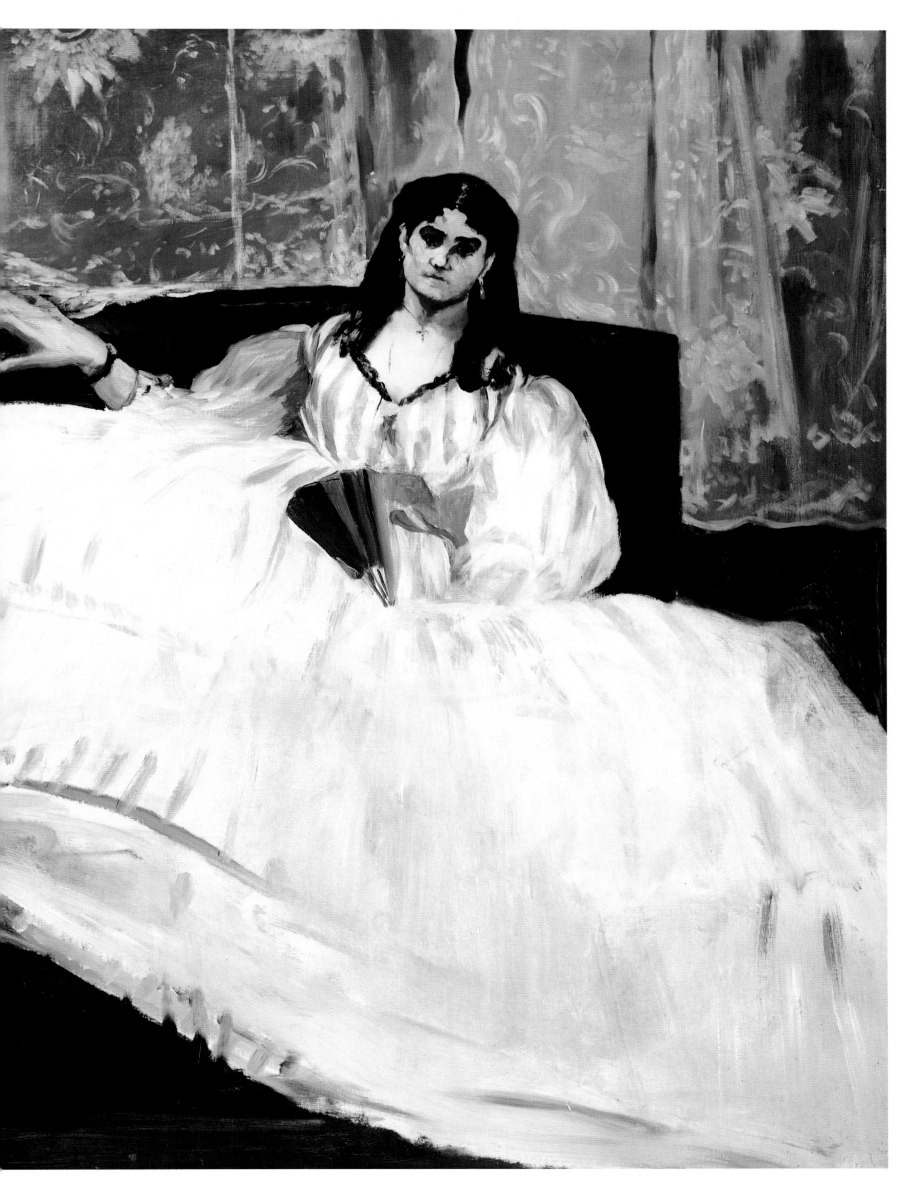

Young Woman Reclining, in Spanish Costume, 1862

Oil on canvas
37¼×44¾ inches (94.7×113.7 cm)
Yale University Art Gallery, New Haven, Connecticut
Bequest of Stephen Carlton Clarke, BA 1903

This work is inscribed 'to my friend Nadar'; Nadar was the pseudonym of Félix Tournachon (1820-1910) to whom Manet may have been introduced by Baudelaire, and this painting is traditionally thought to represent his mistress. It is sometimes suggested that the work is a pendant to Manet's *Olympia* (page 60) painted the following year, and that in coupling the two works in this way, Manet was referring to the *Majas* of Goya: two recumbent and provocative women, one clothed and one nude. This hypothesis does not bear scrutiny however, since the two works are quite different in dimension and the wealth of detail in *Olympia* lends itself to a narrative which is lacking here. It seems more likely that this work was painted at Nadar's express instructions, for he was interested in the vogue for things Spanish. There is certainly a reference to Goya's work here, but equally to the illustrations of Constantin Guys which Manet, Baudelaire and Nadar himself all collected. The work is perhaps closer in spirit to *Mlle V in the Costume of an Espada* (page 49) which was painted about the same time and similarly capitalizes on the Spanish vogue, with a veneer of eroticism from dressing the female model in male clothing. The work was included both in the 1863 exhibition at Martinet's gallery and in the 1867 one-man show on the Pont de l'Alma.

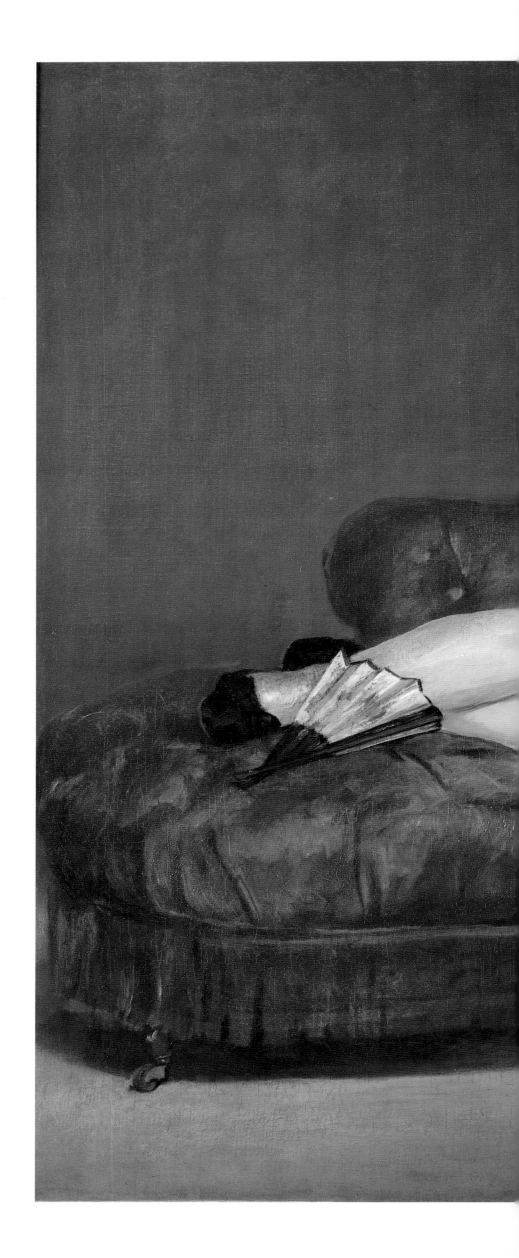

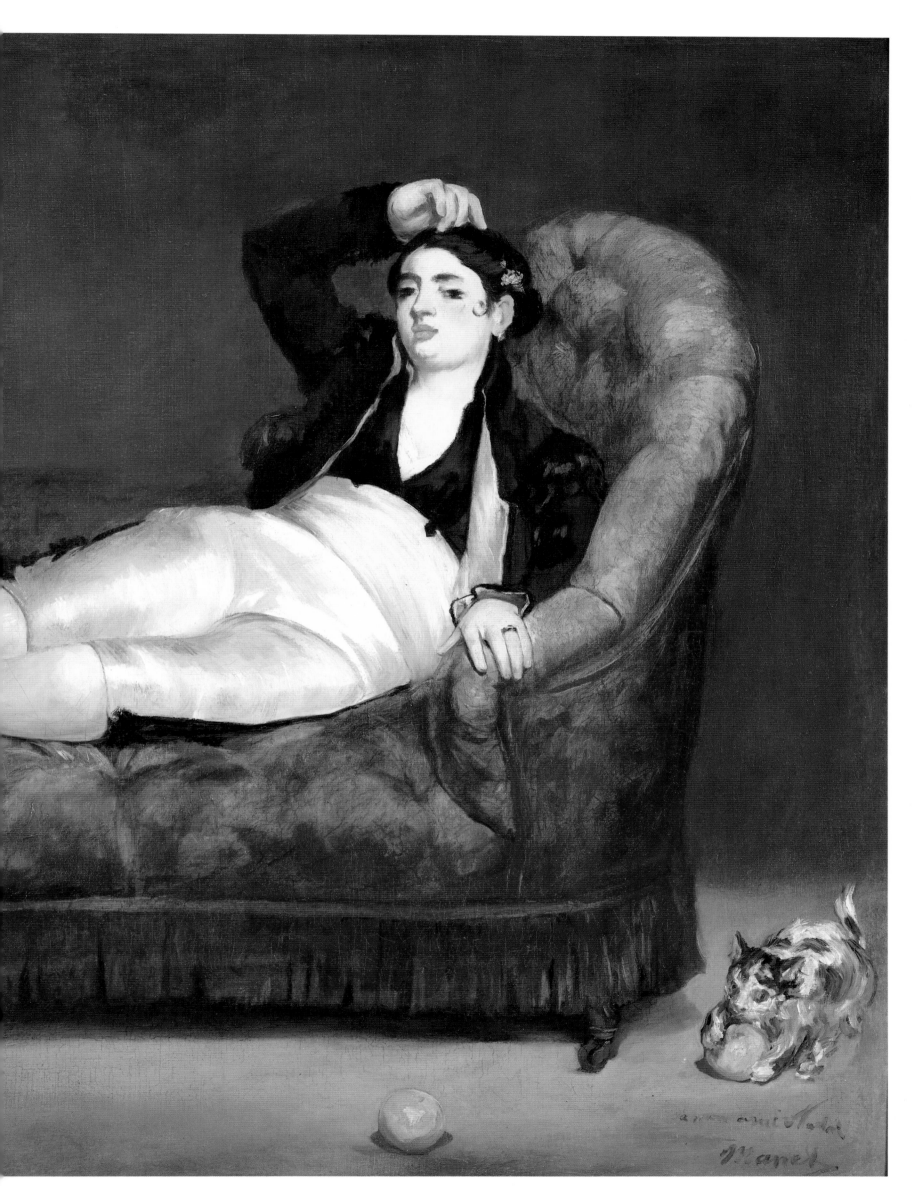

Mlle V in the Costume of an Espada, 1862

Oil on canvas
65×50¼ inches (165.1×127.6 cm)
The Metropolitan Museum of Art,
New York
Bequest of Mrs H O Havemeyer, 1929
H O Havemeyer Collection

Included in the Salon des refusés of 1863 with the *Déjeuner sur l'herbe* (page 56) and *Young Man in the Costume of a Majo* (page 55), this work was one of the earliest in which Manet used Victorine Meurent as his model. She was born in 1844 and was therefore eighteen and already working as a professional model in Couture's studio when she first met Manet. She went on to become his favorite model.

In common with other works of this period, Manet has deliberately fused a modern treatment and subject with references from the old masters: the bull-fighting scene in the background is a direct quotation from Goya's etching *Tauromaquia* of 1815-16. The treatment of the crisp figure of the model illuminated against the far-from-convincing backdrop may derive from Japanese prints, especially those of single figures of an actor, or more likely a courtesan. This allusion may be intentional and Manet may be drawing an analogy between Japanese and French prostitutes who apparently would wear men's clothing for an added *frisson*. Nadar's mistress wears male costume in the *Young Woman Reclining, in Spanish Costume* (page 46) painted around the same time. In giving the work the title *Mlle V in the Costume of an Espada* when he sent it to the Salon, Manet added to the problematic nature of the work by refusing to have it categorized as either genre scene or portrait. When the work was sold to the dealer Durand-Ruel in 1872, Manet asked 4000 francs for it, making it one of his most expensive canvases.

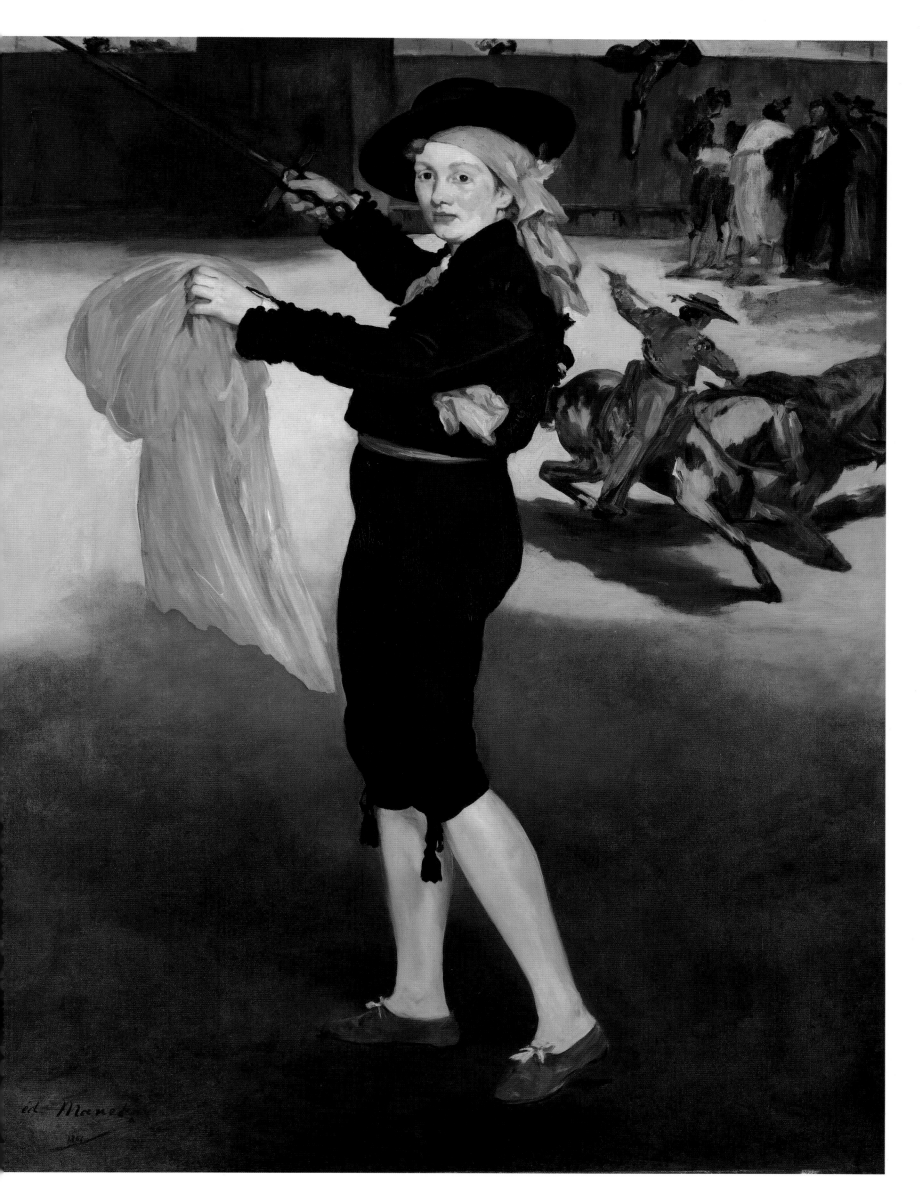

Music in the Tuileries, 1862

Oil on canvas
30×46½ inches (76.2×118.1 cm)
National Gallery, London
Lane Bequest 1917

In 1862 there was a quite discernible change in Manet's subject-matter away from works like *The Old Musician* (page 42) toward the representation of fashionable bourgeois figures within an identifiably urban environment. *Music in the Tuileries* is typical of that shift and despite its apparent spontaneity seems in some respects to be an attempt by Manet to integrate and rationalize a number of disparate sources and influences. As in *Fishing* (page 38), Manet has included a self-portrait (to the extreme left-hand side and slightly attenuated by the picture frame) and this encourages us to read the work as having a personal significance for him. Included in the work are his brother Eugène (the central bowing figure), the composer Offenbach (with the monocle, sitting against the tree trunk), the painter Fantin-Latour (peeping from behind a tree to the left-hand side of the painting), and Baudelaire, Gautier, and Baron Taylor conversing in a little group directly above the two women. By creating what is in effect a group portrait rather than an objective representation of a scene he had witnessed, Manet is paying homage to each of these influential men.

Of all these figures, however, it was Baudelaire who most directly influenced the appearance of the work. Although Baudelaire's *Painter of Modern Life* was not published until 1863, the year after this painting was completed, it had been written in 1859 and Manet must have been conversant with its central argument about the epic, heroic quality of modern life. The work has the grandeur of a history paintings, but is in fact surprisingly small, lending credence to the idea that it was painted in the open air. It is, however, manifestly a studio painting, both in terms of the palette used and the fact that what we are witnessing is a carefully contrived set of portraits, possibly assembled from photographs.

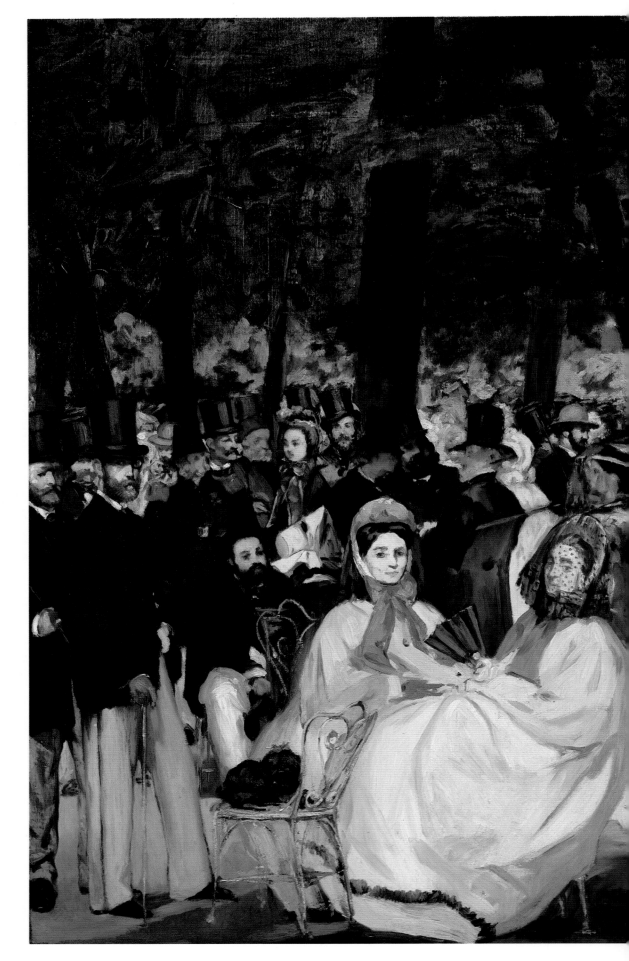

50

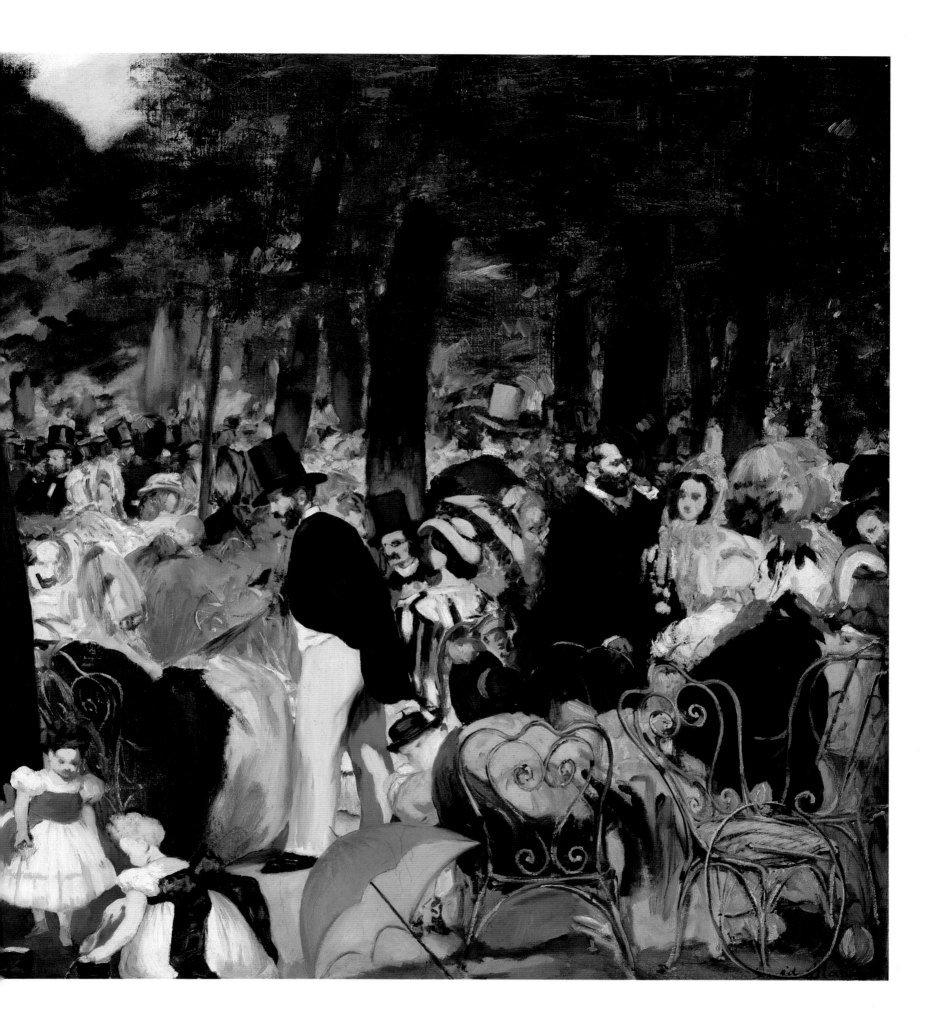

Lola de Valence, 1862

Oil on canvas
48½×36¼ inches (123×92 cm)
Musée d'Orsay, Paris

Painted at the same time as *The Spanish Ballet, Lola de Valence* depicts the prima ballerina from Camprubi's troupe then performing for their second successful season in Paris, at the Hippodrome at the Porte Dauphine. Edmond Bazire wrote about it in his biography *Manet* published in 1884, recounting its inclusion at the 1863 Martinet exhibition:

The big event of the exhibition was the portrait of *Lola de Valence* – the famous Lola which had been so disparaged and which was so often the-subject of attacks – which, as the picture, had the very great fault of being an honest portrait, in fact an extremely lifelike and striking representation of an elegant woman, whose figure is not disguised by the heavy drapery of her national costume.

The size and treatment of the painting, as well as its popular subject-matter, suggest it may have been conceived as a Salon painting, but in the end Manet submitted two other pseudo-Spanish works to the exhibition the following year: the *Young Man in the Costume of a Majo* (page 55) and *Mlle V in the Costume of an Espada* (page 49). There is little in the work to suggest the cause of the attacks which Bazire relates. In fact this may have more to do with the erotic nature of the quatrain which Baudelaire composed to accompany the etching after the painting with its infamous sexual connotation in the '*bijou rose et noir*' than any perceived faults with Manet's technique or theme:

Among so many beauties, everywhere to be seen
I can well understand, friends, that Desire swings to and fro;
But in Lola de Valence one sees shine
The unexpected charm of a jewel, rose-colored and dark.

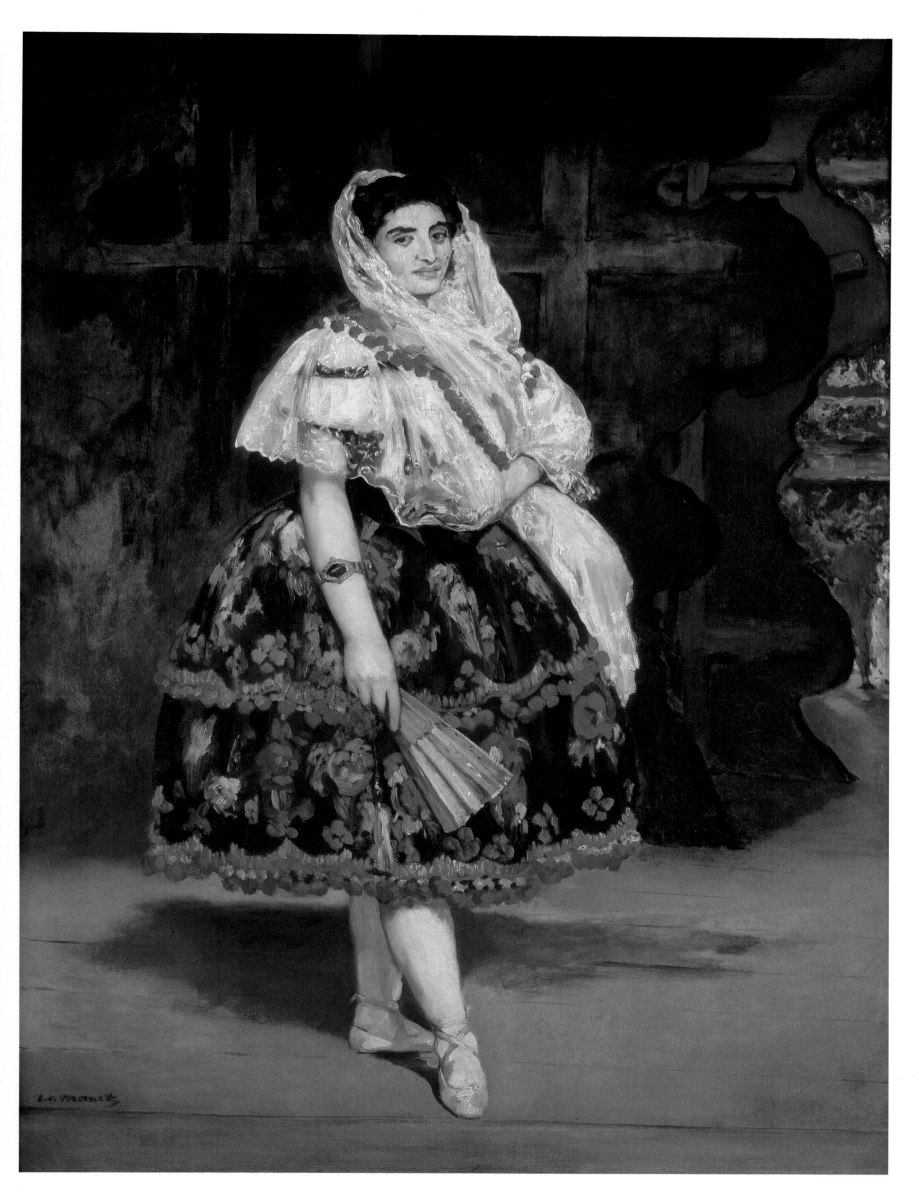

Young Man in the Costume of a Majo, 1863

Oil on canvas
74×49⅛ inches (188×124.8 cm)
The Metropolitan Museum of Art,
New York
Bequest of Mr H O Havemeyer, 1929
The H O Havemeyer Collection

Manet submitted six works to the Salon in 1863: three etchings and three oil paintings, including *Le Déjeuner sur l'herbe* (page 56), *Mlle V in the Costume of an Espada* (page 49), and this canvas. They were rejected by the jury and so unprecedented was the number of refused works that year that an Imperial decree was issued, providing for the organization of a counter-Salon, the Salon des refusées, at which all of Manet's works were displayed. In comparison with the critical reception that greeted *Le Déjeuner sur l'herbe*, the two Spanish subjects were treated leniently by those writers who came to mock the exhibition and thereby support the original decision of the jury.

Indeed, the treatment of the *Young Man in the Costume of a Majo* is not very different from the successful formula Manet had used for the *Spanish Singer* (page 33) at the previous Salon – a full-length, life-size depiction of a figure dressed in a Spanish-style costume depicted against a minimal background. Like *Mlle V* the work eluded categorization – at first sight a genre scene, it was in fact a portrait of his younger brother Gustave. As Zola wrote, Manet had an assortment of props and Spanish costumes in his studio and would use these with little regard to their authenticity; he did not visit Spain until 1865.

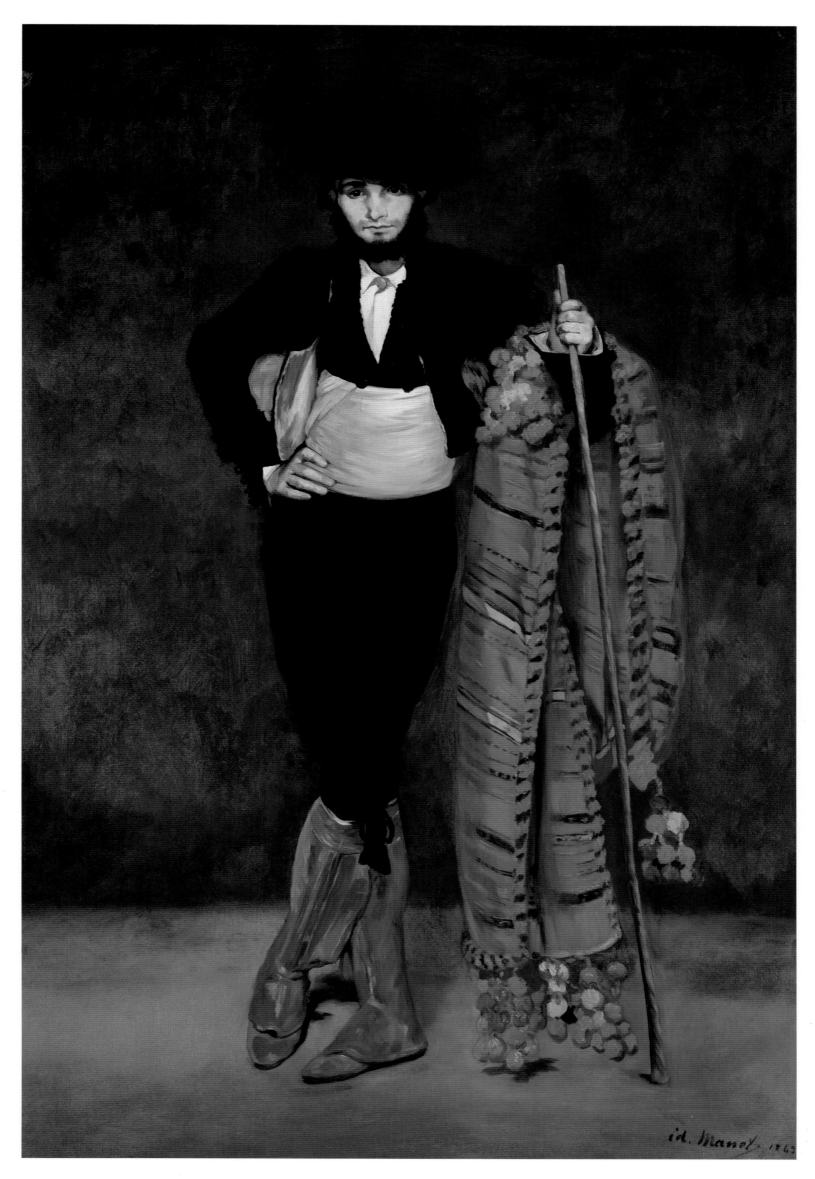

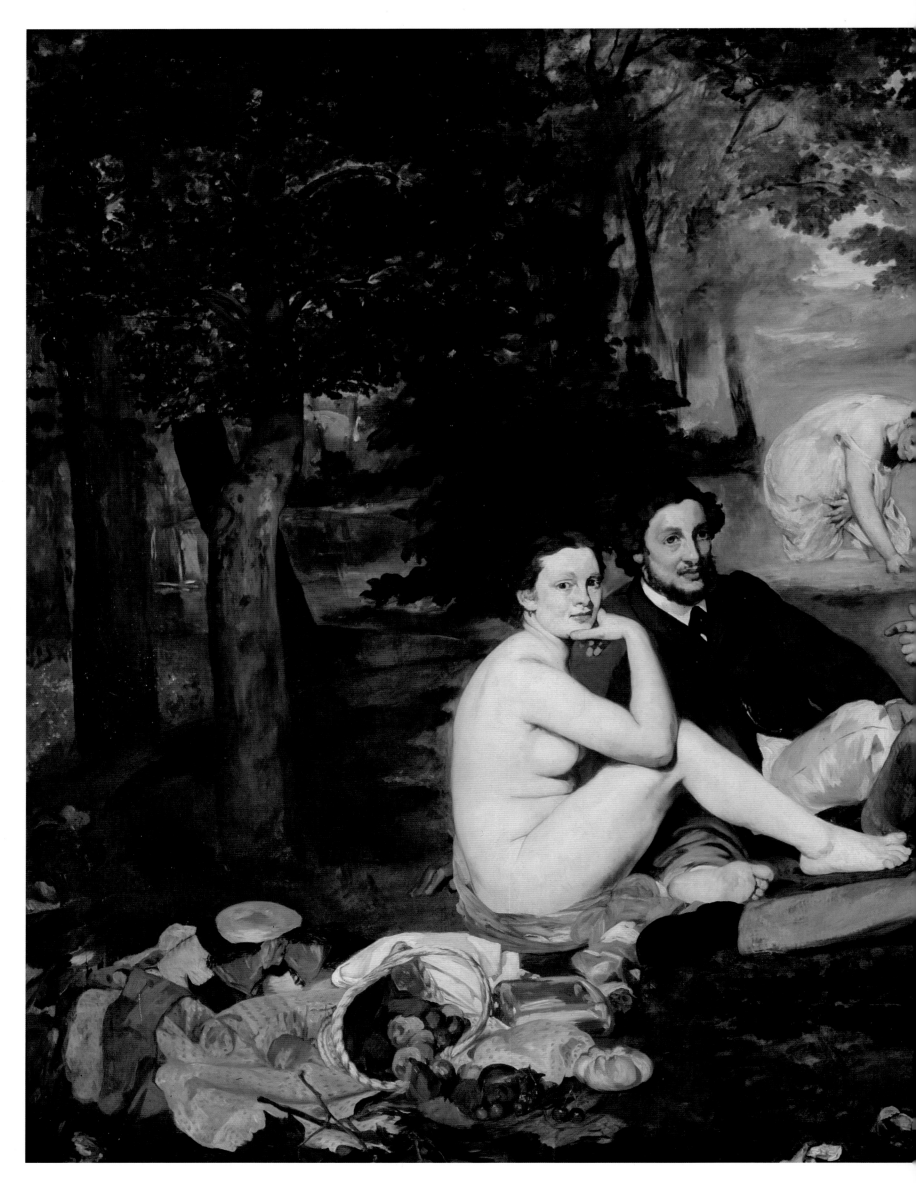

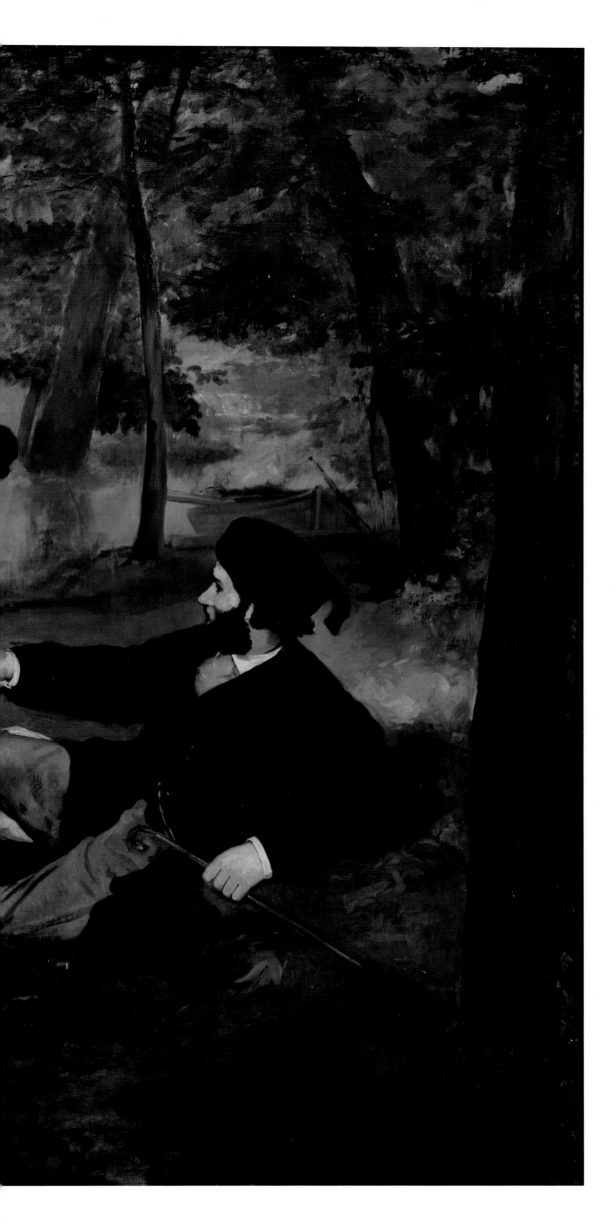

Le Déjeuner sur l'herbe, 1863

Oil on canvas
84¼×106¼ inches (214×269.9 cm)
Musée d'Orsay, Paris

At the Salon des refusés with *Mlle V in the Costume of an Espada* (page 49) and *Young Man in the Costume of a Majo* (page 55) and his three etchings, Manet exhibited another oil painting entitled *Le Bain* which was only given the name *Le Déjeuner sur l'herbe* four years later. Writing in the preface to the brochure which accompanied Manet's 1867 one-man exhibition, Zola presented the work as 'Edouard Manet's largest picture in which he realized every painter's dream – to pose life-size figures in a landscape. We know the power with which he overcame these difficulties.' Yet at the time there were few encouraging reviews of the work. The critic Théophile Thoré who described how it was displayed at the Salon des refusés commented:

Le Bain is very daring . . . the nude hasn't a good figure, unfortunately, and one can't think of anything uglier than the man stretched out next to her, who hasn't even thought of taking off his horrid padded cap out of doors. It is the contrast of a creature so inappropriate in a pastoral scene with this undraped bather that is shocking. I can't imagine what made an artist of intelligence and refinement select such an absurd composition, which elegant and charming characters might perhaps have justified.

Thoré implicity recognized that the work belonged to a tradition of *Fêtes champêtres* in which clothed men and nude women coexist quite happily: the precedents were obvious enough – any one of a number of eighteenth-century *fêtes galantes* by French masters or more specifically Titian's *Concert Champêtre* of 1508, which was then ascribed to Giorgione and hung in the Louvre. However by making his figure demonstrably undressed and having her clothing lying in a heap beside their picnic, Manet is effectively rendering her contemporary and thereby changes the tenor of the work. Not only were the references to Titian apparent here, but also as early as 1863 the critic Chesneau recognized that the composition had been borrowed in a quite flagrant manner from an engraving by Marcantonio Raimondi after a lost painting by Raphael, *The Judgment of Paris*.

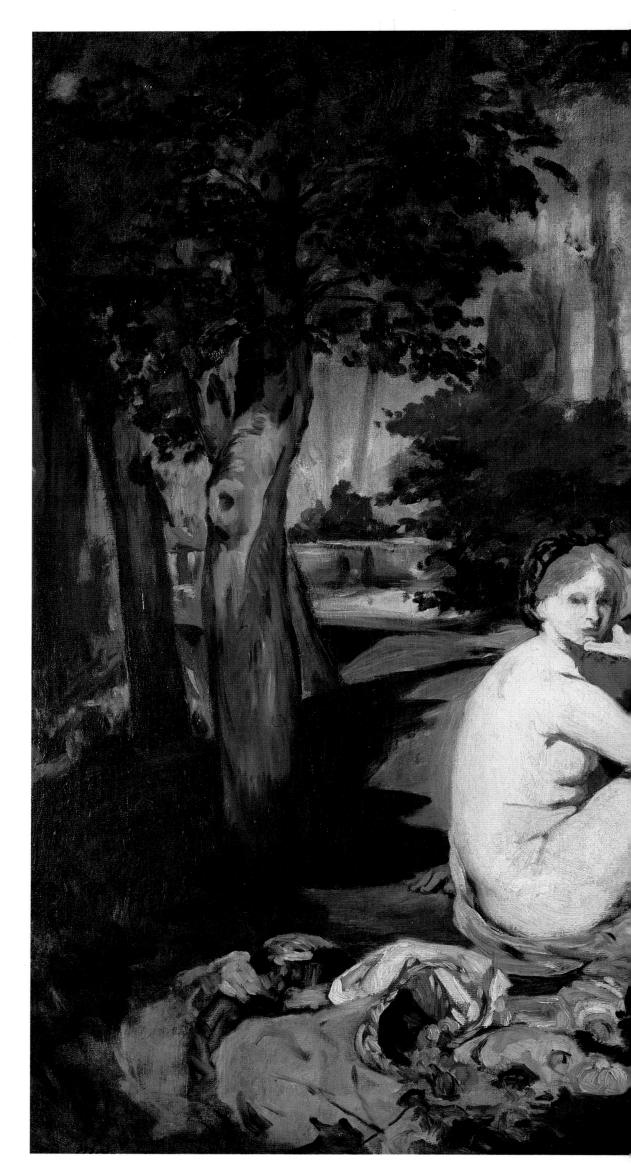

Le Déjeuner sur l'herbe, c. 1863

Oil on canvas
84¼×106¼ inches (214×269.9 cm)
Courtauld Institute Galleries, London

The scale, subject-matter and reworkings of *Le Déjeuner sur l'herbe* betray its final destination as the Salon and it would therefore have been normal practice for Manet to have planned the idea thoroughly using preparatory sketches. It is often assumed, therefore, that this work precedes the finished painting, but the freedom with which it is executed suggests that it may have been done after the large picture was underway, perhaps even after it was finished. X-rays of the painting in the Musée d'Orsay reveal that Manet changed a number of aspects of the finished work and the painting in the Courtauld Institute Galleries shows none of that hesitancy.

The male models in this work and in the large version were Ferdinand Leenhoff, a Dutch sculptor and Manet's brother-in-law who sits next to the nude woman, and his brother, either Eugène or Gustave, perhaps both, posed for the gesticulating man. In the work at the Salon des refusés, the central woman was posed by Victorine Meurent, but her appearance is quite different here and it is not known who modeled for this blonde woman. There is a watercolor of the scene in the Ashmolean Museum, Oxford, which is as resolved as this work and may have been traced from a photograph of the larger version, possibly in preparation for an etching.

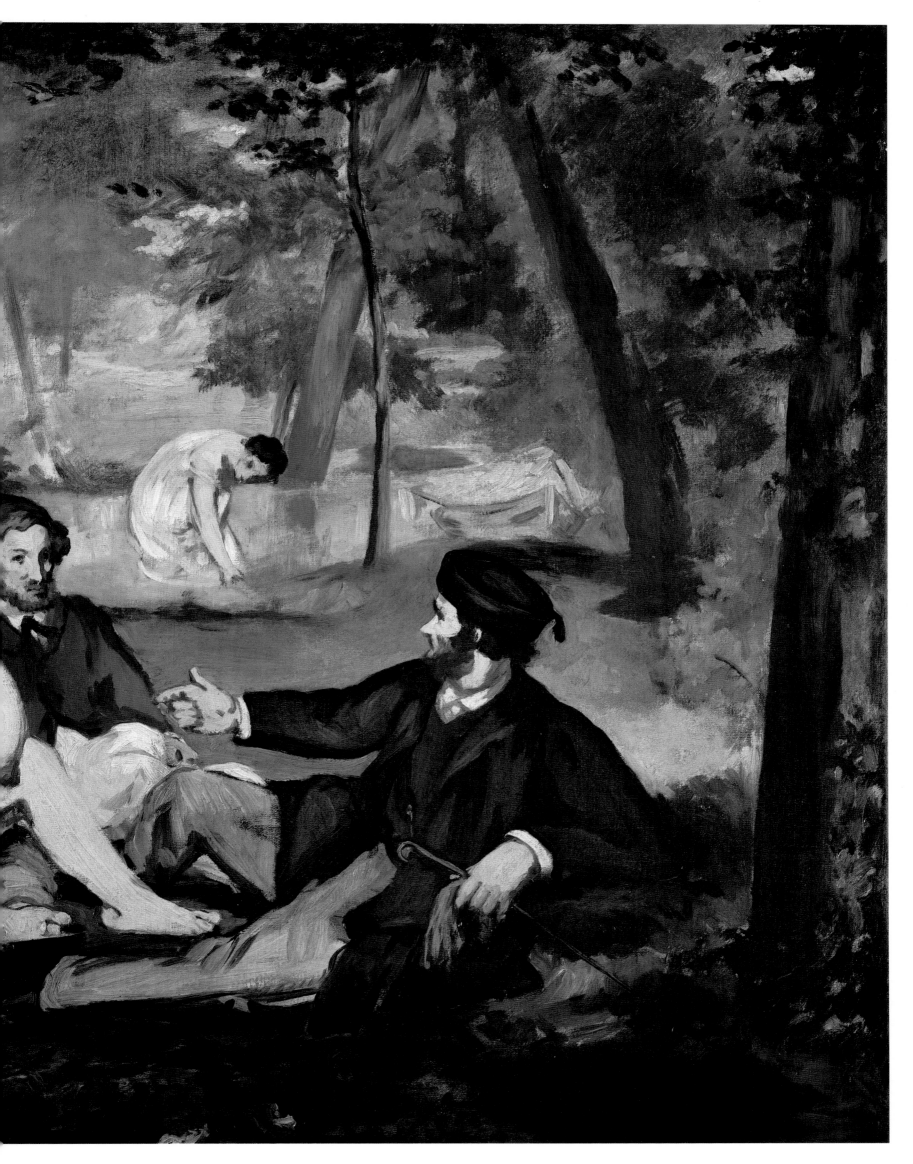

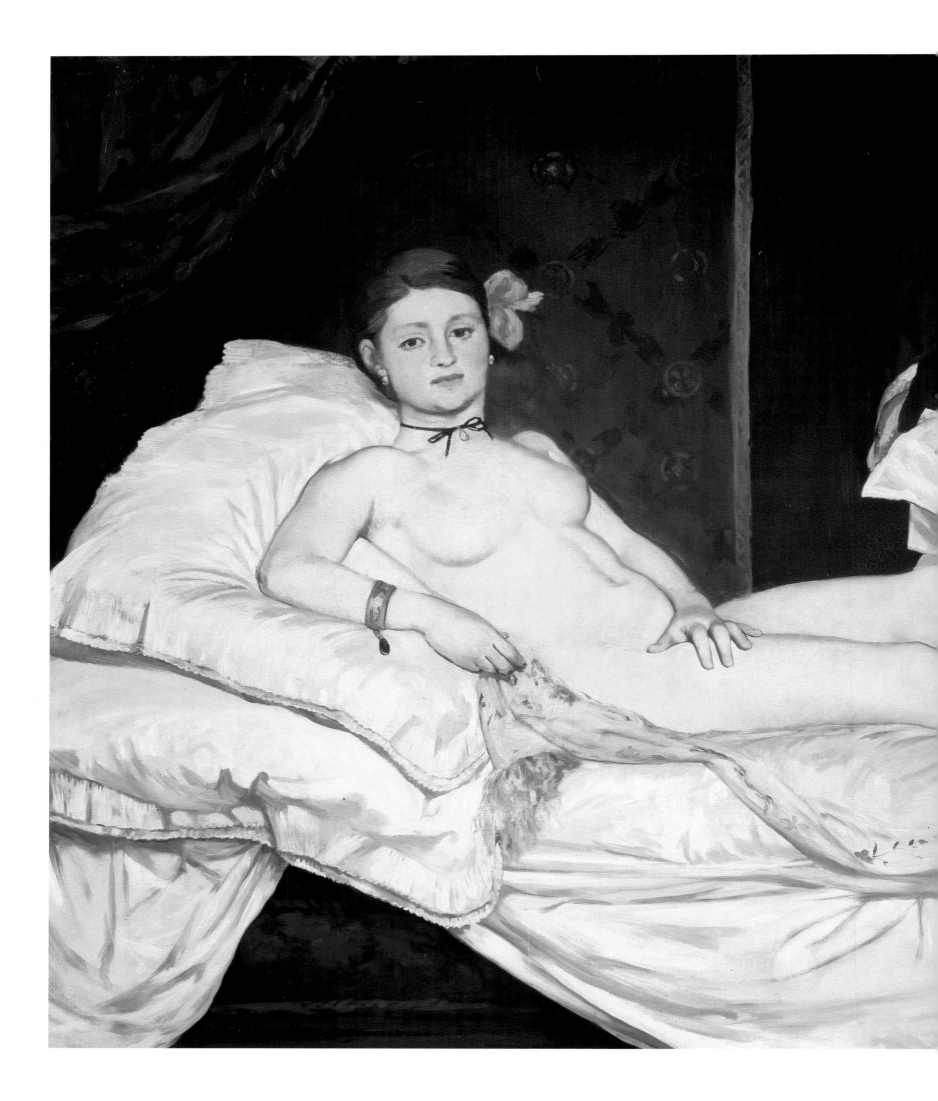

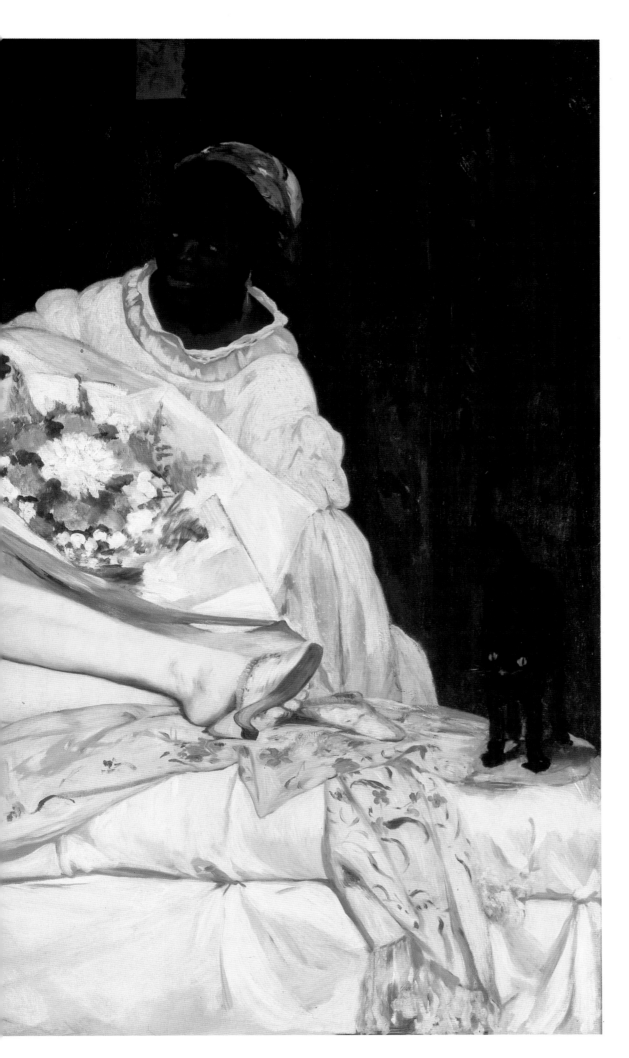

Olympia, 1863

Oil on canvas
51¼×74¾ inches (130.2×189.9 cm)
Musée d'Orsay, Paris

Manet submitted *Olympia* to the Salon of 1865 with *Christ Mocked* (page 69), but it had in fact been painted in 1863 and it is perhaps his last major work in which the influence of Baudelaire is overtly apparent. As with *Lola de Valence*, an association with Baudelaire's poetry fueled public outrage at the apparently scandalous subject-matter. One of the poems which had been suppressed by the police on publication of *Les Fleurs du Mal* in 1857 was entitled 'Les Bijoux' and much of the imagery used in it is close to Manet's painting of the nude:

My darling was naked, or nearly, for knowing my heart
she had left on her jewels, the bangles and chains
whose jingling music gave the her conquering air
of a Moorish slave on days her master is pleased.

For their she lay on the couch, allowing herself to be adored, a secret smile indulging
the deep and tenacious currents of my love
which rose against her body like a tide.

Like Baudelaire, Manet has taken a courtesan as his subject, and her lack of shame, coupled with her manifest success suggested by the jewels she wears and the black maid she employs, meant that contemporaries who saw her at the Salon were unable to categorize her as a 'fallen woman.' This absence of any recognizable frame of reference must have made the image deeply frustrating. That Manet should have coupled her with a naked Christ would have seemed like an impertinence which would have been further exacerbated by his apparent attempting to lend her a kind of spurious validity by overt quotations from Titian's *Venus of Urbino* of 1538 (page 9) which he had copied in the Uffizi in Florence in 1853 or 1856.

The Dead Christ with Angels,
1864

Oil on canvas
70⅝×59 inches (179.4×149.9 cm)
The Metropolitan Museum of Art,
New York
Bequest of Mr H O Havemeyer, 1929
The H O Havemeyer Collection

At the Salon of 1864 Manet exhibited two oil paintings, *The Dead Christ with Angels* and the *Episode from a Bullfight* which was later cut up into *The Bullfight* (New York, Frick Collection) and *The Dead Toreador* (page 66). In general the critics did not think highly of the work and condemned it for its 'realism' or 'vulgarity.' Théophile Gautier, who had admired *The Spanish Singer*, (page 33) in 1861, called Manet a 'frightful realist' whose Christ:

seems never to have known soap and water. The livid aspect of death is mixed with soiled half tones, with dirty, black shadows which the Resurrection will never wash clean, if a corpse so far gone can ever be resurrected. The angels, one of whom has brilliant azure wings, have nothing celestial about them, and the artist hasn't tried to raise them above a vulgar level.

The work was judged by the terms of Renan's *Vie de Jésus* which had been published the previous year and which attempted to locate Christ as an historical figure devoid of miraculous powers. It is the corporeal rather than the spiritual aspect of Christ that Manet has emphasized in this work and his apparent disregard for the scriptures was made clear by placing the wound on Christ's left- rather than right-hand side.

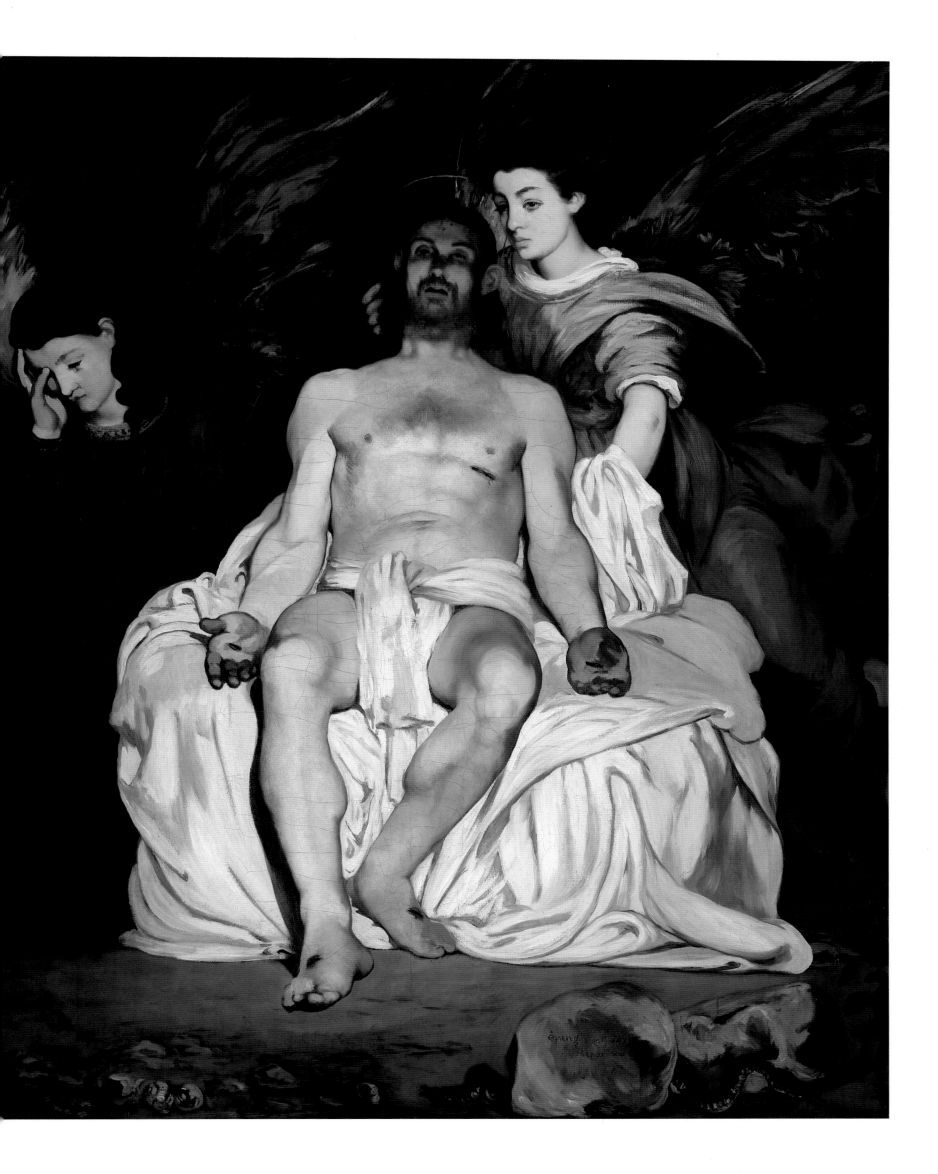

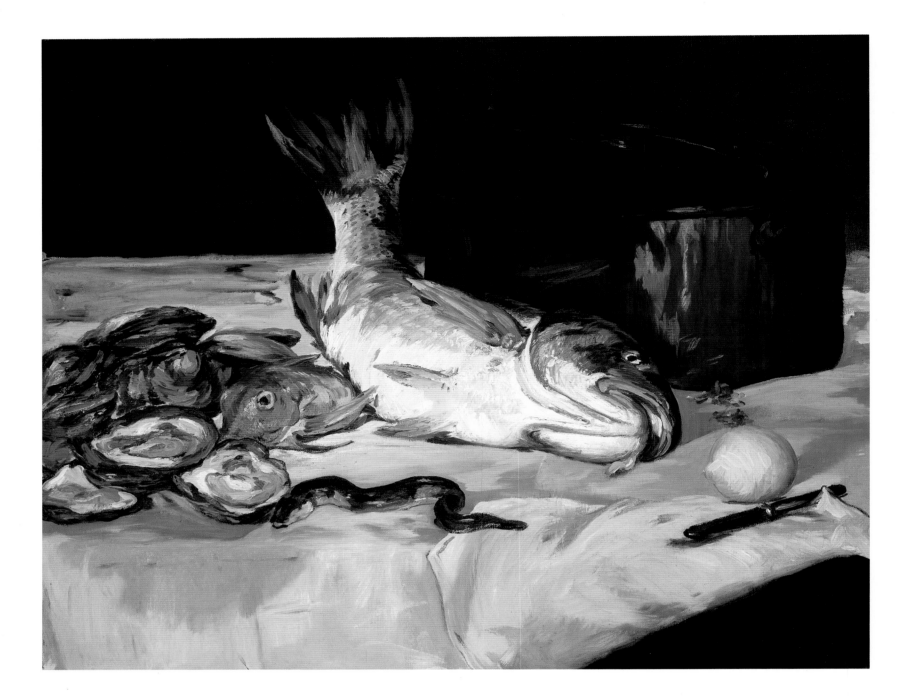

Still Life with Fish, 1864
Oil on canvas
28⅞×36¼ inches (73.4×92.1 cm)
Art Institute of Chicago
Mr and Mrs Lewis Larned Coburn
Collection

Although still life was the lowest of the genres according to the academic hierarchy, Manet nevertheless painted several (pages 70 and 163-165) during his career. Those painted at the end of his life, however, when he was effectively paralyzed by locomotor ataxy were much more intimate and usually used flowers, possibly for their symbolic connotations. This is, however, a grandiose still life in the manner of the eighteenth-century French painter Chardin, whose works were undergoing a marked revival at this time. The careful choice of the large carp and the smaller

fish, balanced by the copper tureen and the delicately positioned silver knife and lemon, on top of a gleaming white table cloth, were all trappings of the traditional eighteenth-century still life when they still retained a vestige of symbolism. Although flavours and textures are differentiated here, suggested by the judicious coupling of the oysters and the lemon, they seem rather to have their basis in reality, as we known that the work was painted during the summer of 1864 when Manet was in Boulogne-sur-Mer and where such produce would have been in plentiful supply.

Battle of the Kearsarge and the Alabama, 1864

Oil on canvas
54⅝×51⅛ inches (138.7×129.9 cm)
Philadelphia Museum of Art
John G Johnson Collection

In the summer of 1864 the Confederate cruiser *Alabama* took refuge in Cherbourg harbor to avoid the Union corvette *Kearsarge*. Napoleon III's régime supported the confederalists, partly because of French interest in Mexico and the ensuing battle was witnessed by a number of day trippers and

was widely reported in the French press when Captain Seemes of the *Alabama* eventually attempted to run the blockade on 10 June 1864, which ended in the *Alabama* being sunk. Despite Proust's account to the contrary, it seems that Manet was not present but that his picture was constructed from descriptions and perhaps photographs of the event. The work is his first attempt at the depiction of a contemporary political event and the mixture of drama and reportage that he achieved here was to be explored further a few years later in *The Execution of the Emperor Maximilian* (pages 86-90).

The sense of detachment that is suggested by having the action depersonalized and removed from the spectator by locating the sinking ship against a very high horizon, has sometimes been attributed to the influence of Japanese prints. Writing in *Le Gaulois* on 4 July 1872, Jules Barbey d'Aurevilly commented on the work:

M Manet has set back his two ships to the horizon. He has had the fortunate idea of diminishing them by distance. But the sea which surges all around, the sea which stretches right up to the frame of his picture, tells sufficient of the fight itself.

The Dead Man (The Dead Toreador), 1864-5

Oil on canvas
29⅞×60⅜ inches (75.9×153.3 cm)
National Gallery of Art, Washington DC
Widener Collection

Manet exhibited two oil paintings at the Salon of 1964, *Dead Christ with Angels* (page 63) and *Episode from a Bullfight*. The latter was condemned by critics for the flaws in its perspective. Edmond About described it as 'a wooden toreador killed by a rat' and contemporary caricatures point to an apparent discrepancy between foreground and background. It appears that Manet cut the work up after the show, retaining two main fragments and discarding

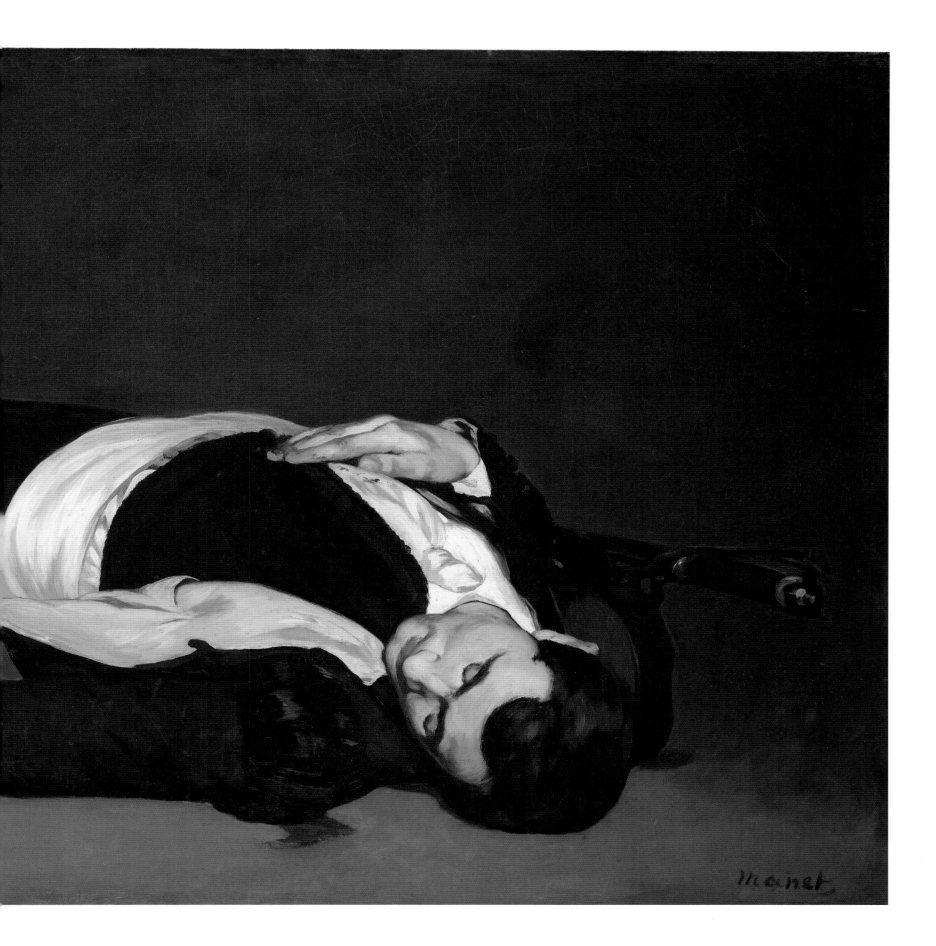

the rest. The *Bullfight* (Frick Collection, New York) and *The Dead Toreador* give some indication of the scale and treatment of the original work with a starkly illuminated, grossly foreshortened figure in the foreground and a much more freely painted background. Presumably the differences in treatment did not help to unify a painting that was already beset by a problematic perspective. It would seem that Manet was satisfied with the new painting and included it in his one-man exhibition in 1867 as *The Dead Man*. As several commentators pointed out, the composition and pose of the figure owned something to *The Dead Soldier* in the Pourtalès collection, then attributed to Velázquez (now National Gallery, London). Although Manet may not have seen the original he could have seen a photograph of this seventeeth-century painting which was published about this time.

Christ Mocked, 1864-65

Oil on canvas
75×58⅜ inches (190.3×148.3 cm)
Art Institute of Chicago
Gift of James Deering

In 1865 Manet sent *Olympia* (page 60) and *Christ Mocked* to the Salon. This was his second religious work at the Salon – he had submitted *Dead Christ with Angels* (page 63) the previous year – and it may have been done as a calculated attempt to mitigate the provacative aspect of *Olympia*. The work owes something to works by Van Dyck and Titian whose depiction of an *Ecce Homo* had been illustrated in Charles Blanc's *Histoire des Peintres* which Manet would have known. In his account of Titian's meeting with the Charles V, Blanc recounted a popular anecdote that Titian presented the Emperor with a nude *Venus* and a representation of Christ crowned with thorns. Although the story is apocryphal, Manet may have been tempted to draw a parallel with his submissions to the Salon jury that year.

Christ was posed by a popular model, Janvier, who was widely recognized by the public when the work was exhibited, and this must have heightened the effect of the modernity of the subject-matter, which was made explicit in the odd mixture of clothes worn by Christ's tormentors. These anachronistic attempts of realism must have emphasized the notion of Christ as an historical figure that Renan had described in his *Vie de Jésus*, which had been published in 1863.

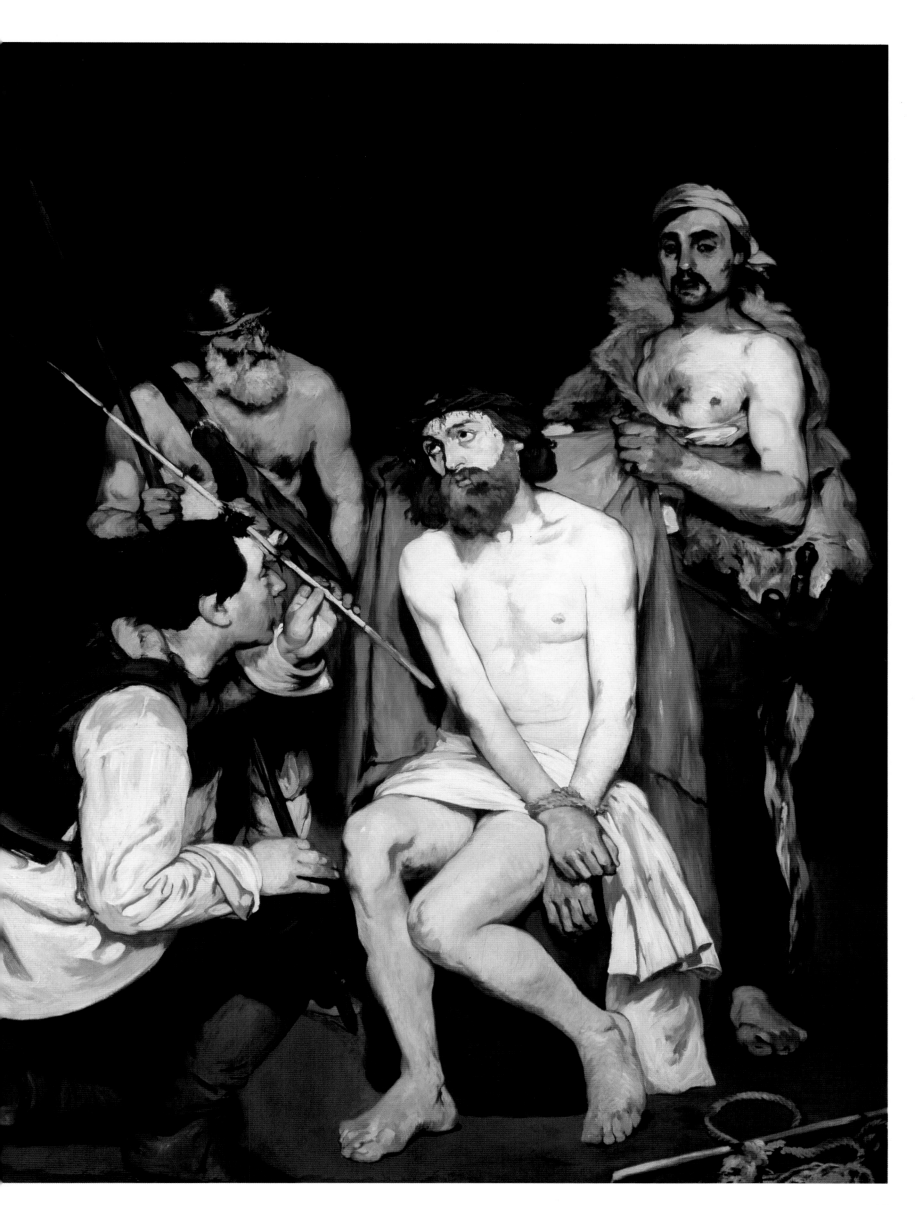

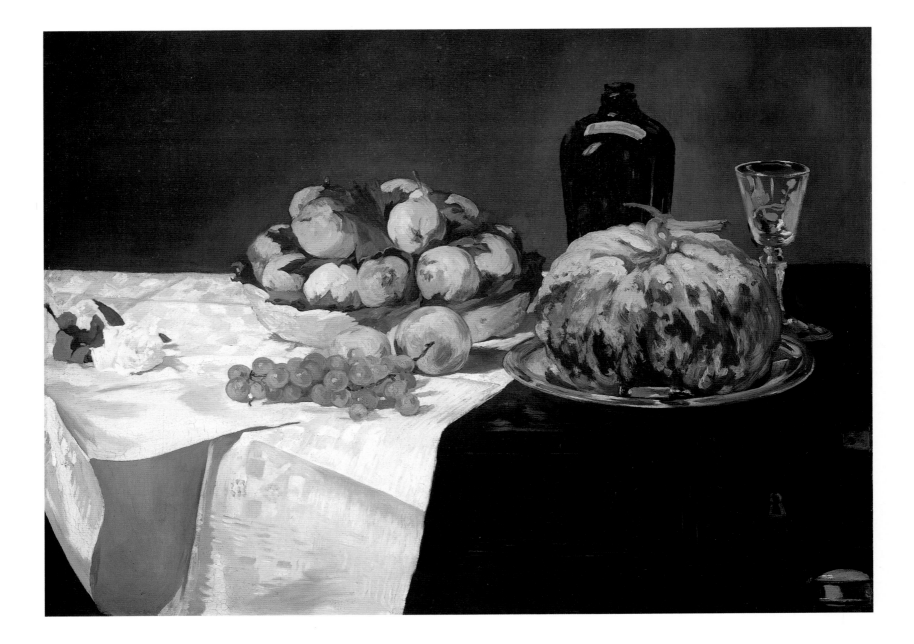

Still Life with Melon and Peaches, c.1866

Oil on canvas
27⅛×36¼ inches (69×92.2 cm)
National Gallery, Washington DC
Gift of Eugene and Agnes Meyer

In his still-life paintings, Manet is at his most conventional. The solid placement of the objects parallel with the picture plane, the contrived positioning of details like the white rose, and the conpicuous display of wealth make his work part of an enduring French tradition in still life which dates from the seventeenth and eighteenth centuries, and which reached its height with the work of Chardin, which was enjoying a reassessment during the Second Empire. Because of its debased status in the hierarchy of the genres, artists could afford to be more innovatory in their display of virtuosity in works like this, and many contemporaries commented on Manet's technical gifts when painting still lifes.

Paradoxically this could be counter-productive. Writing in 1865 the journalist and painter Gonzague Privat noted 'the proof that Manet lacks knowledge is that when he paints a still life he executes a very beautiful painting, seeing that it's less difficult to do a casserole or a lobster than a nude woman.' It is this kind of comment that has encouraged twentieth-century formalist critics to deny the importance of subject-matter for an assessment of Manet's work and to suggest that it should be valued for its formal qualities alone. It is however, of importance that Manet continued to submit the higher genres to the Salon and that his entry in 1865 was the nude *Olympia* (page 60).

The Tragic Actor, 1865-66

Oil on canvas
73¾×42½ inches (187.2×108.5 cm)
National Gallery of Art, Washington DC
Gift of Edith Stuyvesant Gerry

Manet submitted two works to the Salon of 1866, *The Fifer* (page 73) and *The Tragic Actor,* about which he had written to Baudelaire in March of that year 'a portrait of Rouvière in the role of Hamlet, which I am calling the Tragic Actor to avoid the criticism of those who might not find it a good likeness.' In the event, both works were refused.

Philibert Rouvière (1809-65) was depicted in his most famous role, that of Hamlet in Paul Meurice and Alexandre Dumas' adaptation of the play, which he had first created in 1846 and continued to play until 1863. As well as being a very dramatic actor, he had also trained as a painter under Baron Gros (1771-1835) and had a number of works shown at the Salon. Several of his paintings represented scenes from *Hamlet.* Shakespeare's play was very popular during the mid-nineteenth century when it provided the basis for a number of paintings by Romantic artists, including Rouvière's friend Delacroix. Manet himself depicted the opera singer Faure as Hamlet in 1877 (page 143). The pensive pose suggests that this may depict Hamlet's famous soliloquy from Act 3, Scene 1:

To be or not to be – that is the question
Whether 'tis nobler in the mind to suffer
The slings and arrows of outrageous fortune
Or to take arms against a sea of troubles.

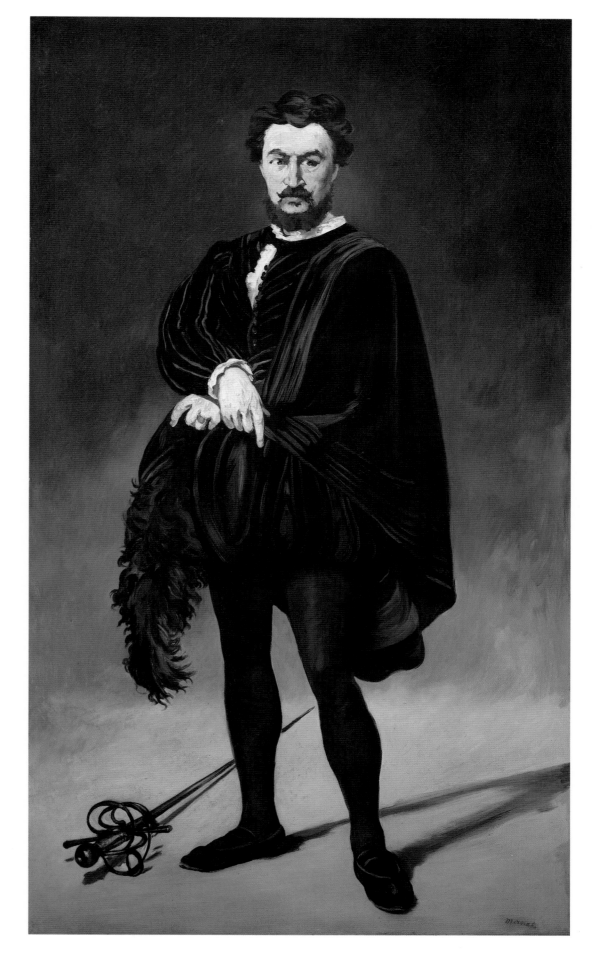

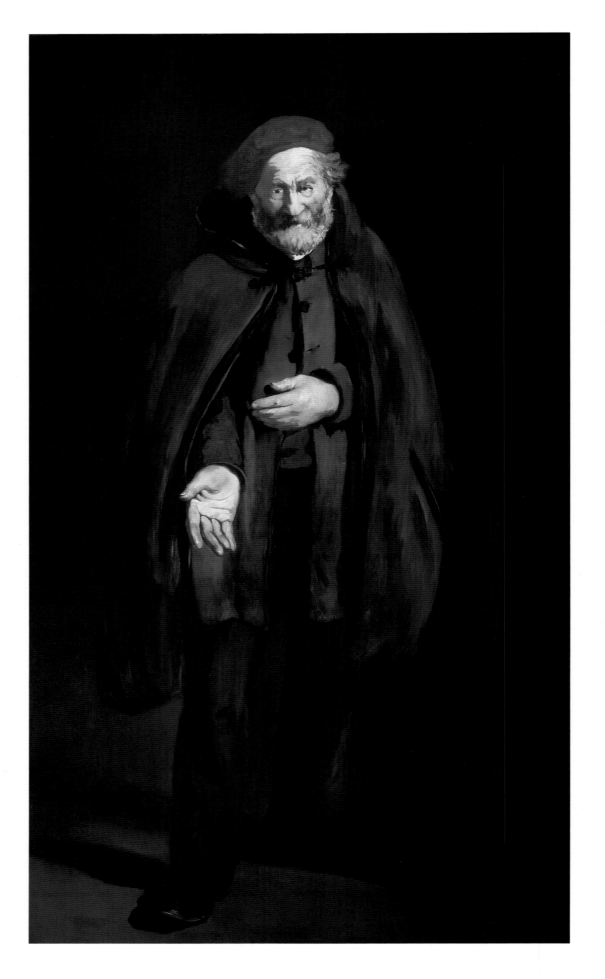

Philosopher, 1865

Oil on canvas
73⅞×43¼ inches (187.7×109.9 cm)
Art Institute of Chicago
A A Munger Collection

The beggar-philosopher has a well-defined role in Manet's early oeuvre when his painting was influenced by Baudelaire's writing. In *The Absinthe Drinker* (page 27) the rag-picker had been identified with the drunken figure in *Les Fleurs du Mal* whom Baudelaire had described as the 'poet' of modern life. The same figure had recurred in *The Old Musician* (page 42) where he had been associated with those other figures on the fringes of society who had been uprooted by Haussmann's rebuilding of Paris. In 1865 Manet began a series of representations of beggar-philosophers which owed something to the paintings of the same types by Velázquez which he had admired that summer in Spain and where there was a well-established tradition in the seventeenth century of identifying beggars as wise men. A chapter in *Les Français peints par eux-mêmes* gave a description of rag-pickers which could have provided him with information on costume, gesture and expression.

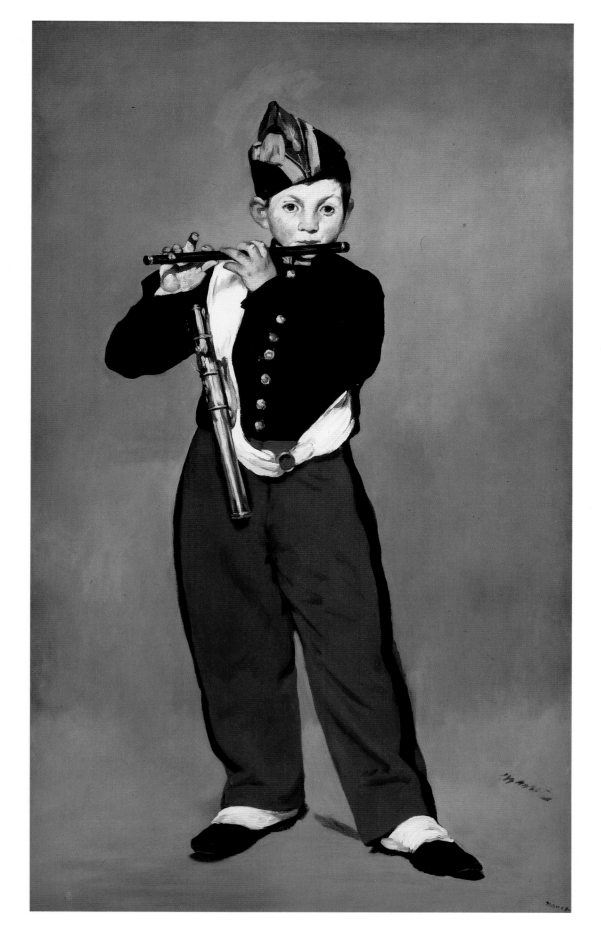

The Fifer, 1866

Oil on canvas
63⅜×38⅛ inches (161×97 cm)
Musée d'Orsay, Paris

The model for this work was a young boy from the Imperial Guard who was taken to Manet's studio by Commandant Lejosne, a friend of the artist and Baudelaire. Along with *The Tragic Actor* (page 71) it was submitted to the 1866 Salon but both works were rejected. The work was particularly admired by Zola who described it as:

a small gentleman, a child musician, who is blowing his instrument with all his might and all his heart. One of our great modern landscape painters has said that this picture is a 'tailor's signboard,' and I agree with him if he means that the costume of the young musician is treated with the simplicity of a poster. The yellow of the braid, the blue-black of the tunic, the red of the trousers, are here again no more than flat patches of color. And this simplification, produced by the acute and perceptive eye of the artist, has resulted in a picture which is totally light and naive, charming to the point of delicacy, yet realistic to the point of roughness.

Portrait of Zacharie Astruc, 1866

Oil on canvas
35½×45¾ inches (90×116 cm)
Kunsthalle Bremen

Included in the *Music in the Tuileries* (page 50) was one of Manet's very earliest supporters, the critic and poet Zacharie Astruc (1835-1907) who later achieved some notoriety as a sculptor. After the stiff formality of the *Portrait of M and Mme Auguste Manet* (page 31), the *Portrait of Zacharie Astruc* is much more relaxed and intimate. This is in part because of the difference in purpose of the two works: the portrait of his upright bourgeois parents was befitted to the Salon, whereas Astruc is depicted as a bohemian and the work is inscribed on the Japanese book on the table 'to the poet Zacharie Astruc [from] his friend Manet, 1866'. Passages like the background and the left hand are freely painted, yet the whole is still traditional in conception: the fluid handling owes as much to the practice of the *ébauche* as to any desire to be revolutionary; the painting has darkened considerably because of the use of bitumen; objects piled on the table are conventional attributes of the man of letters and the distinction drawn between the foreground and background owes something to Titian's *Venus of Urbino* (page 9) which Manet had copied in the 1850s. The area to the left-hand side of the picture space has often been identified as a room behind the writer, or sometimes as a mirror, but neither interpretation is completely plausible. It may in fact depict a large canvas, either real or imaginary, of Mme Astruc.

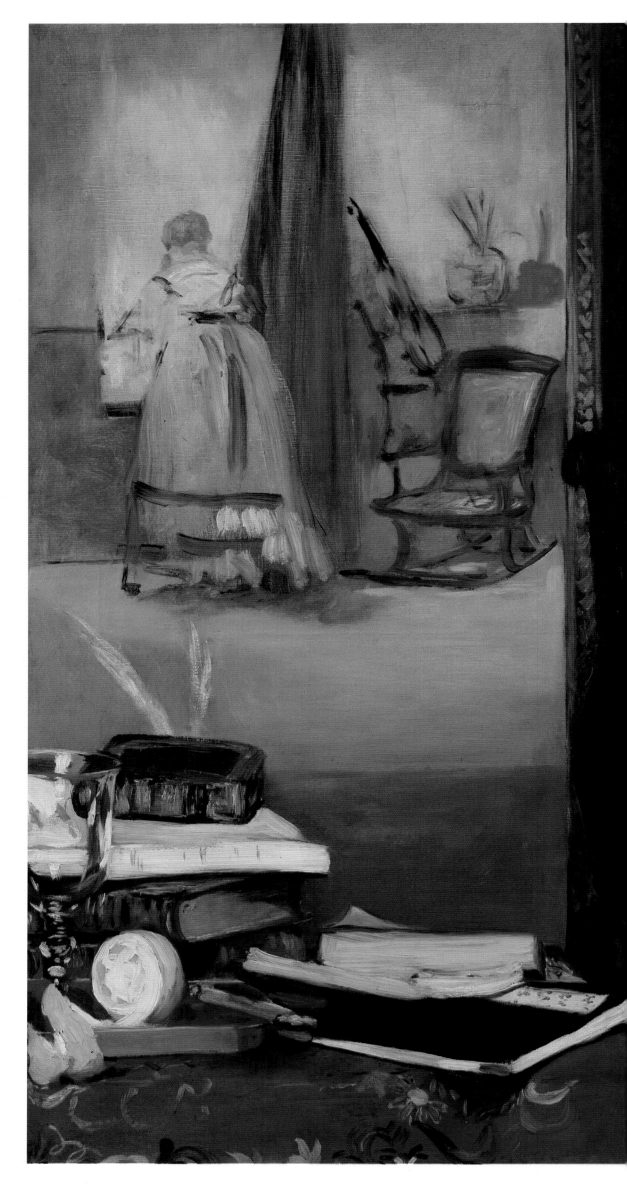

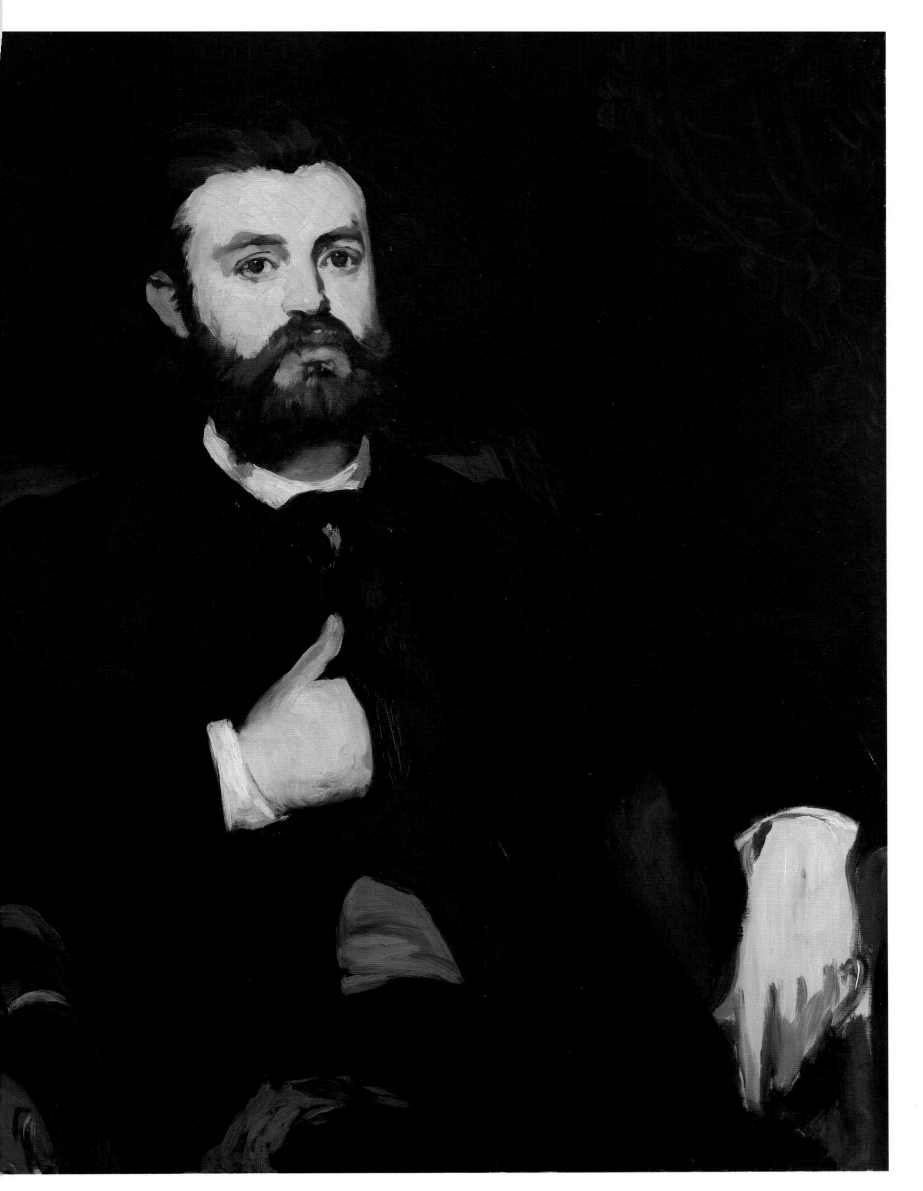

Young Lady of 1866 (Woman with a Parrot), 1866

Oil on canvas
72⅞×50⅝ inches (185.1×128.6 cm)
The Metropolitan Museum of Art,
New York
Gift of Erwin Davis, 1889

At the Salon of 1868 Manet was represented by the *Portrait of Zola* (page 94) and this work, which had been included in his 1867 one-man exhibition. Victorine Meurent had posed for it, but rather than being a portrait it was in fact a genre piece or study of modern life which demanded attention by virtue of its large scale. Originally called *Woman with a Parrot,* Zola had renamed it in the pamphlet he had published on the artist, and this alternative title emphasizes the contemporary subject-matter. The model is wearing a ribbon around her neck, similar to that worn by *Olympia* (page 60) and a concealing dressing gown which nevertheless manages to convey an air of intimacy. At the same time, her rather affected gesture of smelling the little bunch of violets which she holds, while looking archly out of the picture-space, may suggest a gift from a male admirer who is implicated in this scene, a notion similar to that which Manet had explored in *Olympia.* However, while the trappings of the prostitute in that work were undeniably modern, the still-life elements here, like the artfully arranged lemon, the bird on the perch, and the flowers themselves, suggest that the work may be an allegory of the five senses and, by virtue of the short-lived nature of sensory pleasures, point to the brevity of life.

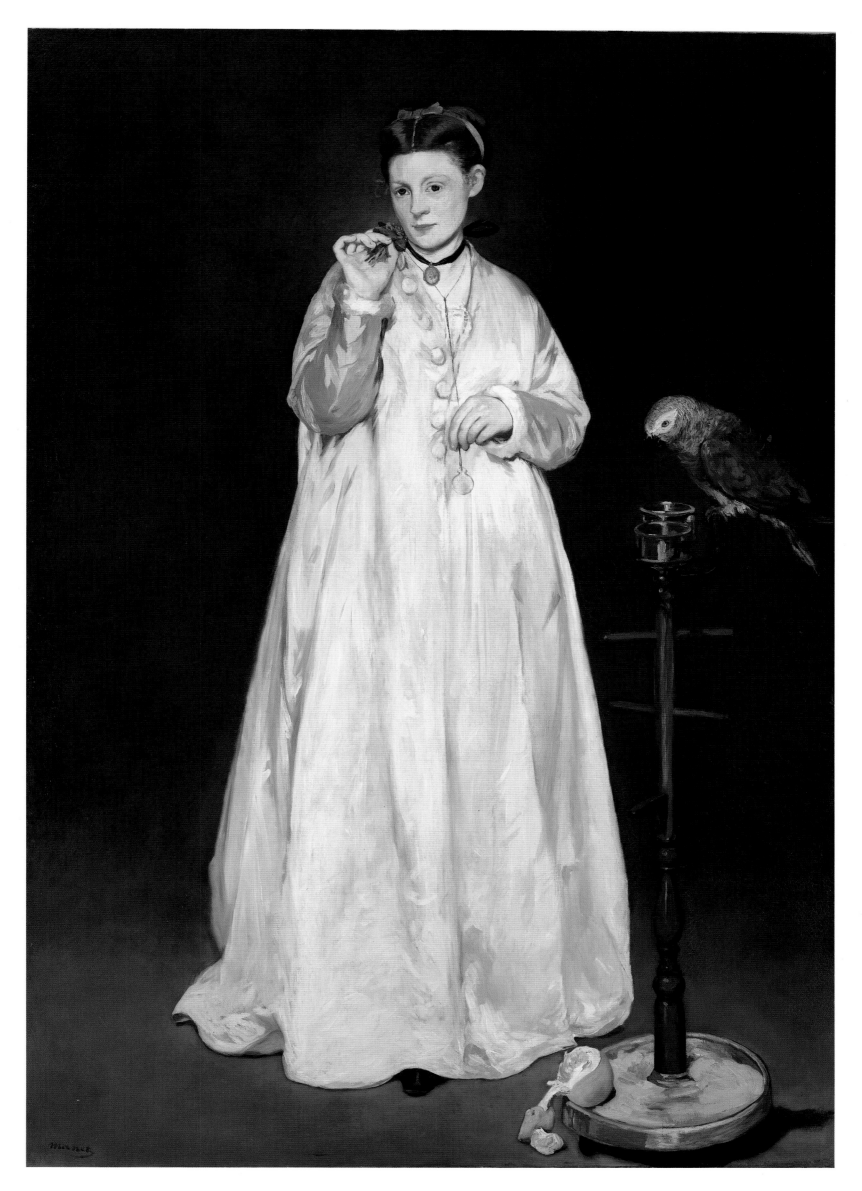

Reading, 1865-73?

Oil on canvas
23⅞×29 inches (60.5×73.5 cm)
Musée d'Orsay, Paris

This work was in Manet's studio after his death and at that time was identified as a portrait of Madame Manet and her son, Léon Koëlla-Leenhoff. Although Suzanne Manet was about 35 when the painting was begun, she in fact looks rather younger, in part because of the *contre-jour* effect of the lighting. In some respects Léon Koëlla looks to be about the same age and certainly not thirteen years old, as he would have been when the work was begun. The discrepancy in their ages may be explained by the fact that Manet kept the painting in his studio and did not complete it until about 1873, by which time Léon would have been 21 years old.

The intimacy of the double portrait is helped by the fluidity of handling, which makes it quite different from the somber tones of the earlier painting of Manet's parents (page 31) and the virtuoso use of white suggests that Manet may have looked to Whistler's *White Girl* (page 10) which had been exhibited at the Salon des refusés of 1863.

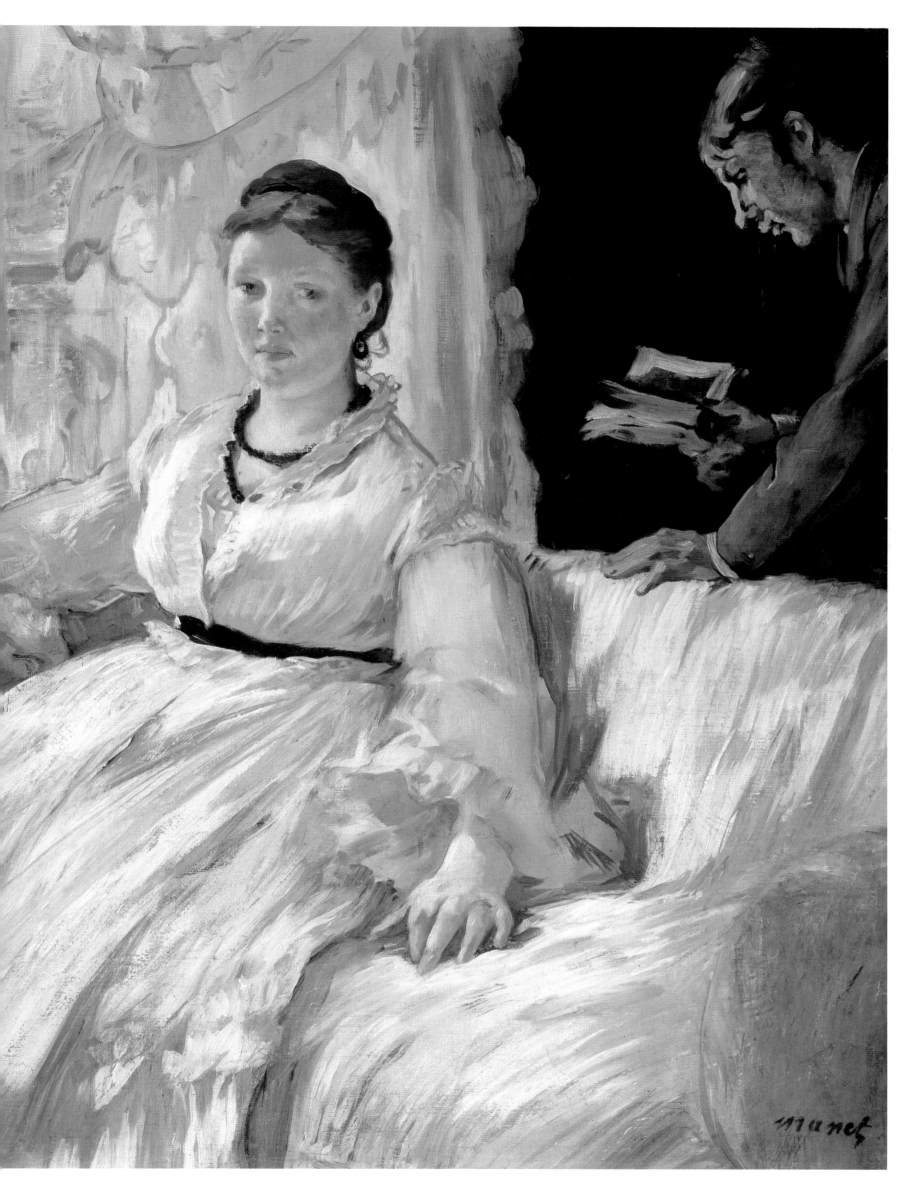

The Funeral, 1867-70

Oil on canvas
28⅝×35⅝ inches (72.7×90.5 cm)
The Metropolitan Museum of Art,
New York
Wolfe Fund, 1909.
Catharine Lorillard Wolfe Collection

In this unfinished work Manet has represented a funeral procession moving across the foot of the Butte Mouffetard in southeastern Paris and in the background, from left to right, the Observatory, the church of Val-de-Grâce, the Panthéon, Saint-Etienne-du-Mont and the Tour de Clovis. In fact, not all of these landmarks would have been visible from this site and it is clear that he took certain liberties with rearranging them. The panoramic vista is reminiscent of Manet's *View of the Exposition Universelle* (page 84) of 1867 and this work may have been painted that same year. If the other painting depicts an optimistic vision of the Second Empire, then in subject-matter and treatment, *The Funeral* depicts the downside of Napoleon III's

régime. In both works there are specific references to the Empire: here a grenadier of the Imperial Guard brings up the rear of the line of mourners following the funeral cortège.

If the date of 1867 is accepted, then it is possible that the funeral is that of Baudelaire which took place on a stormy day at Montparnasse cemetry on 2 September 1867, and which Manet attended. With its realist, modern-life subject, this would have been a fitting tribute to the writer, but at the same time because of the specific Parisian and Imperial references it is tempting to read the work as a metaphor for the passing of a political era, especially when coupled with the *View of the Exposition Universelle.*

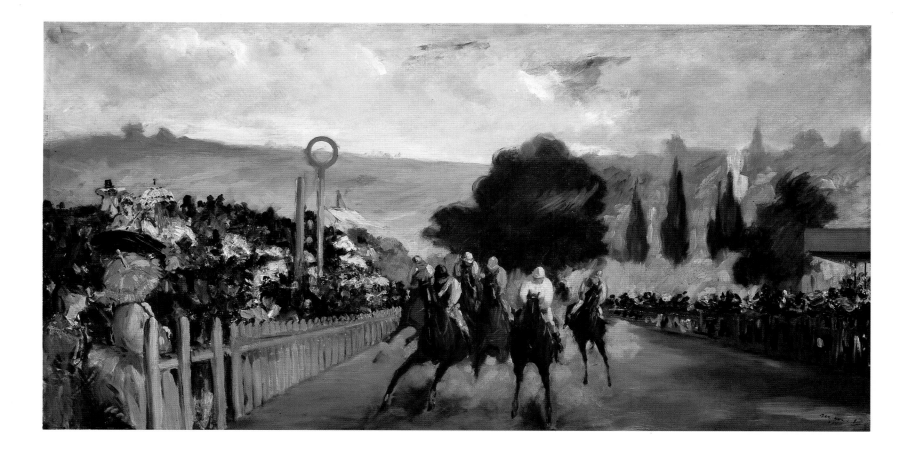

Races at Longchamp, c.1867

Oil on canvas
17¼×33¼ inches (43.9×84.5 cm)
Art Institute of Chicago
Mr and Mrs Potter Palmer Collection

Haussmann's rebuilding of Paris included the development of the Bois de Boulogne as an area for leisure to the west of the city, traditionally the haunt of the middle and upper classes. This included the Long-champ racetrack which Manet has depicted here. Horseracing, both flat-racing and steeplechase, had started as a pursuit of the wealthy but had been popularized through gambling which during the Second Empire was run by about 200 bookmakers who worked at the racetracks. At the same time, the sport had not lost its aristocratic associations: the Jockey Club

which had been founded in 1833 was one of the most prestigious and exclusive clubs in Paris.

The work derives its novelty from the freedom of execution and from the angle from which the race has been depicted. Previously, French artists had looked to English sporting prints and had depicted galloping horses in profile, with all four legs off the ground, as if they were flying through the air. Manet has chosen to represent them as if they were moving towards him in steep perspective, contributing to a sense of action.

Matador Saluting, 1866-67

Oil on canvas
67×44 inches (171×113 cm)
The Metropolitan Museum of Art,
New York
Bequest of Mrs H O Havemeyer, 1929
The H O Havemeyer Collection

This work was included in Manet's one-man exhibition held at the Pont de l'Alma which was intended to complement the Exposition Universelle of 1867. His interest in things Spanish had been evident from 1861 when his painting of *The Spanish Singer* (page 33) had won Manet an honorable mention at that year's Salon. This *hispagnolisme* was part of a much wider enthusiasm in France at the time, and a number of paintings in the 1860s take Spanish figures and especially bull-fighting scenes as their subjects (pages 28, 33, 46, 49 and 55). Unlike these earlier works, the *Matador Saluting* was painted after

Manet's trip to Spain in August 1865, which had been planned for him by Zacharie Astruc (page 74) and which included visits to Burgos, Toledo, Valladolid and Madrid where he was joined by Théodore Duret (page 96) who bought this work from the artist in 1870 for 1200 francs. Manet's interest in Spanish subject-matter was gradually supplanted by more native concerns, but the use of fluid paint, the harmonization of grays and blacks, and the stark compositional format which characterize his Spanish works were retained in later works typical of which is *The Balcony* (page 100).

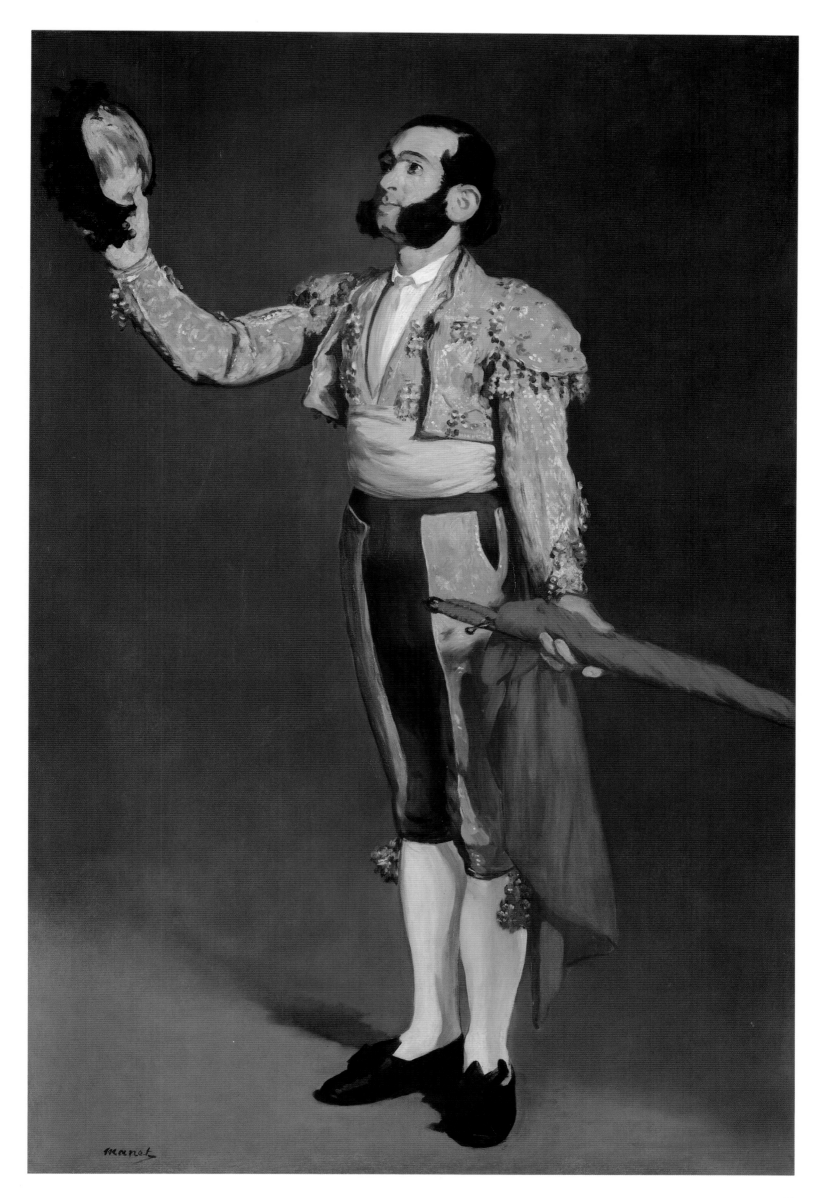

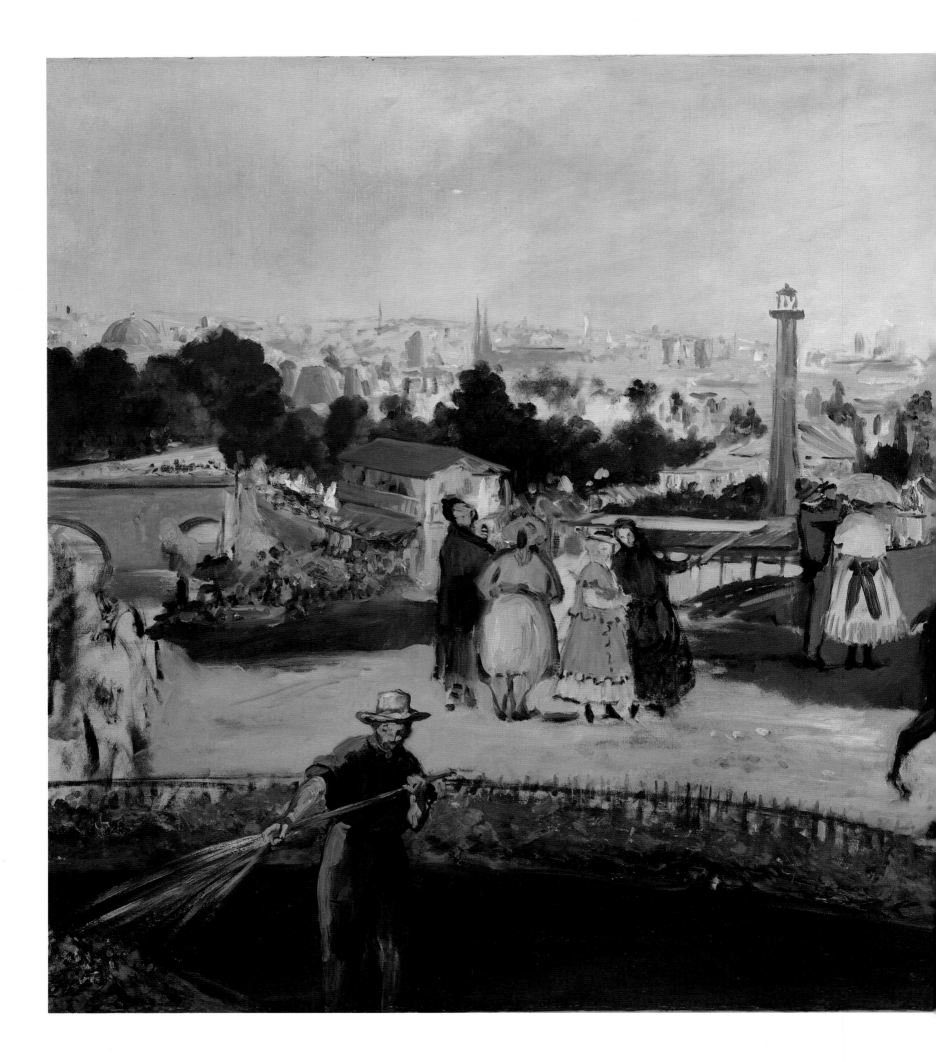

View of the Exposition Universelle, 1867

Oil on canvas
42½×77⅛ inches (108×196 cm)
Nasjonalgalleriet, Oslo

Begun at the time of Manet's one-man show at the pont de l'Alma, the *View of the Exposition Universelle* represents the official view of the exhibition of 1867. Depicted from the freshly landscaped Trocadéro, the view is over the Champ de Mars, the military parade ground in front of the Ecole Militaire, where the exhibition had been staged, to Sainte-Clotilde, Notre-Dame, Saint-Louis-des-Invalides and the Panthéon in the background. The two towers which formed part of the exhibition proper, were both dedicated to the electric light. The French tower is left of center, while the British one, with its open girders, is off to the right-hand side.

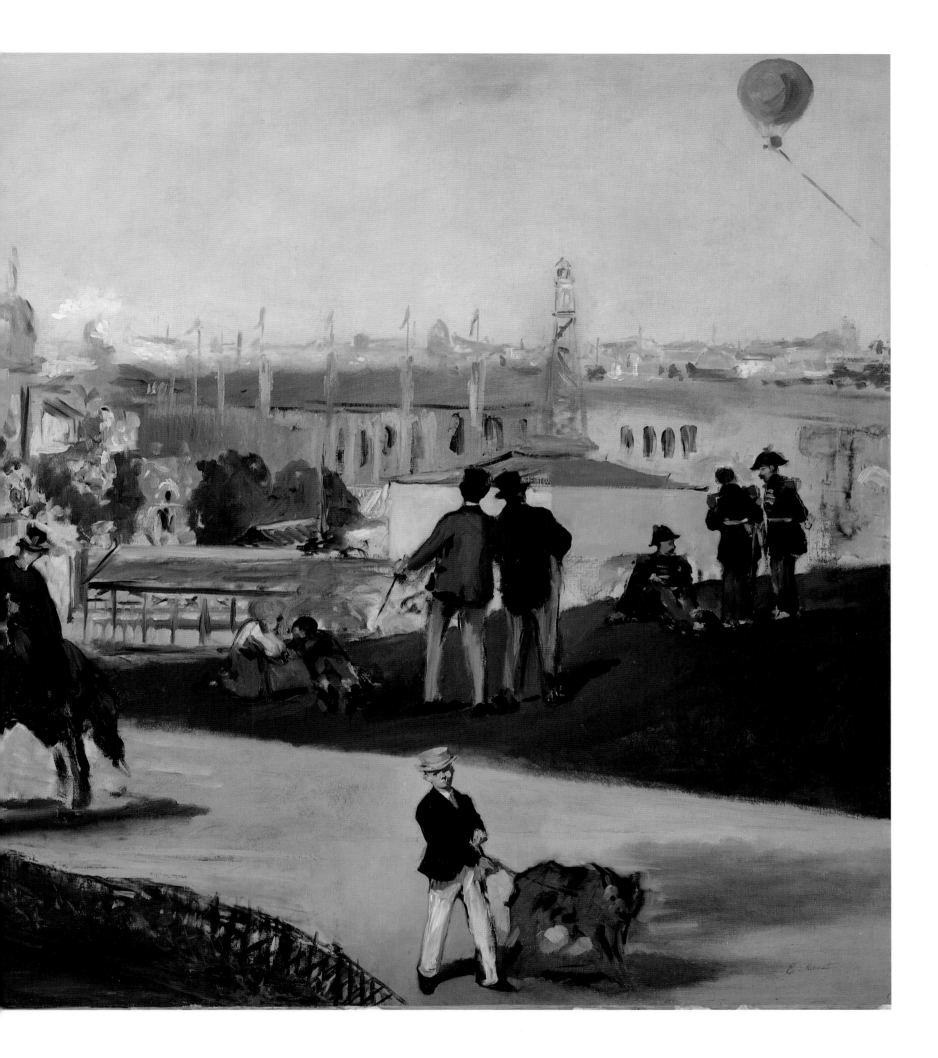

The static, flat nature of the composition, and discrepancies between foreground and background, suggest the theatrical nature not only of Manet's painting, but also of the exhibition itself which was calculated to demonstrate French superiority under Napoleon III's leadership. The Empire is suggested within the picture space by the three imperial guardsmen to the right-hand side who survey the landscape. In this respect, the work is akin to *The Funeral* (page 80) which Manet may have painted that same year. Both depict Parisian panoramas where the Empire is represented by a member of the military and in which a dislocation is suggested between foreground and background which enhances the artificiality of the scene and which suggests that these are representations of French society in its widest sense. Although the somber mood of *The Funeral* is absent here, the theatrical nature of the work suggests a gloss which covers a far from harmonious society.

The Execution of the Emperor Maximilian, 1867

Oil on canvas
77⅛×102¼ inches (196×259.8 cm)
Museum of Fine Arts, Boston
Gift of Mr and Mrs Frank Gair Macomber

During the public spectacle of Napoleon III's triumphant Exposition Universelle (page 84), news began to filter into France that Maximilian, the Emperor of Mexico had been executed at Querétaro on 19 June 1867 with his generals Miramón and Mejía by the Liberal forces of Juárez.

Within French liberal circles there had already been dissatisfaction at the way in which Napoleon III had pursued his expansionist policies in the New World, by installing Maximilian of Austria as a puppet ruler there in 1864 and financing the venture by raising domestic taxes. The Emperor and his generals were executed after Napoleon withdrew French support from the area, and there were many who believed that this was the direct cause of their murders. In France, the event became the focus for political dissent from liberal and republican supporters, which included Manet. His response was to produce a series of four oil paintings and one lithograph which in their increasing sophistication chart his dissatisfaction with the imperial régime and at the same time his strong commitment to the tradition of large-scale history painting as a vehicle for socio-political comment. By virtue of its size and its summary execution this work is easily identifiable as an *ébauche,* the first step in a painstaking process towards a highly finished Salon painting. It was followed by the version in London (page 88), then by that in Copenhagen and finally by the work in Mannheim (page 90).

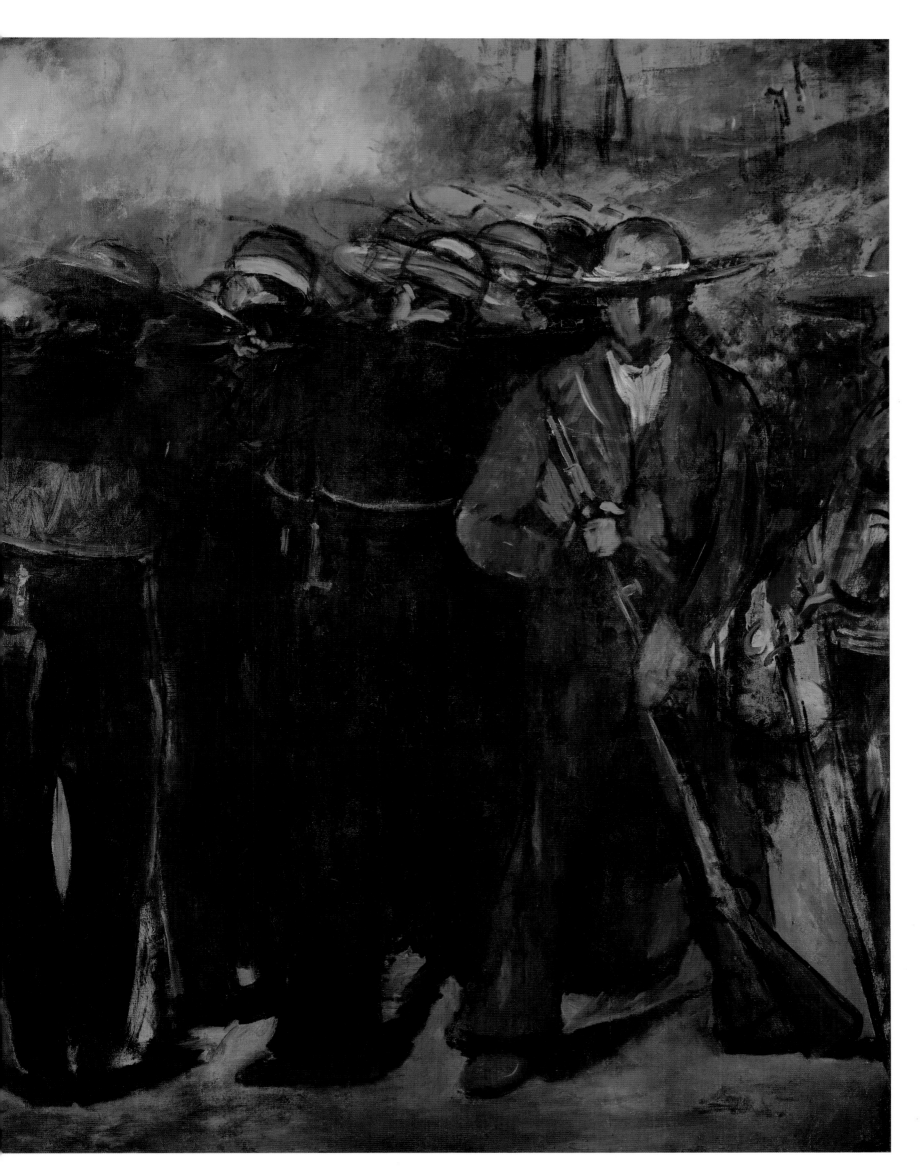

The Execution of the Emperor Maximilian, 1867

Four oil on canvas fragments
75×99 inches (190.5×251.5 cm), maximum
National Gallery, London

Manet worked on his various representations of *The Execution of the Emperor Maximilian* from the summer of 1867 until the winter of 1868-69. This version followed the earliest *ébauche* (page 86) and demonstrates that in the period between the two works Manet must have received more information including newspaper reports and photographs from Mexico about Maximilian's death. For example, his earliest work depicts the executioners wearing sombreros, but in later versions these have been substituted by the képis that the troops wear here. The similarity to the headgear worn by French soldiers has proved fortuitous for Manet's purposes, as it has allowed him to implicate Napoleon III by association.

While retaining the initial format used in the *ébauche,* which owes something to Goya's *Third of May, 1808* (page 21) which Manet had seen in Madrid in the summer of 1865, the drawing here is much tighter as befits its finished state and whereas in the study the action had been shrouded in gunsmoke, this has been replaced with a graphic representation of the execution itself, although Maximilian himself is not visible. The canvas was presumably rolled up after completion and because it had deteriorated in various places, it was later cut up either by Léon Koëlla or by Manet himself. The work was later reassembled from these four fragments by Degas.

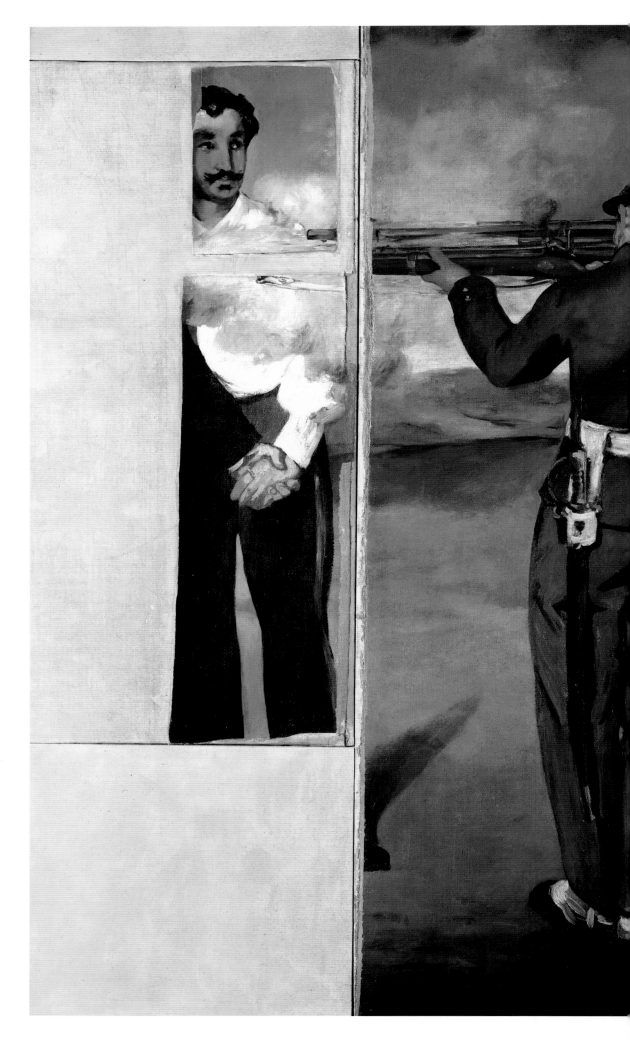

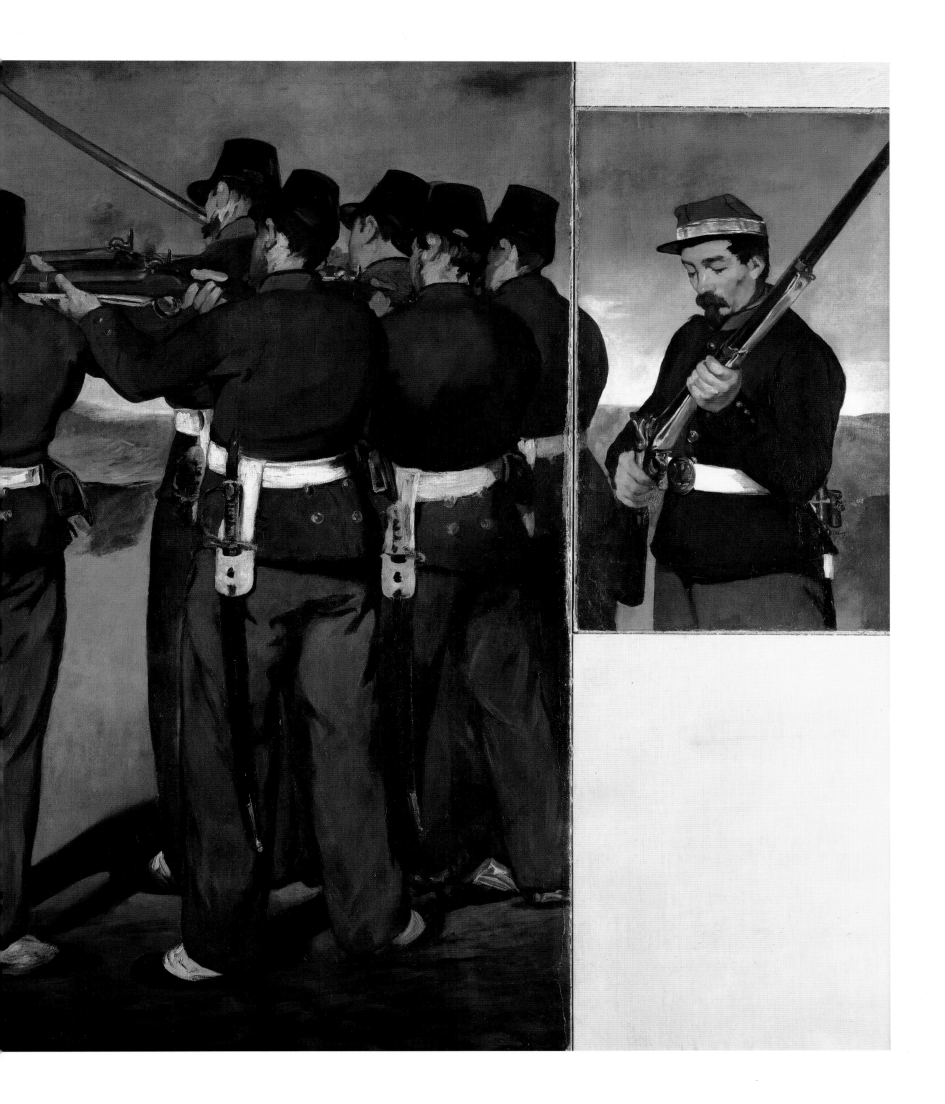

The Execution of the Emperor Maximilian, 1867

Oil on canvas
99¼×120 inches (252×305 cm)
Kunsthalle, Mannheim

This is the final, most resolved version of the *Execution of the Emperor Maximilian,* which builds on the previous two paintings and the *ébauche.* The work is signed and dated 19 June 1867, the date of the execution itself. After completing a lithograph of the scene, Manet's printer applied to the Dépôt Légal in February 1869 to have it published, but it was suppressed and the artist was informed that the oil painting would not be accepted for the Salon. It is presumably this version which Manet had intended exhibiting there. The political implications of the work would have been apparent and in this final work Maximilian is depicted not only as a political martyr but the iconography is equally reminiscent of Christ on the cross between the two thieves, and the sombrero here begins to look like a vestigial halo. Of course, it also suggests that Maximilian was more committed to Mexico than those who shot him, with their képis which effectively apportion the blame securely with Napoleon III.

In this cycle of works, Manet has returned to the history painting, working through an idea from the early *ébauche* to the climax of this finished work, demonstrating a synthesis of his commitment to modern life subjects with the scope and grandeur of a Salon painting.

90

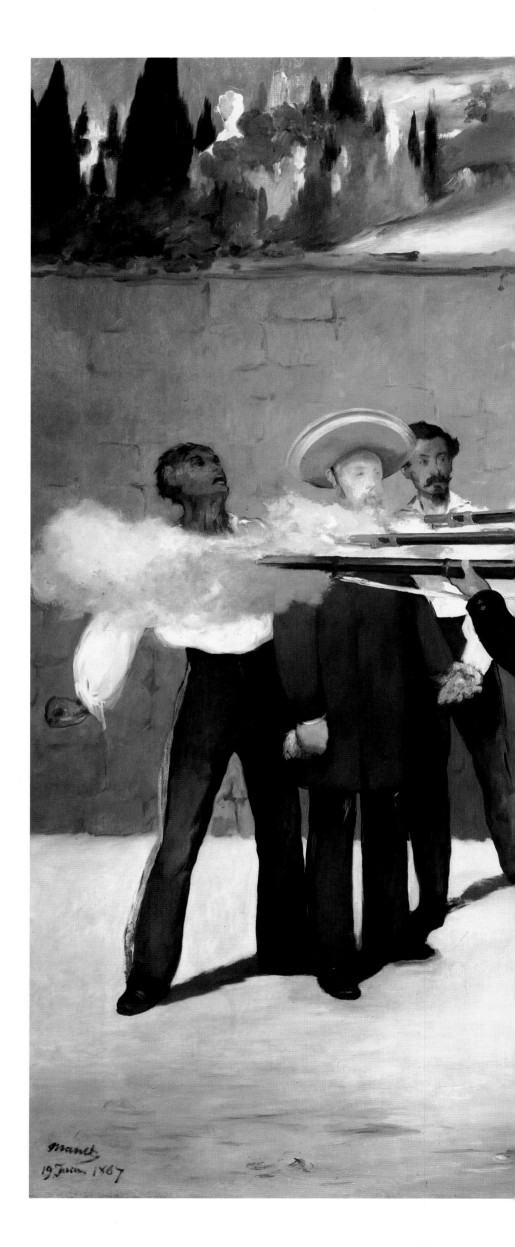

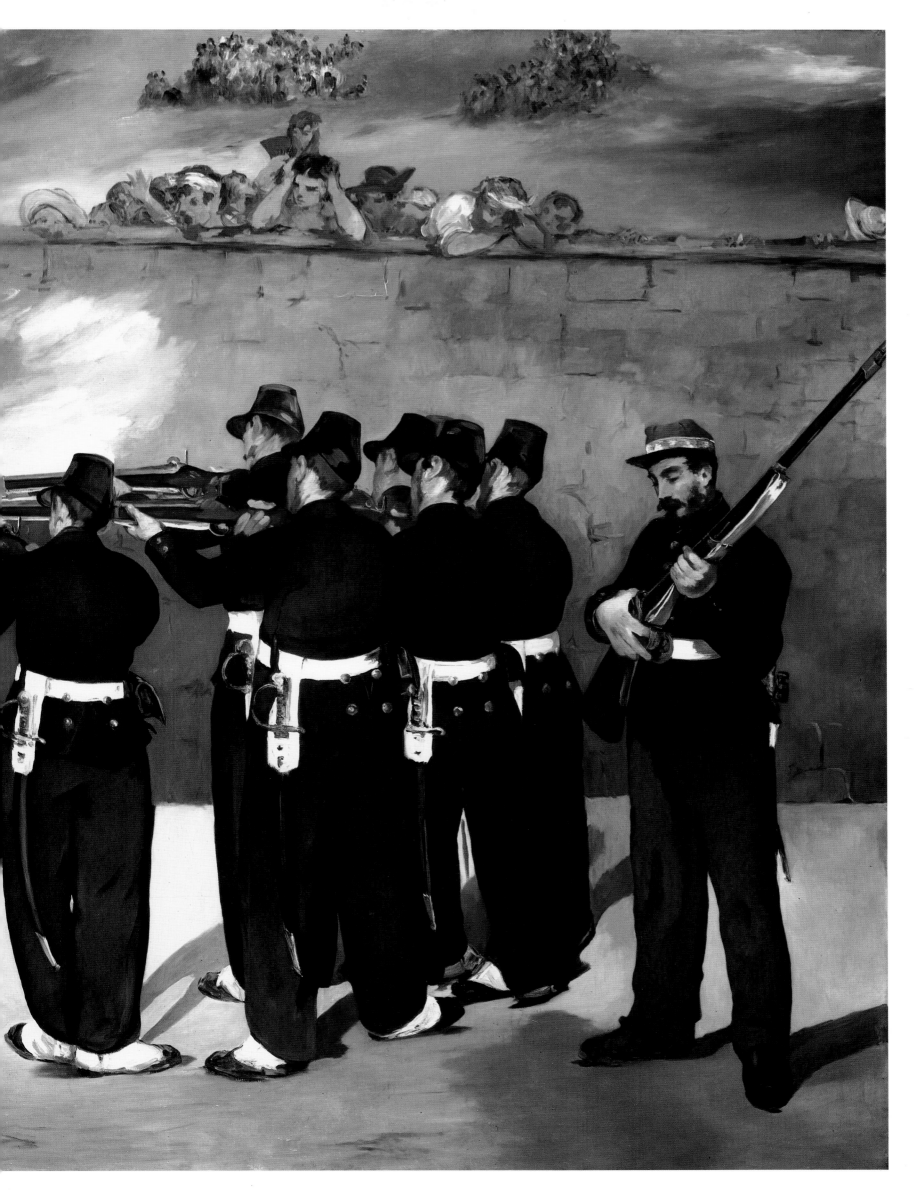

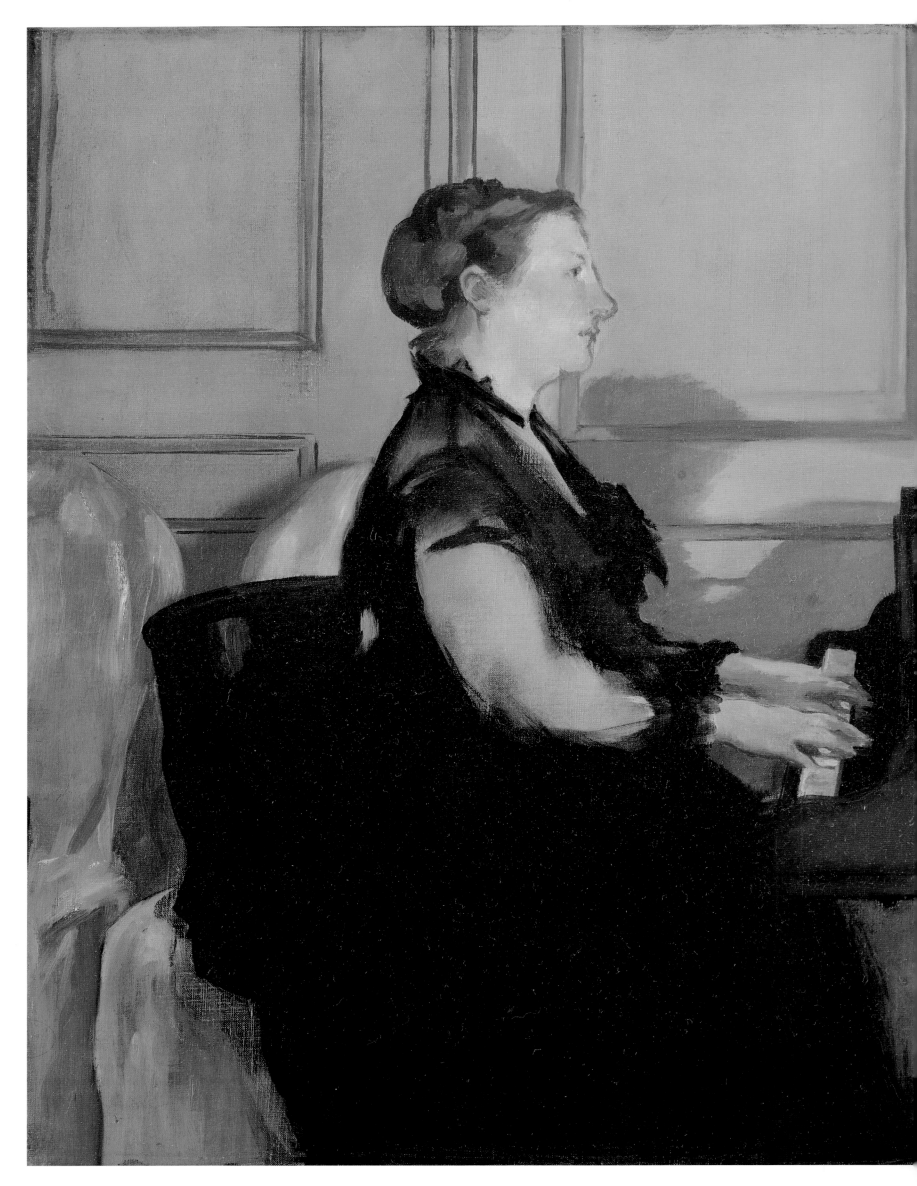

Mme Manet at the Piano, 1867-8

Oil on canvas
15×18 inches (38×46 cm)
Musée d'Orsay, Paris

Manet met the young Dutch pianist Suzanne Leenhoff (1830-1906) in 1849 when she had been engaged to give piano lessons to the Manet brothers. Her son Léon Koëlla-Leenhoff who was born in 1852 was always referred to in society as being her younger brother. The handsome provision Manet made for him in his will has led most commentators to speculate that he was Léon's father, but it has recently been suggested that in fact Manet *père* was the child's father. Certainly, Manet did not marry Suzanne Leenhoff until the year after his father's death, although the two had been living together for some time.

Madame Manet is playing in the salon of her mother-in-law's home at 49 rue de Saint-Pétersbourg and the furniture, including the ornate clock shown in the mirror above the piano, is identifiable. At the same time however, Manet seems to have deliberately selected still-life elements to include in a portrait which point to the brevity of life, itself suggested by the music which escapes on the air, a fairly conventional conceit in both French and Dutch painting.

93

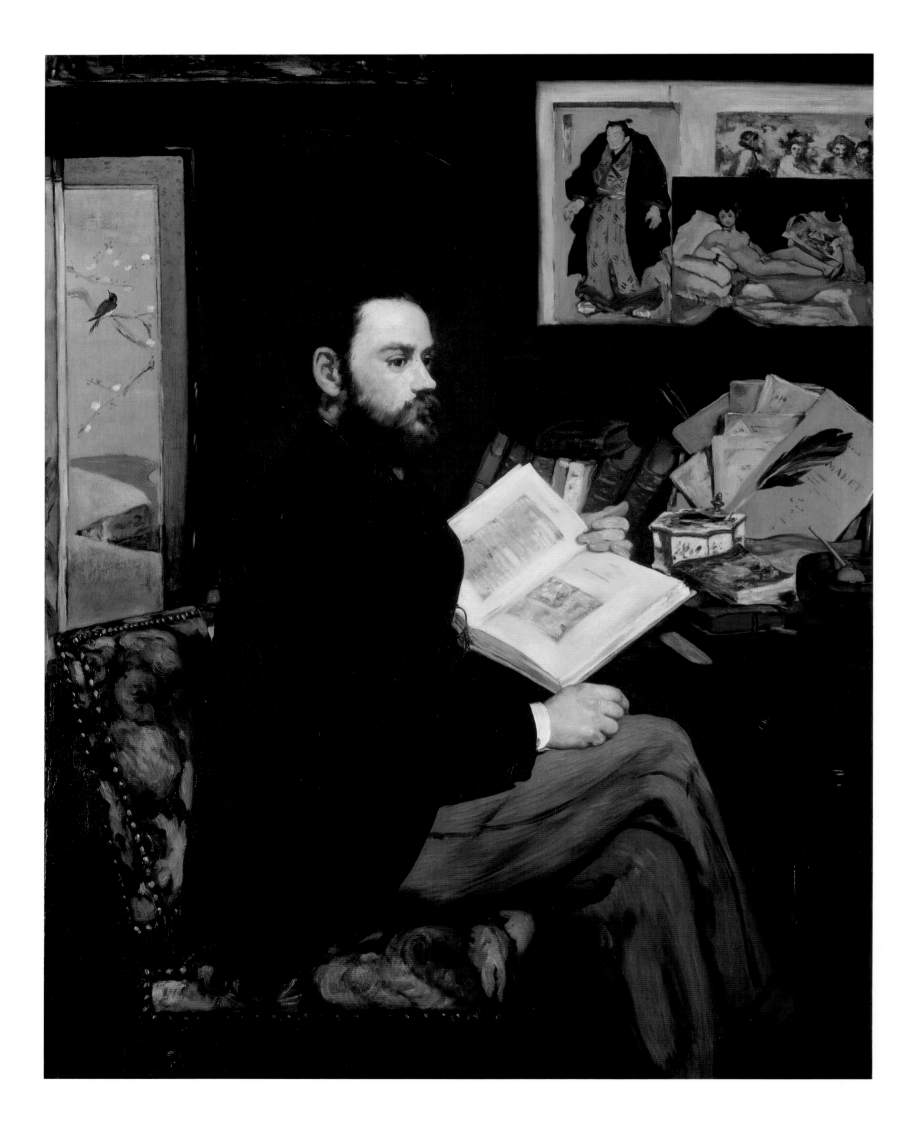

Portrait of Emile Zola, 1868

Oil on canvas
57½×45 inches (146×114 cm)
Musée d'Orsay, Paris

In a letter of February 1868 to Théodore Duret (page 96), Zola (1840-1902) announced 'Manet is doing my portrait for the Salon.' Between November 1867 and February 1868 Zola had visited Manet's seven or eight times to pose for this portrait, which was intended as a token of gratitude after the critic had republished his article of 1 January 1867 as a brochure for Manet's exhibition of fifty paintings at the pont de l'Alma in the summer of 1867. As with other intimate portraits of his friends and family (pages 92, 100, 109 etc), Manet has littered the canvas with a number of still-life clues which help establish the character of the sitter and locate him firmly within a contemporary context. In a typical gesture, Manet's signature is prominently displayed as the title for the little pamphlet Zola had just published, propped up behind the inkstand and quill pen. Zola's (and Manet's) taste for fashionable Japanese art is suggested by the silk screen in the background and by the print of a wrestler by Kuniaki II which forms part of a collection of pictures in a frame in the background. These include a photograph of *Olympia* (page 60) which Zola had defended vigorously, and which partially obscures an etching by Nanteuil after Velázquez's *Los Borrachos*. The work was shown at the Salon of 1868 along with the *Young Lady of 1866 (Woman with a Parrot)* (page 77).

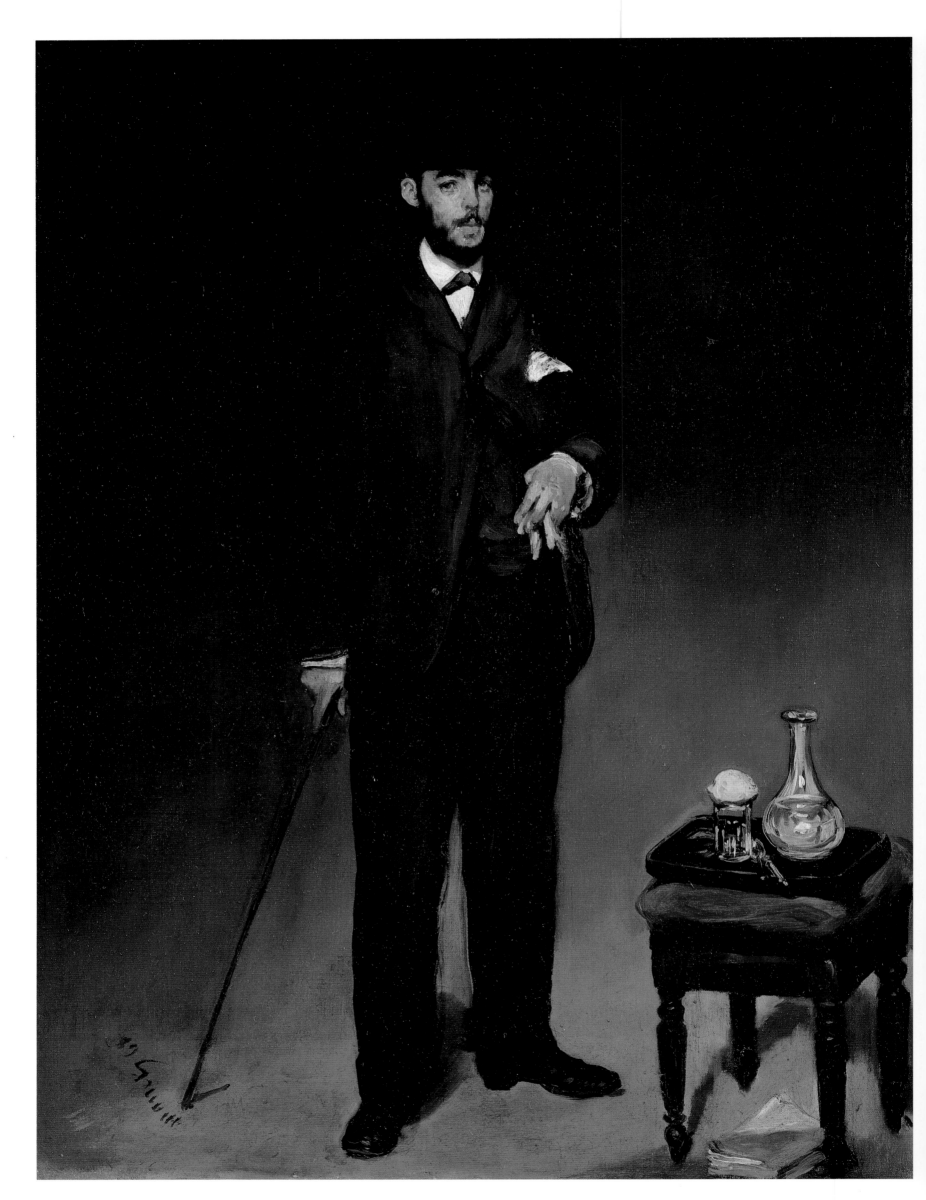

Portrait of Théodore Duret, 1868

Oil on canvas
17×13¾ inches (43×35 cm)
Musée du Petit Palais, Paris

Manet met Théodore Duret (1838-1927) in Madrid in 1865 and the two went to the Prado together to see the works by Velázquez and to Toledo to see the cathedral and the El Greco paintings, as well as attending a number of bullfights. At the time Duret was a businessman dealing in cognac, but he later became a journalist and art critic and in 1867 he published *Les Peintres français en 1867* in which he discussed Manet's work. The two became intimates and Manet left Duret with his canvases during the seige of Paris in 1870 and appointed him as his executor.

Like the *Portrait of Emile Zola* (page 94) this work was undertaken by Manet as a token of appreciation for an early supporter, but in other respects the two works are quite different: this is done on a very small canvas and the writer is depicted full-length; while Zola was represented casually seated in a bohemian studio littered with references to modern life, Duret was depicted standing, portrayed as a dandified figure who has come to call (one glove is removed); and the still-life references are timeless rather than specific. After accepting the portrait, Duret asked Manet to remove his rather prominent signature and paint it discreetly in the shadows, so that anyone passing judgment on the work would not be influenced by any hostility to Manet as a personality, but would rather have to look at the work in as unprejudiced way as possible. Manet capriciously interpreted Duret's request rather differently, and instead added his signature upside down and with Duret's cane pointing to it in an ostentatious manner.

Luncheon in the Studio, 1868

Oil on canvas
46½×60½ inches (118×154 cm)
Neue Pinakothek, Munich

Both of the paintings which Manet exhibited at the Salon of 1869, *The Balcony* (page 100) and *Luncheon in the Studio,* deal with modern life, but this work eludes further categorization. On the one hand, it looks like a fairly straightforward genre scene as the title implies. Yet on closer inspection there is very little to suggest an artist's studio here, other than the slightly incongruous heap of armor in the foreground. Moreover the remains of the meal, the maid who brings in the coffee, and the air of post-prandial tranquility exuded by the man's cigarette suggest a bourgeois dining-room. However, there is little of the interaction between the figures demanded by a representation of everyday life, and the fact that the boy has been identified as Léon Koëlla, and the man in the background as the painter Auguste Rousselin who had been in Couture's studio, means that the work functions as a kind of double portrait. The trouble taken with incidentals of clothing and particularly of still-life elements had been common to Manet's earlier portraits, like that of *Zola* (page 94), and one is tempted to read these objects as attributes. The artful arrangement of the half-peeled lemon and the silver knife which protrudes over the edge of the table seems to have been lifted from the kind of Dutch seventeenth-century still life which had been illustrated in Charles Blanc's *Histoire des peintres*. The inclusion of the armor, less common in French still-life paintings, was associated with Dutch vanitas themes, and the juxtaposition of these empty emblems of power with the young dandy who gazes dispassionately out of the picture space is not without irony.

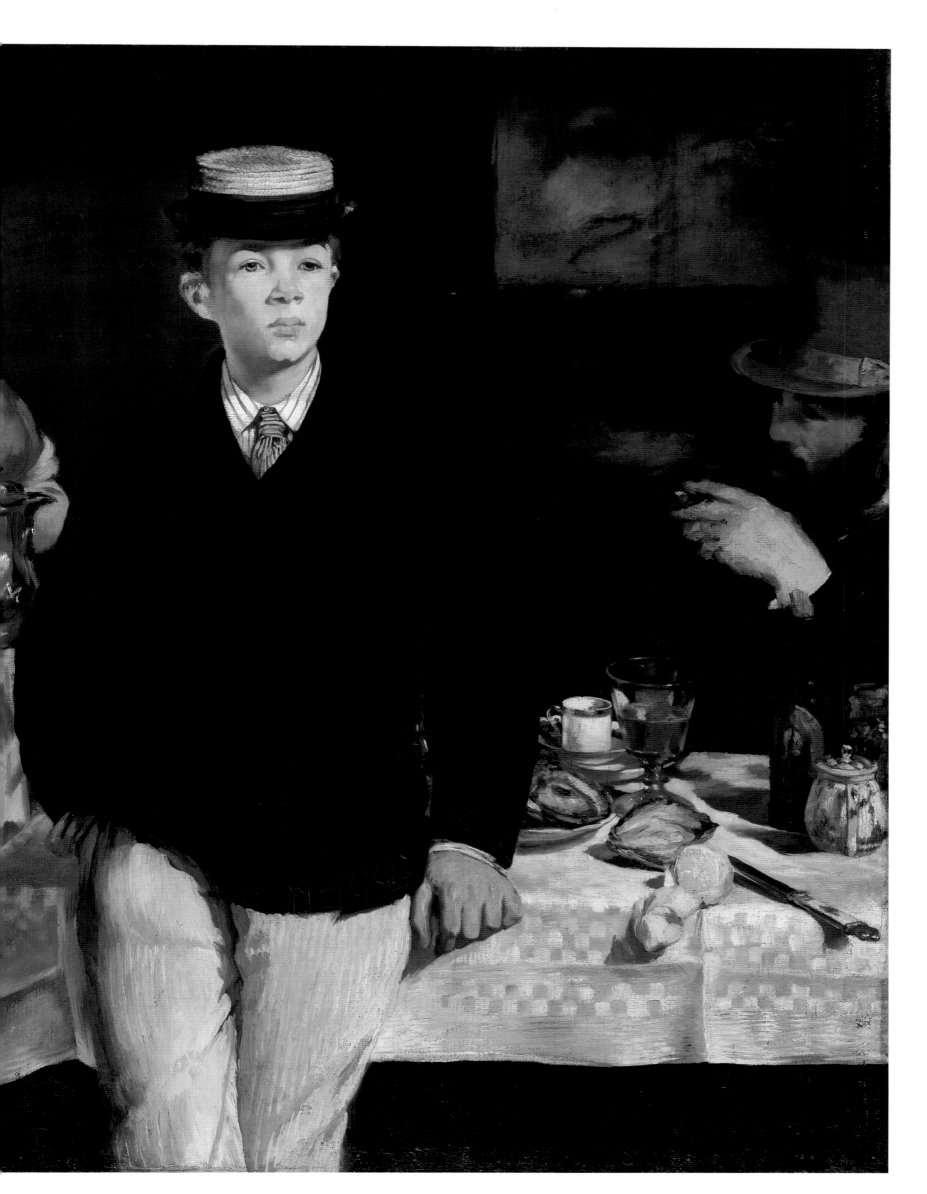

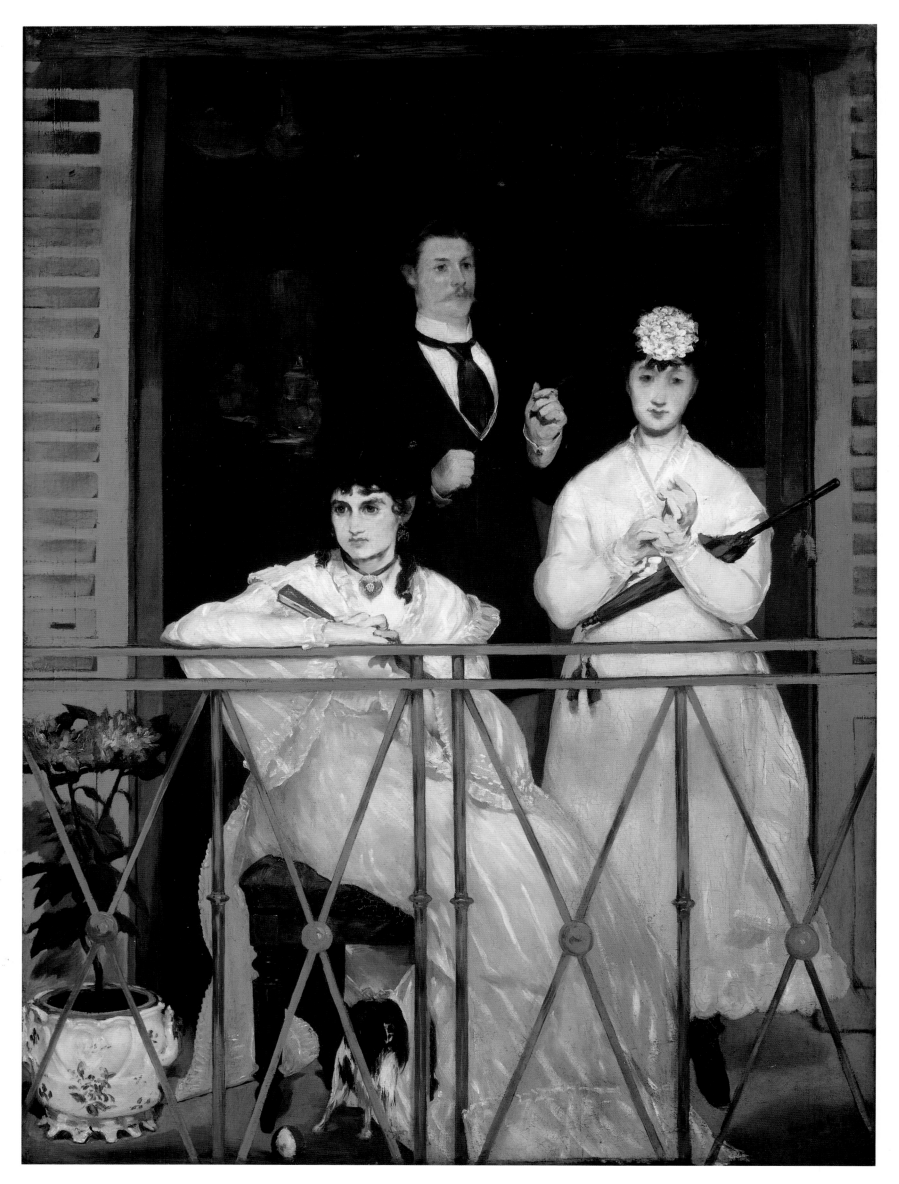

The Balcony, 1868-69

Oil on canvas
67×49 inches (170×125 cm)
Musée d'Orsay, Paris

Manet sent *The Balcony* to the Salon of 1869 with *Luncheon in the Studio* (page 98) which was also a genre painting incorporating portraits of those who were close to him at the time. Seated in the foreground with her fan is the painter Berthe Morisot (1841-1895), who had met Manet in 1867 while she was copying in the Louvre and who was to marry Eugène Manet in 1874. Beside her, holding an umbrella, is the violinist Fanny Claus (1846-1877) who often played with Suzanne Manet and in the background the painter Antoine Guillemet (1842-1918). The three figures are inside an apartment, looking out from one of the balconies that was typical of Haussmann's Paris and in the background the boy who carries some food on a tray is in fact a direct quotation from his very much earlier work *Spanish Cavaliers* (page 28). Morisot wrote to her sister about the work, and Manet's reaction to its reception, just after the Salon opened:

You can well understand that one of my first concerns was to make my way to Gallery 'M'. Here I found Manet, his hat over his eyes, looking bewildered. He begged me to go and look at his picture because he didn't dare to do it himself. I have never seen such an expressive face. He laughed uneasily, insisting one minute that his picture was very bad and the next that it would be a great success . . . I appear more peculiar than ugly. It seems that the description 'femme fatale' is going the rounds of the sightseers.

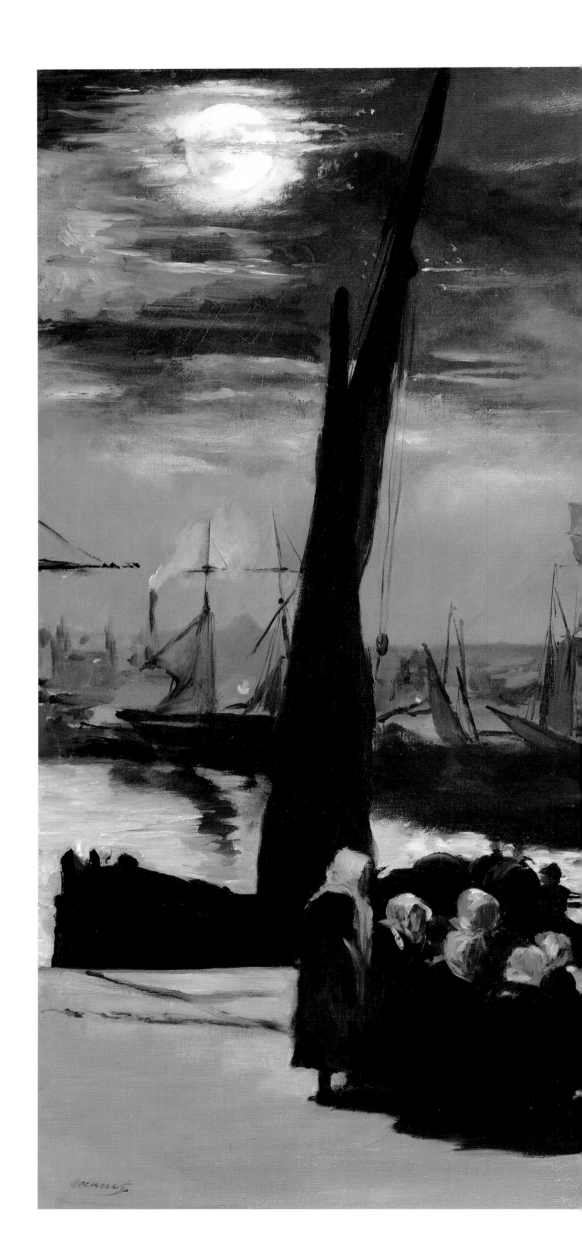

Moonlight over Boulogne
Harbor, 1869

Oil on canvas
32×40 inches (82×101 cm)
Musée d'Orsay, Paris

The Manet family spent the summer of 1869 in Boulogne, a favorite tourist spot for Parisians, where they stayed at the Hôtel Folkestone. While he was there Manet produced a number of marine paintings from his hotel window which overlooked the harbor below. The scene represents the women, wearing local dress, going to meet the night boats to take the fish to the morning market.

Although the painting's broad execution and very limited range of colors suggest that this was never really intended as a finished picture but rather as an *esquisse* or study, the relatively large size and signature together with the fact that the work was exhibited in Brussels in 1869 and in London in 1872 demonstrates that it was a finished work. Its painterly handling and earthy tones make it much closer in appearance to realist works of the 1850s and 1860s than the very much more luminous impressionist works with their varied brushwork which were produced in the following decade (pages 107-158).

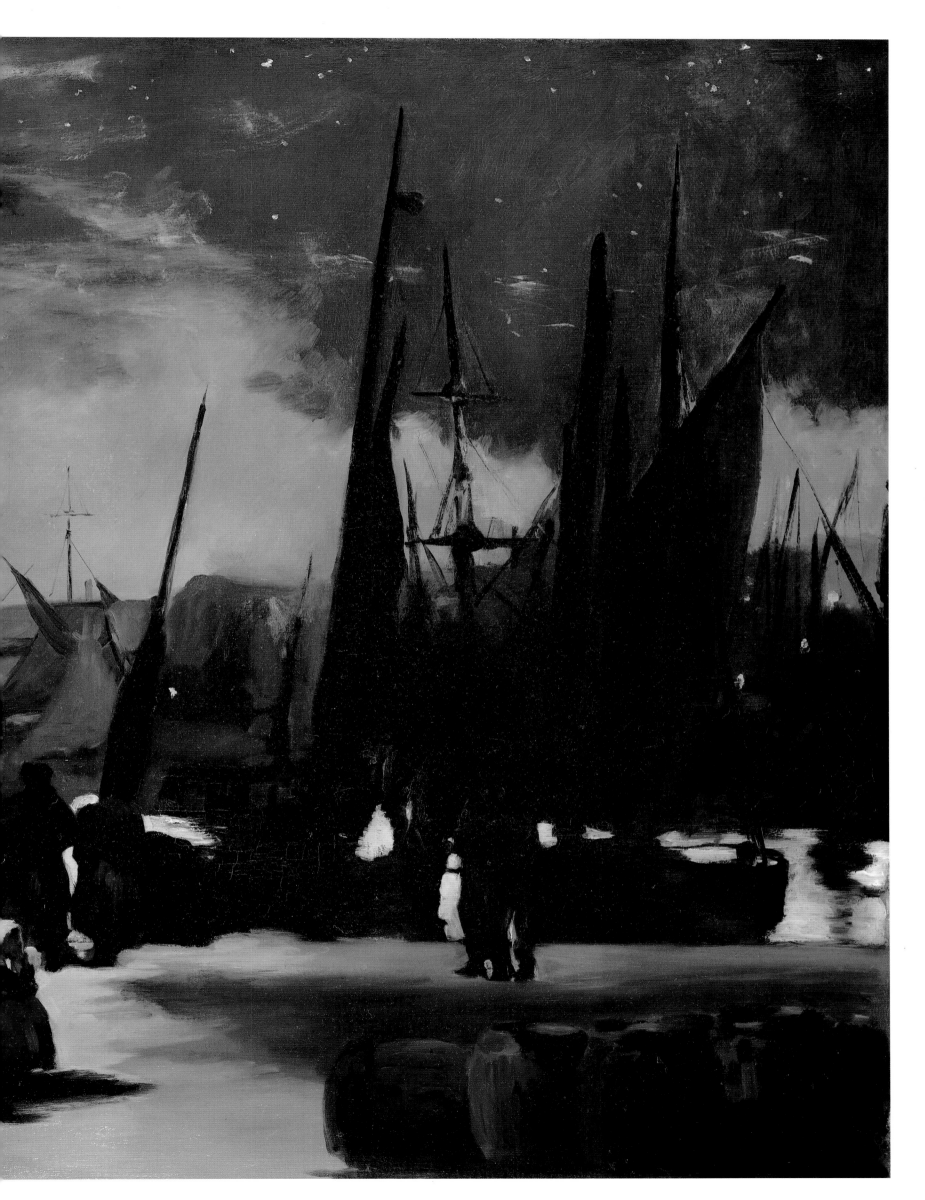

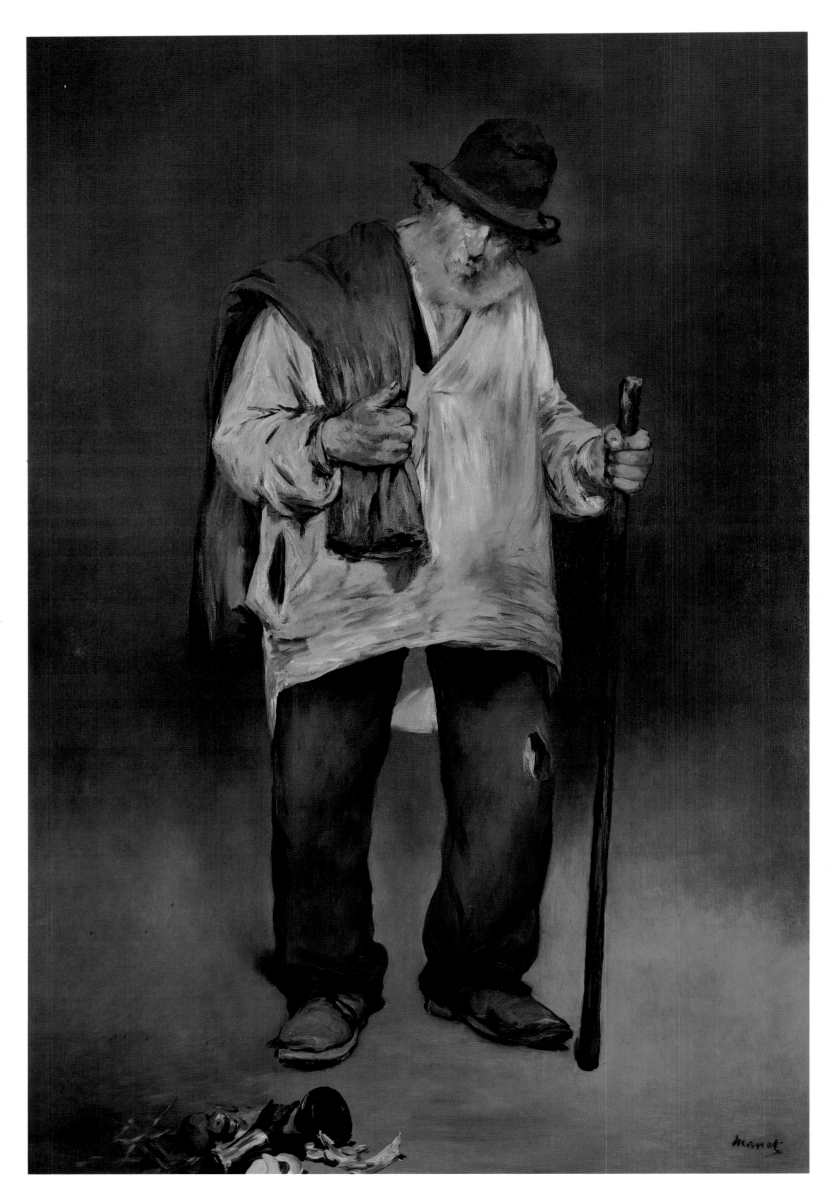

The Ragpicker, 1869

Oil on canvas
76¾×51¼ inches (195×130 cm)
The Norton Simon Art Foundation,
Pasadena

Manet produced a number of works using the subject of the ragpicker (page 72) and in each the figure is treated not only as an individual example of 'modern life' but also as a generic type, embodying the notion of the 'beggar-philosopher.' In both of these incarnations, which were by no means irreconcilable, the ragpicker has been influenced by Manet's reading of Baudelaire's *Painter of Modern Life* and the *Fleurs du mal.* Just why he should have returned to the subject at the end of the decade after Baudelaire's death and when he had ceased to be so interested in low-life scenes is far from clear. Yet the handling of *The Ragpicker* which is demonstrably freer than that in earlier works does mark it off as being later than a painting like *A Philosopher* (page 72).

The problem of the dispossessed and those living on the edges of Parisian society had not improved by the end of the Second Empire and although Manet's subject-matter was now generally drawn from the milieu of the leisured bourgeoisie the curiously dignified treatment of these social outcasts is as powerful as in this earlier work.

Eva Gonzalès, 1870

Oil on canvas
75¼×52⅜ inches (191×133 cm)
National Gallery, London

Manet submitted the *Portrait of Mademoiselle E G* to the Salon of 1870 along with *The Music Lesson* (page 92). The initials stood for Eva Gonzalès (1849-1883) who is sometimes referred to as Manet's only pupil. The two had been introduced in 1869 by the artist Alfred Stevens and Manet began work on her portrait in February of that year. A number of letters between Berthe Morisot and her sister chart its progress which was painstaking and slow. In August she wrote:

Manet lectures me, and holds up that eternal Mlle Gonzalès as an example; she has poise, perseverance, she is able to carry an undertaking to a successful conclusion, whereas I am not capable of anything. In the meantime he has begun her portrait again for the twenty-fifth time. She poses every day, and every night the head is washed out with soft soap. This will scarcely encourage anyone to pose for him.

It is often suggested that the reason for Manet's taking so long over the work is that he was infatuated with the beautiful Gonzalès, and that this was reciprocated, which may be inferred from the rather aggrieved tone of Morisot's letter. However the difficulty may also have sprung from his ambivalent relationship to a young woman who was not a model by profession but belonged to the bourgeoisie and whom he does not seem to have been able to treat as a fellow artist. Certainly there is little sense of that present in the portrait. Gonzalès is in a drawing room, rather than a studio, putting the finishing touches to her framed picture of flowers, concentrating not on her work, but dreamily gazing at something outside the picture space. The little finger of the hand holding the palette is daintily crooked, and she appears to be exercising great care not to get paint on her fashionable dress. The intimacy of a work like *Claude Monet Painting in his Studio Boat* (page 128) is absent and in the end the work is a contrived portrait of a dilettante society woman rather than a representation of an aspect of modern life.

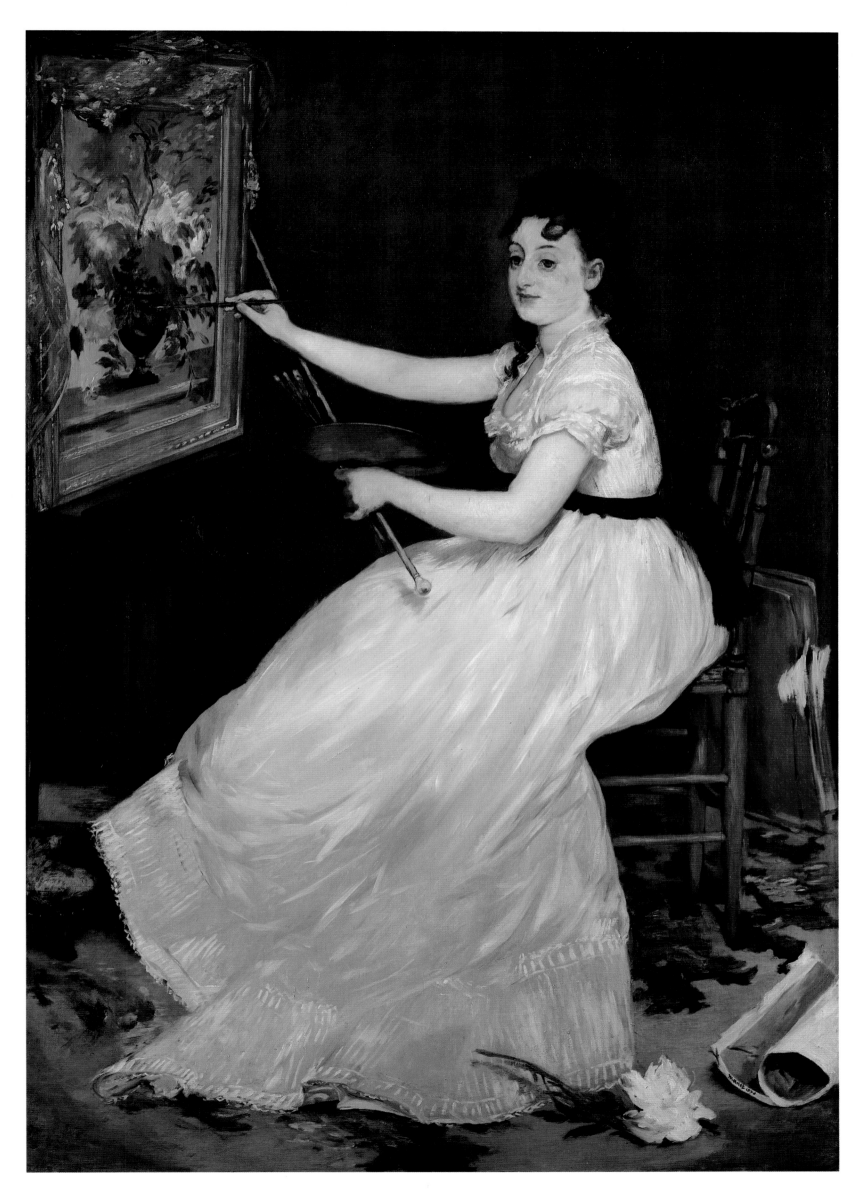

107

Repose, 1870

Oil on canvas
59⅛×7⅞ inches (150.1×121.6 cm)
Museum of Art, Rhode Island School of Design, Providence

Le Repos was shown by Manet at the Salon of 1873 with *Le Bon Bock* (page 116) but had in fact been painted three years previously, although he may have retouched it before sending it to the Salon. It was Manet's second portrait of his future sister-in-law Berthe Morisot (1841-1895), after *The Balcony* (page 100). In fact the work shows certain affinities with *Eva Gonzalès* (page 107) which Manet produced around the same time. Both show young women with whom he enjoyed equivocal relationships, who belonged to the same social class as Manet himself yet pursued careers as artists. His deference to their social status meant that the works in which they were represented did not have the direct quality of those depicting professional models (page 112) but instead are couched in the visual language of the bourgeois drawing room. Morisot is wearing a white dress similar to that worn by Gonzalès and is shown on a sofa under a triptych by the Japanese artist Kuniyoshi.

Writing in the *National*, Théodore de Banville commented on it when he saw it at the Salon:

Le Repos is an engaging portrait which holds our attention and which imposes itself on our imagination by an intense character of modernity, if we may use this now indispensable barbarism. Baudelaire was indeed right to esteem Manet's painting, for this patient and sensitive artist is perhaps the only one in whose work one discovers that subtle feeling for modern life which was the exquisite originality of the *Fleurs du mal*.

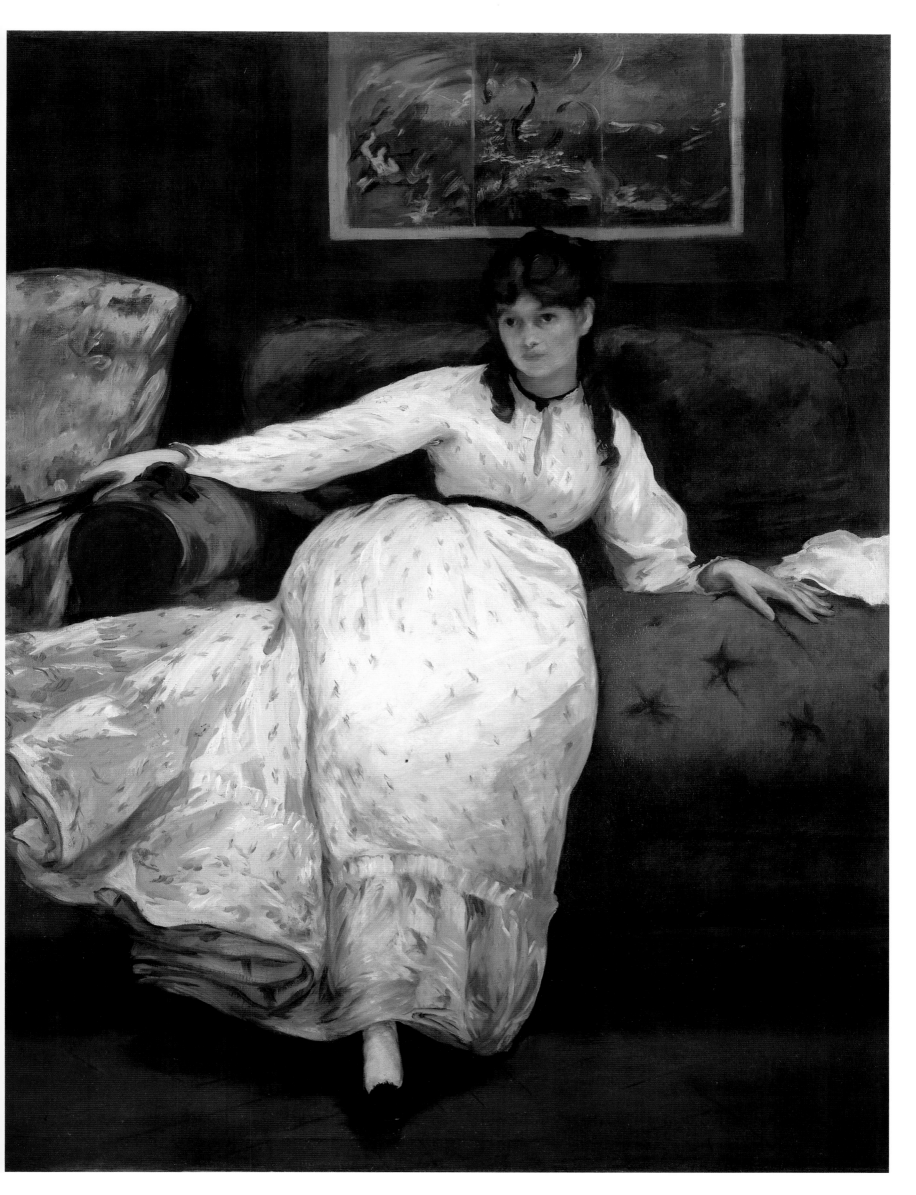

The Barricade (Civil War), 1871
Pencil, watercolor, gouache and ink wash
18×13 inches (46×32.5 cm)
Szépmüvészeti Museum, Budapest

It seems odd given Manet's Republican sympathies which had been embodied in as major a project as the *Emperor Maximilian* (pages 86-90), that he did not exploit the subject-matter of the seige of Paris and the ensuing Commune more than he did. Only this watercolor and some drawings and sketches recount some of the horrors of that period. Manet wrote to his wife and mother on 11 February 1871 after the end of the seige that he was about to journey to Oloron-Sainte-Marie to accompany them back to Paris. They completed the journey in stages, which meant that he was most

probably not in Paris during the worst of the Commune, the so-called 'semaine san-glante' [week of blood] between 21 and 28 May 1871, and therefore did not witness scenes such as the execution of Commu-nards in front of a barricade that he depicts here. However, he had managed to convey the execution of the Emperor Maximilian forcefully without being present in Mexico and any sense of reportage in these works was manufactured from oral, literary, and photographic records. A lithograph made after the watercolor was never published during Manet's life.

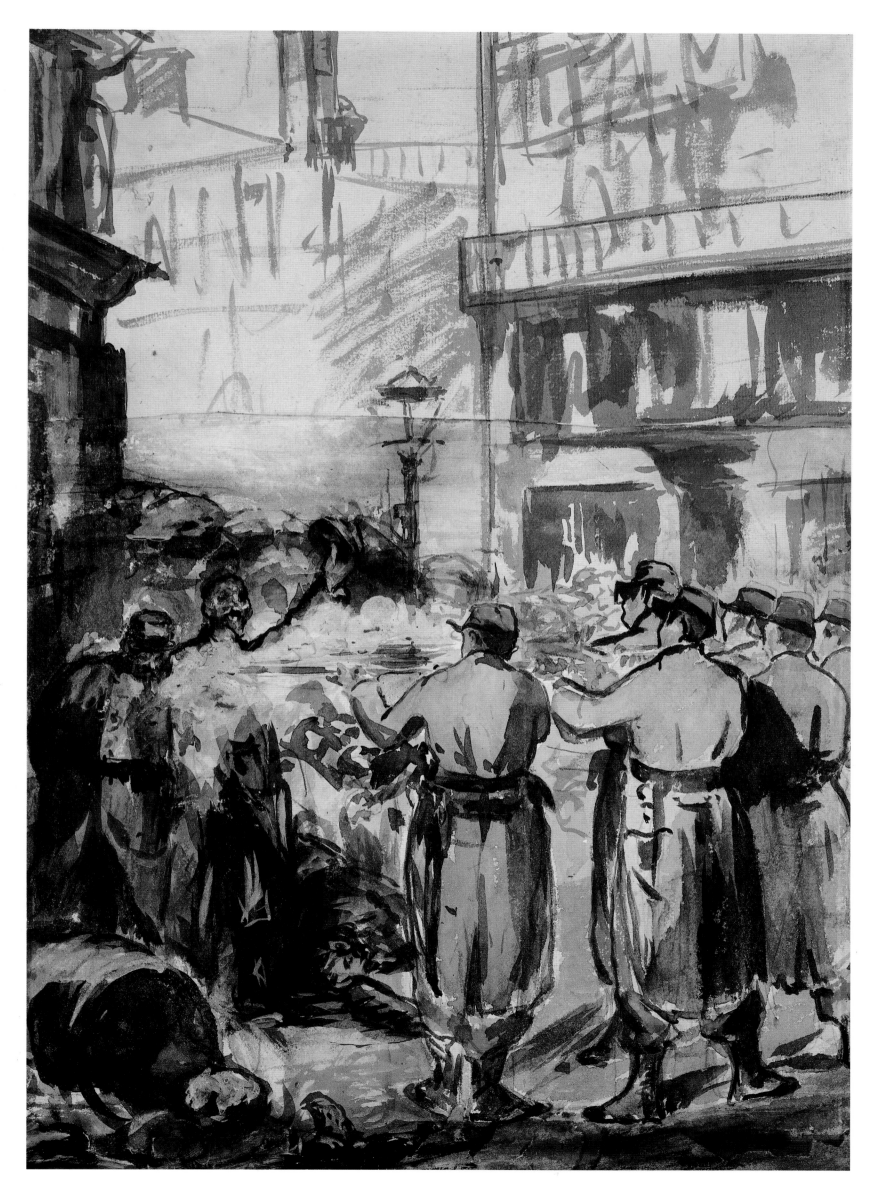

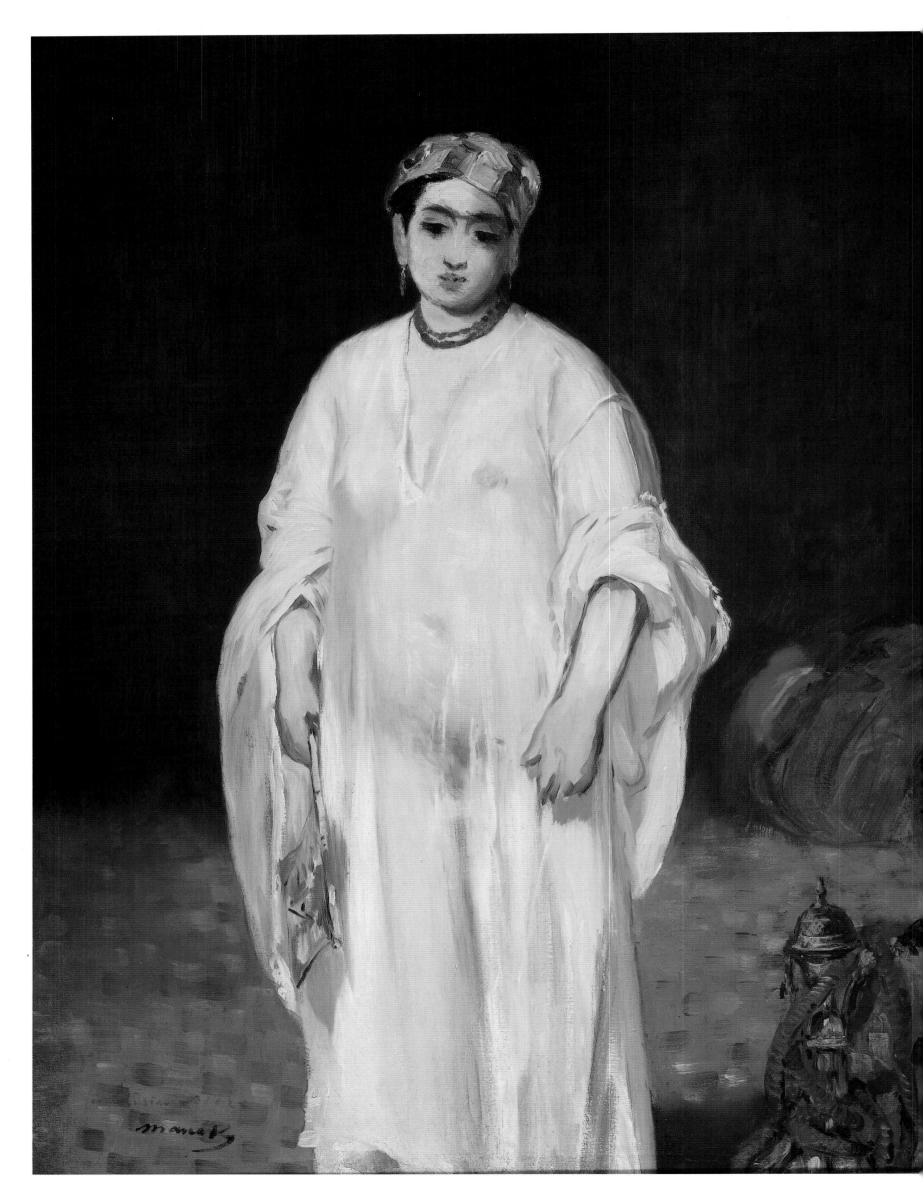

Young Woman in Oriental Costume, 1871

Oil on canvas
36×29 inches (92×73 cm)
E G Bürhle Collection, Zürich

The theme of the 'orient,' specifically the French colonies in North Africa, had been a favorite with writers and painters since the 1830s when France first colonized Algeria. The 'exotic' subject-matter of 'oriental women' had been exploited by romantic artists, most notably Delacroix, who represented a view of the 'orient' which was highly fictionalized and which depended on the perpetuation of the myths surrounding the 'primitive' nature of the North Africans. The subject had remained popular, particularly at the Salon where it reinforced notions of national superiority and France's pre-eminent role in the modern world. Renoir's *Odalisque: Woman of Algiers* (National Gallery of Art, Washington DC) which was shown at the Salon of 1870, presented an exotic vision of life in the harem which had no basis in reality and for which he used a white model. It seems probable that Manet would have seen that work and in part this painting is a response to it, while drawing on a much richer cultural vocabulary. The provocative, lascivious nature of Renoir's model has gone, but Manet's work too relies on the notion of a Parisian merely playing at being North African, as the title implies.

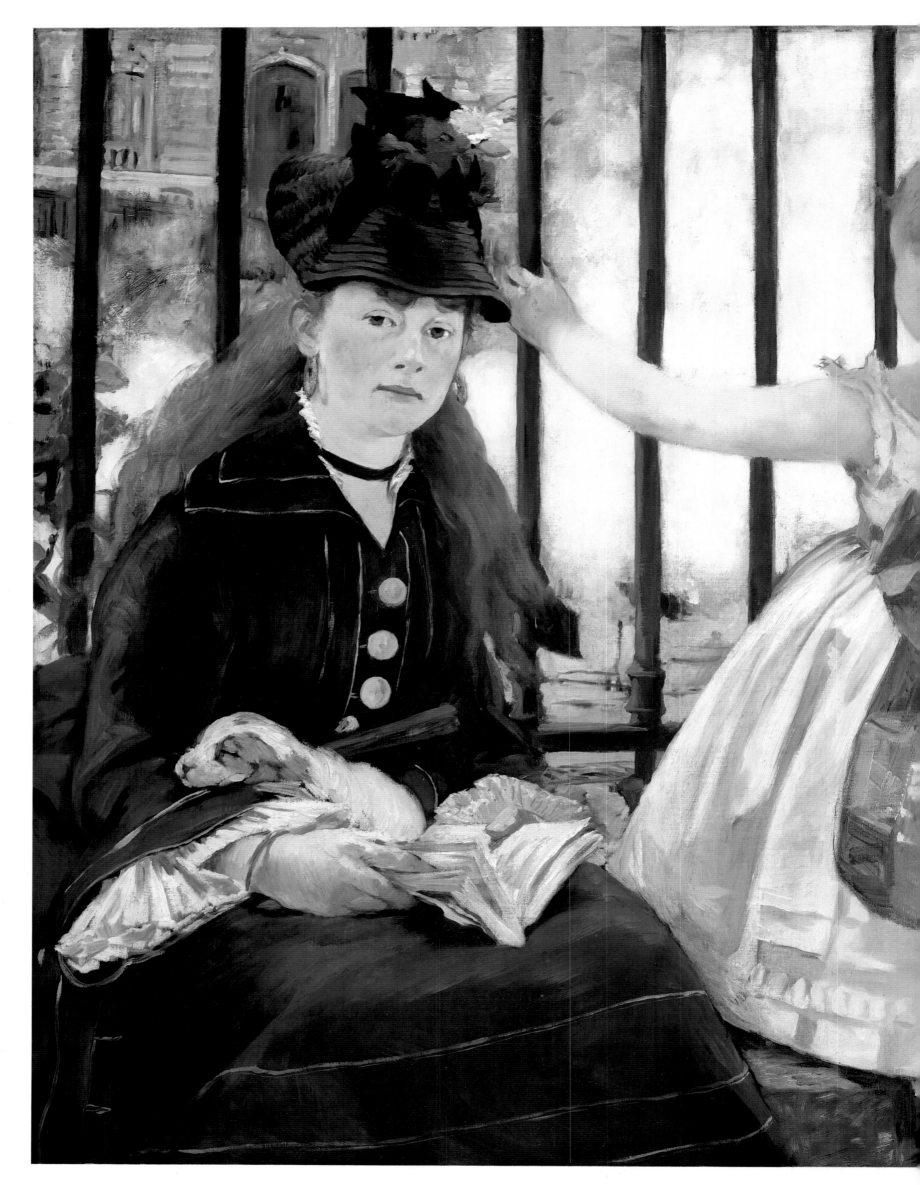

The Railroad, 1872-73

36¾×45⅛ inches (93.3×114.5 cm)
National Gallery of Art, Washington DC
Gift of Horace Havemeyer in memory of
his mother, Louisine W Havemeyer

For the first time in seven years Manet had
two works rejected by the jury at the salon
of 1874: *The Swallows* (page 132) and the
Masked Ball at the Opera (page 120). Only a
little watercolor of *Polichinelle* and this
work were accepted, but were not well re-
ceived. The *Journal amusant* described it as
'two madwomen, attacked by incurable
Manetmania, watch the passing train
through the bars of their padded cell.'

The subject-matter of the Gare Saint-
Lazare, the busiest commuter station in
Paris, which was to be especially popular
with Monet, was an obvious choice; not
only was it a modern life subject, but also it
was visible from Manet's studio at 4 rue de
Saint-Pétersbourg. The painting itself was
completed in his studio and in the garden
of his friend Alphonse Hirsch, although it
can hardly be called 'plein air' in the man-
ner of the Impressionist painters who had
their first group exhibition that same year
from 15 April to 15 May. Victorine Meurent
and Hirsch's daughter Suzanne were the
models. The critics' dissatisfaction with
the work seems in part to have stemmed
from their inability to categorize it accord-
ing to the different genres. The critic of the
Revue des deux mondes summarized the
problem:

Is Manet's *Railway* a double portrait or a sub-
ject picture . . . ? We lack information to solve
this problem; we hesitate all the more con-
cerning the young girl which at least might be a
portrait seen from the rear. . . . It is apparent
that in spite of his revolutionary intentions
Manet is essentially a bourgeois painter . . . he
belongs to a school which, failing to recognize
beauty and unable to feel it, has made a new
ideal of triviality and platitude.

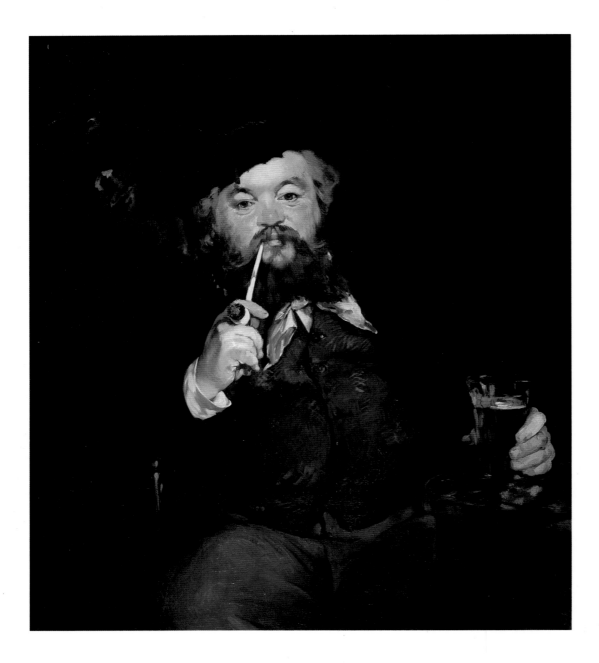

Le Bon Bock, 1873

Oil on canvas
37¼×32¾ inches (94.6×83.2 cm)
Philadelphia Museum of Art
Mr and Mrs Carroll S Tyson Collection

In June 1872 Manet had visited the newly opened Frans Hal museum in Haarlem and *Le Bon Bock* is in part a response to the seventeenth-century Dutch artist's depictions of jolly drinkers. At the same time, it is a portrait of the engraver and lithographer Emile Bellot who formed part of the loosely knit group at the café Guerbois, to which Manet belonged. The work was sent to the Salon of 1873 with *Repose* (page 109) and it was Manet's first popular success. Some critics recognized that the *enfant terrible* who had produced the *Déjeuner sur l'herbe* (page 56) had matured into a forty-year-old who was still in pursuit of critical success at the Salon, and implied that Manet had pragmatically softened his tech-

nique. Others praised the 'realism' of the subject-matter which although being identifiably modern was less challenging than earlier works which represented those on the fringes of society (page 104). One critic described the drinker as:

a greying old man wearing a woollen bonnet, whose face is red, his hair and beard uncombed, who is relaxed and carefree and whose clothes are completely dishevelled. He sits upright in his armchair, drinking his mug of beer and smoking his clay pipe. You only have to look at his sensuous lips and twinkling eyes, full of good sense and wit, to know that here is a man who doesn't care a fig for convention and theoretical subtleties.

On the Beach, 1873

Oil on canvas
23½×29 inches (59.5×73 cm)
Musée d'Orsay, Paris

The Manet family spent a three-week holiday at Berck-sur-Mer on the Normandy coast in the summer of July 1873, where Manet painted a number of works including this one. It depicts Eugène Manet who was to marry Berthe Morisot (page 109) the following year and Suzanne Manet relaxing on the beach and; contrary to Manet's usual practice it was painted on the spot, which is demonstrated by some stray grains of sand within the pigment. Manet was never to embrace fully either the aims or methods of the orthodox Impressionists, but was close to Monet (page 128) at this period and may have been influenced by his *plein-air* approach. At the same time, the artful positioning of the high horizon, with the bands of color for the sky, sea, and sand is much closer to the pattern-making of someone like Degas, who like Manet preferred to work in the studio.

By this time Manet had begun to achieve a degree of financial success – he had sold a number of works to the dealer Durand-Ruel the previous year and *Le Bon Bock* (page 116) had attracted much favorable comment at the Salon a couple of months before this was painted.

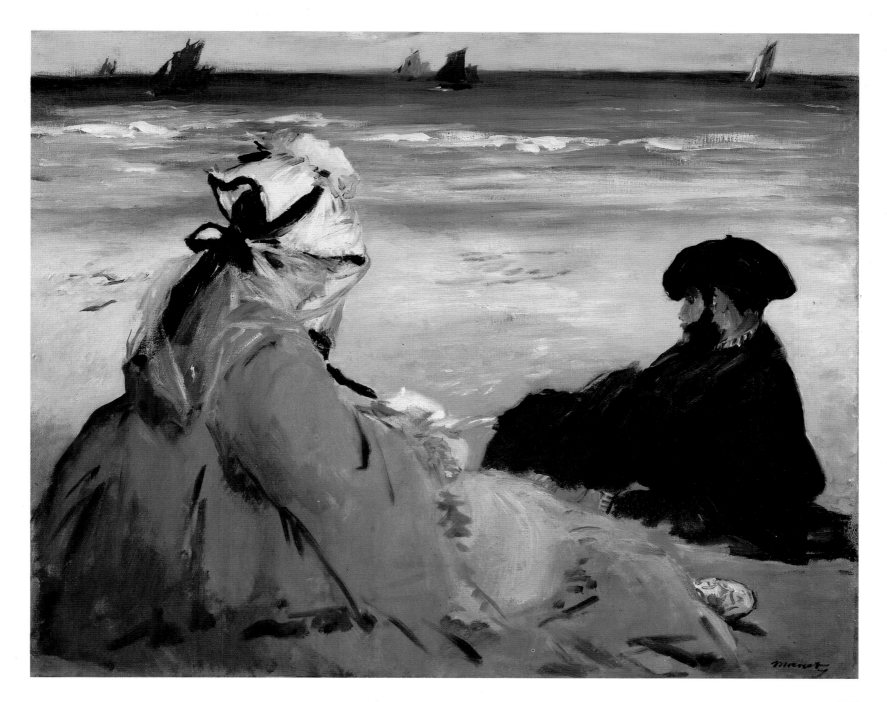

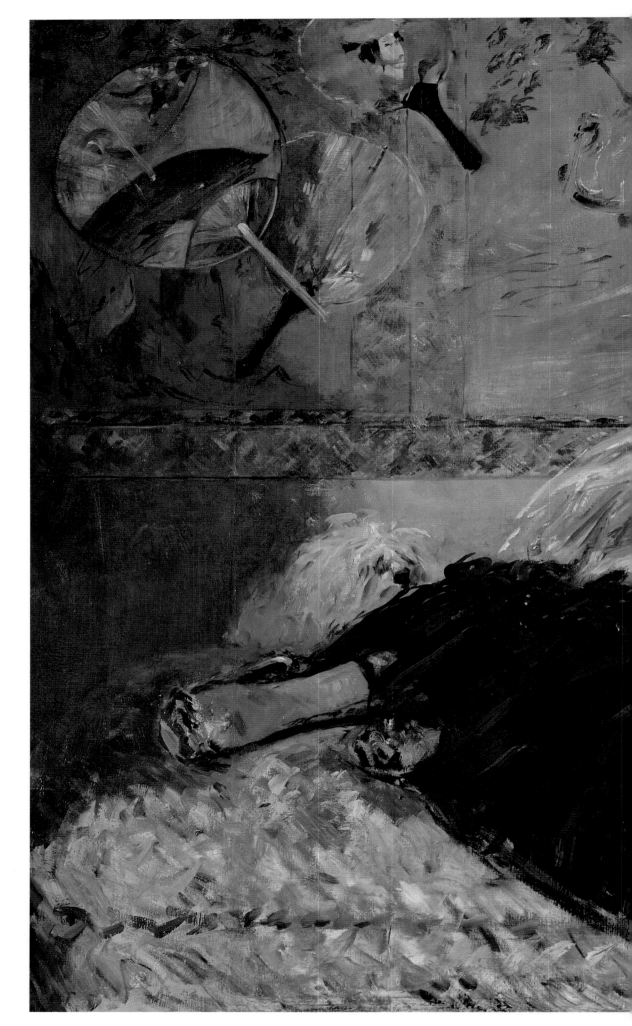

Lady with Fans (Nina de Callias), 1873-74

Oil on canvas
44½×65 inches (113.5×166.5 cm)
Musée d'Orsay, Paris

The musician Marie-Anne Gaillard (1844-1884), also called Nina de Villard, was best known by the name of her estranged husband Hector de Callias, a critic and editor at *Le Figaro*. From about 1868 until her death she hosted one of the best-known salons in Paris which was attended by literary figures, politicians, and painters including Manet. It is in the guise of society hostess that she has been painted, although the work was posed in Manet's studio at 4 rue de Saint-Pétersbourg. Her Bohemian character has been suggested not only by the decor of the room, including the Japanese fans and silk hanging which was to appear in *Portrait of Stéphane Mallarmé* (page 139) and couch, but also by her rather eclectic costume, which combined 'Algerian' dress with a Spanish bolero and heavy jewelry.

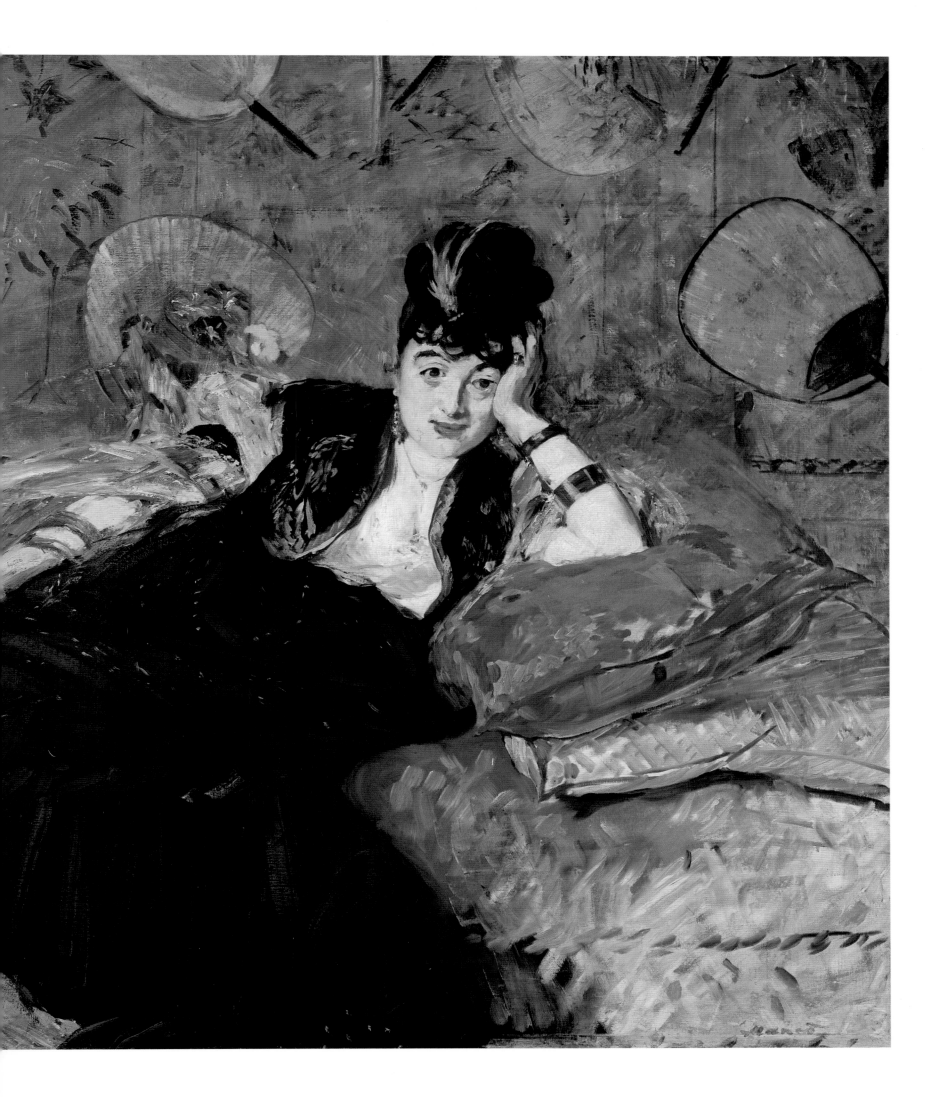

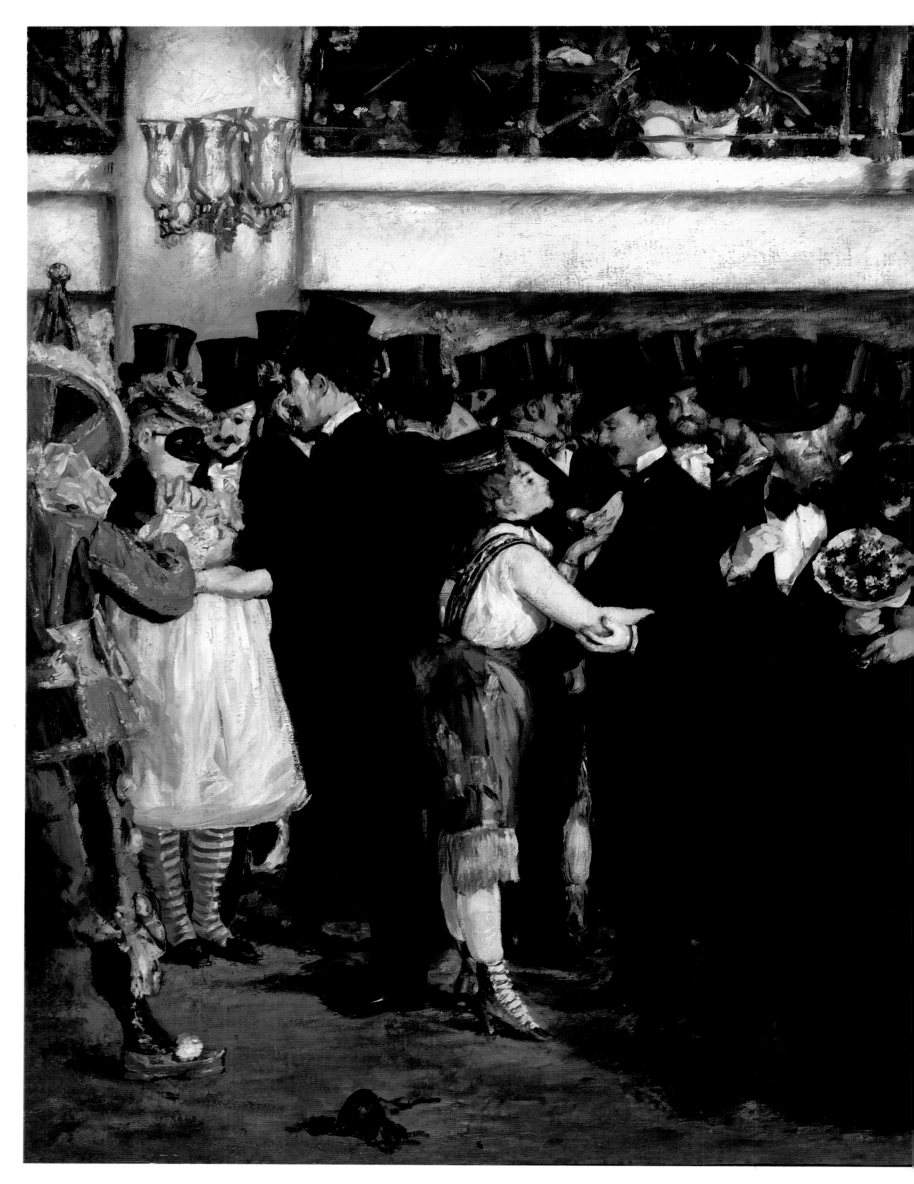

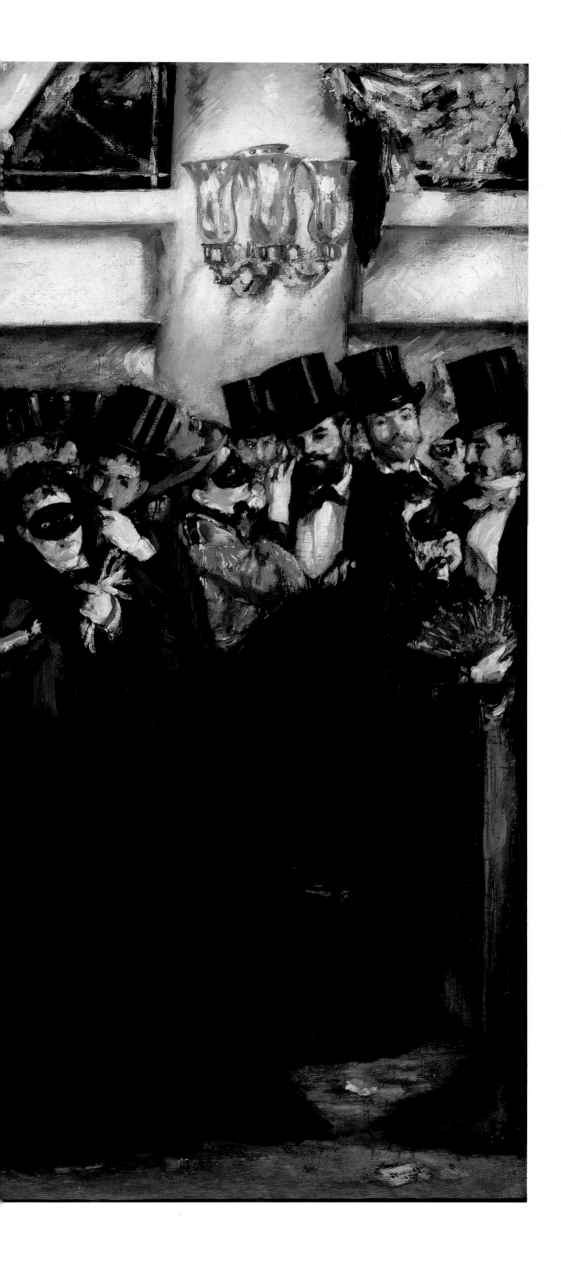

Masked Ball at the Opera,

1873-74

Oil on canvas
23¼×28½ inches (59×72.5 cm)
National Gallery of Art, Washington DC
Gift of Mrs Horace Havemeyer in
memory of her mother-in-law, Louisine
W Havemeyer

On 18 November 1873 Manet sold a number of paintings to a new patron, the famous baritone, Jean-Baptiste Faure (1830-1914), who had been a member of the Paris Opéra since 1861. The works included *Le Bon Bock* (page 116), *Lola de Valence* (page 53), *Luncheon in the Studio* (page 98) and this work. Unfortunately, when Faure allowed him to submit it to the following year's Salon, it was rejected by the jury.

The scene represented is one of the weekly masked balls held during Lent in the old Opéra on the rue Lepeletier. Garnier's new Opéra, ironically the most grandiose of Haussmann's schemes for the second Empire, was not completed until 1874, after the old Opéra had been destroyed by fire, during the course of Manet's working on this painting. At the time, the opera was often used as a social occasion to meet friends and to socialize with the young women in the cast, and fashionable figures might not arrive until during the second act. Like *Music in the Tuileries* (page 50), Manet has presented a view of a social class and included a number of his male friends who mix freely with anonymous working-class women. The composer Chabrier, the banker Hecht and Duret (page 96) are all recognizable, as is Manet himself who stands second from the left looking out of the picture space. Directly under his feet is a discarded *carnet de bal* on which his signature has been scribbled.

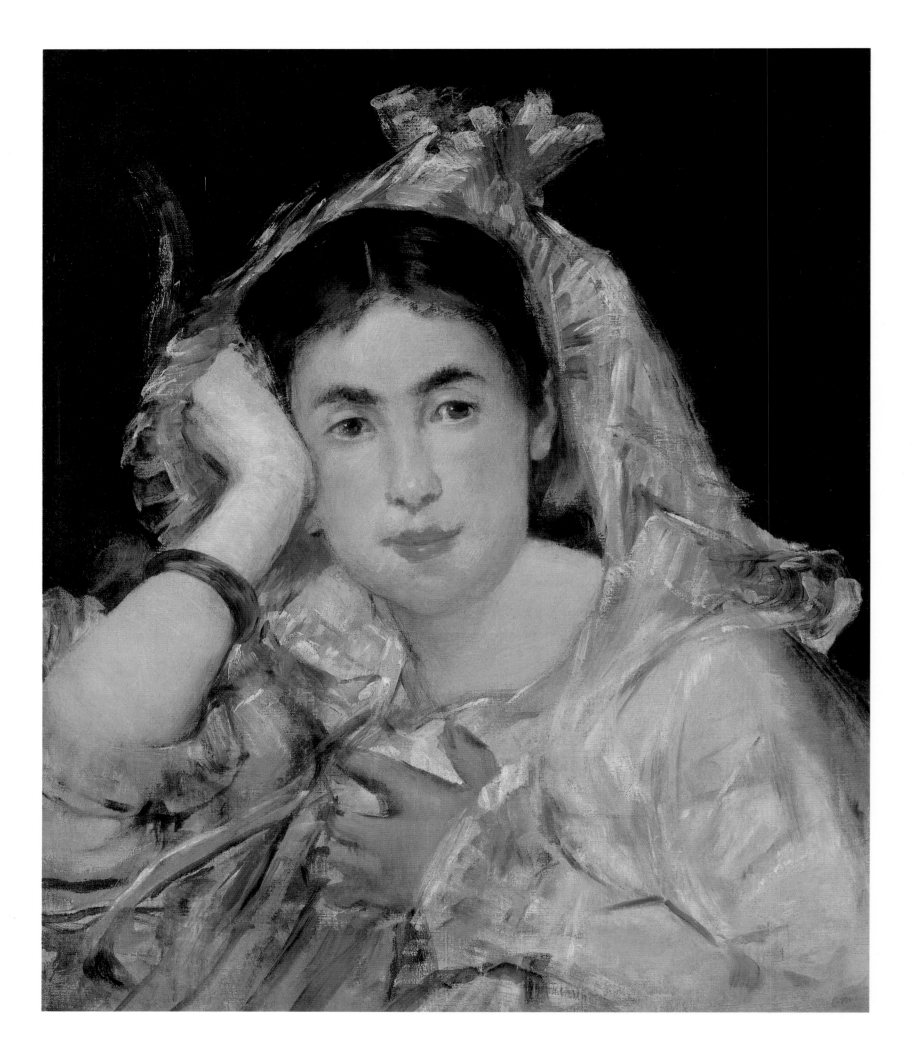

Portrait of Marguerite de Conflans, 1873

Oil on canvas
21¾×18 inches (56×46 cm)
Oskar Reinhart Collection 'am Römerholz,' Winterthur

At the same time as painting representations of a *demimondaine* class in his modern-life subjects like *Masked Ball at the Opéra* (page 120), Manet produced portraits of wealthy upper-class women with whom he mixed socially, such as those of Berthe Morisot (page 109), Eva Gonzalès (page 107), Mina de Callias (page 118), and Marguerite de Conflans. The mood of these paintings sets them apart from the early, formal portrait of the artist's parents (page 31) in which the sitters' rigid poses, aloof postures and the finished quality of the work not only suggests their circumscribed lives but also betrays the work's ultimate destination as being the Salon. Marguerite de Conflans like her female peers, however, is intimate and confiding in mood as she leans towards the spectator, her head framed by the gauzy hood of her costume, her casual pose underlined by her head resting on her arm. The informality of the subject is heightened by the rapidly executed material of her clothing.

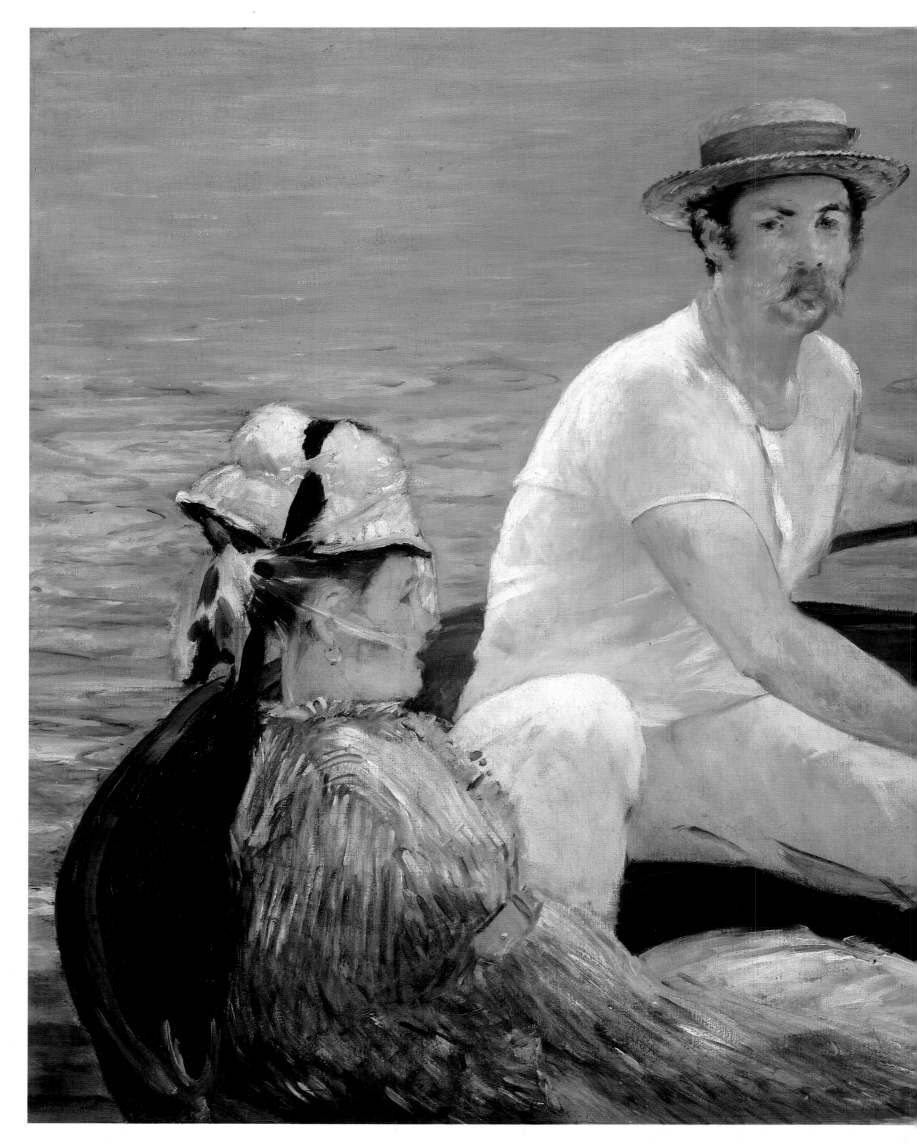

Boating, 1874

Oil on canvas
38¼×51¼ inches (97×130 cm)
The Metropolitan Museum of Art,
New York
Bequest of Mrs H O Havemeyer, 1929
The H O Havemeyer Collection

In the summer of 1874 Manet was at the family home at Gennevilliers on the Seine, opposite Argenteuil, where *Boating* was painted. At this time he was frequently joined by Monet, who had been living in Argenteuil for some time, and occasionally by Renoir. Manet painted Monet and his wife (pages 128 and 130) and it was at this period that he came closest to adopting the impressionist idiom of working in the open air, using short rapid brushstrokes and adopting a much higher key than in his earlier work. This painting however is in many ways still tied to Manet's traditional practice. It is much larger than the portable canvases Monet and Renoir were using at this time and this would suggest it was done in the studio. Similarly, there is none of the apparent spontaneity that characterized impressionist works of this period, particularly in the rather contrived nature of the composition, which owes much to careful planning and is closest in spirit to Japanese prints.

The work was shown at the Salon of 1879 where its affinities to Impressionism were noted by a number of critics. Huysmans wrote:

The bright blue water continues to exasperate a number of people. Water isn't that color? I beg your pardon, it is, at certain time, just as it has green and gray hues . . . Manet has never, thank heavens, known the prejudices stupidly maintained in the academies. He paints, by abbreviations, nature as it is, and as he sees it. The woman, dressed in blue, seated in a boat cut off by the frame as in certain Japanese prints, is well placed in broad daylight.

Argenteuil, 1874

Oil on canvas
60×45 inches (149×115 cm)
Musée des Beaux-Arts, Tournai

Manet sent only this work to the Salon of 1875. It had been painted the previous summer while he was vacationing in Gennevilliers near Argenteuil where Monet was working. In terms of its handling, subject-matter and color, the painting is the closest Manet ever came to producing an orthodox impressionist work and yet it was clearly destined for the Salon from the outset. The work is much larger than typical impressionist canvases, which had to be easily portable to facilitate *plein air* practice, and the apparent spontaneity of the work belies its rigorously premeditated system of horizontals and verticals, from the chimneys of Argenteuil in the background to the masts of the boats and even the costumes of the two day-trippers who sit in the foreground. The models for *Argenteuil* were Manet's brother-in-law Rudolph Leenhoff and an unknown woman, both of whom posed for *Boating* (page 124) which was painted at the same time.

In a posthumous review of Manet's work which appeared in *Le Temps* Paul Mantz recognized Manet's attempts at a refined impressionist style in this work which:

cancels out Manet, the instinctive painter, and substitutes Manet the scientific painter. A man and a woman are seated in a canoe in sunshine. It is the light of full summer. The torrid hot season and the sunshine has turned them to gold. Their faces and arms are painted orange with a touch of brown. Manet wished to emphasize the flesh tints of these figures, and then recalled what he had learned in textbooks. So, anxious to achieve harmony, by the use of complementary colors, he introduced blue into the background against which the figures are set, and then, delighted with the result, he wanted to enhance the blue tones even more and so forced up the azure tones. He forgot all about Argenteuil and geography and turned the Seine into a deliciously blue Mediterranean. The harmonious contrast of the two colors is interesting, but the intellectual accident is even more so. It proves conclusively that Manet is anything but a 'realist.'

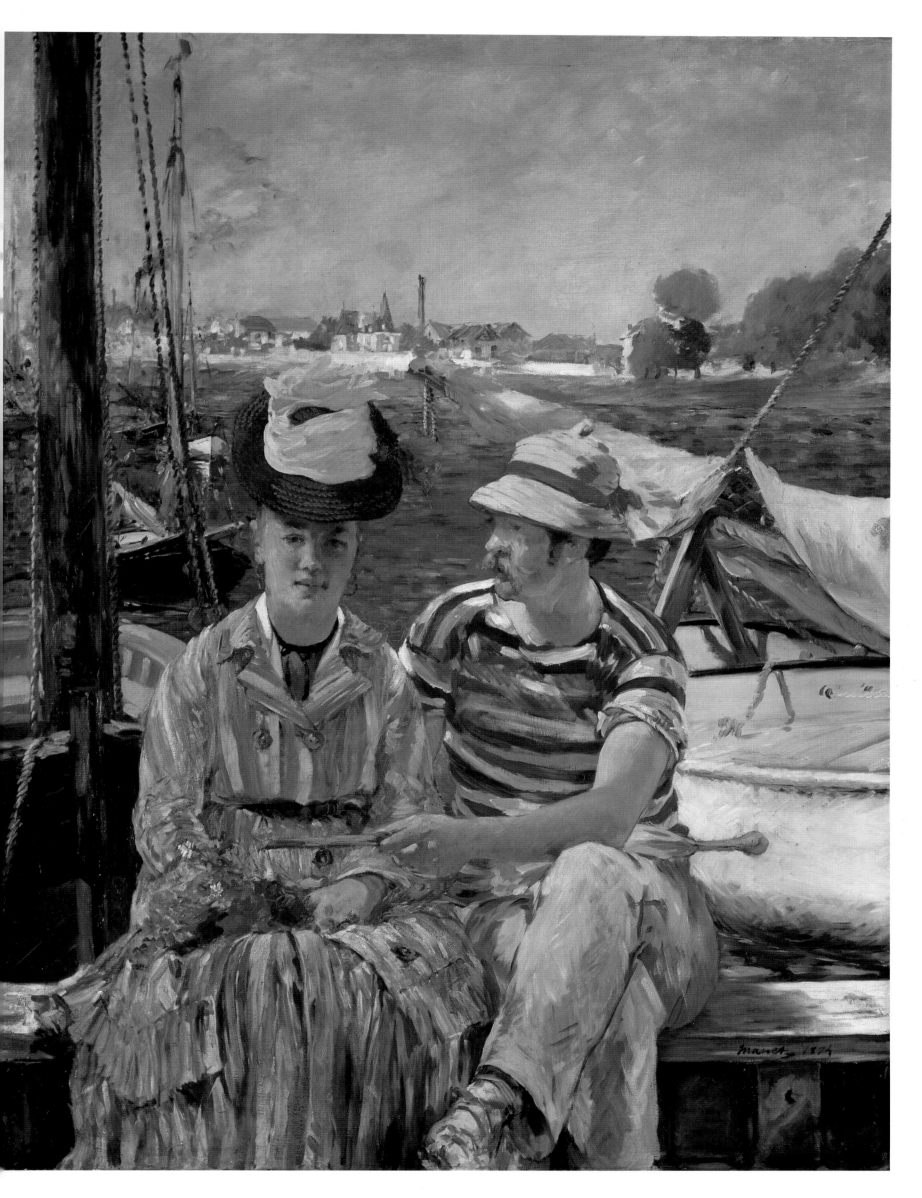

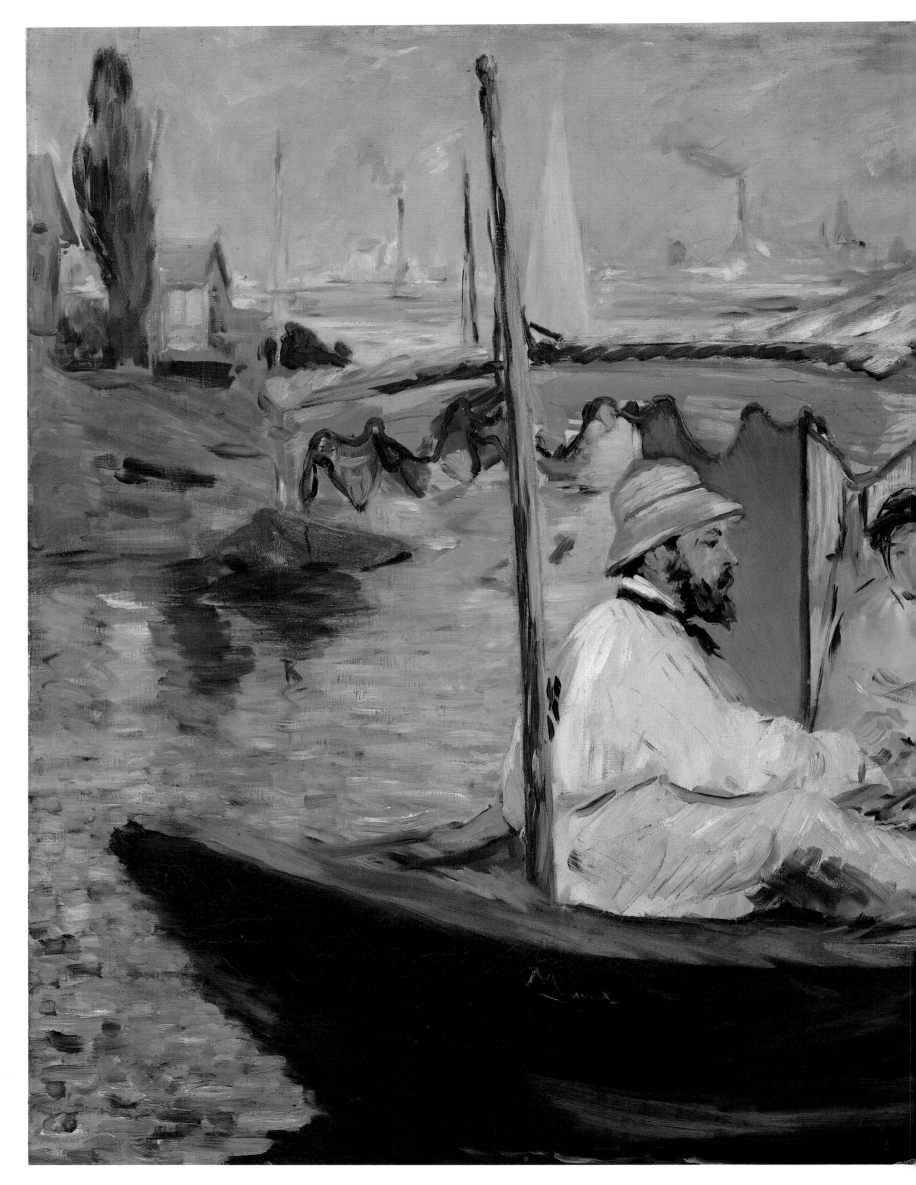

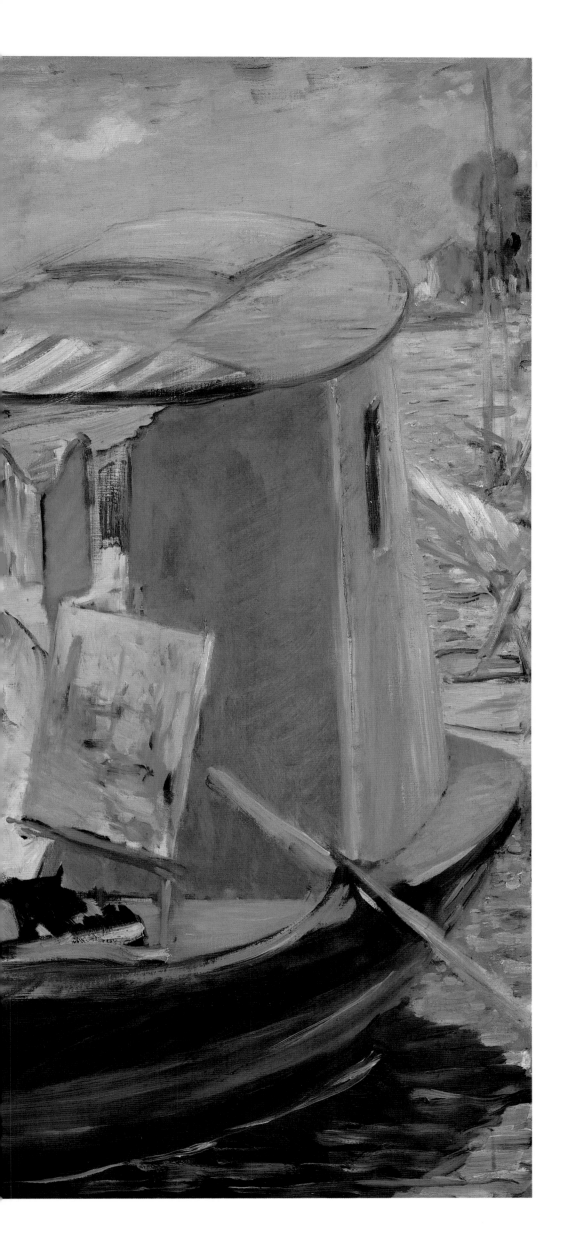

Claude Monet Painting in his Studio Boat, 1874

Oil on canvas
32½×40⅛ inches (82.5×104 cm)
Neue Pinakothek, Munich

Painted at the same time as *Boating* (page 124) and *Argenteuil* (page 127), *Claude Monet painting in his Studio Boat* marks the highpoint of Manet's flirtation with the impressionist idiom, in which he used the typical rapid *facture*, the interest in a scene of leisure depicted in the open air, and colors which were noticeably lighter than those used a year or two previously, while still retaining black. At the same time, it is almost as if he is graphically delineating the impressionist credo. Claude Monet (1840-1926) is depicted on the small boat which he had converted into a floating studio, which enabled him to traverse the Seine in search of landscape subject-matter and he is working on a small, white canvas directly from the motif. In the background his wife Camille is sheltering under the awning of the studio boat. The work seems to be a testament to Monet's desire to capture the fleeting and the momentary and to record what was directly in front of him. In fact Monet had gone to Argenteuil in 1871 partly because it was cheaper to live there than in Paris, but also it would seem from a growing dissatisfaction with urban subject-matter. In Argenteuil and on the Seine he could deliberately select and construct motifs which offered a more timeless vision of nature. It is interesting that it is Manet who has chosen to depict the chimneys in the background, and Monet who on his studio has deliberately chosen to ignore them and turn to a more picturesque scene. Far from recording his immediate sensations, Monet has used his studio boat to allow him to represent the external world selectively.

129

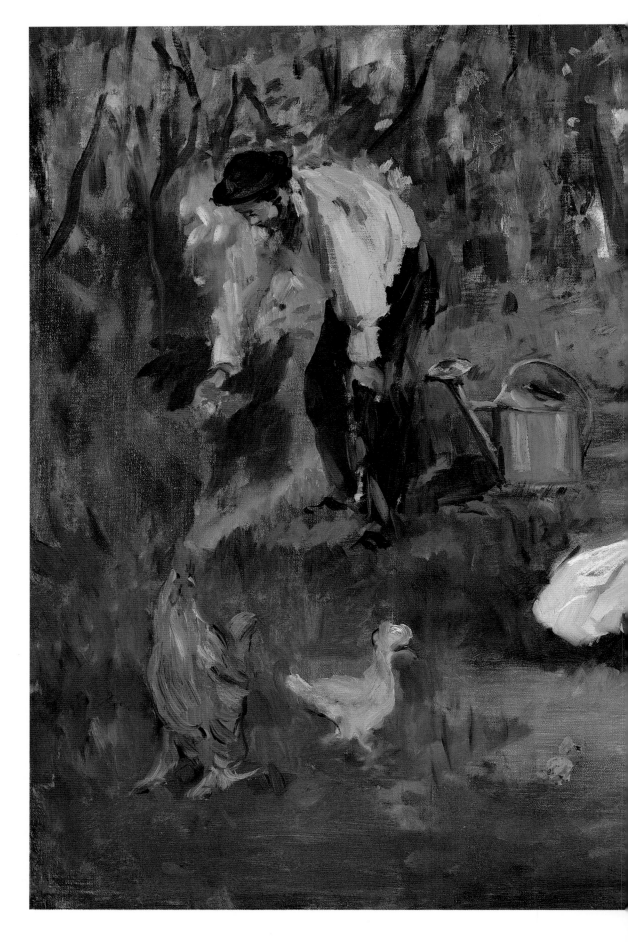

The Monet Family in the Garden, 1874

Oil on canvas
24×39¼ inches (61×99.7 cm)
The Metropolitan Museum of Art,
New York
Bequest of Joan Whitney Payson, 1975

Manet spent part of July and August of
1874 in the family home at Gennevilliers
on the river Seine, near Argenteuil where
Monet had been living since 1871 with his
family. The two often worked together and
were sometimes joined by Renoir.
Although Manet had chosen not to exhibit
with the Impressionist group at their first
show in the spring of 1874, preferring in-
stead to pursue success at the official
Salon, his style and subject-matter in *The
Monet Family in the Garden* is in part a re-
sponse to the work of the two younger
artists and quite different from the more
finished evocations of modern life which
he produced before and after this date.

A painting by Renoir, *Mme Monet and
her Son in their Garden at Argenteuil*
(National Gallery of Art, Washington DC),
shows Camille and Jean in exactly the same
pose beneath the tree but in close-up and
from a slightly different angle: the two
works were in all probability painted at the
same time. Their fluid paint and rapid
brushwork suggest that both would have
been done in a single sitting on the spot,
with only minor adjustments in the studio,
quite contrary to Manet's usual practice.

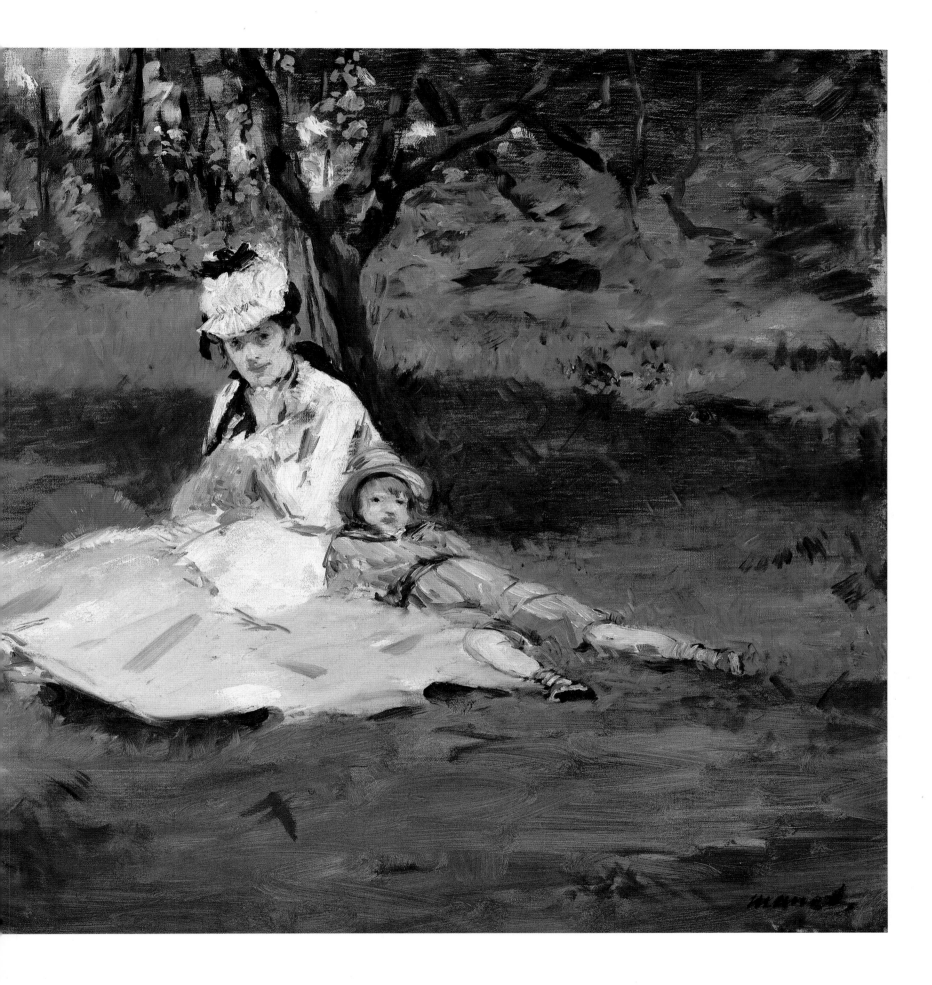

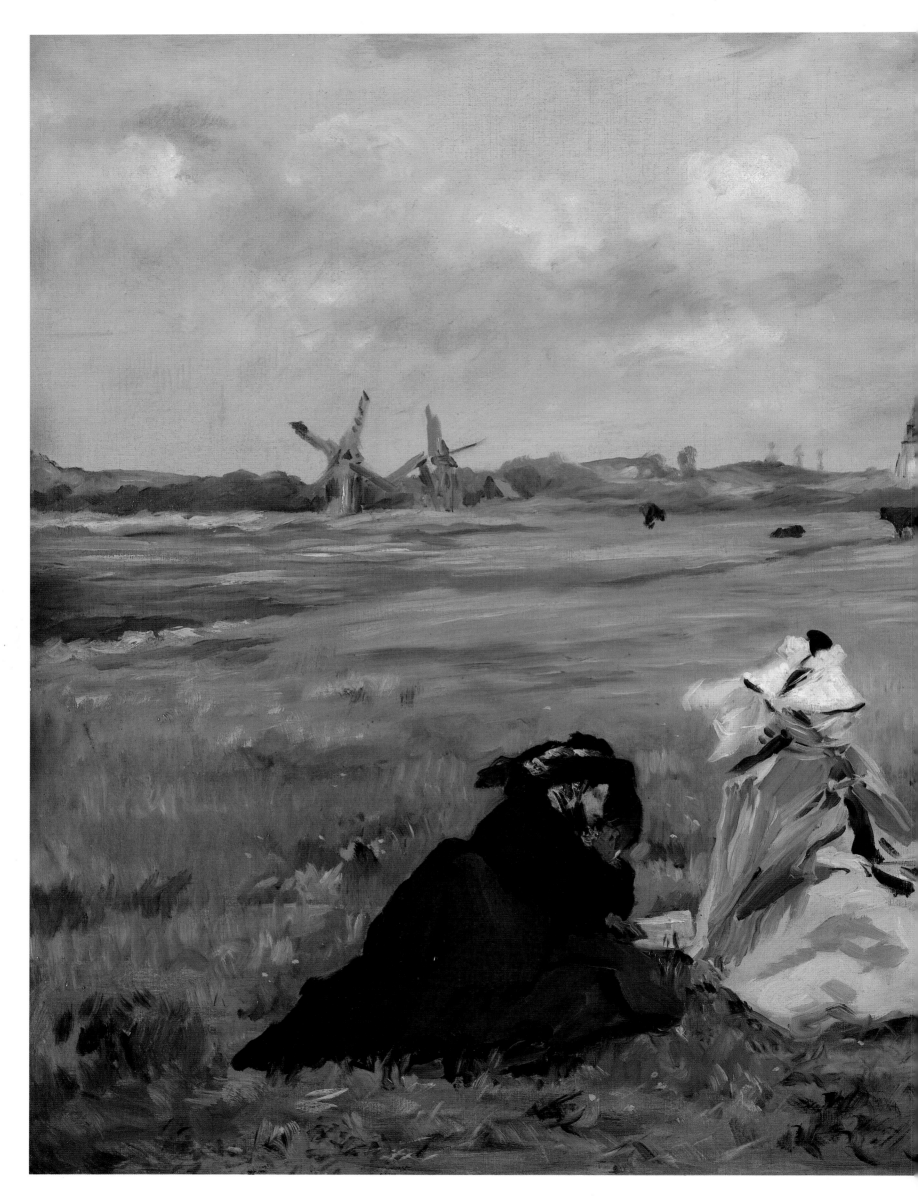

The Swallows, 1873
Oil on canvas
26×32 inches (65.5×81 cm)
E G Bürhle Collection, Zürich

In 1874 Manet chose not to exhibit with the Impressionist group but instead sent four works to the Salon. Only two of these, *Polichinelle* and *The Railroad* (page 114) were accepted while *The Masked Ball at the Opera* (page 120) and *The Swallows* were rejected. This work had been painted at Berck-sur-Mer near Boulogne where the Manet family had been on vacation in August and September the previous summer. The two figures in the foreground have been identified as Eugénie Manet, the painter's mother, and Suzanne Manet, his wife. The work has a number of affinities with *On the Beach* (page 117) which was painted at the same time, including the high horizon, fluid handling of paint and rapid execution most probably done on the spot, and has often been described as being one of Manet's most impressionist paintings. However, the work is different from that of both Renoir and Monet in that Manet has continued to use black and has not broken his tones down in the same way. The handling perhaps comes closest to that of Berthe Morisot who had been one of the participants in the first Impressionist exhibition and who was to become Manet's sister-in-law the following year.

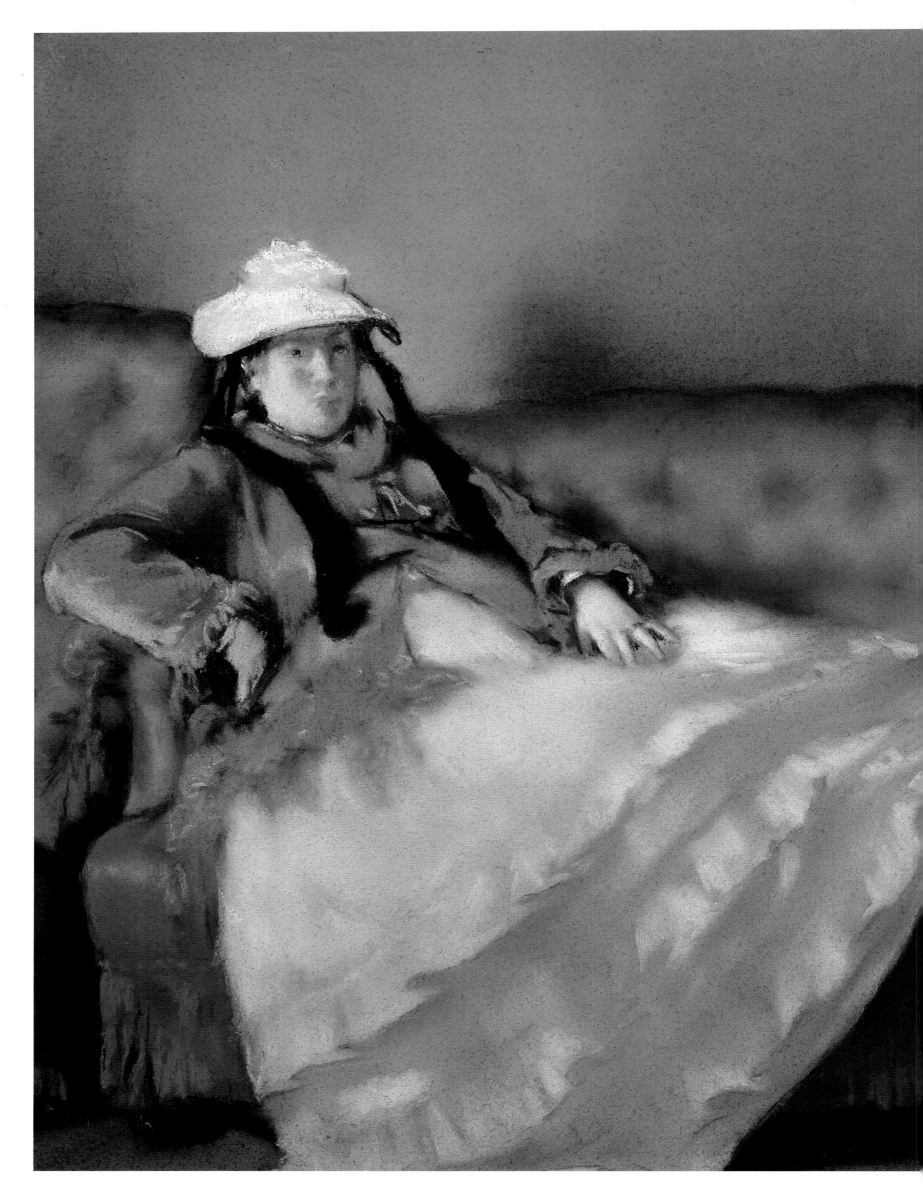

Mme Manet on a Blue Couch,
1874
Pastel on paper
25½×24 inches (65×61 cm)
Musée d'Orsay, Paris

Of the Impressionist circle, it was Degas (1834-1917) who pioneered a revival of interest in pastels which had fallen out of favor in France since their popularity in the eighteenth century. At the same time, a reappraisal of rococo art generally at this time may have led Manet to experiment with the medium, and he produced a number of portraits in pastel from the mid-1870s. In fact in handling and subject-matter this portrait of his wife is perhaps closer to some of the intimate scenes of bourgeois life by someone like Chardin and the melting quality of the different fabrics and the contrast of blue and orange lend the work a richness which is more in keeping with the eighteenth-century masters of daily life than the rather freer style that characterized Degas' use of pastel.

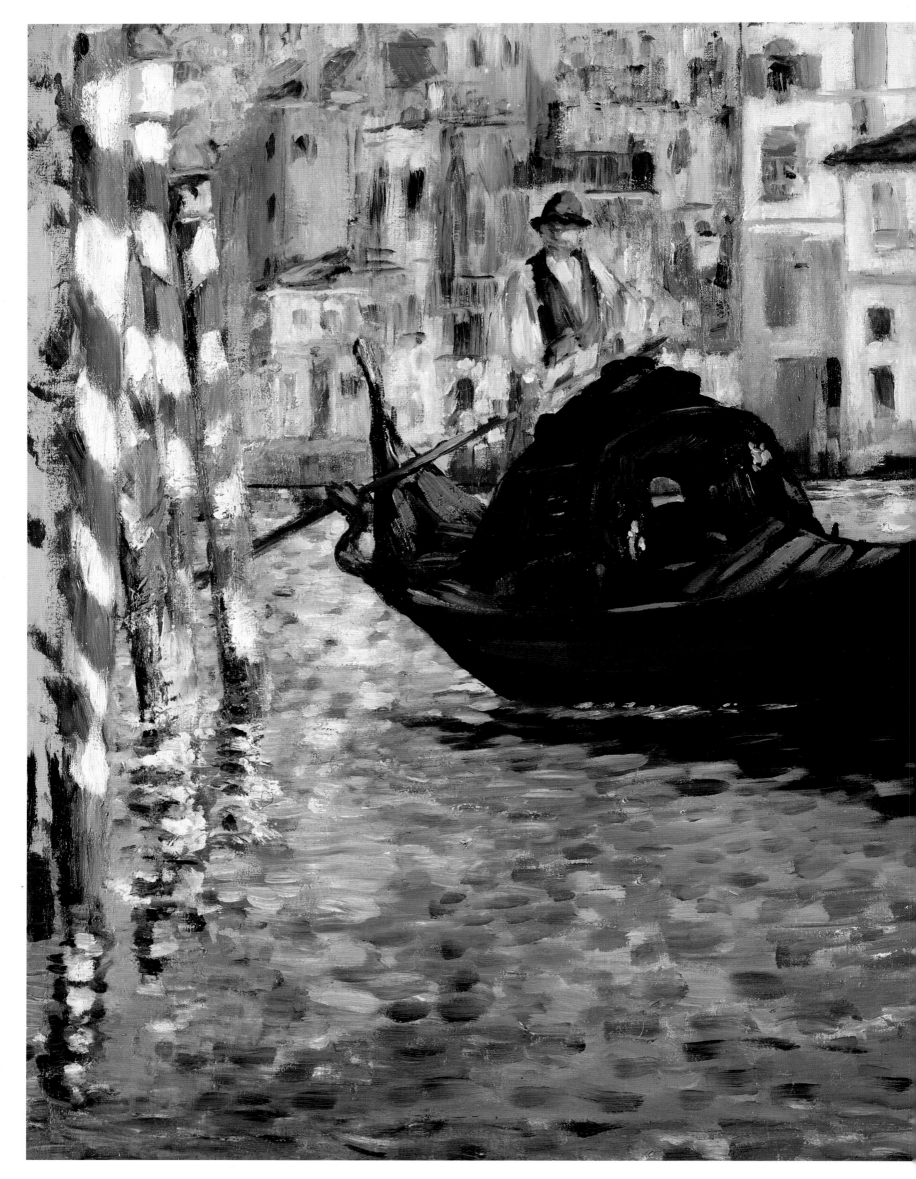

The Grand Canal, Venice (Blue Venice), 1875

Oil on canvas
23×28 inches (59×71 cm)
The Shelburne Museum, Shelburne, Vermont

This canvas was included in the Manet retrospective at the Ecole des Beaux-Arts where it was seen by Joseph Péladan who wrote:

An unusual little canvas represents a corner of the Grand Canal in Venice. Water and sky are indigo; the white mooring posts are garlanded with blue strips. This symphony in blue major is neither absurd nor untrue to life. I have seen Venetian afternoons of just that color; but Manet has exaggerated an impression to an almost chimerical degree. Behind these efforts by this unfortunate man, who has fallen in love with clarity, one is aware of his search for light and of his exceptional idealism.

Like other contemporary commentators, Péladan was at pains to link Manet with the vanguard impressionist painters, but his review is interesting because it pushes beyond that and points to the extent to which Manet has transcended a desire for objectivity and arrived at a more profoundly constructed work which relied on a rearrangement of the raw ingredients of the scene. And in fact, the buildings in the background of the painting are not painted from life, but seem to have been borrowed from some imaginary Mediterranean hillside. Manet had taken the trip to Venice in the fall of 1875 with his wife and the painter James Tissot (1836-1902).

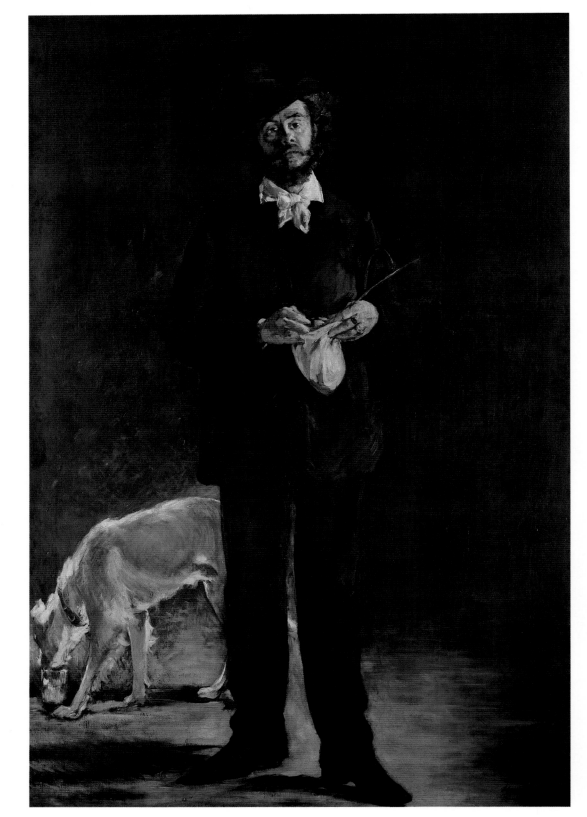

The Artist, 1875

Oil on canvas
76×51.2 inches (193×130 cm)
Museu de Arte, São Paulo

In 1876 Manet's two submissions to the Salon, *The Laundress* (page 15) and *The Artist* were rejected. The latter was a portrait of the engraver and painter Marcellin Desboutin (1823-1902) who exhibited with the Impressionists at their second group show that spring. Desboutin was from an aristocratic background and had attended the Ecole des Beaux-Arts and had probably met Manet when the two frequented the café Guerbois in the early 1860s.

As in 1867, after his rejection by the Salon jury, Manet decided to mount a private exhibition of his work and opened his studio at 4 rue Saint-Pétersbourg from ten until five o'clock from 15 April until 1 May to allow the public to see the refused works. The show was well attended and a number of writers criticized the harshness of the jury. Among them, Castagnary pointed out that Manet's absence at the Salon only made him more conspicuous:

His portrait this year, this portrait of Desboutin which you refused, would have been one of the strongest canvases of the Salon. But the success of *The Bon Bock* frightened you; you didn't want it repeated on a larger scale. What folly! the public, who only trusts you halfway, has run to the painter's studio, and these eager visitors have amply compensated for your brutal rejection.

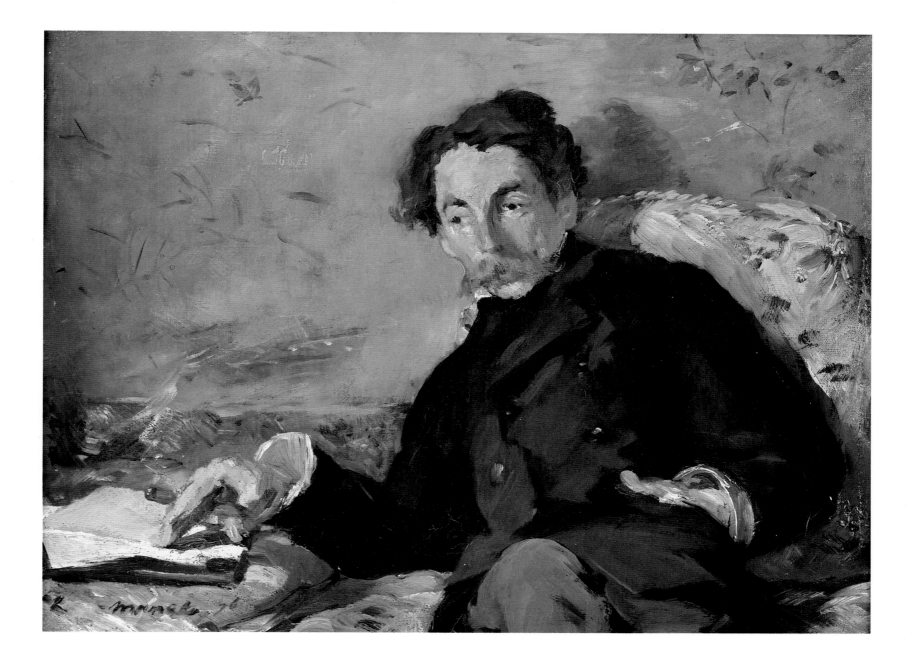

Portrait of Stéphane Mallarmé,

1876
Oil on canvas
10½×14 inches (27×36 cm)
Musée d'Orsay, Paris

Manet met the writer Stéphane Mallarmé (1844-1898) around the time of his first Salon success with *Le Bon Bock* (page 000) in 1873. They may initially have been drawn together by a mutual regard for the work of Baudeliare, by whom Mallarmé was greatly influenced at this time, but he later went on to develop a Symbolist style of poetry. In 1874 he had written an article about the harshness of the jury at that year's Salon which had rejected two of Manet's paintings (pages 120 and 132) but it is for the long article 'The Impressionists and Edouard Manet' written in 1876 and now known only in English translation that he is best remembered. The article is one of the first to establish Manet as the leader of the Impressionist group of painters, despite the fact that he had chosen not to exhibit with them at either of their exhibitions. As with earlier portraits of literary figures, including Zola (page 94) and Duret (page 96), this work may in part have been carried out as a token of appreciation for the writer's support.

The painting was executed in Manet's studio (the silk hanging behind his head had already appeared in *Lady with Fans* (page 118) and after it was finished he gave it to the poet. A description of Mallarmé by Antonin Proust recounts the first time he had met the poet in Manet's studio, shortly before this portrait was produced:

He was then in the full flower of youth. His eyes were large, his nose straight, a thick moustache was emphasized by firm lips; his forehead jutted out beneath thick hair. His beard came to a point above a dark cravat wound round his neck.

Nana, 1877

Oil on canvas
61×45 inches (154×115 cm)
Kunsthalle, Hamburg

Manet sent two works to the Salon of 1877, *Faure as Hamlet* (page 143), a costume piece representing one of his most important patrons, and *Nana*. The latter was originally accepted and may even have been hung, but it was withdrawn before the exhibition opened, presumably on the grounds of its demimonde subject-matter. *Nana* was inspired not by Zola's novel of that name, which was not to be serialized until October 1879, and not published as a book until February 1880, but rather by a minor character in another Zola novel, *L'Assommoir,* which was serialized from the fall of 1876. In that novel Nana is the daughter of the central characters Gervaise and Coupeau, who by the end has man-

aged to 'catch a count,' who may be the male figure shown in Manet's canvas.

Nana continues the theme of *Olympia* (page 60), of the courtesan in the presence, whether overt or merely implied, of her male admirer. References to modern life are much clearer here – Nana is in a boudoir with its strange mixture of Louis XV furniture and *japonaiserie* (the silk hanging in the background had been used by Manet in *Lady with Fans* (page 118) while her wealthy 'protector' watches her apply cosmetics. His clothing and attitude allow us to define Nana's class as a member of the demimonde. In fact, the figure had been modelled by Henriette Hauser, an actress who was then the mistress of the prince of Orange.

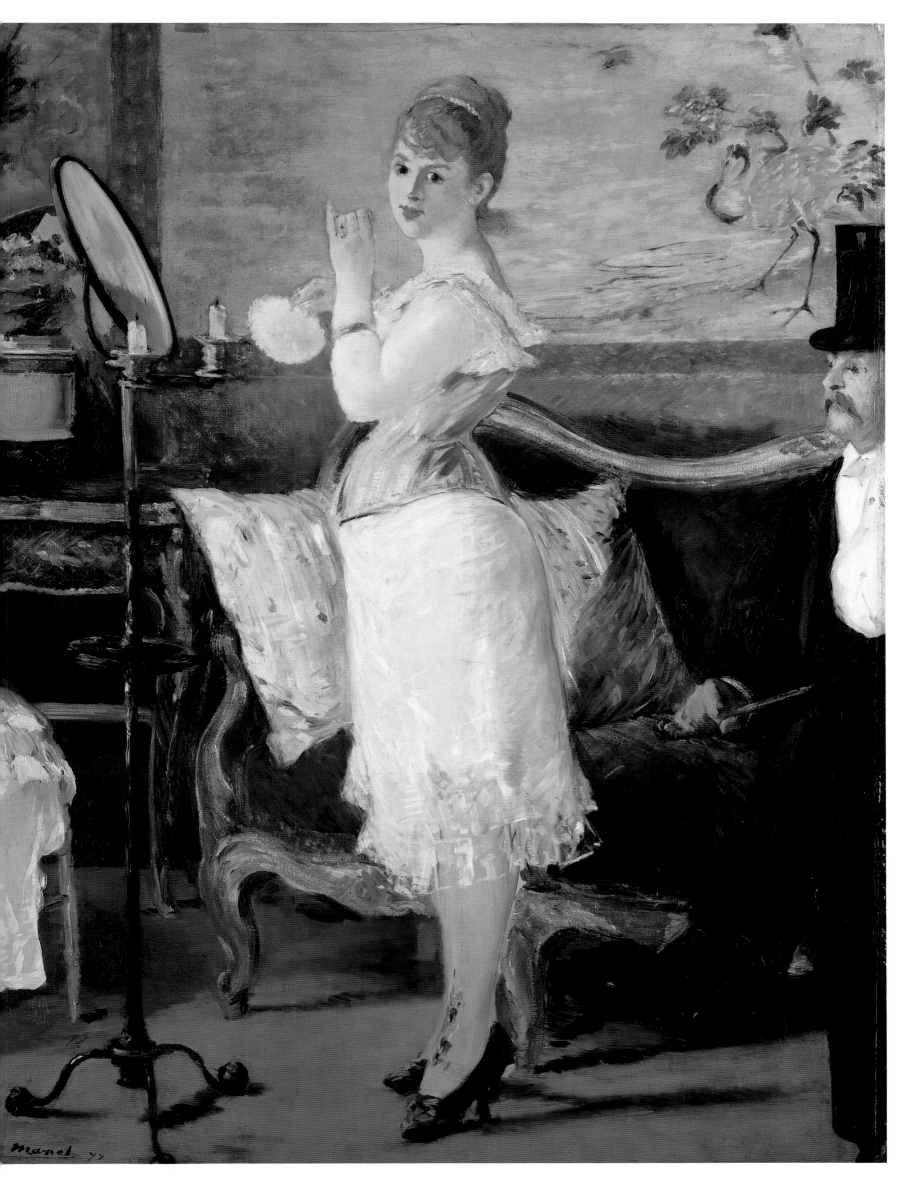

Faure as Hamlet, 1877

Oil on canvas
77⅛×51⅛ inches (196×130 cm)
Kunsthalle, Hamburg

Refusing to join the Impressionist group at their third exhibition in 1877 Manet chose instead to send two works to the Salon of 1877, *Nana* (page 118) and *Faure as Hamlet* (Folkwang Museum, Essen) for which this large work is a complex preparatory study. Jean-Baptiste Faure (1830-1914) the famous French baritone had been one of Manet's principal patrons and when he retired from the Paris Opéra he commissioned Manet to paint a commemorative portrait of him as Hamlet from Ambroise Thomas' opera which he had first popularized six years previously at its premiere and which he chose for his farewell performance. The subject of Hamlet had already been treated in a similar Salon painting *The Tragic Actor* (page 71) which had been rejected in 1866. In both the figure is shown full-length and life-size, solitary against an indistinct background, and in both Manet has chosen a dramatic moment from the play, here when the prince of Denmark first sees his father's ghost.

The singer did not accept the work after it was finished, apparently because he did not like the pose, but instead had the role immortalized by the fashionable portrait painter Giovanni Boldini (1845-1931).

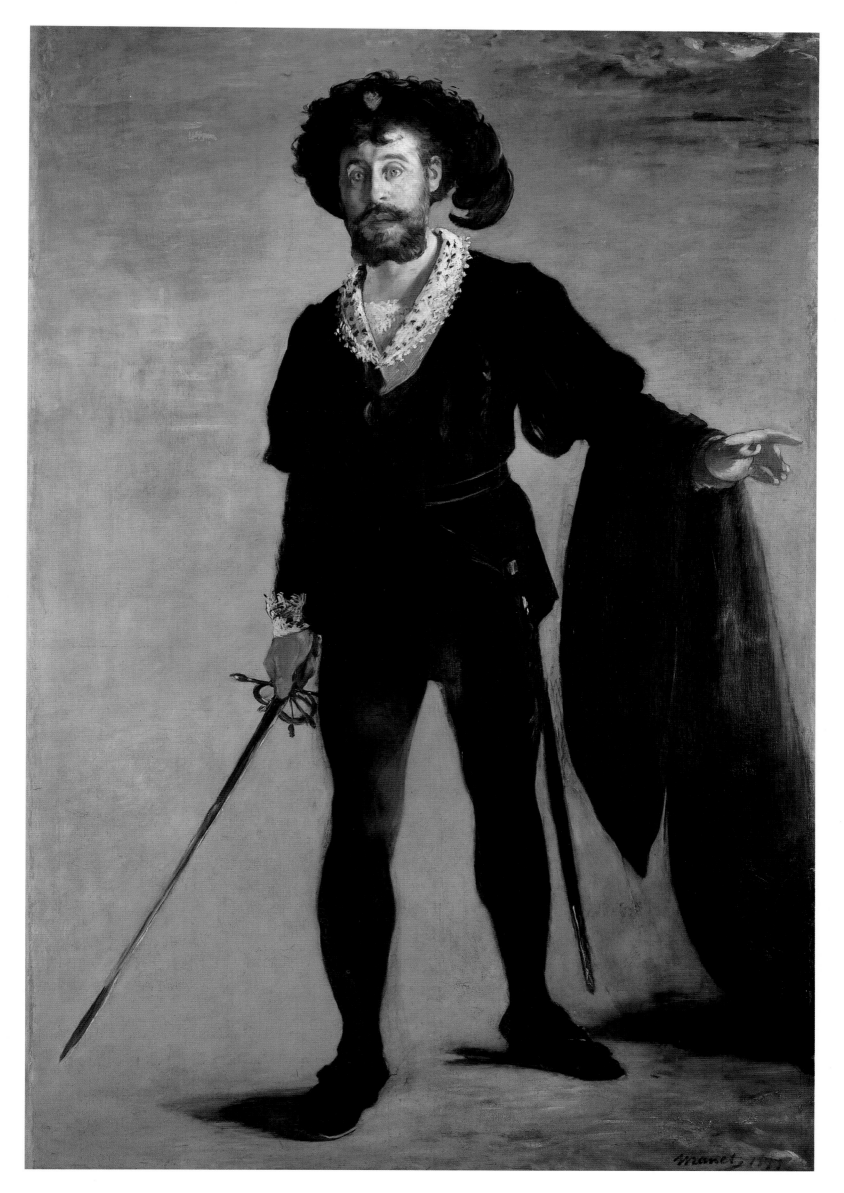

143

Road Menders, rue de Berne,

1878
Oil on canvas
25×31½ inches (64×80 cm)
Private Collection

This is one of a series of paintings that Manet produced of the rue Mosnier, called the rue de Berne from 1884. The view was from a window in his studio at number 4 rue de Saint-Pétersbourg which he was then on the point of leaving. In recording the scene from his window, Manet has used a deliberately impressionistic idiom: broad color application, the capturing of a specific time of day and lavender injected into the shadows that creep across the street. At the same time, it is also a record of the way in which the city had changed: the apartment blocks, sidewalks and streetlamps of Haussmann's renovations are quite visible and the group of pavers in the foreground attest to a constant modernization of the city, in this instance in honor of the national holiday which was to be held on 30 June 1878 for the first Exposition Universelle of the Republic. The sense of the transformation of the area is enhanced by the inclusion of a removal wagon in the middle distance.

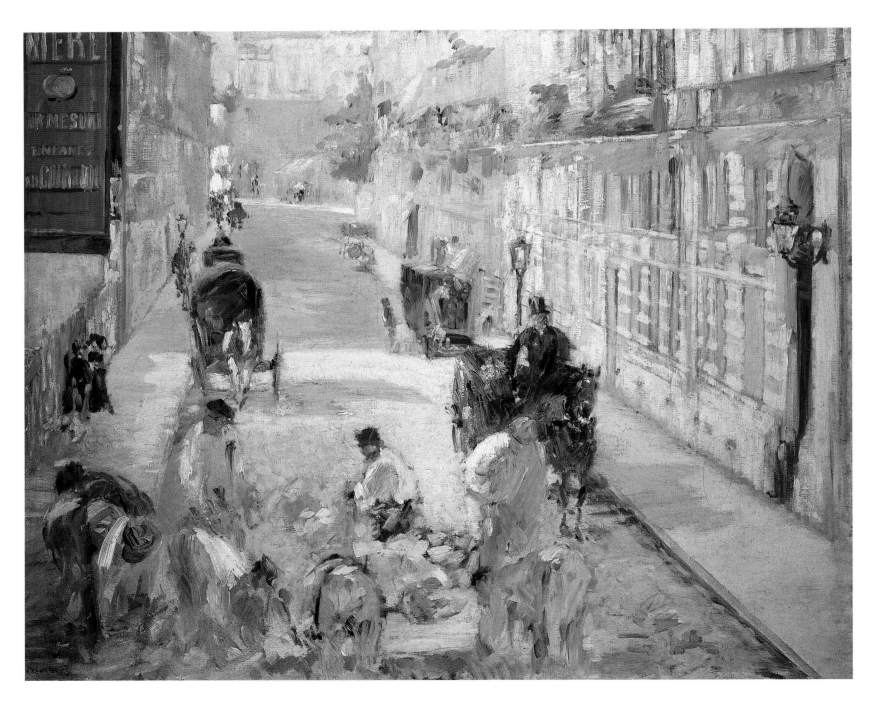

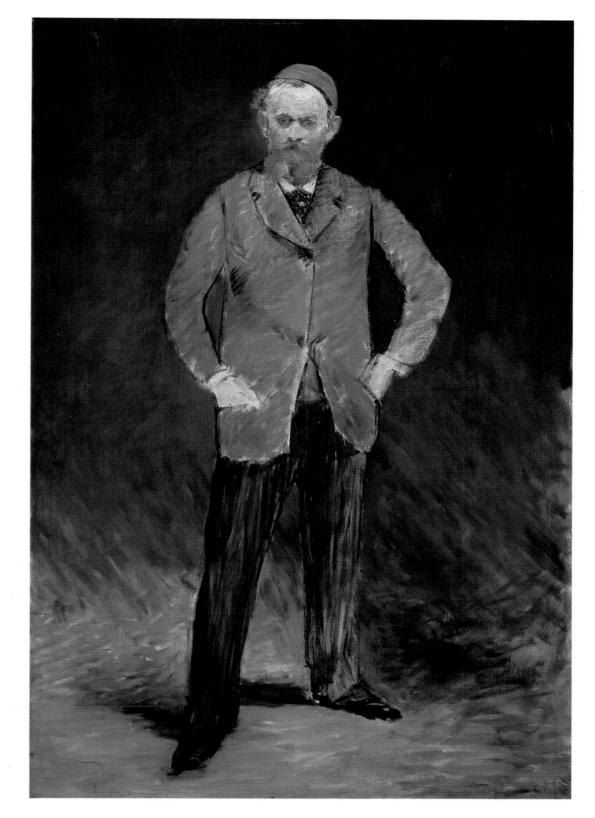

Self-Portrait, 1878-79
Oil on canvas
37×26⅜ inches (94×67 cm)
Bridgestone Museum of Art, Tokyo
Ishibashi Foundation

Prior to this self-portrait, Manet had only painted himself as part of a larger social grouping, as in *Music in the Tuileries* (page 50) and *The Masked Ball at the Opéra* (page 120) where he looks out of the canvas at the spectator. In both of these works he is portrayed as an elegant, leisured dandy, at ease with his peers in the milieu of contemporary Paris. This rare self-portrait therefore comes as rather a surprise, which is in part due to the tentative nature of the handling – the work never progressed beyond the *ébauche* state – but also because he has depicted himself with no props and nothing to refer to his profession. Contemporary commentators noted that Manet's usual practice was to include still-life elements in his work after the main subject had been resolved, to lend compositional and coloristic balance. Duret's account of how Manet painted his portrait (page 96) reveals that the red-covered stool and the lemon astride the glass were not added until the work was virtually complete. The painter's odd position here has been ascribed to the pain in his legs from which he began to suffer around this time.

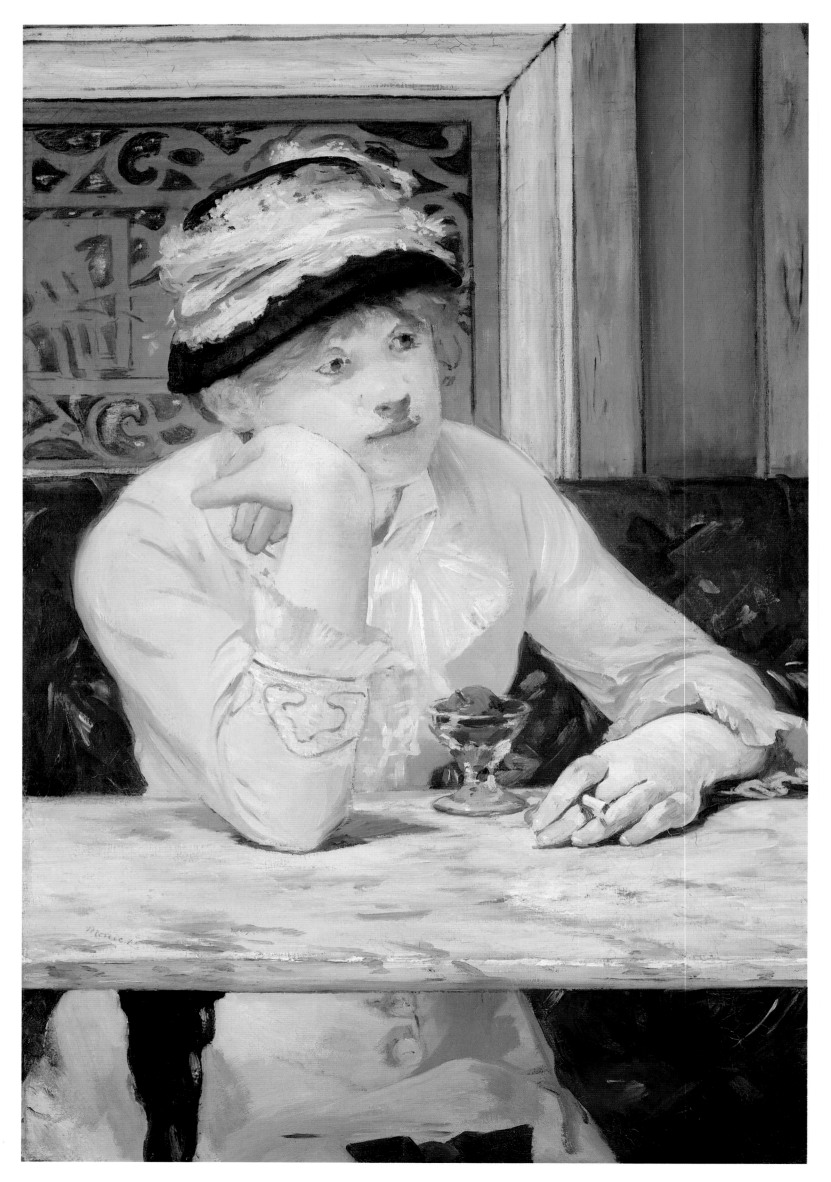

The Plum, 1878-79?

Oil on canvas
29×20 inches (73.5×50 cm)
National Gallery of Art, Washington DC
Collection of Mr and Mrs Paul Mellon

One of a series of café scenes which Manet painted at the end of the 1870s (pages 146-154), *The Plum* comes closest to Degas' *Absinthe* (page 13) in its composition, but the mood which pervades that pessimistic work is absent here. By contrast the sitter in *The Plum* conveys a sense of expectancy and a certain amount of narrative is suggested by the absence of spoon for her dessert – these brandy-soaked plums had long been a Parisian delicacy – and a light for her cigarette. We are perhaps invited to speculate about the imminent arrival of a male companion, but at the same time our proximity to her on the opposite side of the marble-topped table suggests that the spectator is forced into the same kind of role with the young woman as with the courtesan in *Olympia* (page 60). Indeed, she has sometimes been identified as a prostitute waiting alone in a café in the evening (suggested by the harsh tonal contrasts of the flesh tints which evokes artificial lighting) but her demure costume and her studiously uninterested gaze does not imply the sort of provocation Manet implied in paintings which deal with an exchange of that kind.

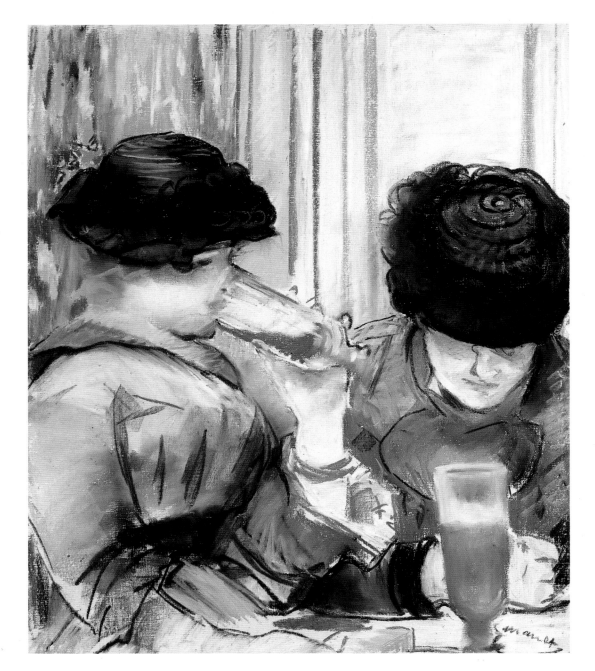

Two Women drinking Beer, 1878

Pastel
21⅝×18⅛ inches (55×46 cm)
Burrell Collection, Glasgow

From 8 until 30 April 1880 an exhibition of Manet's work was held at *La Vie Moderne* in Paris, organized by the publisher Georges Charpentier (1846-1905) who had founded a weekly journal of the same name the previous year which was devoted to literature, art and society gossip and who commissioned work from a number of avant-garde artists and arranged exhibitions of their work at his gallery.

Few of Manet's pastels have been identified today, although contemporary sources report his preference for the medium, from early examples like *Mme Manet on a Blue Couch* (page 134) to a whole series from the end of the 1870s until his death. As the pain caused by his locomotor ataxy increased and his movement was restricted, Manet turned to smaller format pictures, often of more intimate scenes. In this work the close-up examination of the two women, their relative anonymity, the attenuation of the figure at the right-hand side and the interest in the crown of her bonnet all point to the influence of Degas who exhibited pastels at the Impressionist exhibitions.

The Café-Concert, 1878

Oil on canvas
18⅛×15½ inches (47.5×39 cm)
The Walters Art Gallery, Baltimore

The café-concert was an important part of working-class culture in nineteenth-century Paris and was particularly effective in creating a sense of identity among what were often very disparate groups of immigrant laborers, many of whom who had been lured to the city as it began to industrialize and who had helped in the massive building program instigated by Haussmann. The numbers of cafés-concerts or cabarets grew after 1865 when legislation governing the performers was relaxed, and they were particularly important in consolidating oral traditions and creating new ones which existed into the twentieth century. Compared with the theater or opera their appeal was obvious, being much less formal in manners and dress and correspondingly less expensive. Of course, they were often visited by fashionable men in search of working-class *grisettes,* as seems to be happening here, or in the company of society women in search of less sophisticated pursuits. Typically, customers could eat and drink while watching the shows, but often these were merely a sideline to which the customers paid little attention, except if it were to hurl abuse at the performers. The woman in the upper-left hand corner is identifiable as 'La Belle Polonaise' ('the beautiful Polish woman') who worked at the Brasserie de Reichshoffen, and although the audience appear to have turned their backs on her, she is in fact reflected in a mirror above their heads, a device Manet was to use again in *A Bar at the Folies-Bergère* (page 172).

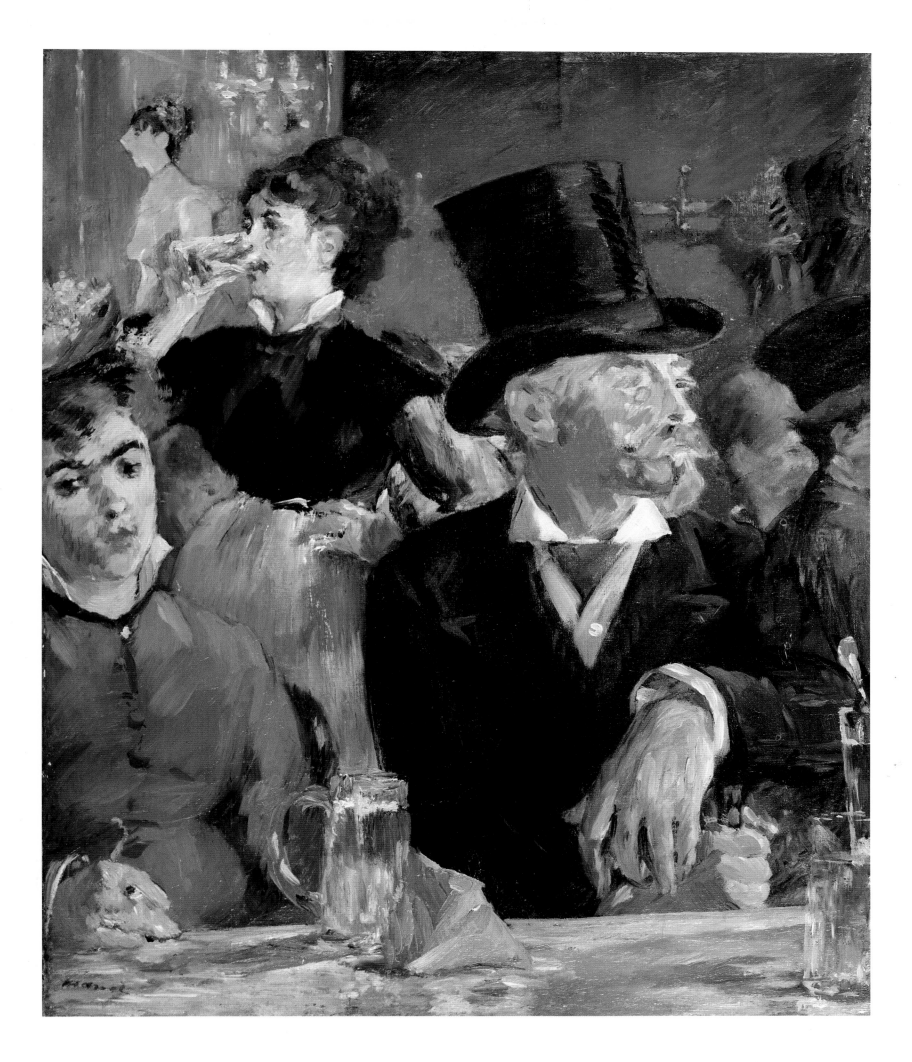

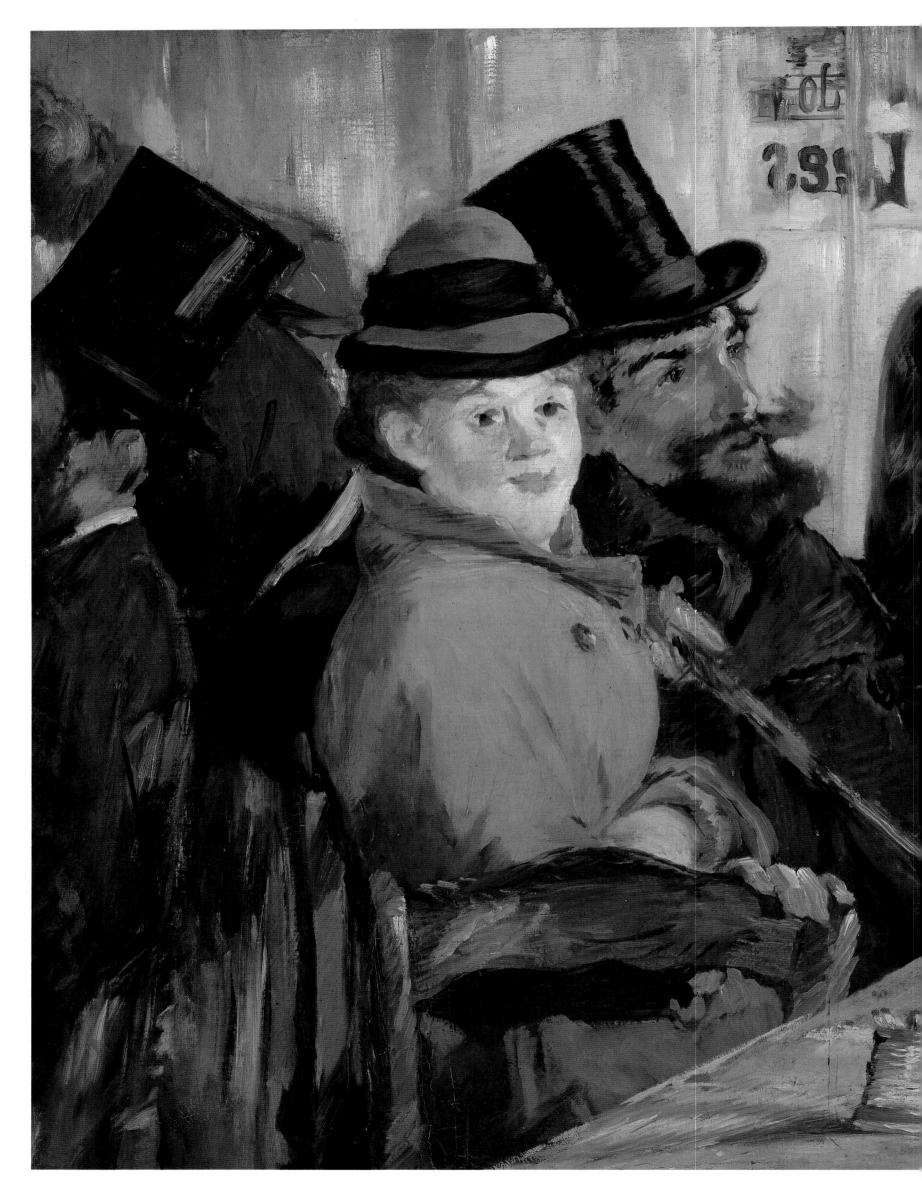

Au Café, 1878

Oil on canvas
30⅓×32⅝ inches (77×83 cm)
Oskar Reinhart Collection 'am
Römerholz,' Winterthur

Au Café and *The Waitress* (page 152) were originally painted by Manet on a single large canvas entitled *Café-Concert de Reichshoffen* which he subsequently cut and altered. The right-hand edge of *Au Café* met the left-hand side of *The Waitress* which has had a strip of canvas added down its right-hand at some stage. Because of his customary practice of abruptly attenuating figures and because of the changes Manet made in both works they now function satisfactorily as independent paintings. The main bourgeois couple in this work were posed by two of Manet's friends: the actress Ellen Andrée, who had appeared in Degas' *Absinthe* (page 13) and the engraver Henri Guérard who married Eva Gonzalès (page 107) the following year. The poster on the window above the head of the other young woman, who has not been identified, advertises the Hanlon Lees acrobats who appeared at the Folies-Bergère. The formal similarity to Degas' *Absinthe* is quite apparent in the use of the marble-topped counter which simultaneously welcomes and excludes the spectator, although the woman's quizzical look and the chair she proffers suggest that an invitation has been issued.

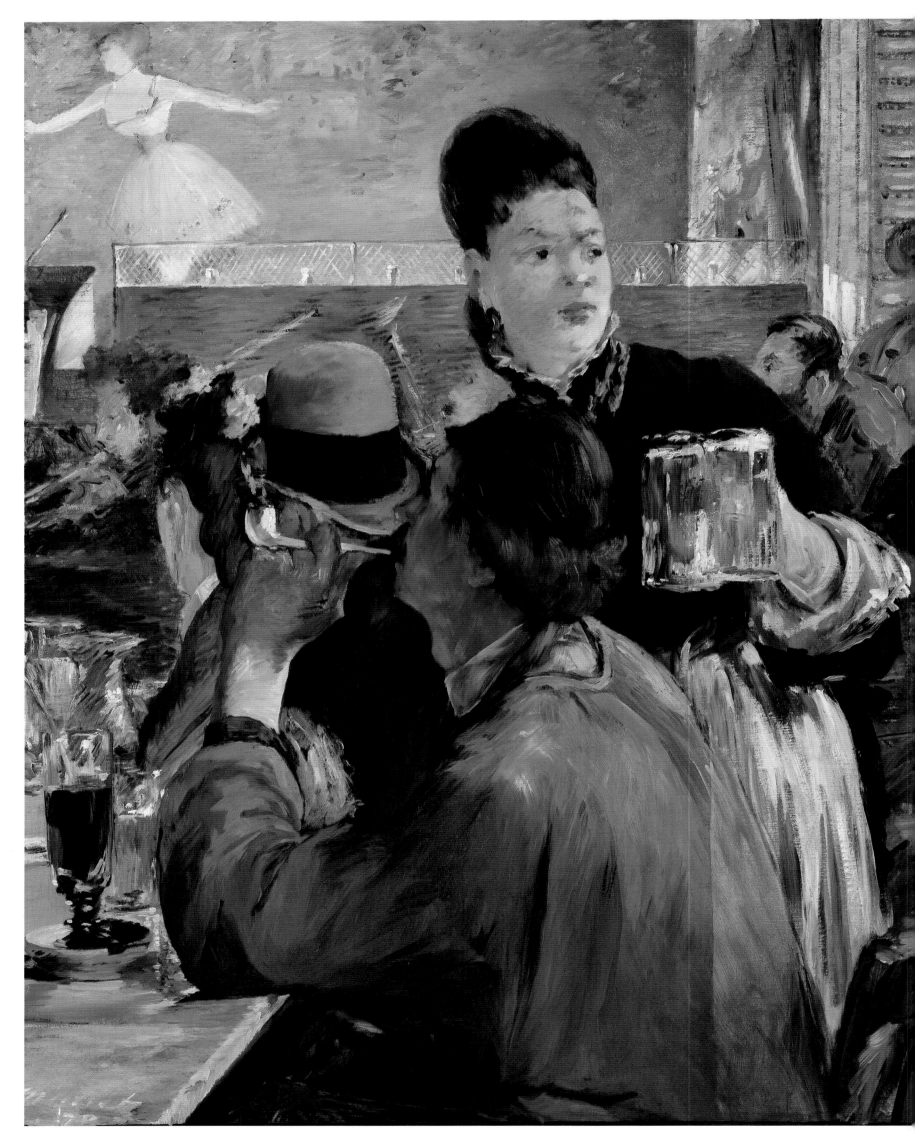

The Waitress, 1878-9

Oil on canvas
38×30½ inches (98×79 cm)
National Gallery, London

Manet began a large canvas depicting the interior of the Brasserie Reichshoffen, supposedly on the boulevard Rochechouart or the boulevard de Clichy, in August 1878 but at some stage cut the canvas in half and created two separate works – *Au Café* (page 150) and *The Waitress* which would originally have formed the right-hand portion. After the work was cut in two *The Waitress* had a strip of canvas added at the right-hand side which is quite visible in the blue of the smock of the man sitting in the foreground.

Although works like this might be based on a number of studies done on the spot, the painting itself would have been executed in Manet's studio. Apparently the waitress, one of the novel attractions at such venues, was from the Reichshoffen and consented to pose for Manet if she could be accompanied by her male companion, whom Manet has incorporated sitting smoking in the foreground. While the changes to *Au Café* were slight the background to this painting has been heavily reworked and drastically altered from Manet's original representation of the scene. For this reason it may be assumed that this painting precedes the related *Woman Serving Beer* (page 154).

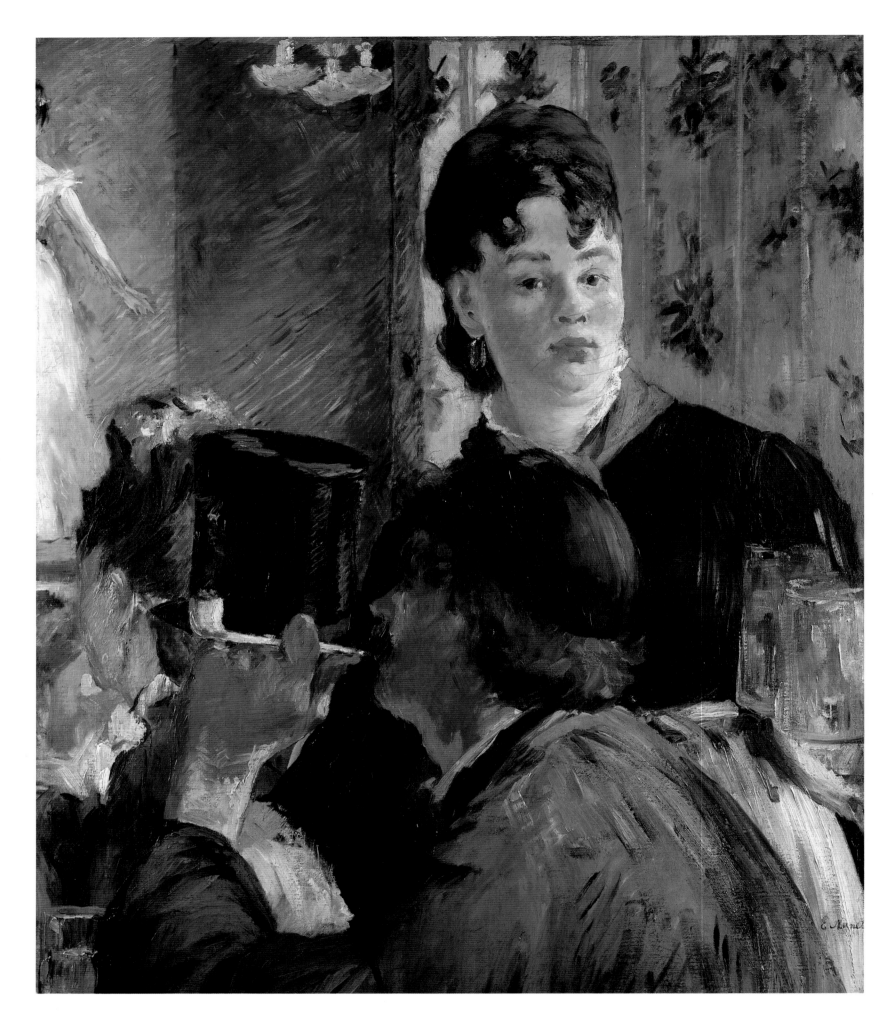

Woman Serving Beer, 1879
Oil on canvas
30½×25½ inches (77.5×65 cm)
Musée d'Orsay, Paris

The exact nature of the relationship between *Woman serving Beer* and *The Waitress* (page 152) remains vague, although the two are clearly related. Given Manet's traditional working practice, and his habit of producing sketches and studies before embarking on a finished painting, it is tempting to conclude that this very much smaller work precedes the version in

London. However, the fact that this is a much more compressed view of the right-hand side of the original work, after it had been cut in two, would suggest that in fact this is the later painting. The rather more resolved nature of the background, which is treated with a greater economy of means and the almost caricatural placement of the three heads in a row, from the casual cap of

154

the laborer, through to the top hat of the bourgeois and the elegant coiffeur of the woman beside him, suggest that Manet has been trying to convey the impression of the cross-section of Parisian society who attended these venues in a much more direct way than he had managed in the larger version.

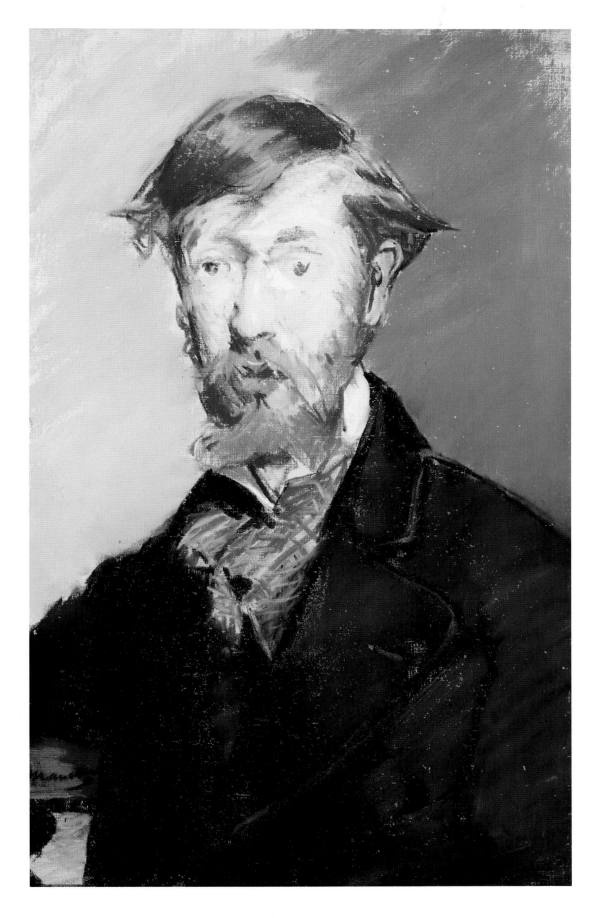

Portrait of George Moore, 1879
Pastel on canvas
22×14 inches (53.3×35.6 cm)
Metropolitan Museum of Art, New York
HO Havemeyer Collection

This pastel sketch of George Moore (1852-1933) was done in Manet's new studio at 77 rue d'Amsterdam, into which he had moved in April 1879, around the time that he first met Moore in the Café de la Nouvelle Athènes. An Irishman by birth, Moore had come to Paris to train as an artist at the Ecole des Beaux-Arts and in the studio of Cabanel, but later went on to become a successful critic and novelist. An unfinished oil painting of Moore (page 9), done about the same time, gives us a clear

indication of Manet's working procedure, where he has painted directly on to the canvas without any preparatory charcoal drawings, working in oil paint diluted with turpentine and sketching the contours of the composition with his brush. It is unclear why this painting was abandoned at this early stage, although we know that a further portrait of Moore in a garden was left in an unfinished state. Only the pastel, which was done in a single sitting, was completed.

In the Conservatory, 1879

Oil on canvas
45¼×59 inches (115×150 cm)
Nationalgalerie, Berlin

Between July 1878 and April 1879 Manet
rented the studio of the Swedish painter
Otto Rosen at 70 rue d'Amsterdam after
leaving his studio at 4 rue de Saint-Péters-
bourg and before establishing his final
studio at number 77 rue d'Amsterdam.
Rosen's studio had a conservatory attached
where Manet painted this double portrait
of his friend Jules Guillemet and his young
American wife who owned a fashionable
dress shop on the rue du Faubourg Saint-
Honoré. The size, subject-matter and
detailed finish of the work made it ideal for
sending to the 1879 Salon where it was
accompanied by *Boating* (page 124),
painted five years earlier.

Castagnary, writing in *Le Siècle,*
observed that the combination of the two
works may have been a pragmatic move by
Manet who still craved critical and popular
recognition:

Manet gives us once more the elegance of
fashionable life and the pastimes of the sport-
ing world. Of his two pictures, *Boating* and *In
the Conservatory,* the latter is the better, and
positively entrancing. On a garden bench, shel-
tered by palms and exotic plants, a young
woman sits, a parasol in her hand. Leaning on
his elbows on the back of the bench and bend-
ing over to speak to her is a middle-aged man
who resembles the painter himself. Nothing
could be simpler than the composition,
nothing more natural than their poses. One
thing, however, deserves even more praise: the
freshness of the hues and the harmony of the
colors! And what do we have here? Faces and
hands are more carefully drawn than usual: is
Manet making concessions to the public?

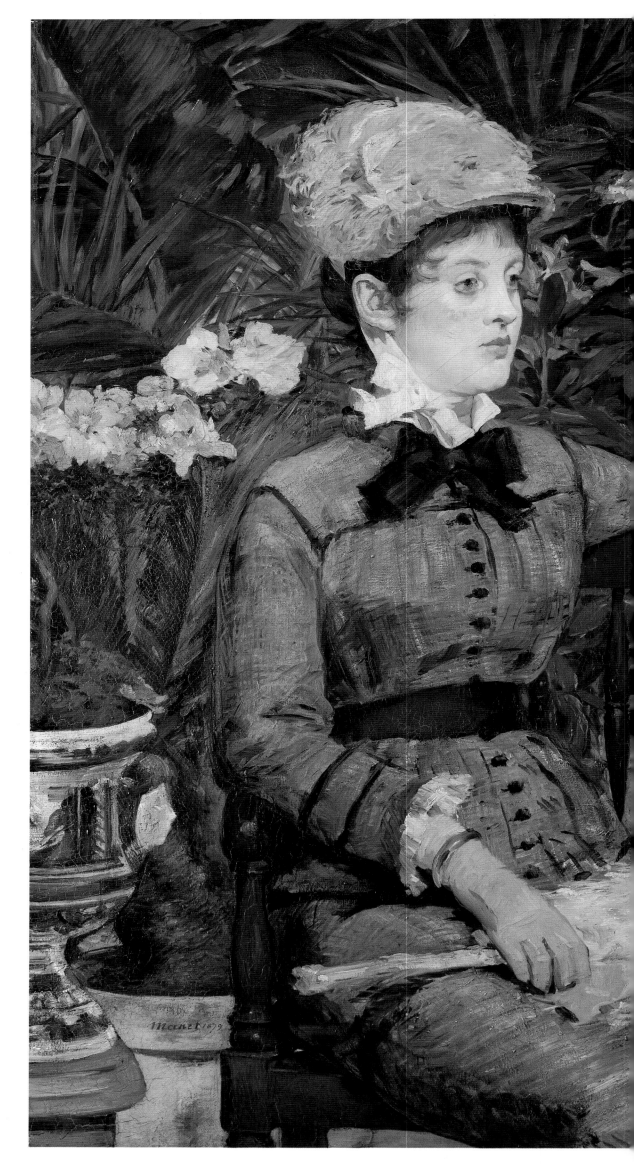

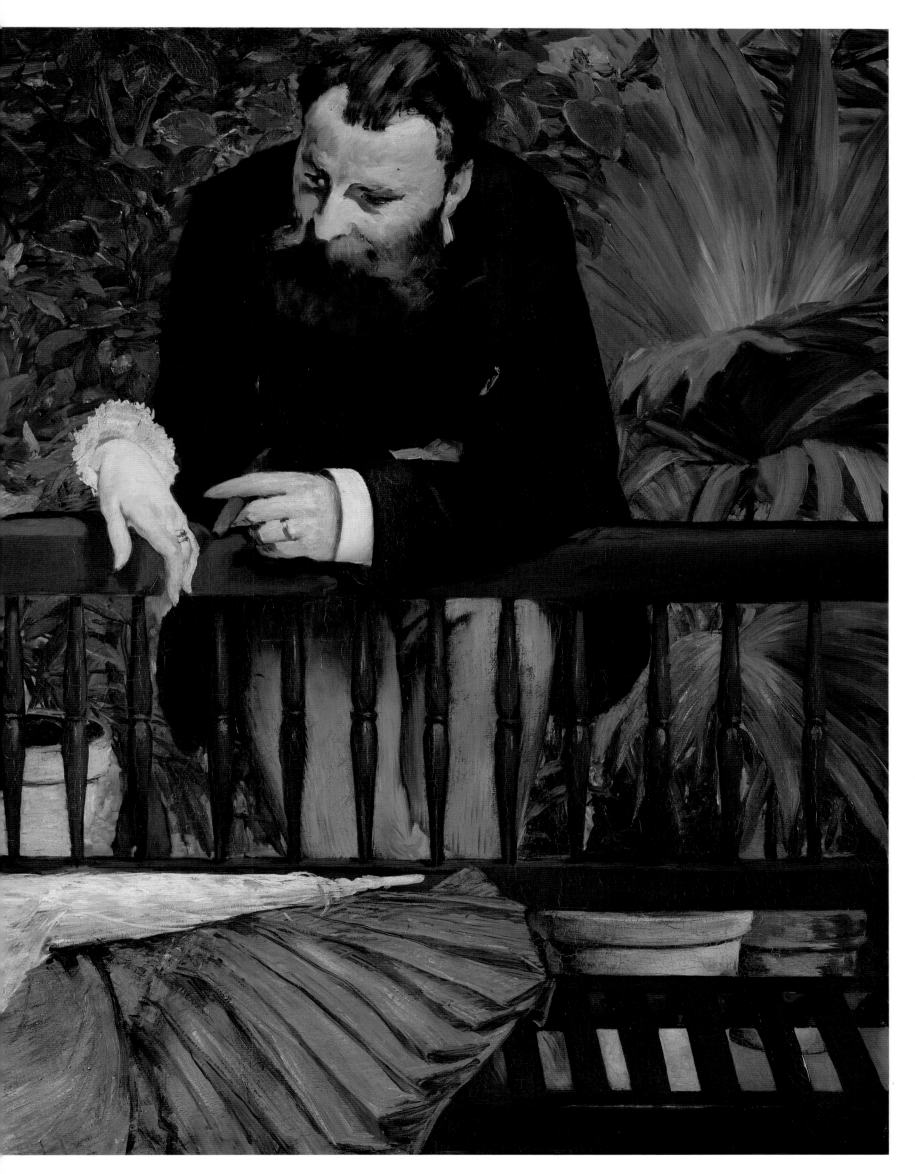

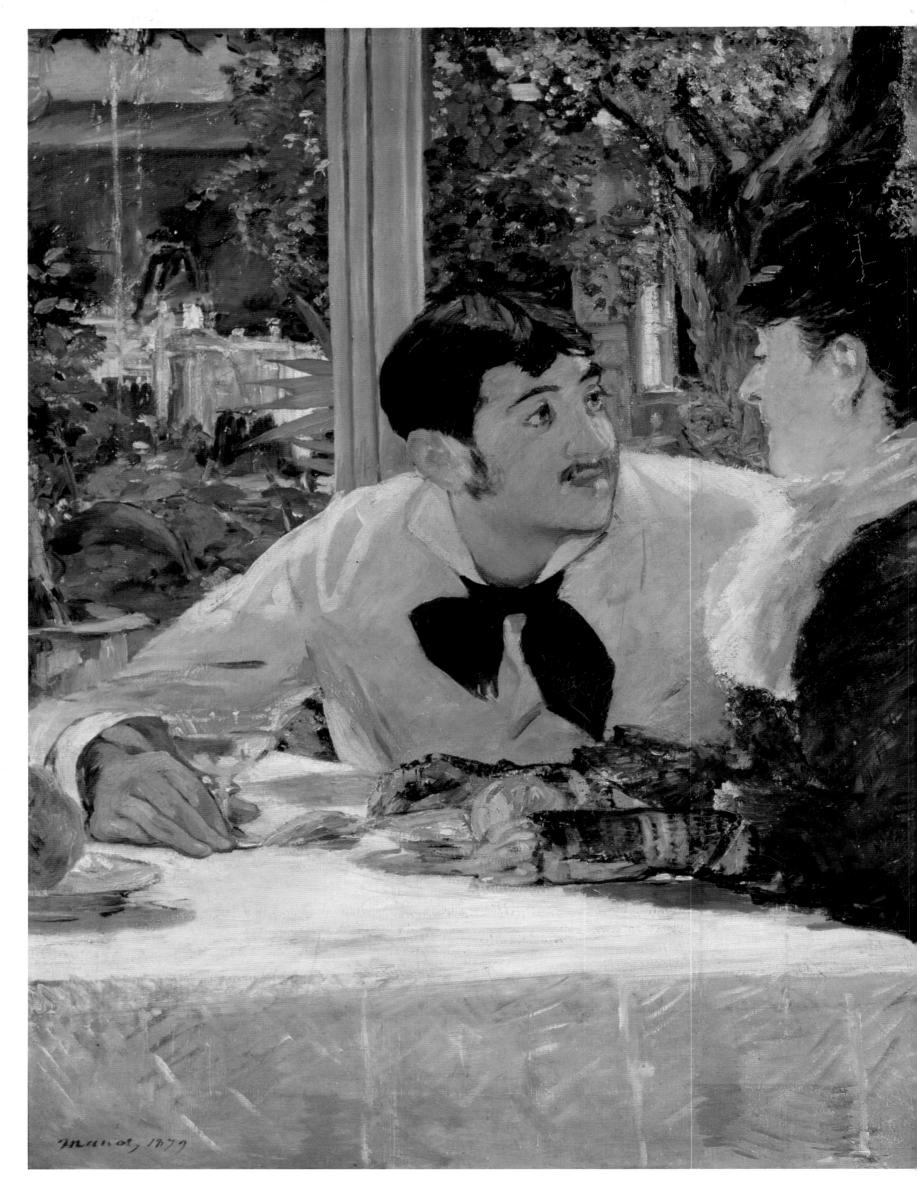

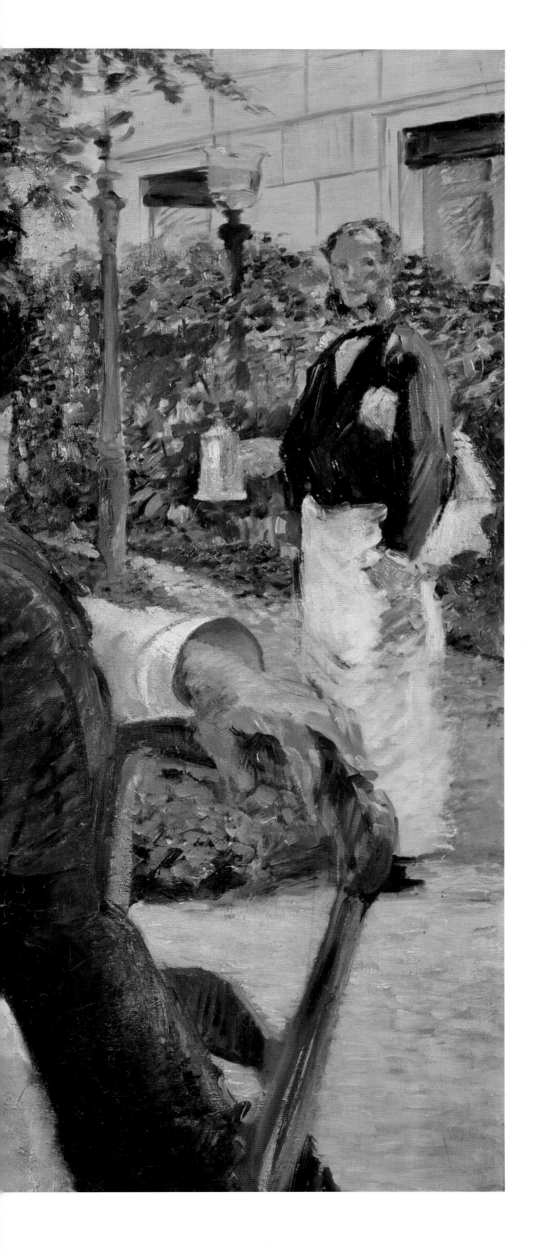

Chez le Père Lathuille, 1879

Oil on canvas
36⅝×44 inches (93×112 cm)
Musée des Beaux-Arts, Tournai

According to Antonin Proust, 'in 1879 Manet was obsessed by two *idées fixes* – to paint a picture entirely out-of-doors, in which the features of persons would melt, as he put it, "in the vibrations of the atmosphere" and to paint a picture of me (page 162).' The outdoor subject was *Chez le Père Lathuille,* another work in the series of café scenes that Manet produced in the late 1870s (pages 146-154), depicting the terrace of the popular restaurant near the Café Guerbois, for which Louis Gauthier-Lathuille, the proprietor's son, and the actress Ellen Andrée posed, although a different female model was used to complete the work. In the end both works were submitted to the Salon of 1880. Reviewing the exhibition Zola, who was by then a wealthy and successful novelist, described the work of a man he clearly considered his protégé:

a *plein-air* scene, *Chez le Père Lathuille* has an astonishing gaiety and delicacy of tones. Fourteen years ago I was one of the first to defend Manet against the imbecilic attacks of the public and press. Since then he has worked hard, constantly battling, impressing himself on men of intelligence with his rare artistic qualities and the sincerity of his efforts, an originality, so apparent and distinctive, of his color.

Portrait of Clemenceau at the Tribune, 1879-80

Oil on canvas
46×37 inches (116×94 cm)
Kimbell Art Museum, Fort Worth

Georges Clemenceau (1841-1929), political radical and committed Dreyfusard, who went on to become Prime Minister of the Third Republic in the twentieth century, had been the president of the Paris municipal council until he was succeeded by Manet's younger brother Gustave in 1876. He was to found his radical journal *La Justice* a few months after this work was begun. This and another similar portrait of the politician (Musée d'Orsay, Paris) were probably painted at the same time, in the winter of 1879-80, as there are a couple of letters from the sitter to the painter rearranging appointment times. Neither work appears to have been finished, presumably because of the politician's busy schedule, although contemporary reports suggest he was dissatisfied with both images. According to Tabarant, who met Clemenceau, Gustave Manet arranged the sittings

In 1879, Clemenceau renewed his appeals to the Chamber of Deputies to grant a general amnesty to persons convicted for their association with the Commune.

The Deputy for Montmartre was brought to the studio in the rue d'Amsterdam by the artist's younger brother, Gustave Manet. Gustave was an inspector of prisons and was interested in politics and knew the magistrature. Whatever might be said to the contrary, Clemenceau posed several times at the studio, and remarked in connexion with these visits: 'I so enjoyed chatting with Manet! He is so witty.'

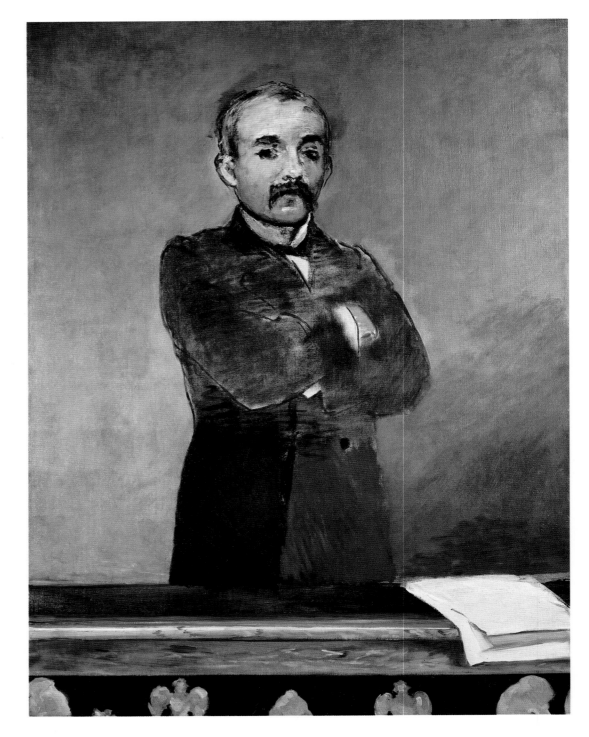

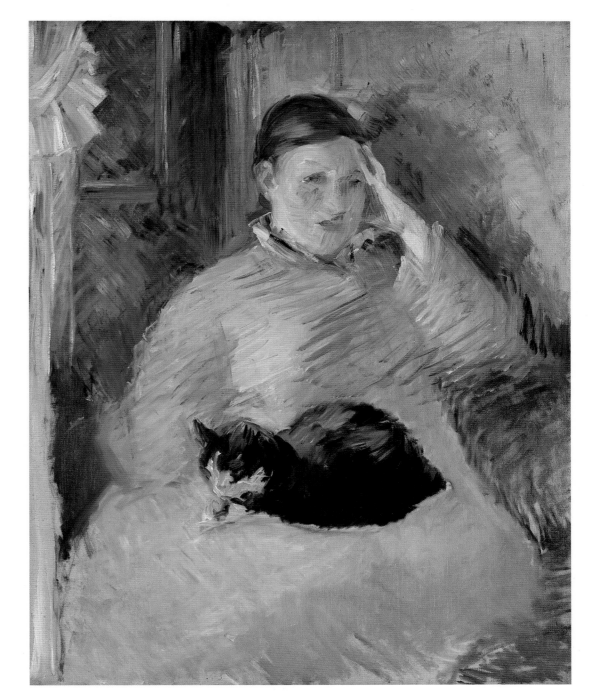

Portrait of Mme Manet, 1882

Oil on canvas
36¼×28¾ inches (92×73 cm)
Tate Gallery, London

According to Léon Koëlla-Leenhoff, who
would have been almost thirty when this
work was painted, it was done not in
Manet's studio but rather in their apart-
ment at 39 rue de Saint-Pétersbourg, to
which the family moved in 1878. It is
unclear when precisely Suzanne Manet sat
for her portrait, but recent opinion sug-
gests that it may have been painted the year
before Manet's death. From about 1880
there had been a marked deterioration in
the painter's health and he had undergone
a series of courses of hydrotherapy and
vacations in the country in an attempt to
find a cure for the pain in his legs caused by
locomotor ataxy and syphilis. The large,
complex, and detailed Salon paintings of
his youth gave way to much more intimate,
smaller works, often still lifes (pages 163-
165 and 169) and rapidly executed
esquisses, like this portrait.

Manet had met the Dutch pianist
Suzanne Leenhoff (1830-1906) in 1849
when she gave music lessons in the Manet
household and they married in 1863.
Earlier portraits of her (pages 92 and 134)
show her within a domestic environment,
often somewhat distant. This work, rather
more informal, shows her looking out of
the picture space while a veil of rapidly
hatched fluid strokes fuse her face, dress,
the sofa and the cat on her lap.

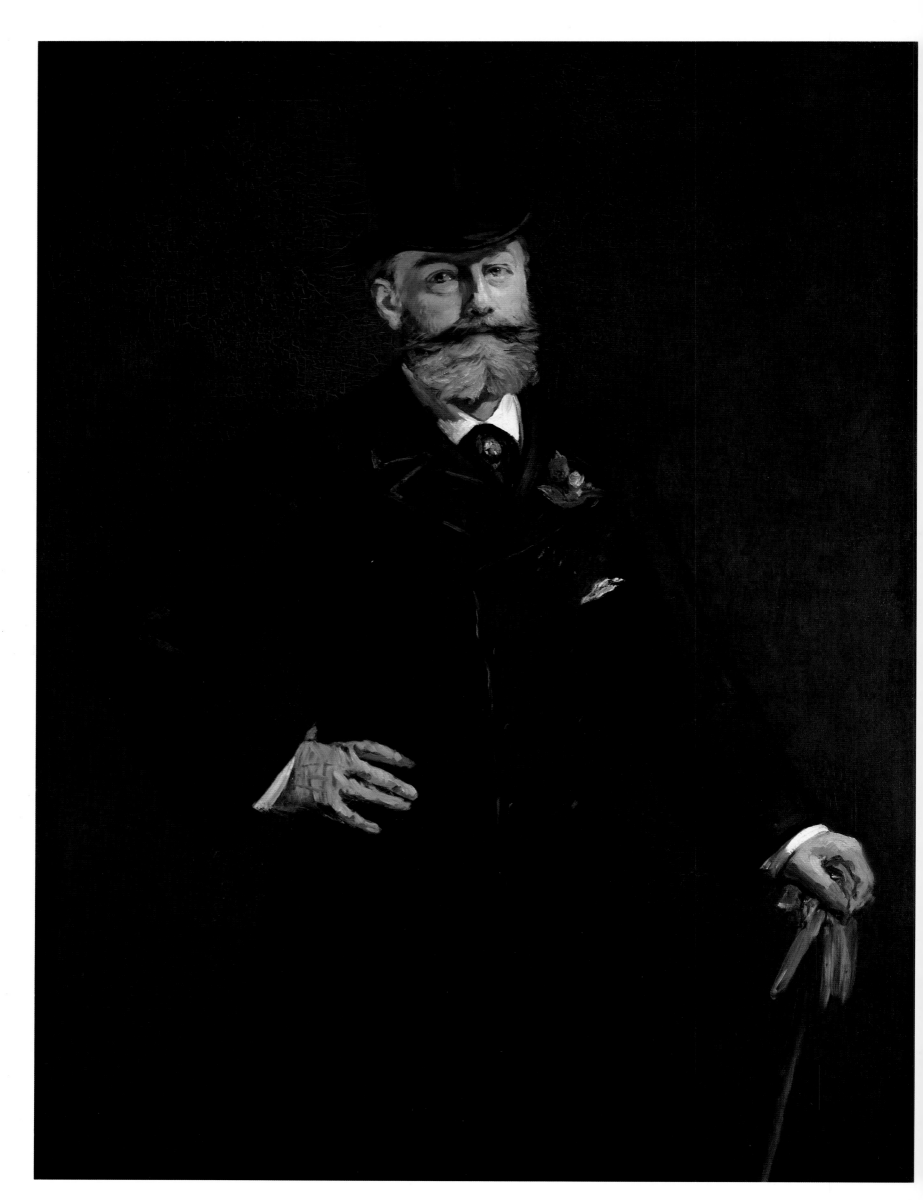

Portrait of Antonin Proust, 1880

Oil on canvas
51×37¾ inches (129.5×96 cm)
Toldeo Museum of Art, Ohio

According to Antonin Proust (1832-1905), in 1879 Manet planned the two paintings which he was to show at the following year's Salon, with extreme precision. These were *Chez le Père Lathuille* (page 158) and this portrait, which Manet planned to execute;

on a non-prepared white canvas in a single sitting. . . . After using up seven or eight canvases, the portrait came off in one go. Only the hands and certain parts of the background remained to be done. In the evening when he had finished this portrait, he turned it face to the wall as he did not want to show it to anybody until it was framed.

The two had met as pupils at the Collège Rollin and Proust is now best remembered for the reminiscences about Manet's early life and time when they were both students at Couture's, which were serialized in the *Revue Blanche* in 1897 and published as a book *Edouard Manet, Souvenirs* in 1913. There is perhaps a sense of the kind of 'concessions' here with which some critics had recently begun to charge Manet in his Salon paintings, not only in the elegance of the sitter, who was to become Minister of Fine Arts at the end of the following year, but also in the rather finished nature of the work, which belies Proust's claim that the work was produced in a single session. Despite sympathetic reviews, Manet was not pleased with the work's reception and wrote to Proust:

Your picture has been on exhibition in the Salon for the last three weeks – badly hung near a door, on a divided panel and, even worse, criticized. But it seems to be my lot to be reviled and I take it philosophically. . . . Your portrait is painted with the utmost sincerity possible. I remember, as if it were only yesterday, the quick and simple way I treated the glove you're holding in your bare hand and how, when you said to me at that moment, 'please not another stroke,' I felt in complete sympathy with you and could have embraced you.

During his short tenure as Minister for Fine Arts Proust managed to secure the Légion d'honneur for his friend.

The Asparagus, 1880

Oil on canvas
6×8 inches (16×21 cm)
Musée d'Orsay, Paris

Bunch of Asparagus (page 164) was painted for Charles Ephrussi (1849-1905), the collector, and owner and director of the *Gazette des Beaux-Arts* from 1885, who had commissioned it for 800 francs. So pleased was he with the result that he sent Manet 200 francs above the agreed price and the painter sent him this tiny canvas by return with a note explaining 'there was one missing from your bunch'.

The freedom with which the work is painted, the fluidity of the pigment, the merest suggestion of the table-top and the nonchalant initial in the upper-right-hand corner are in marked contrast to the finished and detailed quality of the main work and demonstrate the visible difference between a small intimate sketch and a larger, public work.

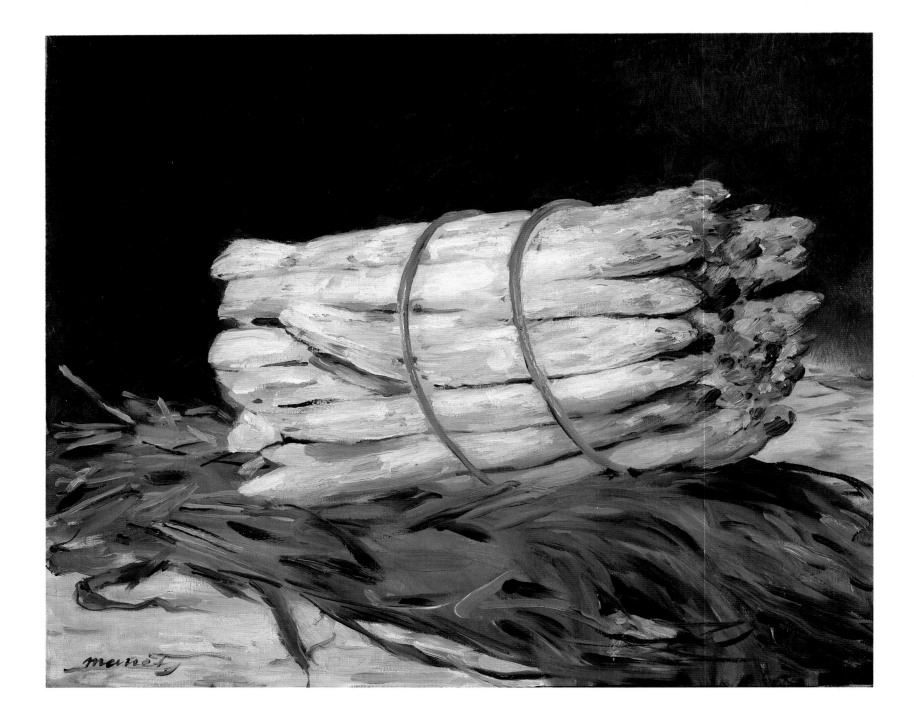

Bunch of Asparagus, 1880

Oil on canvas
18⅛×21⅝ inches (46×55 cm)
Wallraf-Richartz-Museum, Cologne

The syphilis and the locomotor ataxy from which Manet was suffering by the end of the 1870s caused him much difficulty in moving and he was reluctant now to embark upon huge canvases as readily as he had earlier in his life. Despite rest and courses of hydrotherapy his mobility did not improve and many of the works produced towards the end of his life tend to be small. Following the notion of the hierarchy of the genres, which had long been a central tenet of academic theory, still-life paintings, by virtue of the absence of people, were relegated to the lowest level and were correspondingly small in size. It is not coincidental that those early critics who were hostile to his work, or those who damned it by faint praise, conceded that Manet was a fine still-life painter. At the same time, an expansion of the art market from the early 1860s and a loosening of the State monopoly of the Salon for exhibitions meant that there was a growth in art dealers and a corresponding expansion in a middle-class market which clearly did not wish to purchase for a domestic setting large and arcane history paintings more appropriate for the Salon. The bourgeois simplicity of the still-life perfected by Chardin in the eighteenth century became popular again and some of the finest of Manet's late works exploit the genre.

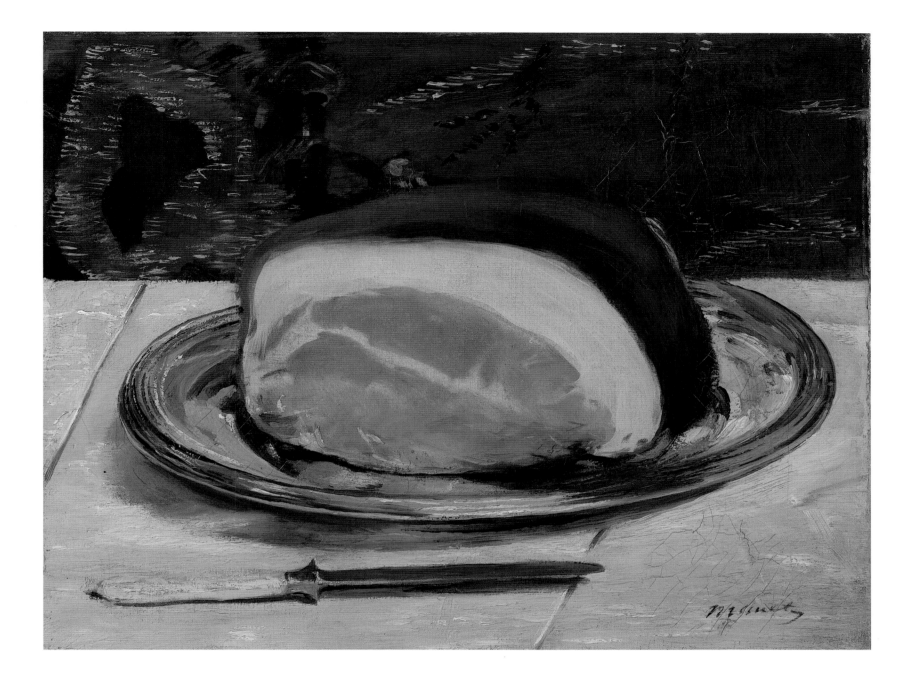

The Ham, 1880

Oil on canvas
12⅝×16½ inches (32×42 cm)
Burrell Collection, Glasgow

Part of a series of still-life paintings that Manet produced towards the end of his life (pages 163 and 164), *The Ham* is quite unprecedented in his oeuvre and indeed rare in nineteenth-century French art. Still lifes tended to be of fruit, flowers, fish, rarely of game (page 169), and only very exceptionally of butchered meat.

Because the painting is unique it is notoriously difficult to date. It has traditionally been assigned a date of around 1880 because it was first owned by Pertuiset the lion hunter (page 170) who purchased a number of Manet's late still lifes

directly from the painter. In the background, however, a wall-hanging very similar to that found in works of the late 1870s, like *Nana* (page 141) and *Portrait of Stéphane Mallarmé* (page 139) is visible (in fact there appears to be a pair of crane's legs in the upper-right-hand corner which are similar to those in *Nana),* which may suggest a slightly earlier date. The finished picture has been cut from a larger canvas, and Manet seems deliberately to have aimed for a much less complex image with a radical flattening of space, typical of the Japanese-print-influenced paintings.

The Escape of Rochefort, 1880-81

Oil on canvas
57½×46 inches (146×116 cm)
Kunsthaus, Zürich

Henri Victor Rochefort, born the Marquis de Rochefort-Luçay (1830-1913), had been a committed Republican and active opponent to Napoleon III and had been imprisoned for his political beliefs until the Second Empire collapsed in September 1870. He was a member of the government of the National Defense during the seige of Paris and in his profession as pamphleteer he supported the Communards which led to his being exiled to the penal colony on New Caledonia in 1874. Three months later he managed to escape with three other men and they were taken by an Australian ship to America, from where he returned to Europe and continued his journalism in Geneva. It was only after the general amnesty had been granted to the Communards in July 1880 that he man-aged to return to France and established the radical newspaper *L'Intransigeant*. Some time after Rochefort's return Manet decided that this romantic adventure of a Republican hero would make an ideal subject for his next Salon painting in the vein of contemporary history painting which he had explored with *The Execution of the Emperor Maximilian* (pages 86-90) and the *marine* of the battle of the *Kearsarge and the Alabama* (page 65). He therefore produced two canvases of the scene, in which he has taken certain liberties with the representation, giving Rochefort a prominent place at the tiller and setting the scene during daylight, both of which conflicted with the account of the escape. In the end, neither version met with his satisfaction and they were substituted by a *Portrait of Rochefort*.

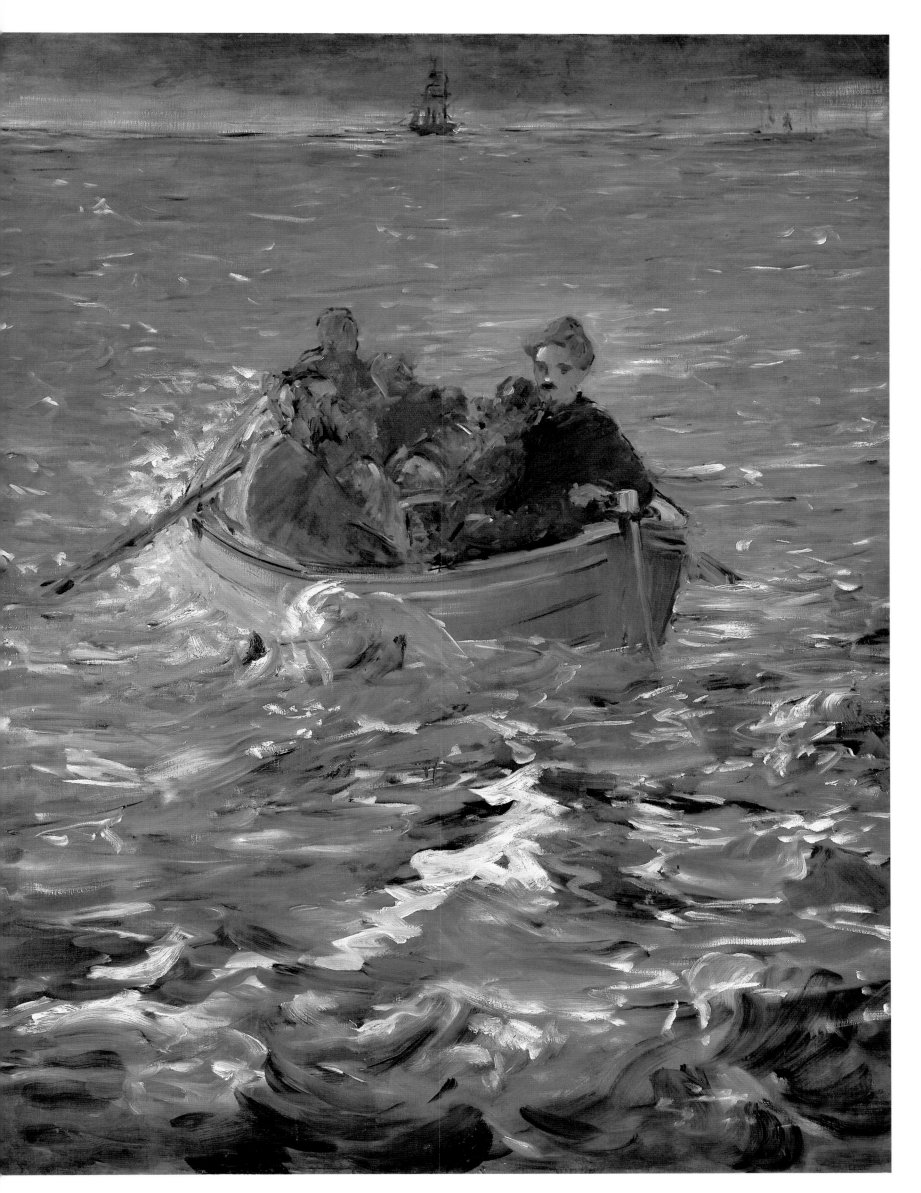

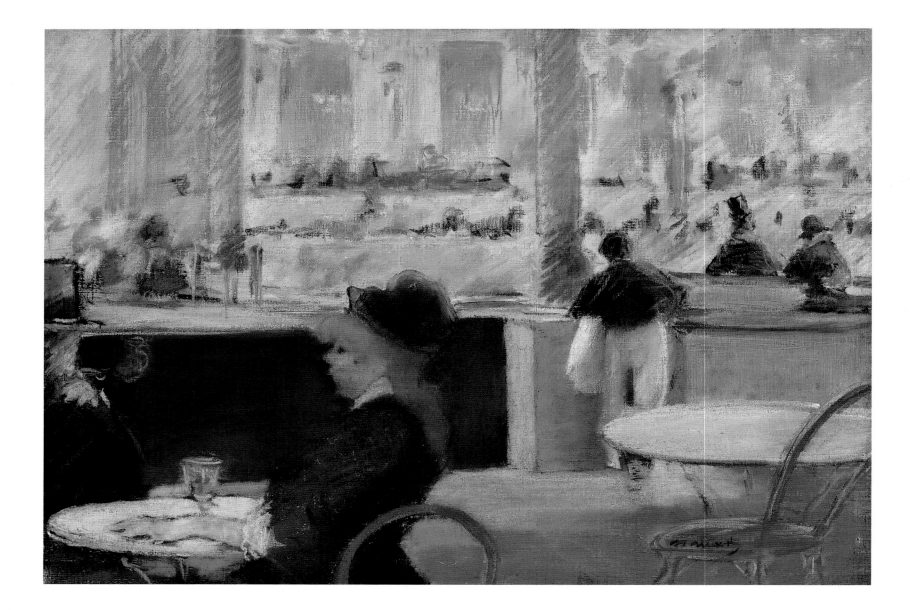

Café on the Place du Théâtre-Français, 1881

Pastel
12⅝×17¾ inches (32×45 cm)
Burrell Collection, Glasgow

After early experiments in pastel with works like *Madame Manet on a Blue Couch* (page 134), Manet quickly assimilated the medium and exploited it in the rapidly executed strokes which lend to the mood and narrative of this little piece. Proceeding by a system of clues, he builds up a description of a member of the Parisian working classes in the young woman who occupies the foreground of the work. She is depicted at ease, sitting at a curious angle on the bentwood chair. Her hands are outstretched on the table top in front of her, encircling a single drink which lies untouched and which suggests that she was alone before being joined by the shadowy male figure who sits opposite her and who is apparently arbitrarily cut off by the pic-

ture frame. His dark clothing, top hat, and fat cigar are in marked contrast to her costume and the difference in their social classes is made clear with great economy of means. Although some transaction appears to be taking place, the young woman is clearly not a professional street walker, but perhaps one of the growing band of immigrant laboring women who had flocked to the capital and who had to supplement their meager incomes by occasional prostitution. The general haziness of the technique used in the pastel suggests not only the alienating environment in which she is forced to operate but also a world in which social distinctions appear increasingly blurred and distorted, a feature to some extent of all Manet's café scenes.

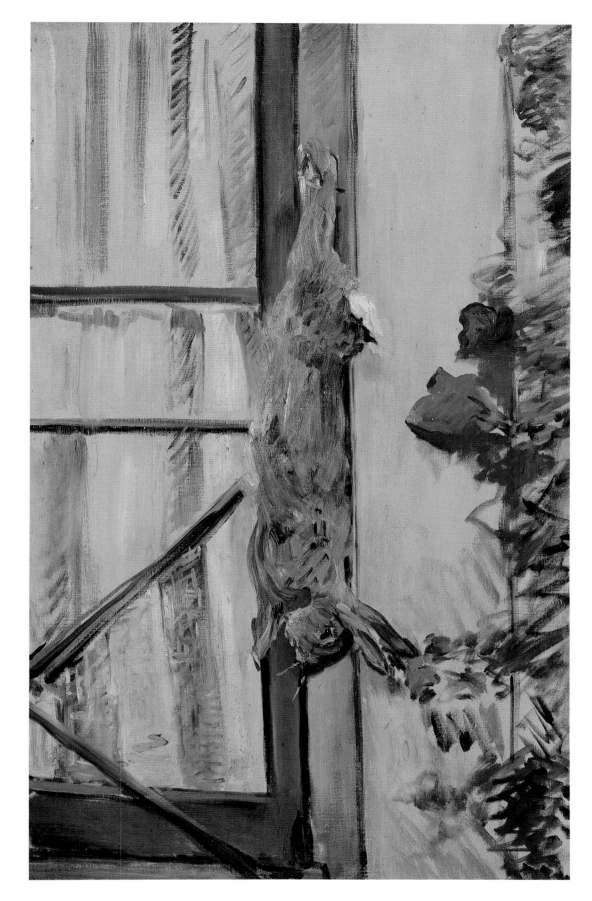

The Rabbit, 1881

Oil on canvas
37×23 inches (94×58.5 cm)
National Gallery of Wales, Cardiff

In the late spring of 1881 Manet's doctor prescribed rest in an attempt to alleviate his illness and at the end of June he went to spend the summer at Versailles. In a letter to Eva Gonzalès he complained about this enforced exile:

Like you, alas, we have been having frightful weather. I believe it's been raining here for a good month and a half. And so, having come to do some studies in the park laid out by Lenôtre, I've had to content myself with painting only my garden, which is the unloveliest of gardens. A few still lifes, and that's all I'll bring back . . . '

This is doubtless one of the paintings to which he referred, a study of a dead rabbit hanging from a nail outside a window and one of a series of four decorative panels, all of approximately the same size, of dead game, flowers and a corner of the garden.

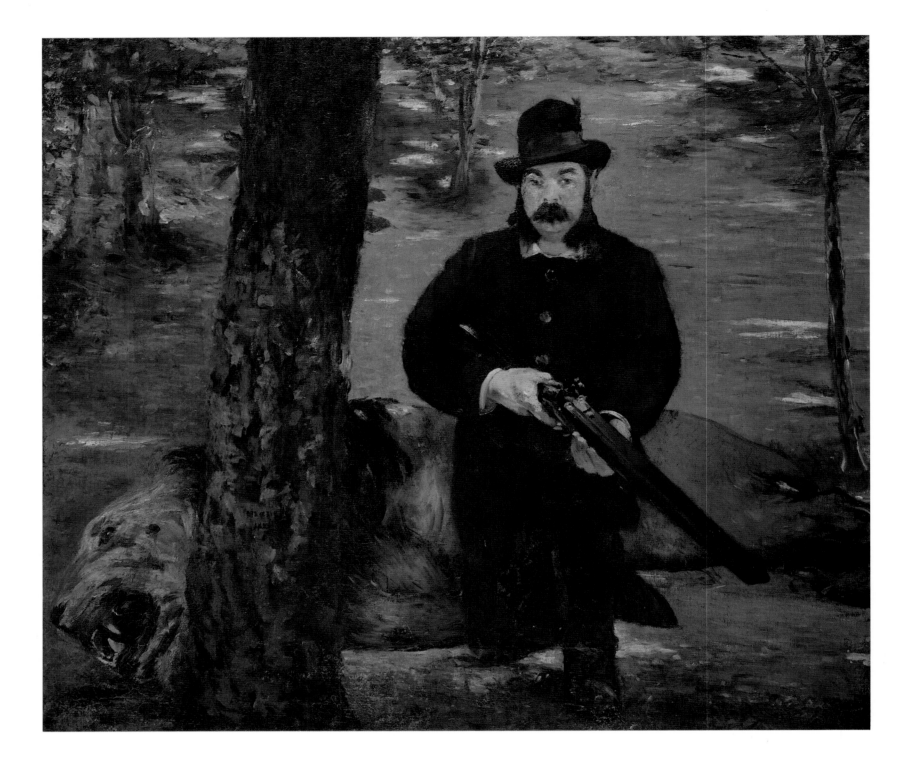

Portrait of Pertuiset, the Lion Hunter, 1881

Oil on canvas
59×67 inches (150×170 cm)
Museu de Arte, São Paulo

The explorer, big-game hunter and occasional painter Eugène Pertuiset owned this and a number of other canvases by Manet. It was submitted to the Salon of 1881 with the *Portrait of Rochefort,* perhaps in an attempt to deflect attention from the subject of that work, since the amnesty for Communards was still a politically sensitive issue with some Parisians. If it was intended as a conciliatory gesture, then the ruse worked, for Manet was given his first Salon recognition since *The Spanish Singer* (page 33) of 1861 and was awarded a second-class medal which made him exempt from the selection procedure at any future exhibitions.

It was Manet's largest Salon painting for many years and the handling of the subject is strangely mannered, almost as if Manet were deliberately imitating a stiffly posed studio photograph. There has been no attempt to suggest an exotic location and the setting is demonstrably Pertuiset's garden in Montmartre, although the figure had been posed in Manet's studio along with the far-from-convincing lion skin.

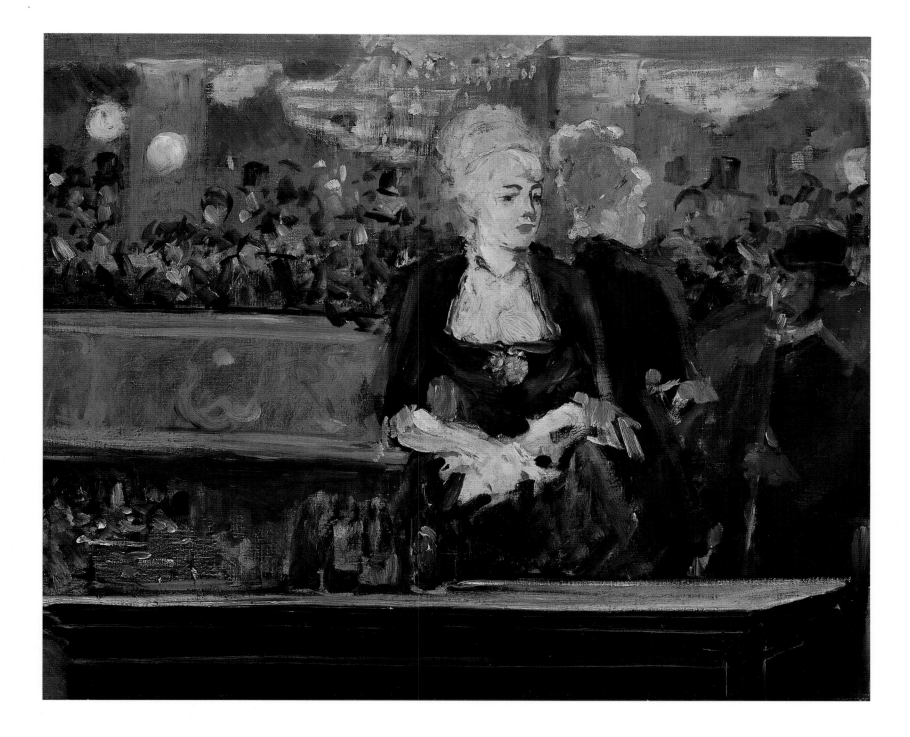

A Bar at the Folies-Bergère, 1881

Oil on canvas
18⅛×22 inches (47×56 cm)
Stedelijk Museum, Amsterdam

After the summer spent resting at Versailles where, according to letters he sent to friends in Paris, Manet failed to paint much that satisfied him, he seems to have returned to the capital determined to paint another unequivocal representation of modern life to send to the following year's Salon, the first where he did not need to submit his work for the approval of the jury. The Folies-Bergère, a café-concert at 32 rue Richer, near the boulevard Montmartre, provided him with the subject-matter for the final canvas in a series of café paintings which he had begun in the late 1870s (pages 146-154). One of a number of cabarets which had first been patronized

by the working classes, it had quickly become fashionable with the bourgeoisie in search of déclassé thrills and was widely recognized as providing a suitable opportunity to meet prostitutes.

It would seem that Manet planned the work as a Salon painting from the outset, planning it carefully through a series of sketches done on the spot and by this complex oil sketch which according to Léon Koëlla-Leenhoff was executed in the studio, the model for the barmaid being posed by a different woman from the one who appears in the final version, and her male customer apparently modelled by the military painter Henry Dupray.

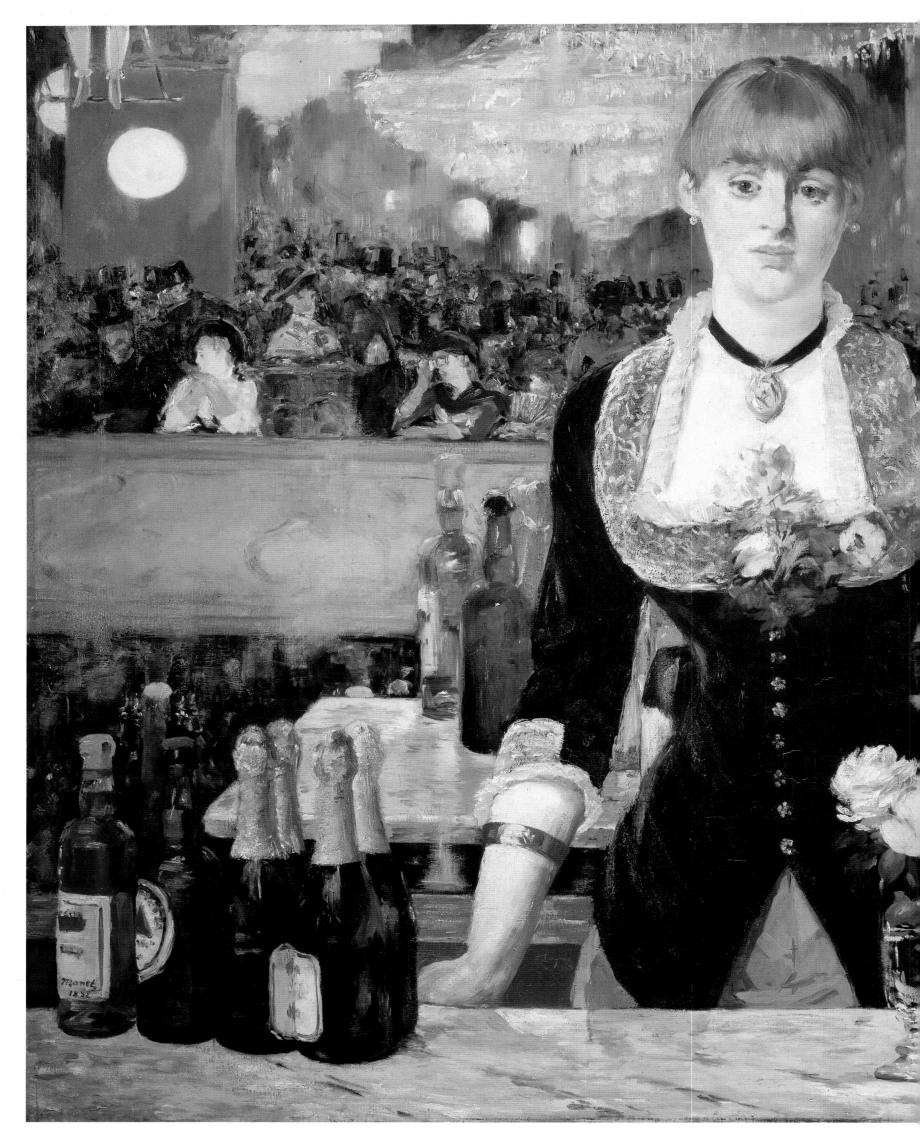

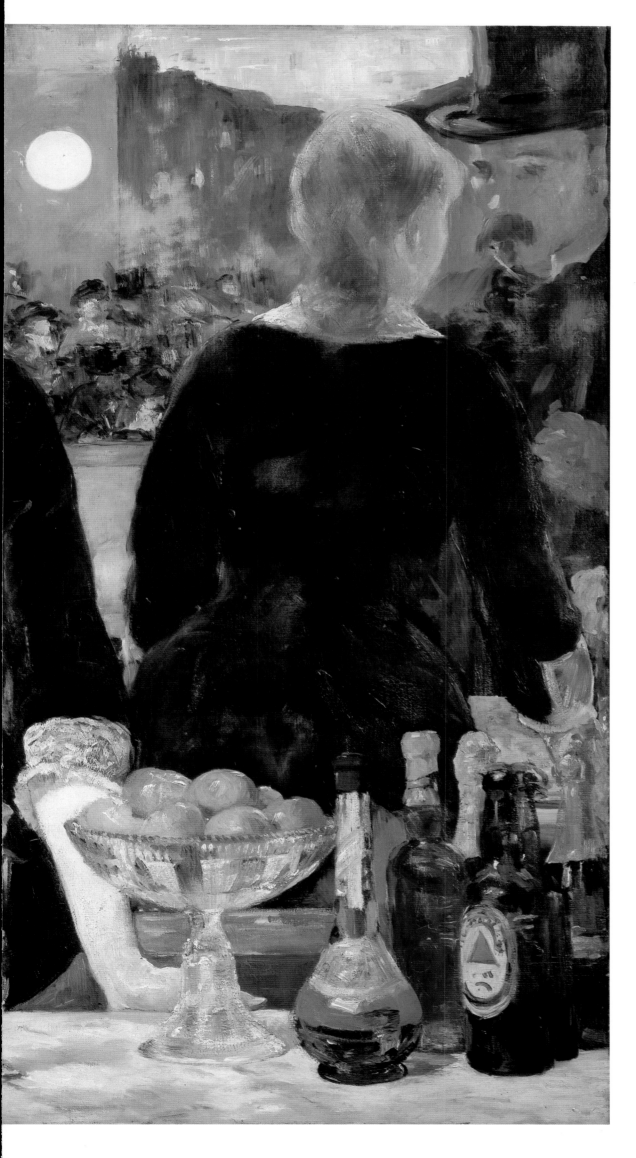

A Bar at the Folies-Bergère,
1881-82
Oil on canvas
38×51 inches (96×130 cm)
Courtauld Institute Galleries, London

A Bar at the Folies-Bergère was sent with *Jeanne* (Private Collection) to the Salon of 1882. It is arguably a more ambitious and finished work than earlier Salon paintings, in which Manet has tried to synthesize a number of themes which had interested him since the early 1860s and is a noteworthy exception to the increasingly sketchy and intimate paintings that he had been constrained to paint as his illness grew worse. An account by the young painter Georges Jeanniot, who visited Manet's studio while the work was in progress gives some idea of the physical effort the work cost him:

the model, a pretty girl, was posed behind a table loaded with bottles and victuals. Manet recognized me immediately and, shaking my hand said, 'It's annoying but excuse me, I am obliged to remain seated . . .' Manet stopped painting to sit on the divan which was against the right-hand wall. It was then that I noticed now much his illness had affected him. He walked leaning on his stick, and seemed to tremble. But, for all that, he remained cheerful and talked about his impending cure.

The models for the finished version have changed from those used for the sketch: the painter Gaston Latouche is the customer looming over the barmaid in the reflection in the mirror, and she was modelled by a young woman named Suzon who worked at the Folies-Bergère. The changes from sketch to final painting highlight a number of discrepancies in the work. Because of the use of the mirrored background and the reflection of the elegant dandy in the upper-right-hand corner, one is forced to conclude that the spectator, and certainly the Salon spectator for whom it was originally conceived, is entering into some kind of typical negotiation with the young barmaid. The difference between the aloof exterior which she projects to the outer world and her rather more accommodating alter ego which leans invitingly towards her male customer in the mirror, hints at the kind of shady transactions that were struck at the Folies-Bergère.

Index

Acknowledgments

The publisher would like to thank Martin Bristow, who designed this book, Sara Dunphy, the picture researcher, Alice Mackrell, the indexer, and Aileen Reid, the editor. We would also like to thank the following agencies and institutions who supplied the illustrations:

The Art Institute of Chicago: pages 7 (The Stickling Fund, 1905), 12 (F S Worcester Collection), 22 (Charles Netcher, in memory of Charles Netcher), 64 (Mr and Mrs Lewis Larned Coburn Memorial Collection), 69 (Gift of James Deering), 72 (A A Munger Collection), 81 (Mr and Mrs Potter Palmer Collection)

Barnes Foundation, Merion Station, PA 19066: page 15 (photo © 1992 Barnes Foundation)

Bettman Archive/Musée d'Orsay, Paris: page 19 (above)

Bibliothèque Nationale, Paris: page 14 (above; Photo Bulloz)

Bridgestone Museum of Art, Tokyo: page 145 (Ishibashi Foundation)

Bridgeman Art Library/Galleria degli Uffizi, Florence: page 9 (above)

Bridgeman Art Library/Museo del Prado, Madrid: page 21

Bridgeman Art Library/Private Collection: page 144

BPA: page 24 (below)

Burrell Collection, Glasgow: pages 148, 165, 168

Calouste Gulbenkian Foundation Museum, Lisbon: page 29

Courtauld Institute Galleries, London: pages 58-59, 172-173 (Courtauld Collection)

E G Bührle Foundation, Zurich: page 112

Folkwang Museum, Essen: page 143

Kimbell Art Museum, Fort Worth, Texas: pages 19 (below), 160

Kunsthalle, Bremen: pages 74-75

Kunsthalle, Hamburg: page 141

Kunsthaus, Zurich: page 167

The Metropolitan Museum of Art, New York: pages 9 (below; Gift of Mrs Ralph J Hines, 1955), 33 (Gift of William Church Osborn, 1949), 38-39 (Purchase, Mr and Mrs J Bernhard Gift), 40 (Gift of Erwin Davis, 1889), 49 (Bequest of Mrs H O Havemeyer, 1929, The H O Havemeyer Collection), 55, 63 (both Bequest of Mrs H O Havemeyer, 1929, the H O Havemeyer Collection), 77 (Gift of Erwin Davis, 1889), 80 (Wolfe Fund, 1909, Catharine Lorillard Wolfe Collection), 83, 124-125 (both Bequest of Mrs H O Havemeyer, 1929, The H O Havemeyer Collection), 130-131 (Bequest of Joan Whitney Payson), 155 (Bequest of Mrs H O Havemeyer, 1929, The H O Havemeyer Collection)

Musée des Beaux-Arts, Lyons: pages 26, 28

Musée des Beaux-Arts, Tournai/Photo Giraudon, Paris: pages 127, 158-159

Musée Carnavelet, Paris/Photo Bulloz: page 11

Musée du Louvre, Département des Arts Décoratifs/Réunion des Musées Nationaux: page 14 (below)

Musée d'Orsay, Paris/Réunion des Musées Nationaux: pages 6, 8, 13, 16, 17, 20, 31, 53, 56-57, 60-61, 73, 78-79, 92-93, 94, 100, 102-103, 117, 118-119, 134-135, 139, 154, 163

Musée du Petit Palais, Paris/Photo Musées de la Ville de Paris: page 18

Museo Nacional de Bellas Artes, Buenos Aires: page 36

Museu de Arte de São Paulo: pages 138, 170

Museum of Art, Rhode Island School of Design, Providence: pages 1, 109 (Bequest of Mrs Edith Stuyvesant Gerry)

Courtesy, Museum of Fine Arts, Boston: pages 36 (Bequest of Sarah Choate Sears in memory of her husband, Joshua Montgomery Sears), 86-87 (Gift of Mr and Mrs Frank Gair Macomber)

Nasjonalgalleriet, Oslo: pages 84-85

Nationalgalerie, Berlin: pages 156-157

National Gallery, London: pages 50-51, 88-89, 107, 152

National Gallery of Art, Washington DC: pages 10 (Harris Whittemore Collection), 42-43 (Chester Dale Collection), 66-67 (Widener Collection), 70 (Gift of Eugene and Agnes Meyer), 71 (Gift of Edith Stuyvesant Gerry), 114-115 (Gift of Horace Havemeyer, in memory of his mother, Louisine W Havemeyer), 120-121 (Gift of Mrs Horace V Havemeyer, in memory of her mother-in-law, Louisine W Havemeyer), 146 (Collection of Mr and Mrs Paul Mellon)

National Gallery of Wales, Cardiff: page 169

Neue Pinakothek, Munich: pages 2, 98-99, 128-129

Norton Simon Art Foundation, Pasadena, California: page 104

Ny Carlsberg, Glyptothek, Copenhagen: page 27

Oskar Reinhart Collection 'am Römerholz,' Winterthur: pages 121-123, 150-151

Philadelphia Museum of Art: pages 25 (the Henry P McIlhenny Collection, in memory of Frances P McIlhenny), 65 (the John G Johnson Collection)

Shelburne Museum of Art, Shelburne, Vermont: pages 136-137

Städtische Kunsthalle, Mannheim: pages 90-91

Stedelijk Museum, Amsterdam: page 171

Szépmüvészeti Museum, Budapest: pages 44-45, 111

Tate Gallery, London: page 161

Toledo Museum of Art, Toledo, Ohio: page 162

Wadsworth Atheneum, Wadsworth, Connecticut: page 24 (above; Bequest of Anne Parrish Titzell)

Wallraf-Richartz-Museum, Cologne: page 164

Walters Art Gallery, Baltimore, Maryland: page 149

Yale University Art Gallery, New Haven, Connecticut: page 46 (Bequest of Stephen Carlton Clark, BA 1903)